City / Art

City/Art

THE
URBAN SCENE
IN LATIN AMERICA

REBECCA E. BIRON,

EDITOR

Duke University Press

Durham and London

2009

© 2009 Duke University Press

All rights reserved

Printed in the United States

of America on acid-free paper ♾

Designed by Amy Ruth Buchanan

Typeset in Quadraat by

Tseng Information Systems, Inc.

Library of Congress Cataloging-in-

Publication Data appear on the last

printed page of this book.

To Miami

Contents

Acknowledgments

The idea for this collection first arose at the 2002 Latin American City Symposium hosted by the University of Miami. I coordinated that event in conjunction with my course, "Problems in Cultural Analysis: The Latin American Mega-city," and with the University of Miami School of Architecture's conference, "New Civic Art: Euro-Latin American Connections." I am deeply grateful to the symposium's sponsors at the University of Miami: the Department of Foreign Languages and Literatures, the Joseph Carter Memorial Fund, the Center for Latin American Studies, and the dean of the College of Arts and Sciences. I also thank the individual participants and supporters of the Symposium: David Ellison, Robert F. Levine, James Wyche, Lillian Manzor, Christina Civantos, Viviana Díaz Balsera, Marc Brudzinski, Elena Grau-Llevaría, Steven Butterman, Jane Connolly, Greta West, Gylla Lucky, Lilly Leyva, Jean-François LeJeune, Felipe Agüero, Bill Smith, Steve Stein, Roxana Dávila, Daniel Balderston, Debra Castillo, Nelson Brissac Peixoto, Adrián Gorelik, Amy Kaminsky, José Quiroga, Nelly Richard, Marcy Schwartz, George Yúdice, Cristina Mehrtens, Raúl Rubio, Laura Podalsky, Carlos Monsiváis, Beatriz Sarlo, Carlos Alonso, Celeste Delgado, Ralph Heyndels, Juan Carlos Pérez, and Michelle Warren. Discussions with the students in my 2002 course contributed much to the focus of this volume; I thank María Isabel Alfonso, Michel Arellini, Greg Barnett, Meredith Chin-Sang, Iván Figueroa, Amanda Goldberg, Letitia James, Martín Ponti, Salvador Raggio, Alberto Vaquer, Nick Belha, and Rosario Ramírez for their enthusiastic and insightful participation. Dartmouth College provided me with sabbatical support and research funds that made the final preparation

of this volume possible. Miguel Valladares and Dennis Grady assisted with the location and reproduction of many of the images included here. Miguel Valladares also lent his extraordinary research expertise to the chasing down of elusive bibliographic materials. I thank the editors and production team at Duke University Press, as well as the attentive anonymous readers whose excellent advice significantly improved this collection. My deepest gratitude goes to Michelle Warren for her careful reading and suggestions regarding the introductory essay.

James Holston's essay, "The Spirit of Brasília" originally appeared in *Brazil: Body and Soul*, copyright 2001 The Solomon R. Guggenheim Museum, New York. It is reprinted here with permission.

Introduction
City/Art: Setting the Scene

Rebecca E. Biron

La ciudad entonces tiene y vive el color del símbolo. Y el símbolo de cada ciudad no se produce solo, sino en estrecha convivencia y por tejido hecho por los ciudadanos que la habitan, la recorren y la representan. La ciudad de ese modo es creación estética permanente. Y también tejido simbólico.

—Armando Silva, *Imaginarios urbanos, Bogotá y São Paulo*

Rio de Janeiro. Miami. Buenos Aires. Mexico City. São Paulo. Santiago de Chile. Caracas. Lima. Havana. Bogotá. Montevideo. Brasília. La Paz. Tijuana. These cities are nodal points in Latin America's cultural tapestry. They provide that tapestry with strength and structure, but they also pose knotty problems for those who wish to identify and appreciate all the threads they bring together. Students of today's Latin American urban scene face the challenge of untangling the historical, economic, and political threads that combine to produce these cities. At the same time, they must avoid reducing each lived, creative city to any one of those threads; such limitation would render the cultural tapestry illegible. The cities one can live in, visit, or analyze emerge as the material results of violence and social conflict, ideological agendas, economic practices, architectural vision, and survival strategies. Some of these elements are formal, legally sanctioned, and organized; they have names. Others are informal, illegal, or spontaneous; they may be anonymous or collective. All of these creative forces intertwine with one another to produce cities that are inextricably tied to place and time even as they also participate in a global network of meanings.

This collection provides students and scholars of urban cultural studies

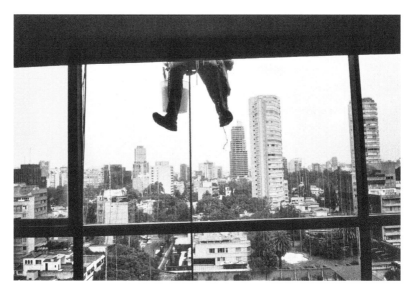

C. Madrazo Salinas, "Polanco Skyline," 1997. Photograph. Reprinted with permission. Copyright 1997 by the J. Paul Getty Trust. All rights reserved.

with a range of models for approaching Latin American cities as sites of creativity. Certainly, artistic representations of a city reflect the creative energy in that city. But what happens when one takes seriously Armando Silva's claim that the city itself is a permanent aesthetic creation? Cities can be considered works of art, where art is understood in its broadest sense as the material and performative expression of both ideas and sensibilities. Such an approach confronts the ways in which different urban imaginaries account for the spatial and temporal particularity of the Latin American urban scene.

Urban Imaginaries

Centers of world communication, economic exchange, and cultural expression, Latin America's cities bustle with the urgency of a perpetual present. At the same time, their physical grounding grants them special status as monuments and museums of history. The majority of today's urban centers were founded in the sixteenth and seventeenth centuries by Spanish and Portuguese colonizers. Therefore, they have a long history as administrative enclaves loosely tied together to weave into existence an entity called Latin America. Condensing the New World's immensity into specific places,

they embody the region's history. They display the evolution of the colonial ideal of ordered city planning into the frenetic movement of twenty-first-century megacities, mass migrations, and globalization. As with cities anywhere, seen from the air, they give the impression of carefully sculpted space; they reveal intricate patterns and designs. From the ground, however, they seem spontaneous. They provide a place to live or to work. They offer spaces that protect us, but they also confront us with spaces that frighten and threaten us.

Latin America's cities present the beauty of extreme contrast: design and dysfunction, control and chaos, the vast and the very small, the distant past and the distant future. These cities traditionally concentrate political and economic power in their respective countries, but they also intensify the conflicts generated by that power. Thus, since the European conquest, urban centers have served as rich indicators of the region's history and future. Not surprisingly, then, Latin America's largest cities figure among the forms of cultural expression that are the most difficult to study. In these urban centers, crowding increases cultural vibrancy along with social chaos. Violence often subtends the greatest levels of economic productivity. Approaching cities as sources of cultural information requires us to recognize their simultaneous status as elaborate physical spaces, economic systems, collective as well as individual experiences, communities, sites of alienation, zones of social conflict, and dreams (both idealistic and apocalyptic) of modernization and globalization.

Latin American urban studies in the last half-century has featured a number of geographers, demographers, sociologists, and policymakers who sound timely alarms about the social ills wrought by the emergence of the Latin American megacity in the twentieth century. Effective urban planning and the implementation of social policies depend on such powerful analyses of quantifiable and structural problems caused by overpopulation, rapid and uncontrolled immigration to urban centers, pollution, failed industrialization movements, and corrupt or inept local governments. An equally powerful analysis of the continually negotiated images of urban space, however, is required to produce an affective understanding of the lived city. Such analysis must eschew the rhetorical safety of objective distance; it must find ways to enter into the urban imaginary it hopes to describe.

The Mexican philosopher and educational activist, José Vasconcelos, wrote about what it means to enter into the urban imaginary after his first visit to Rio de Janeiro in 1925:

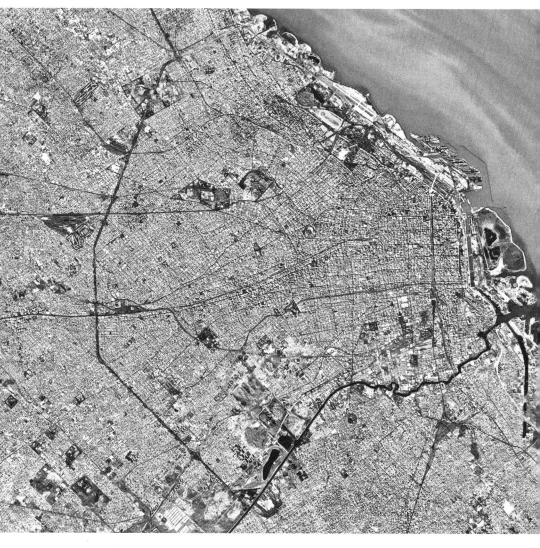

Satellite view of Buenos Aires, 1995. Instituto Geográfico Militar.

Elena Castro, "Calle del Cartucho." Photograph taken in Bogotá, 1992.
Reprinted with the artist's permission.

Entrar en la esencia de una gran ciudad es tarea complicada y fascinadora; se necesita una sensibilidad instantánea, una como telepatía para recibir a un tiempo muchos mensajes. Penetramos en los senderos nuevos, enlazamos analogías, nos remontamos a los antecedentes, abarcamos el conjunto, adivinamos mil proyecciones y perseguimos en el ambiente una íntima esencia creada por el roce y el ansia de las almas particulares. (Vasconcelos [1925] 1928, 53)

To enter into the essence of a major city is a difficult and fascinating task; you need an instantaneous sensibility, like telepathy, to receive multiple messages all at once. We forge paths, we connect analogies, we overcome antecedents, we grasp the whole of it, we divine a thousand projections, and we follow an intimate essence created by the friction and the yearning of individual souls.[1]

Today the urban scene in Latin America comprises an even more vertiginous array of messages and images than Vasconcelos confronted with such poetic sensibility. His argument that one must combine multiple forms of perception with intentional analysis in order to understand a city is more necessary now than ever before. A careful parsing of this passage will help frame key concepts and set the stage for my argument that critical engagement with cities must be approached as a creative art in the same way that today's cities themselves are best understood as knotty conglomerations of creative practices.

Vasconcelos begins by addressing the challenges of movement and definition. The goal is "to enter into the essence of a major city" rather than to describe it or fully account for it. Vasconcelos seeks "the essence" rather than a simple, direct definition or circumscription of the city. Notably, he does not mention buildings, infrastructure, politics, economics, or competing social groups when fleshing out what this concept implies. His search for the essence of the city focuses on the challenge posed to the traveler, to the person who wishes to enter the city. Thus, the urban scholar or critic imagines him- or herself, taking a physical journey in order to gain a type of knowledge that is to be "followed" rather than possessed.

Vasconcelos's elaboration of this journey addresses temporality, communication, direction, connection, originality, the relation of the whole to its parts, and the role of individuals in the constitution of the urban collective. Regarding temporality, Vasconcelos underscores the "instantaneous" nature of attending to many messages at once. In the Rio of the 1920s, this means

the messages sent to urban pedestrians by storefront advertisements, over-heard conversations, and styles of clothing. One might easily expand this reference to the instantaneous messages sent by old architectural styles that have endured for centuries to stand in aesthetic juxtaposition to new ones. Instantaneity in this case refers to the physical proximity of past and present in buildings and streets whose designs have evolved over time.

The idea of direction in the Vasconcelos passage combines space and time. He writes, "penetramos en los senderos nuevos," which I translated as "we forge paths." The Spanish phrase is richer than my translation would indicate; its ambiguous use of "new paths" allows for the possibility that they are forged for the first time, and that they are encountered for the first time by the first-person plural subject of *penetramos*. We penetrate, explore, or enter paths new to us; we also forge paths that have never been walked before. The urban traveler's role must be dual; we follow those who go before us, and we invent new itineraries.

"We connect analogies, we overcome antecedents." This rhetoric of bringing together disparate images and of adding to, or transcending, older stories also emphasizes temporality. Connecting analogies implies find-ing parallelism among different ways of entering the city. For example, a tourist or resident can stroll through the historic center to visit the colonial cathedral, the former palace, the administrative buildings, the plaza, and the open marketplace that remain in many Latin American cities today. It is possible to trace with one's steps the sites, architectural styles, and human impact of different forms of government and economy that have dominated these places. This journey in the present can parallel the historic passage of political epochs. The synchronic nature of the city, which can make the past visible in the present, ironically preserves the diachronic nature of the city, which requires us to acknowledge the many paths that have led to the present.

"We overcome antecedents, we grasp the whole of it." This segment of Vasconcelos's rhetorical thread indicates that our combination of syn-chronic and diachronic images of the city allows us to imagine the big pic-ture. Perhaps that was possible in 1925, but the scale of Latin America's twenty-first-century cities renders this statement absurdly romantic for our present. Interestingly, Vasconcelos immediately retreats from it, and offers his synthetic summation of what he believes to be the real task of the critical urban traveler: "We divine a thousand projections, and we follow an inti-mate essence created by the friction and the yearning of individual souls."

Here Vasconcelos seems to abandon the notion of "the whole of it." He now foregrounds creativity, diversity, and discontinuity. The thousand projections he refers to may come from city planners, governments, architects, scholars, or the city's heterogeneous residents. Vasconcelos's traveler, however, divines those projections, which is to say he or she imagines and interprets them based on the urban analogies and antecedent images or stories to which he or she has access. To this store of received and projected images and narratives the traveler adds an awareness of individual people and their experiences. After all, individuals make up the city. They do so in two ways. First, in the simple sense, population *makes* a city. In a more complex sense, by pointing out that the "friction and yearning" of individual souls creates the intimate essence of the urban, Vasconcelos suggests that real, conflictive experience combines with imagination and desire to *make up* a city. The city's essence consists of its inhabitants' real experience in the past and present as well as their yearning for the future. Combining the past, the present, and the future, the urban imaginary is both a real and a made-up projection.

By including both diachronic and synchronic perspectives, Vasconcelos's eloquent passage helps us to map the ways in which Latin American cities have been addressed within urban studies. Disciplinary differences lead scholars to privilege specific threads that are tied to other equally important threads in the urban knot. They tell the story of how Latin America's cities have developed by focusing on certain trajectories that typically track in tandem with other ways to map the passage from colonial settlements to today's teeming metropolises. Reading these histories of Latin American cities provides a hands-on exercise in "connecting analogies." Some studies focus primarily on changes in the region's political economy and governmental policies since the conquest.[2] A different frame for seeing the city emphasizes shifts in the relative power wielded by certain social groups.[3] Yet another emphasizes public policy and the problem of managing large urban systems.[4] Some accounts highlight nationalism and its ramifications for the rural/urban divide after the nineteenth-century independence movements.[5] Other narratives trace developments in urban planning, architecture, and aesthetics over time.[6] Still others explore the changes in how certain cities serve the global financial and communications network by debating the definition of global or world cities (Lo and Yeung 1998; Pacioni 2001; Sassen 1991, 2000).

All of these studies acknowledge the connections their narratives make to other disciplinary approaches. While they seldom provide one-to-one cor-

respondence in their organization of the major periods in Latin American urban development, they all generally account for how cities both reflect and influence the region's broad historical trajectory. These various ways of approaching the city in diachronic studies reveal a predilection for seeing cities as nerve centers for socio-economic projects, as providers of services, as uninhabited groups of buildings and street plans (one can certainly better appreciate the intricacies of baroque architecture when not distracted by passersby on the sidewalk), or as containers of representative social groups (Morse 1992).[7] All of these accounts illuminate important aspects of the city, but the current situation of Latin American urban centers exceeds their explanatory capacity. An additional "instantaneous sensibility" is required if we wish to engage productively with the cultural implications of the Latin American urban scene today.

Almost every type of historical narrative or current snapshot of Latin American cities culminates in a discussion of the contemporary crisis of urban definition and manageability. The region's enormous cities and conurbations,[8] with their teeming streets, towering buildings, and sprawling cityscapes, have long overshadowed pre-twenty-first-century images of the region as primarily rural and undeveloped. In *Planet of Slums* (2006), Mike Davis explores the causes and results of the fact that the worldwide urban population has now surpassed that of the countryside. Since the 1980s megacities (defined as cities with over 8 million inhabitants) and hypercities (those with over 20 million inhabitants) in Latin America have grown at rates that dramatically outstrip their capacity to manage or plan for urban expansion. For example, Mexico City's population was 2.9 million in 1950, and 22.1 million in 2004. In the same period of time, São Paulo went from 2.4 million to 19.9 million; Buenos Aires, from 4.6 million to 12.6 million; Rio de Janeiro from 3 million to 11.9 million; Lima from 0.6 million to 8.2 million; and Bogotá from 0.7 million to 8 million. And the population increases are not limited to these extremely large conurbations. Even though primary cities have traditionally shown the most growth, "secondary cities such as Santa Cruz, Valencia, Tijuana, Curitiba, Temuco, Maracay, Bucaramanga, Salvador, and Belem are now booming, with the most rapid increase in cities of fewer than 500,000 people" (Villa and Rodríguez 1996, 27). This vertiginous shift of the majority of the population to the cities reflects overurbanization, a situation in which cities grow in spite of not offering improved job opportunities or a quality of life superior to that of the countryside.[9]

In the early twentieth century, the region's largest cities benefited from

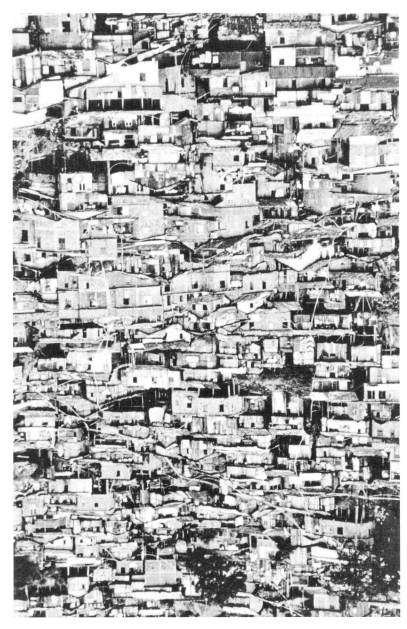

Evandro Texeira, "Favela doña Marta." Photograph taken in Rio de Janerio, 1988.
Reprinted with the artist's permission.

the era of import-substituting industrialization, during which Latin American countries invested heavily in the development and protection of local industry. The First World War and the Great Depression caused shortages of goods formerly exported from Europe and the United States, and Latin America's domestic industry profited. This shift attracted manufacturing plants and expanded government bureaucracies to the advantage of large cities (Szuchman 1996, 20–22). Capital cities in the region received direct investment from national governments to expand social services, architectural innovation, parks, roads, and public works. In turn, large urban migrations brought people streaming in from the countryside to fill the need for industrial labor and to enjoy new urban services. As a result, the period from 1940 to 1980 saw unprecedented urban growth and development.

However, the 1980s export-oriented model of development, applied in response to recession and debt crisis, severely harmed much of Latin America's domestic industry. Governments reduced protections against imports. Subsidies for national industry were curtailed. The largest cities, already becoming overburdened by swelling populations, saw their manufacturing capacities slowed. In the decade of the 1980s, for example, the gross national product of Latin America and the Caribbean declined by 8.3 percent (Gilbert 1994, 33). Absent the promise of continuing economic growth, the cities were less able to provide the advantages of upward mobility and social services they had formerly offered (Gilbert 1998, 196). Trade liberalization shifted wealth away from public development and toward transnational corporations, their managers, and stockholders. That process dramatically increased inequality in Latin America's metropolises. This social division appears in the uncontrolled growth of slums of all types and a concomitant increase in government-sponsored "slum clearance as an indispensable means of fighting crime" (Davis 2006, 111). As Alan Gilbert has pointed out, "the rich are able both to benefit from the advantages of large cities and to escape from most of the diseconomies. There may be excellent hospitals, clubs, restaurants, and universities in large cities, but most are open only to those with money. The poor might as well be living in a different city as far as these kinds of facility are concerned. . . . If the poor gain few of the advantages offered by the mega-cities, they reap most of the disadvantages," like traffic congestion, pollution, and the privatization of services traditionally considered infrastructure (such as water, street paving, and sewers) (Gilbert 1998, 193). While the scale of these problems has reached epic proportions,

the uneven distribution of the positive and negative aspects of city life is really nothing new to Latin America.

Long before the current urban demographic explosion, and indeed since the birth of the first Latin American cities during the European conquest, cities have loomed large as central sites in a complex struggle over the power to define the future of Latin America itself. The Aztecs, Mayas, and Incas had established large cities as much as a thousand years before the conquest. European invaders were stunned to find evidence of sophisticated urban planning and social management, sometimes in communities larger than the largest European cities. The Iberians' subsequent destruction of existing indigenous cities and the establishment of a new network of towns therefore played a powerful role in the creation of Latin America. Spanish and Portuguese colonial administration of the so-called New World relied on this early urbanization to facilitate the communication and exercise of

Unknown artist, *The Conquest of Tenochtitlán* (seventh painting in a cycle of eight), second half of the seventeenth century. Oil on canvas. Copyright by Jay I. Kislak Foundation, Miami Lakes. Reprinted with permission from the Kislak Collection, Rare Book and Special Collections Division, Library of Congress.

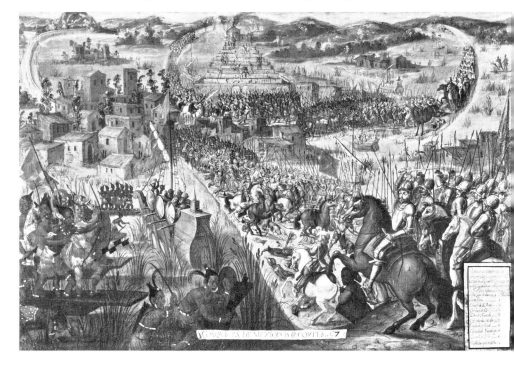

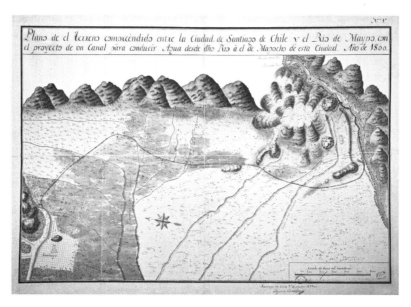

Plano de el terreno comprendido entre la Ciudad de Santiago de Chile y el Río Maypo con
el proyecto de un canal para conducir agua desde dicho río a el de Mapocho de esta ciudad,
Santiago de Chile, 1800. Manuscript map. Copyright by Archivo General de
Indias, Seville. A.G.I. Ref. Perú y Chile, 141.

royal authority. Colonial towns were designed to replicate the Iberian urban
model of the central plaza surrounded by administrative buildings, a church
or cathedral, and elite residences. Where topographically possible, streets
were planned in grids, ensuring a homogeneous, angular mapping of space
outward from the center. Relative distance from the central plaza signified
relative positions in the hierarchy of power.[10] The network of such settle-
ments centralized colonial administrative power physically and symboli-
cally throughout Latin America. Remarkably, as Alan Gilbert points out, this
urban web has remained in place, even though the size and manageability
of each city has drastically transformed the nature of Latin American urban
life (Gilbert 1994, 24).[11]

The tension between the archeological presence of pre-conquest urban
forms and the imposed morphology of colonial cities molded the physical
contours of many of the Latin American cities we see today. That same ten-
sion also shapes the social realities that urban planning and design attempt
to manage, contain, or eradicate, whether we are speaking of the colonial
period, the independence and nation-building period, or the decentraliza-

tion of political power caused by twenty-first-century globalization. Cities reveal the concentrated effects of all the forces that bring about rapid change in social structures and experiences. They do so in multiple and multiply competing ways, from the centers of power as well as from the peripheral rings of poverty and exclusion. Through various historical moments, then, Latin American cities continue to serve as crucibles in which the modernizing process exacerbates tensions between the masses and the elites, the residents and the planners, the preexisting and the possible, the real and the imagined.

Latin American Urban Cultural Studies

In the face of competing urban imaginaries, what does it mean to "do" Latin American urban cultural studies? Any single answer to this question would be inadequate. Because they both take multiple urban imaginaries into account, the most interdisciplinary urban studies projects and the most contextualized cultural studies projects often resemble each other. However, if the primary focus of urban studies tends to be the relationship between policy and planning (or the lack thereof) and their outcomes (whether "successful" or not) in relation to Latin American political economy, the primary focus of cultural studies tends to be meanings and their relationship to power. Specifically Latin American cultural studies engages many critical traditions and analyzes a potentially unlimited number of practices and products. Whether it is conducted from a primarily anthropological, geographical, sociological, literary, or historical perspective, it defines culture generally as "the realm of production, circulation, and consumption of meanings" (García Canclini 2004, 338).

Latin American cultural studies deconstructs simplistic notions of what kinds of cultural expression matter for the circulation of meanings in this particular region of the world. Drawing from the strong multidisciplinary tradition of Latin American cultural theory, literature, and international critical theory, it translates practices and products related to the cultural industries (the design of museums, the dissemination of mass-media, or the formation of national literary canons, for example) as well as those that appear in daily life (playing soccer, riding the metro, selling trinkets on the street, or going shopping) into legible texts that reveal, contest, and in turn shape knowledge about such weighty issues as power, ideology, and social change. The mutual effects of power and culture constitute the core preoccu-

pation of cultural studies (Castro-Klarén 2006). In pursuing its analysis of that mutuality, cultural studies both responds to and produces its objects of study as bearers of meaning.[12]

If it is difficult to formulate any simple definition of cultural studies as a method of analysis, the challenge of analyzing cities per se is exponentially greater. Néstor García Canclini asks in this volume, "what is a city?" and his essay demonstrates how cities famously elude definitive classification. The fact that cities have names suggests that they also have individual character and history in addition to recognizable physical form. However, their physical integrity is continuously violated. Urban design can be altered by informal processes like squatting or slum-building as well as by formal processes like planned urban renewal. Cities' boundaries are flexible and contested; they grow and adapt to economic, political, and demographic changes. In this sense, cities are alive. They consist of collections of things and networks (buildings, streets, marketplaces, transport systems, sewers, electricity grids, mountains of refuse, and so on), but it is not as if cities are simply the hard structure through which human beings flow. People's use of these objects and systems defines cities more than the objects themselves. The material aspects of cities are created by and also interact with human imagination; the two constantly alter each other.

Reading Vasconcelos's prescription for how to "enter into the essence of a major city" from the standpoint of cultural studies, we might understand his use of the term *essence* as a codeword for the ways in which Latin America's cities produce and circulate meanings. Of course, cities are especially charged sites of contested meanings. They are symbols of technological achievement and modernization, but their flaws and internal contradictions erode popular belief in "progress." They bring large numbers of people together in physical proximity, but they also increase social alienation and types of exclusion. Cities live in real space and time, and they are made of real material objects like concrete and bricks. However, they carry meaning only through the ways in which people live in them, imagine them, and represent them. It is impossible to separate objective definitions, descriptions, and explanations of cities from questions of perception, value, and meaning. The fact that cities are at once material and imaginary, that they defy fixed definition on either side of that dichotomy, grants them privileged status as rich sites for cultural studies.

Contemporary Latin American urban cultural studies draws from the region's violent socio-economic history as well as from cultural theory to

account for the heterogeneous nature of its present-day cities. Major topics of debate in the field involve the relationship between formal and informal urban practices, defining that relationship along various axes. Some arguments highlight the difference between dominant and subaltern groups and ideologies. They account for the ways in which formal urban design embodies social exclusion while subaltern practices resist that process (Hardoy 1997; Muñoz 2003).[13] Other studies are concerned with the proper status of signs and symbols relative to materiality; they examine the role of mass media, global marketing, and consumption in structuring urban life on the local level (Monsiváis 1995; Sarlo 2001a, 2001b; García Canclini 1990, 1995a). Yet others address the problem of scale and perspective by attempting to balance systemic views of the city with residents' discrete experiences (García Canclini, Castellanos, and Rosas Mantecón 1996; Sarlo 2001a). Some scholars critique the difference between questions and methods that originate from within Latin America and those that come from elsewhere (Castro-Klarén 2006, Sarlo 1995, Achugar 1998, Moreiras 1998). Finally, other studies worry that by attending exclusively, or simplistically, to the realm of signification and the imaginary, urban cultural studies may risk blocking the possibility of overcoming the current urban crisis in reality (Sarlo 1995; Gorelik 2004).

Angel Rama's *La ciudad letrada* (*The Lettered City*) (1984) figures prominently in Latin American urban cultural studies, because it articulates core questions about the exercise of power in relationship to signification and real urban structures. Rama makes the crucial observation that due to the nature of the conquest and subsequent colonization process, Latin America's cities, more than those of any other region of the world, owe their existence to writing (14–15). The well-ordered foundations of colonial cities were the physical manifestation of legal and theological documents that laid out plans for architecture, street design, and social divisions that would mirror the power of monarchy and church. This process relied on faith in the direct equivalence of the form of a city to the form of its social order (Mumford 1961, 172; qtd. in Rama 1984, 3). It also relied on the idea that the pre-conquest New World was empty of culture, that it offered vacant spaces ready to be written on by civilizing forces. This idea paved the way for the power of words and drawings (urban planning) to pre-imagine cities. It fed the faith that perfect planning could establish and preserve order in the real—and over time (Rama 1984, 8).[14]

However, *La ciudad letrada* charts the development, not so much of Latin America's real cities, as of its intellectual classes—*los letrados* of various types—in their attempts to shape Latin America through writing. Whether they write to support state power or popular resistance to it, Rama argues, they are caught in the same type of projective thinking that founded Latin American cities: "El *sueño de un orden* servía para perpetuar el poder y para conserver la estructura socio-económica y cultural que ese poder garantizaba. Y además se imponía a cualquier discurso opositor de ese poder, obligándolo a transitar, previamente, por el *sueño de otro orden*" (Rama 1984, 11). (The *dream of order* served to perpetuate power and preserve the socio-economic and cultural structure guaranteed by that power. And it was also imposed on any discourse opposed to that power, obligating it to pass first through the *dream of a different order*.) Rama's exploration of the oppressive as well as the liberating implications of this situation up to the late twentieth century confirms the primacy of the imaginary in any discussion of Latin American cities. It draws from Michel Foucault's *The Order of Things* (1966), which argues that different discourses of knowledge respond more to the prevailing values and logic of their particular historical moments than to any transcendent truth or material reality. Rama analyzes the historical founding of cities in Latin America, the professionalization of different types of writing, the independence movements, and twentieth-century revolutions—all quite concrete phenomena—in order to elucidate the complex and changing interaction between the "ciudad letrada" and the "ciudad real." The imaginary is made, then, of projections (*sueños*) as well as efforts to understand and respond to their real effects.

Whereas Rama's work foregrounds words and writing as the sources of knowledge of Latin American cities, Alberto Flores Galindo's *La ciudad sumergida. Aristocracia y plebe en Lima, 1760–1830*, published the same year as *La ciudad letrada*, deals more directly with space. It serves as a complement and counterpoint to Rama's influential study by exposing the city hidden by all the signs that Rama analyzes (Spitta 2003, 11–12). Flores Galindo focuses on violence in colonial Lima, describing the walled enclaves built by the white aristocracy to isolate itself from the masses of blacks and Indians whose settlements surround the center. By foregrounding the people who were excluded from what Rama calls the *ciudad letrada*, Flores Galindo understands the city as a site of real threats and fear more than as a site of imaginary projections and plans. In her preface to the essay collection, *Más allá de la ciudad*

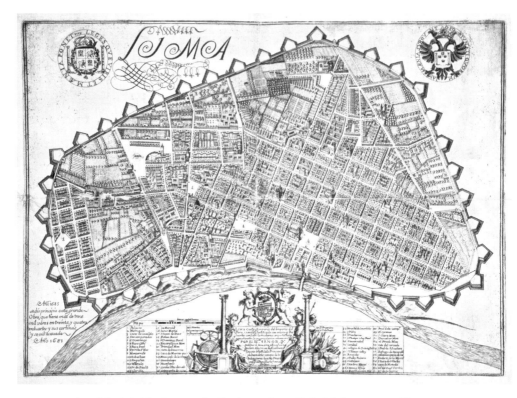

Plano de la ciudad de Lima y sus fortificaciones, Lima (Ciudad de los Reyes), 1687. Manuscript map. Copyright Archivo General de Indias, Seville. A.G.I. Ref. Perú y Chile, 13 A.

letrada: *Crónicas y espacios urbanos*, Silvia Spitta (2003) argues that current Latin American urban cultural studies vacillates its attentions between these two poles of imagined order and real chaos.

It must be noted that Flores Galindo's treatment of subaltern resistance to elite dreams of containment relies on his analysis of legal documents and claims made by the heterogeneous population of free workers and slaves. Spitta observes that "while Rama sees writing as a silencing of orality, Flores Galindo makes legal records tell their stories as if through them one could hear the din of Lima's streets, endless gossip, and the spatial and verbal collage that has always constituted the city and its masses" (Spitta 2003, 19). When urban analysis uncritically privileges the lettered elite, it obscures or dismisses the productive agency of "the people," or the masses. However, as Flores Galindo's historical method exemplifies, revealing the role of non-

lettered culture in constituting the urban scene—its violence, its distribution of space, its chaos—also relies on writing and signs. Talking or writing about the city from either "above" or "below" requires creative, imaginary (re)constructions of real people's creative activity.

Along with the urban scholars who work primarily in the social sciences, however, Angel Rama finds it particularly difficult to analyze the urban situation toward the end of the twentieth century. The era of late capitalism and the global reach of electronic media fundamentally alter the ways in which culture can be defined (Jameson 1984; Franco 2002). The Argentine literary and cultural studies critic Beatriz Sarlo examines the effects of global capitalism on local urban cultural practices (Sarlo 1994). She focuses particularly on the ways in which technology—whether literally accessible to people or only displayed to them through advertising—enters the popular imaginary and shapes (post)modern thinking. She argues that the field of cultural production must be considered in ever more expansive terms if we are to gain any understanding of the contemporary urban experience. The design of shopping malls and video games, or the nature of popular and middle-class consumption of electronic media, leads to a blurring of the formerly clear lines between a dominant, or "high" culture defended by elites and a subaltern culture of the poor. The conditions of global capitalism shift the defining poles of culture, and thus of how cultural production circulates meaning. This is especially true in cities where the percentage and visibility of economically privileged residents are dwarfed by the percentage of underemployed urbanites, even as electronic media project dreams of commodity acquisition to all social sectors equally.

Thus, despite the boundless circulation of meanings pertaining to a globalized urban imaginary of unlimited consumption and economic competition, the fact remains that twenty-first-century Latin American cities still symbolize dysfunction and disunity more than social progress and opportunities for all. At the same time and often in the face of severe social tensions, they also symbolize cultural identity and a sense of belonging for millions of people. As Richard Morse argues, addressing this vexed mix of issues that constitute the contemporary Latin American city is no longer a question of how governments or city planners either dominate or incorporate marginalized groups: "As migrants continue to pour into cities, as the best economic strategies imposed from above go awry, as middle classes collapse into a 'lumpen-bourgeoisie,' and as even 'democratized' regimes squabble over what democracy is and how it can be achieved—one under-

stands why the heart of the urban question has been misconstrued. One may continue to speak of incorporating the marginals but only be redefining marginals. For impoverished migrants are not marginals; they are the *people*. The marginals are the elites, technicians, bureaucrats, and academicians. It is *they* who require incorporation" (Morse 1992, 18). While this statement might seem to echo those studies that focus on class difference as the primary constitutive factor in urban reality, it actually complicates "the heart of the urban question" in a somewhat different way. Morse significantly urges the need for *incorporation* regardless of which group is considered central and which is considered marginal.

In this regard, we must take care to recognize the difference between studying urban imaginaries and discouraging urban imagination. By analyzing the variety of ways in which individuals, artists, governments, scholars, and others envision the nature of the city, cultural studies can identify the goals and biases of different urban imaginaries. For example, modernist urban planning is often strongly criticized for its attempts to manipulate the populace in the service of state power. This critique sees such efforts as an unself-aware continuation of the legacy of the conquest and the colonial foundation of Latin American cities. In this case, the critical discourse of urban imaginaries is used to chip away at the illusions of failed city plans and rigid political programs for urban development. However, limiting analysis to the simple identification and recording of the variety of representations of the city poses two risks. It can become reduced to a facile exercise in naming perspectives and fantasies with no connection to the real. Alternatively it can tend to accuse indiscriminately all organized efforts to intervene in urban developments of top-down authoritarianism (Gorelik 2004).

Therefore, Morse's proposition distinguishes between a stagnant, dichotomous imaginary and a more progressive form of urban imagination. He argues that those concerned with urban dysfunctionality ought to stop seeing the urban poor as the problem facing contemporary Latin American cities, regardless of whether one thinks they should be democratically incorporated into or somehow purged from the city. On the contrary, it is the "elites, technicians, bureaucrats, and academicians" whose urban imaginaries have not caught up to the current reality. Morse attempts to redirect thinking about the city away from simple classification, authoritative imposition, idealization, and denunciation. He looks to the unprogrammed, popular initiatives that are reshaping the Latin American urban environment

in far more spontaneous and creative ways than traditional public planners imagine: "The city as a whole must increasingly depend on popular initiative for reworking institutions, for providing security and dispensing justice, for reconceiving the physical city, for developing alternative services (transport, health, education, religion, leisure), and for creating fresh norms for language and the literary and expressive arts. What the common folk have accomplished in the peripheral or interstitial residential areas during the past forty years now offers guidelines for what must happen to the city as a whole. Cities are now nodal points for the nation and not its citadels of control" (Morse 1992, 19). Morse's expertise centers on questions of economic and political viability rather than aesthetic practices per se. Still, his argument resonates with that of the urban anthropologist Néstor García Canclini, who has focused more on the relations among urban imaginaries, consumer practices, and artistic production.

García Canclini struggles to account for the dialectic between, on the one hand, the metaphor of the urban leviathan as an insatiable monster that devours individuals and cultural distinctions, and, on the other hand, popular cultural practices that carve out paths along which individuals and small groups can navigate the immense urban landscape in order to create a sense of belonging and enjoyment. In his essay in this volume, which is adapted from a lecture series he presented in Buenos Aires in the late 1990s, García Canclini insists on the intertwined elements of actual and imagined space in our experience and assessment of cities: "We should think about the city as simultaneously a place to inhabit and a place to be imagined. Cities are made of houses and parks, streets, highways, and traffic signals. But they are also made of images. These images include the maps that invent and give order to the city. But novels, songs, films, print media, radio, and television also imagine the sense of urban life. The city attains a certain density as it is filled with these heterogeneous fantasies. The city, programmed to function, and designed in a grid, exceeds its boundaries and multiplies itself through individual as well as collective fictions." The real city confronts us with concrete, slums, high-rises, plazas, monuments, traffic, crowding, public transportation, pollution, shopping centers, sewage systems, local governance, specific odors, noises, crime, wealth, underemployment, advertising, and global banking and communications. That reality does not necessarily correspond to the imagined city of urban planning, literature, photography, film, museums, or globalized politics.

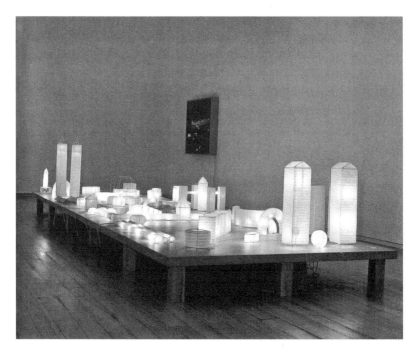

Carlos Garaicoa, *Nuevas arquitecturas, o una rara insistencia para entender la Noche*, 2000. Installation. Reproduced with permission from the Archivo Fotográfico Museo Nacional Centro de Arte Reina Sofía, Madrid.

City/Art: The Urban Scene

A walk through the city may evoke more positive, uplifting, or inspiring feelings than do despairing representations of contemporary urban life that one might find in an art gallery or a sociological study of urban violence. Of course, the comparison might just as easily work the other way to underscore the difference between some modernist visions of orderly, clean, productive cities and the gritty realities of life on the streets. But then again, we apprehend the all-too-real signs of the hyper-urban only through images. Our hurried passage through the streets gives us only snapshot views, partial vistas, representative objects, slogans, and billboards. Perhaps our perception of the incommensurability between the real and the imagined city depends less on the distinction between the material and the abstract, and more on a difference of scale. That is, our bodies inhabit the city through small-scale, direct forms of contact while our minds comprehend the city as a network of large-scale economies. Whether we associate them primarily

with the smells wafting from street vendor's food carts, with multi-ethnic metro passengers, with super highways, or with the invisible electronic monetary transactions they support, big cities in Latin America present themselves on numerous scales all at once. Through images we perceive simultaneously on various levels, we gain fragmentary awareness of how and why the urban scene in Latin America manifests large-scale social and economic change in local, visible, and profound ways.

The urban scene in Latin America offers us a privileged view of the social effects and projections of colonialism, postcolonialism, modernization, industrialization, migration, deconstruction, and globalization. In this context, the art of urban cultural studies can be found in its attempt to register multiple scales of urban reality simultaneously, where "art" is understood as the intersection of material expression, ideas, and aesthetics. The scholar, traveler, or resident moves in a single moment and from a single perspective into different levels and layers of the connections that destabilize the difference between the real city and the imagined city. That movement allows us to follow their interrelationship, producing and responding to multiple urban imaginaries at once.

In this book, essays by anthropologists, an architect, a philosopher, literary critics, and cultural critics are based on the notion that Latin America's major cities render particularly problematic the distinction between the real city and the imagined city. They argue that urban arts shape the imagined space of Latin American cities by also structuring real, lived urban space. By placing creative activity at the center of an examination of the lived city, this book explores a variety of practices that manage, reflect, and continually (re)construct the urban scene in Latin America. It sheds new interdisciplinary light on major sites as different in size and character as Mexico City, Brasília, Buenos Aires, Santiago de Chile, Rio de Janeiro, Havana, Miami, Montevideo, and São Paulo. In such contexts, "the arts" necessarily refers to officially sanctioned as well as commercial and popular forms of expression. The term includes creative urban planning as well as both staged and impromptu performances of the ever-evolving survival strategies employed by urban inhabitants. It also comprises critical discourses that attempt to chart and analyze those performances.

The studies gathered into this volume complicate and extend García Canclini's observations regarding the relationship between cities as physical places and cities as events, or fantasies, that "take place" in Latin America. Following Vasconcelos's advice, the present volume assembles studies by a

group of particularly sensitive, attuned, "telepathic" writers, activists, and scholars who dare to *entrar en las ciudades latinoamericanas* in a variety of ways. All of the essays resonate with Armando Silva's project of assessing Latin American urban space through inhabitants' aesthetic experience and inventions:

> If São Paolo is as grand and extensive as it is flat, if Bogotá is flat but also surrounded by hills, if Valparaíso runs high to low . . . it is because all cities yield to spatial representation. But we also say that São Paolo and Bogotá are gray even if Rio is yellow or Valparaíso is blue; or that we can find feminine streets in Bogotá . . . and dangerous streets or certain places we visit only during the day or only at night; saying that is no less important than identifying the geometric shapes of that which is flat, enclosed, mountainous, or high and low. They are definitions born of their use. Some collective representations come from geometry, but others are born of the built environment or even of the chromatic world of urban color. (Silva 1993, 100)

This collection focuses on the essence of Latin American cities as the intersection of their physicality and their fictionality, where fictionality is understood quite broadly as representation-in-time. This representation is produced by all social sectors and in diverse forms: history, fantasy, association, description, performance, building, resistance, and creative response.

The title *City/Art* cites the São Paulo urban intervention group, Arte/ Cidade. Nelson Brissac Peixoto, one of the contributors to this volume, curates the group's "interventions" in the megacity. Based on extensive research on the planning, design, and evolution of specific areas in the city, these projects invade office buildings, de-industrialized sites, and the vacant areas between highways and viaducts to install collectively produced works of public art. In *Windowless City* (1994) they occupied an abandoned slaughterhouse to emphasize the multilayered uses and meanings of urban space. *The City and its Networks* (1994) installed a variety of elevators, lighting arrangements, periscopes, and telescopes in a group of downtown buildings to explore the disorientation of scale and perspective in the contemporary megacity. They have also stacked full-size, painted train cars on one another in an abandoned steelworks zone to symbolize the precariousness of postindustrial economies. They have built temporary, communal housing for the homeless in supposedly "dead space" under a city viaduct. The idea is to model "strategic alternatives for the city's global restructuring, for decen-

tralized urban politics" in locations that make highly visible "the structural complexity and socio-spatial dynamics that characterize the megalopolis." The group's guiding principle is that public art has the power to help people design "the landscape of global urban reorganization."[15]

In keeping with that project, this essay collection confronts the difficulty of accounting for the myriad ways in which Latin American cities exceed the category of the socially constructed object to be represented. These cities not only inspire, facilitate, and house creative practices; they also *are* the art produced by an anonymous collective. Thinking of them this way allows for thinking in multiple frames at one time, the kind of attentiveness that Vasconcelos calls "an instantaneous sensibility." As with Arte/Cidade's projects, attending to the city as art should be understood as entering into alliance with the kind of urban studies that seeks to protect, preserve, develop, and reform real cities.

The book's subtitle, "The Urban Scene in Latin America," attempts to conjure a number of contradictions that its individual essays address. A scene provides a setting; it gives place to an event or an object so that it can be examined (for example, the "scene of a crime"). A scene can also be captured or framed through painting or photography, both art forms that interpret complex experience by carefully defining a point of view. As opposed to that notion of a "still scene," a dramatic scene is enacted; it cannot be considered static. A scene can be an exaggerated expression of feeling (as in "don't make a scene"). A scene can be a certain social or marketing network (the "dating scene," the "international banking scene"). In all of these senses, a scene is both that which presents itself to us (the real) and that which is constructed to express and elicit certain responses (art).

This collection necessarily draws from a range of disciplines. The essays explore how urban design, graffiti, film, literature, architecture, performance art, museums, tourist advertising, monuments, shopping centers, and music function in tandem with nationalist rhetoric, historical discourse, and cultural studies to produce and define the Latin American cities that are then marketed, critiqued, and consumed in the international arena. The authors engage intellectual history, literary theory, art history, performance studies, marketing, and the study of culture industries. In order to provide a map through this multidisciplinary terrain, with its many divergent and convergent intellectual paths, the collection is divided into three parts: "Urban Designs," "Street Signs," and "Traffic." This division invites readers to journey from the abstract cities we imagine, to the material cities

we inhabit and mark, and finally to the volatile cities through and between which we move as social actors and consumers. The thesis of each essay, however, leads us to the realization that this map could never be exhaustive or even accurate; it is merely useful as a way to enter the city. The three categories are, in fact, blended together in every effective form of urban art or urban analysis.

Part 1, "Urban Designs," contains three essays that focus on the discourses of urban planning and management and how they differ from residents' representations and experiences of the city. *Design* refers to plans, ideals, and illusions. It also refers to the plots into which scholars, writers, artists, and politicians have inserted certain cities. This double meaning of *designs* highlights a variety of processes that interact with one another to produce urban imaginaries. First, the laying out of urban forms on maps and grids represents a two-dimensional, idealized construction of what will inevitably become an unwieldy, unpredictable space of human commerce. Next, the descriptions of the city proffered by politicians, urban planners, and public intellectuals digest and manipulate "original" ideal city plans, adapting them to contingent realities of how urban spaces must be controlled, divided, shifted, or allocated. Attempts to represent the city, whether through the ideological projections of modernist urban planners, through the verbal medium of literary narrative, or through interviews with urban travelers, reveal imaginary maps of social relations, the romanticized identities of particular barrios, or memories and projections of what the city means to certain groups of people. The essays in this section all attend to the question of how we conceive of cities. What are our motives? How and why do we choose to see them from certain points of view? Is it possible for a city to see itself?

Néstor García Canclini's "What is a City?" establishes some major themes of the collection. This essay is adapted from two chapters of García Canclini's book *Imaginarios urbanos*. It critiques some basic definitions of the city that have been used in urban studies. It then juxtaposes those attempts at fixing the parameters of the object of study to García Canclini's own research into how residents of Mexico City think of the metropolis. Employing group interviews of people whose work entails travel through the city, he and his team of researchers acknowledge the impossibility of producing comprehensive maps of it. Rather, they attempt to enter "the essence of the city" (to again borrow Vasconcelos's phrase) through the eyes and experiences of those who live there. This method of analysis em-

phasizes the importance of travel through urban space as the way to register its complexities. García Canclini's study makes visible the disjunction between the systemic thinking of urban studies scholarship and residents' individualized tactics for problem-solving in their daily confrontations with the city.

While García Canclini's essay concerns primarily how differences of scale and point of view affect people's experience of living in Mexico City on a daily basis, Adrián Gorelik's "Buenos Aires is (Latin) America, Too" traces the history of Buenos Aires's preoccupation with its own status and cultural identity. His essay attends to structural interventions in the city as well as to literary and political descriptions. To illustrate Buenos Aires's ambivalence about being Latin American, Gorelik uses the trope introduced in Bernardo Verbitsky's novel *Villa Miseria también es América* (1957), in which a young *bonairense* is shocked to discover a pocket of poverty in the middle of his city. This moment of discovery establishes the idea of Latin America as a fragmented and even triangulated mirror for the city. It sees itself against European, North American, and South American backdrops. Gorelik follows the evolution of Buenos Aires's relationship to a Latin America understood successively "as an idea, a project, and a destiny." He quotes Claude Lévi-Strauss to point out that the problem with Latin American cities is not the weight of tradition. Rather, it is the weight of the modern. Since the European conquest and the intentional "founding" of the Latin American cities as non-indigenous, urban change has continually imposed new structures over the old. Where it does so superficially, it never transforms or transcends the underlying problems of morphological contradiction and social exclusions or inequalities.

In "The Spirit of Brasília: Modernity as Experiment and Risk," James Holston takes up the case of Brazil's quintessentially modern urban project. Brasília represents the height of modernist urbanism. It was built in a mere three and a half years in the mid twentieth century to serve as the administrative center of Brazil. It stands alone in the center of the Central Plateau of Brazil "like an idea, heroic and romantic, the acropolis of an enormous empty expanse." Holston explores the national desire to project itself as modern through experimentation with a new capital city that would seem to appear out of nowhere, and have no history to limit its future. However, Holston argues that the original plan for Brasília was based on premises that actually led to competing notions of the urban. It was motivated by the idea that urban design can directly restructure social order. Brasília's proponents

assumed that the city's success would then model the future of Brazilian society as a whole. Holston shows that they were right, but in ways they did not foresee. Holston finds that the discrepancy between total design and master planning on the one hand and contingency design and improvisation on the other produces in Brasília the same tensions that the modernist project was meant to overcome for Brazil as a whole. By attempting to preserve and memorialize the original plan for Brasília, he suggests, the nation recognizes it as an important aesthetic and social innovation, but ironically denies it a future. Acknowledging the ways that Brasília has evolved beyond and in spite of the original plan, Holston defends the real "spirit of Brasília." He believes that spirit would celebrate multiple and competing forms of urban innovation, regardless of whether they are planned by designers and architects or produced by the workers who built and serve the city.

The first two essays in part 2, "Street Signs," engage the idea of signs as both physical writing in the city and aesthetic works that stress the visual in urban contexts. The third and fourth essays in this section deal with how cities themselves are represented as signs, or symbols of particular identities. In all cases, signs in the city and cities as signs structure human activity, channeling it in certain directions. People write on the city in material and symbolic ways. The four pieces featured here highlight different types of interventions into urban designs. They explain how art actions, graffiti, writing, and film not only redirect our gaze in the physical city, but also affect the meanings cities can bear beyond their physical limits.

Nelly Richard's "City, Art, Politics" takes political messages to the streets in Santiago de Chile through the performance-art works of Lotty Rosenfeld. From her street paintings in the 1980s to her 2002 video installation called *Moción de orden* (Point of order) (2002), Rosenfeld's work exemplifies a segment of Chilean artistic production actively engaged with critical reflection on the relations among urban landscapes, daily life, and artistic happenings. She responds to Chile's repressive political history by critically and forcefully occupying the interstices between urban order and critical and aesthetic disorder. Richard analyzes Rosenfeld's painting on the pavement of real streets, as well as her performances, installations, and videos to explain how they thwart the assumptions about social order that make daily life in the city seem smooth even when it is predicated on diverse forms of violence. Rosenfeld's work exposes the fissures in the buildings and systems that support the illusion of rational urban function. Richard argues that this disruptive work forges spaces in the apparently seamless wall of dominant

power structures, spaces for the exercise of radical democracy as well as cutting-edge art.

Marcy Schwartz's "The Writing on the Wall: Urban Cultural Studies and the Power of Aesthetics," argues that literal writing and drawing on subway tunnels or city walls can alter common notions of the task of cultural studies. Schwartz offers a comparative reading of Liliana Porter's public mosaics in a New York subway station and Julio Cortázar's short story "Graffiti" (1979) to illustrate her claims. Whereas some strains of cultural studies tend to dismiss certain creative products as representative of elite or bourgeois interests that compete with more progressive, popular, or low forms of cultural expression, Schwartz identifies two works that self-consciously blend high and low discourses. She finds that Cortázar's story dissolves the boundaries between form and content by subtly blending words with visual images. His characters communicate with each other through graffiti in the context of a repressive regime in an unnamed city. Schwartz explains how Porter dissolves those same boundaries by installing into a New York City subway station a tile mosaic that represents the pages of a book. Schwartz examines Porter's and Cortázar's creation of "narrative subways and verbal graffiti" that meld urban space, visual art, and writing. This comparative approach defends the political power of urban aesthetics.

Turning to the question of cities as signs, or ciphers, for particular identities, José Quiroga asks what Miami means to the story of Cubans in the United States. His essay, "Miami Remake," treats two popular texts as examples of the way in which the city has been re-coded in relation to specific, traumatic historical events. Quiroga analyzes Joan Didion's journalistic work *Miami* (1987), and Brian De Palma's film *Scarface* (1983). Both texts appeared after the Mariel boat lift from Havana to Miami in 1980, which profoundly changed the Cuban American community. Quiroga points out how that event created a new Miami. The city no longer symbolized primarily the hope for return to Cuba. It began to take on a different symbolic weight for its residents as well as for the larger United States. Quiroga shows that both Didion and De Palma respond to the emergence of "the foreign within the very structure of the city." They register this change in the city by depicting modes of consumption. They distinguish overtly between urban landscape and internal affect to address the consumption of commodities as well as explanatory narratives. The trope of the "foreign" resonates in Quiroga's observation that only outsiders to Miami (neither Didion nor De Palma lived there) could represent any coherent image of the city in the 1980s. Quiroga

finds that rereading these texts is instructive for understanding the present-day relationship between Miami's exile community and the approaching end of its "defining narrative of exile."

Amy Kaminsky's "The Jew in the City: Buenos Aires in Jewish Fiction" juxtaposes twentieth-century narrative texts to reveal the variety of definitions of Jewishness that the city has been taken to symbolize. This study sheds light on the global nature of the city by examining the links between the European and North American imaginary concerning Buenos Aires, the experience of Jews in the city, and the idea of a transnational Jewish cosmopolitanism. Kaminsky compares Antonio Muñoz Molina's *Carlota Fainberg* (Spain, 1999) and Dominique Bona's *Argentina* (France, 1984) to the work of non-Argentine Jewish novelists like Isaac Bashevis Singer and Judith Katz; she also considers Argentine Jewish as well as non-Jewish writers who represent Jewish Buenos Aires. Kaminsky's essay explores the strength of ethnic networks, the central role of migrations, and the power of multiple marginalities to shape what we can "know" about a city. That multi-layered knowledge produces not only an internationalized, or globalized, Buenos Aires, but also the persistent association of certain diasporic identities with certain cities.

Part 3 of the collection, "Traffic," considers exchange and flow. It underscores the ever-fluid dynamics of dissemination and consumption. Where superhighways link private, gated suburban communities to dispersed commercial centers, they bypass de-industrialized zones of the city, slums and informal settlements. How do culture and hypercapitalism interact to alter the urban landscape in Latin America? What sort of traffic, or connection, is possible among the increasingly isolated and fragmented sectors of Latin America's metropolitan areas?

Commerce in the era of the shopping mall and global marketing alters the space and time of urban intercourse. Hugo Achugar's essay, "On Maps and Malls," analyzes the physical and functional transformation of Montevideo's former Punta Carretas Prison into a downtown mall now called the Punta Carretas Shopping Center. He argues that this transformation of a state-run jail into a market-run site of privileged consumption illustrates Uruguay's transition from the dictatorship of 1973 to 1985 to the era of democratic restoration. Achugar examines the shopping center's architecture and aesthetics, reading it as a contemporary version of both Piranesi's eighteenth-century images of fantastic, multi-storied prisons and Walter

Benjamin's reflections on Paris's nineteenth-century arcades. He describes the mall's unique relationship to the city around it. Then Achugar expands his interpretation to offer a metaphorical reading in which the mall's effects on those who walk through it mirror the socio-political effects of Uruguay's contemporary, market-driven self-image. He connects the Punta Carretas Shopping Center to various moments in Montevideo's and Uruguay's history, in which imposed maps and willful forgetting erase the memory of foundational violence. The mall's design and function impose the temporality of the global market on Montevideo's center. They also deliberately obscure the violent history of the building and the city it occupies.

In "Culture-Based Urban Development in Rio de Janeiro" George Yúdice also addresses the relationship between building projects and urban renewal. He juxtaposes two responses to urban crises in Rio de Janeiro since the 1980s. One, represented by the failed plan to build a Guggenheim museum in the port area of the city, involves "lavish investment in cultural infrastructure." It banks on the assumption that improving the city's external image, attracting capital, tourists, and high-end cultural consumers to depressed zones, correlates directly to urban revitalization. The other response, represented by groups such as Central Unica das Favelas and Grupo Cultural Afro Reggae, supports community-based efforts to deal creatively with "exclusion, marginalization, and lack of opportunities." Yúdice asks whether projects like the Rio Guggenheim plan, insofar as they eschew collaboration with the residents of the urban areas they hope to develop, are capable of confronting urban problems such as violence from narco-traffic, segregation, racism, and classism. He argues that citizen-based initiatives like those of Grupo Cultural Afro Reggae are better able to mobilize local values and culture toward urban development. On multiple levels, they practice the collaboration, consultation, and complex networking necessary to effect real urban change. Based on his study of Rio's cultural movements, Yúdice calls for a public investment in urban creative enterprises that attend just as much to the social dimension as to "the economic dimension of culture." His essay offers hope that the frustrated bid to host a new Guggenheim museum in the port area of Rio de Janeiro may in fact have opened space for dialogue with other creative and far more effective sources of urban revitalization.

The last essay in this section, Nelson Brissac Peixoto's "Latin American Megacities: The New Urban Formlessness," serves as a provocative, open

ending to the collection. It is a lyrical manifesto on the need to invent a new kind of urban cartography. Like Richard Morse, Peixoto argues that twentieth-century notions of urban planning and urban decay render us blind to the productive creativity at work when traditionally marginalized social groups occupy city structures—and, perhaps more importantly, the spaces between those structures—for unpredictable purposes. To reconceptualize the typical tension between authorities (whether economic or governmental) and the people, Peixoto employs terms drawn from the theoretical work of Gilles Deleuze: flow, merger, connection, and flooding. He emphasizes the combinations of physical, economic, global, and local factors that are turning Latin American megacities into radically new zones of social, spatial, and functional fluidity. If unregulated mass migrations, radical class disparity, crumbling infrastructure, deindustrialization, pollution, and faulty or corrupt city planning are the most-often cited causes of Latin American urban decay, Peixoto asks whether we might see those processes with different eyes. Rather than focus on the ineffectiveness, or loss, of traditional, monumental, industrial city centers in the face of popular disregard for their planned uses, what happens when we look to the energized, subversive, corrosive, but also potentially reconstructive practices that are in fact continually reshaping the region's urban spaces and experiences? By posing this question, Peixoto challenges us to review the three sections of the present volume with a fresh perspective. We can no longer see the various cities only as places to be represented. We now see them as living sites and sources of unlimited creative potential.

This collection takes multiple detours through urban space. Its appeal to urban design, street signs, and traffic provides familiar landmarks, but it does not lead to any single destination. It does not reach any particular endpoint, or city center. It does not mean to deal with a representative sample of Latin American cities. It does not reduce the particularity of each city to a set of common characteristics. Nor does it seek to limit the definition of urban creativity to the forms addressed here. Rather, this collection of essays should serve as a model for how to open up specific, concrete urban sites to creative, comparative, analytic inquiry. It enters and then moves through many cities, many images, theories, experiences, and perspectives to elucidate how cities produce the arts that in turn produce cities.

Notes

1 Unless otherwise indicated, all translations are mine.

2 *La ciudad iberoamericana* (Generalitat Valencia 1992) provides a useful introduction to the founding of a number of important Latin American cities. It includes colonial maps and the physical evolution of the cities in separate essays on Santiago, Buenos Aires, Cuzco, Havana, Montevideo, Salvador da Bahía, Cartagena, Mexico City, Caracas, Santiago de Guatemala, and Quito. See also Mark D. Szuchman's narrative of the historical evolution of Latin American urban issues in *I Saw a City Invincible* (Szuchman 1996). He arranges this history into categories of colonial organization and postindependence challenges: "The Middle Period" (the seventeenth century through the early nineteenth), "The Age of Reform," "The Challenge of the Countryside and Urban Recovery," and "The Leviathan."

3 For example, José Luis Romero divides his book into seven chapters: "Latinoamérica en la expansión europea"; "El ciclo de las fundaciones"; "Las ciudades hidalgas de indias"; "Las ciudades criollas"; "Las ciudades patricias"; "Las ciudades burguesas"; and "Las ciudades masificadas" (Romero 1976).

4 *The Mega-city in Latin America* (Gilbert 1996) is a useful and representative collection that demonstrates high quality approaches of this sort, while focusing exclusively on the largest cities.

5 Jorge E. Hardoy offers a particularly insightful and cogent example of this approach in "Las ciudades de América Latina a partir de 1900" (Hardoy 1997).

6 The architect and urban designer Jean-François Lejeune (2003b) traces this history in his elegant essay, "Dreams of Order: Utopia, Cruelty, and Modernity." He divides his narrative into categories that mark the philosophical and political motivations for the development of certain aesthetic principles in Latin American urban design: Roman influence and medieval foundations; the culture of perspective; the first instructions of population; the encounter of pre-Colombian space; a Renaissance and Mexican utopia; the Laws of the Indies; consolidation and syncretism; modernization in Hispanic America and Brazil; the city as landscape; university cities—the last utopia; modernity, globalization, and cruelty.

7 "In the Western world the inherited ways of classifying cities tend to fall into taxonomies determined by those who design them (classical and baroque cities), by functions that cities perform (for administration, religion, defense, maritime and internal trade, agrarian-based activities, industry, leisure), by modes of transportation that condition their growth (animal haulage, canals, railways, automobiles, airplanes), by sociological paradigms (orthogenetic-heterogenetic), and so forth. When cities are identified with social actors (José Luis Romero's aristocratic, creole, patrician, bourgeois, and massified cities, for example), the actors in question may be treated more as representing than as creating a social order, or as being exemplars rather than agents of urban change" (Morse 1992, 3).

8 This term is sometimes used to refer to "greater metropolitan areas"; in other

contexts it refers to urban zones in which two or more neighboring cities have expanded so much that their outer limits blend into each other.

9 "Rather than the classical stereotype of the labor-intensive countryside and the capital-intensive industrial metropolis, the Third World now contains many examples of capital-intensive countrysides and labor-intensive deindustrialized cities. "Overurbanization," in other words, is driven by the reproduction of poverty, not by the supply of jobs. This is one of the unexpected tracks down which a neoliberal world order is shunting the future" (Davis 2006, 16).

10 Jean-François Lejeune (2003b, 32) explains that this pattern of checkerboard city blocks with a central square arose from "a fluctuating synthesis of four main influences: the new foundations in Spain during the medieval Reconquista; the theories of the Renaissance and the Ideal City; the expression of a rational will of Roman-imperial inspiration; and, finally, the encounter with the pre-Columbian cities and civilizations." He cites Salcedo Salcedo 1996 and Gasparini 1991 as sources for this explanation of the primary form of colonial Latin American urbanization.

11 Accessible accounts of this history can be found in Hardoy 1975 and Morse 1971.

12 See Trigo 2004 and Ríos 2004 for two essays that provide a useful introduction to the foundational texts and trends of Latin American cultural studies, and the field's distinction from and relationship with British and U.S. cultural studies.

13 "Si la ciudad encarna la forma más lograda del dominio humano sobre la naturaleza, es también el espacio donde el estado de colapso de la modernidad capitalista, bajo el signo de la ausencia de poder para el ciudadano y la multitud, se muestra de modo más claro" (If the city represents the most successful form of human dominion over nature, it is also the clearest site of capitalist modernity's collapse, all under the sign of citizens' and the masses' lack of power) (Muñoz 2003, 76). Jorge E. Hardoy also points out that the current situation in Latin American cities has been reduced to a competition between "two parallel, tightly interconnected cities, but with different visual expressions": the legal city and the illegal city (Hardoy 1997, 273).

14 "El orden debe quedar estatuido antes de que la ciudad exista, para así impeder todo futuro desorden, lo que alude a la peculiar virtud de los signos de permanecer inalterables en el tiempo y seguir rigiendo la cambiante vida de las cosas dentro de rígidos encuadres. Es así que se fijaron las operaciones fundadoras que se fueron repitiendo a través de una extensa geografía y un extenso tiempo" ("The notion that statutory order must be constituted at the outset to prevent future disorder alludes to the peculiar virtue of signs: to remain unalterable despite the passage of time and, at least hypothetically, to constrain changing reality in a changeless rational framework. Operating on these principles, the Iberian empires established rigid procedures for founding new cities and then extended them methodically across vast stretches of time and space" [Rama 1996, 6]) (Rama 1984, 8).

15 See Arte/Cidade's website, http://www.pucsp.br/artecidade.

PART 1 / URBAN DESIGNS

What is a City? / *Néstor García Canclini*

Let's begin with this basic question. Current urban studies literature does not answer it very clearly. Many scholars address the question of the city without ever providing an adequate definition. The literature typically offers a range of approaches to this question, but ultimately leaves it unresolved. I would like to revisit some of the more oft-cited answers from different moments in urban theory in order to arrive finally, and with some historical grounding, at the problems we currently face in our attempts to study cities, especially big cities.

One approach to defining cities opposes them to the rural, conceiving of them as that which is not the countryside. This focus, quite popular in the first half of the twentieth century, led to an overly sharp contrast between the countryside, seen as a communal space where primary relationships dominated, and the city, understood as a space of secondary associations that produces more divisions among social roles along with a multiplicity of social connections. Given the prominence of this model in Argentina, by virtue of the influence of one of that nation's world theorists, Gino Germani, there is little need to belabor this point.[1] Germani spoke of the city as a nucleus of modernity, precisely because it is there that we can dispense with mandatory, primary relations of belonging—those intense personal, familial, or neighborhood contacts found in small towns or small cities. From his functionalist point of view, Germani studied the anonymity of freely chosen, associative relationships in larger cities, where roles are more separated and defined.

Among the many critiques that have been made of such a strong opposi-

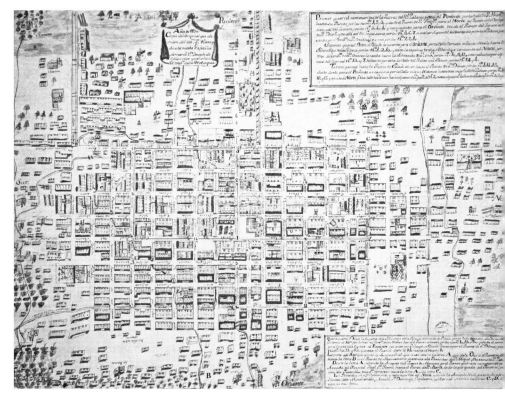

Plano de la ciudad de México remitido por la Sala del Crimen de México con expediente sobre la división de la ciudad en cuarteles para las rondas, México, 1750. Manuscript map. Archivo General de Indias Ref. México, 178.

tion between the rural and the urban, I would like to point out that the distinction is limited to superficial traits. Such a descriptive differentiation explains neither the structural differences nor the similarities that sometimes arise between what happens in the city and what happens in the countryside or in small towns. Additionally, we often describe our Latin American cities as having been invaded by the countryside. One often sees *campesinos* traveling through the city in horse-drawn carriages, or the urban space used as if it were rural, as if it would be difficult to imagine a car passing by there. Such literal intersections between the rural and the urban show the insufficiency of defining the urban through opposition to the rural.

Another kind of definition, which has enjoyed long usage since the Chicago School,[2] uses spatio-geographic criteria. Louis Wirth (1938), for example, defined the city as a relatively dense, expansive, and permanent

settlement of socially heterogeneous individuals. The problem with this spatiogeographic characterization, however, is that it does not take into account the historical and social processes that create urban structures, dimensions, densities, and heterogeneities.

A third approach sees the city through a specifically economic lens, defining it as the result of industrial development and capitalist concentration. Indeed, the city has favored a greater rationalization of social life and has, to a point, more efficiently organized the reproduction of the workforce by consolidating production and mass consumption. Authors like Manuel Castells, whose book *The Urban Question* (1977) continues to hold great interest because of its historical vision, argue that these economic criteria omit important ideological aspects (which Castells himself treats only rudimentarily in his book). Later, it became commonplace to question this economistic method of analyzing the city, the daily experience of living there, and the urban inhabitants' representations of the city.

Other authors claim that we can define the city based on the experience of living there. Antonio Mela, for example, published an excellent article in *Diálogos* (1989) that isolates two key characteristics: the density of interactions and the accelerated pace of the exchange of messages. Mela explains that these are not only quantitative phenomena; they also exercise a sometimes contradictory influence on the quality of city life. The increase in communicative codes requires residents to gain new skills, as is evident to any immigrant who arrives in a new city, gets lost, and has trouble making a place for herself in this density of interactions and this acceleration of the exchange of messages. When this issue starts to gain visibility, especially with the mid-century migrations, the question of who can use the city comes to the fore.

This line of analysis, which expresses the urban question in terms of the tension between achievement and expressivity (Mela 1989), has led to a rethinking of urban societies as a type of language. In other words, cities are not only physical phenomena, modes of occupying space, or types of agglomeration; they are also places where expressive phenomena enter into tension with rationalization, with the goal of rationalizing social life. More than any other social force, the cultural industries of expressivity, insofar as they are constitutive of the order and experience of urban life, have addressed this question.

To the extent that we are seeking a definition of the urban, all these theories fail in some way. They do not offer a satisfactory answer. Rather, they

offer multiple approaches that are all necessary, that currently coexist as credible aspects of a certain sense of urban life. The sum of all these definitions, however, cannot be easily articulated. It is not possible to shape them into a unitary, satisfactory, more or less functional definition with which to continue studying cities. This uncertainty with regard to the definition of the urban becomes even more dizzying when we try to speak about megacities.

What is happening in the megacities these days? A recent book by Paolo Perulli (1995), *Atlas Metropolitano, el cambio social en las grandes ciudades*, opens by pointing out that the crisis of contemporary cities, which was one of the truisms of urban studies until the 1980s, is now seen differently. Perulli argues that, in reality, we are in a phase of returning to the cities, what another Italian author, Aldo Bononi, calls "a renaissance of the city" (Bononi 1992). There are metropolises in full economic recovery, grand urban renovation projects and large-scale physical transformations in the cities.

While the 1970s saw urban crisis and territorial dispersion, there has been much discussion of the 1980s as the decade of return to the city centers, of urban recentralization. Perulli cites Paris and Berlin as prime examples of revitalization. Paris is currently reaping the fruits of large-scale urban policies established decades earlier, while Berlin has benefited from German and European unification processes. But other metropolises in the region are taking steps in this same direction, especially along the southern European band: Barcelona, Munich, Lyon, Zurich, Milan, Frankfurt, Stuttgart. In all these cases, we can see a resurgence of the cities. They are improving employment rates—and not only tertiary employment, but also industrial employment, which had been in decline. They are setting up new networks for intangible infrastructure, and they are starting or bringing to completion large-scale public works.

It is not necessary to belabor the point that Latin American cities are beginning to experience similar changes. We already see emerging signs of it. In Mexico City and São Paulo, of course, the same characteristics are evident. The Mexican capital, for example, which had 3,410,000 inhabitants in 1950, exceeded 20,000,000 by the beginning of the twenty-first century as a result of massive migrations and the incorporation of twenty-nine peripheral municipalities. We can also consider other regional cities, or inter-urban axes like Mercosur. One thinks of the new highways as well as other types of connections, including electronic ones, between São Paulo and Buenos Aires, or among Santiago, Buenos Aires, and Montevideo. Obviously, Mercosur's emphasis on regional integration is contributing to these developments, but

I believe other, equally globalized processes are leading us in this direction as well.

In this context we should rethink what is happening in the cultural dimension of our cities. In the current situation, even with very limited prospects for renewal, we are finding a dynamism that ten or fifteen years ago we did not expect to see when we considered the crises of cities like Mexico and São Paulo. These crises have not disappeared. In fact, some indicators show a worsening of the situation, as with pollution, for example, or the absence of solutions to strategic and structural urban problems. But on the other hand, we also see the undeniable presence of quite dynamic processes grounded in cultural movements.

Imaginaries as Urban Heritage

Mexico City looks more like a contradictory and chaotic video clip than like a city. Instead of their being hyperconnected, "information" cities, one sometimes has the sensation that our cities actually make communication more difficult. The contradictions one faces in Buenos Aires and Mexico City can also be felt in other, younger, Latin American cities. In Rio de Janeiro or in São Paulo, where optic fibers are only recently being installed, telephonic communications can be so unreliable that university professors and business people sometimes have to wait until nine or ten o'clock at night to log on to their email because there are not enough open lines during the day. Of course there is email access—the number of computers multiplies continuously—and there are thousands of new users all the time, but infrastructural deficiencies impede those users' attempts to establish themselves as serious competitors in global networks.

By "video clip city," I mean the city that brings together at an accelerated pace an effervescent montage of cultures from different epochs. It is not easy to comprehend how such diverse ways of life interact in these huge cities, but it is even more difficult to understand the myriad urban imaginaries that they generate. We have a physical experience of the city, we travel through it and we feel in our bodies what it means to walk for a certain amount of time, or to have to stand while on the public bus, or to get caught in the rain before we can catch a cab. However, we also imagine while we move through the city. We draw conclusions about what we see, about the people we come across, about the sections of the city with which we are unfamiliar and that we have to traverse in order to reach some specific destination. In other

words, we invent ideas about what happens to us *with the others* in the city. A large part of what happens to us is imaginary because it does not derive directly from real interactions. Every interaction has an imaginary element, but even more so in the case of those evasive and fleeting interactions that are particular to the megalopolis.

Different imaginaries have fed all of urban history. Writers and literary critics make that fact particularly evident. In her article "La ciudad en el discurso literario" (The city in literary discourse), published in Buenos Aires in the journal *SyC*, Rosalva Campra asks where cities are founded, and she answers thusly: "On top of a mountain, for better defense, or by the sea in order to have port access, or—as myths typically explain it—beside a river in order to orient itself and give a sense of identity to the group" (Campra 1994, 21). But, she adds, cities are also founded in books, or they are founded by books. She goes on to explore how cities have been connected to foundational books, books that speak of how to tame a desert, how to distinguish a city from a desert, how to delineate space, or how to build based on one's ability to imagine a city.

This process can sometimes be very dramatic, as we can see in literature and films about cities. In Mexico we study this diversity of urban imaginaries by charting how the city is constituted every day in journalistic discourse, and through radio and television. How have these media multiplied the spaces of urban communication? In general, radio is more participatory, with open telephone lines that invite citizens to express their views, and with its ability to create a local clientele for its market. In contrast, television tends to be more authoritative and more censored.

Armando Silva's research on urban imaginaries considers the microspaces within which such imaginaries are produced and consumed. He has focused on São Paulo, Caracas, Santiago de Chile, Barcelona, and other cities (Silva 1992, 1993). The same concerns inform Mike Davis's research on Los Angeles (1998), as well as *La cultura de la noche*, a book about Buenos Aires by Mario Margulis (1994). In conducting an experiment that was similar to that of Margulis's book, my research group studied dance halls, which are an important space for generational gatherings in Mexico City (García Canclini, Castellanos, and Rosas Mantecón 1996). We also included sites where rock concerts take place, funk pits, and other similar venues. Even as the megacities become less and less articulated, these places mark specificity, and thus they reorganize the public and private terrain. These spaces signal belonging for certain sectors. They are places where one can dance,

and "feel at home." These public spaces largely function as if they were private, as spaces appropriated by certain groups. Thus they are simultaneously semipublic and semiprivate.

At this point, I would like to reposition some of the preceding ideas within the more specific frame of the study of the formation of imaginaries in the megacity of Mexico. It may be helpful to explain why I subsequently decided to explore the constitution of the urban imaginary by focusing on journeys through the metropolis, and also to identify the methodological tools my team and I developed in the course of our research.

First of all, we should think about the city as simultaneously a place to inhabit and a place to be imagined. Cities are made of houses and parks, streets, highways, and traffic signals. But they are also made of images. These images include the maps that invent and give order to the city. But novels, songs, films, print media, radio, and television also imagine the sense of urban life. The city attains a certain density as it is filled with these heterogeneous fantasies. The city, programmed to function, and designed in a grid, exceeds its boundaries and multiplies itself through individual as well as collective fictions.

Cities are made to be lived in, but also to be traversed. In Mexico City, millions of people spend between two and four hours each day traveling through the city by metro, bus, taxi, or private car. In the fifteen hundred kilometers that the city occupies, twenty-nine million personal trips were taken every day by the mid-1990s. These journeys through the capital represent modes of appropriating urban space as well as sites from which to launch imaginaries. Visiting zones with which we are unfamiliar, we come across multiple actors and imagine how these "others" live in settings that are different from our own neighborhoods and workplaces.

That is why such trips through the city serve as a productive object of study in visual anthropology. Anthropology, which has always sought to understand the relationship with the other through exploring distant continents, finds in western multicultural cities a similar sudden and intriguing contact with other ways of life. The simple expansion of modes of transport through urban pathways, and the violent interactions they provoke, can be compared to the eruption of modernity in so-called primitive populations. Through direct experience as well as through mass media, we discovered numerous disturbances caused by the construction of new metro lines, or the introduction of huge buses and speeding private cars in the narrow streets of small neighborhoods. Areas originally planned so that residents could walk

serenely or even stop to chat with one another, as if the pleasant streets were extensions of their own patios, are increasingly invaded and overwhelmed by speed, noise, and pollution. In the crisscrossing of private cars and public transport, of trucks and pedestrians, of traffic and street peddlers on foot, one sees many of the types of encounters that modern life offers as alterity and difference.

Megalopolis and Micropolis

In order to explore these multicultural encounters in the city, we made rather unconventional use of photography.[3] Photography differs from other ways to register and construct imaginaries, such as print media, film, or television, because it more profoundly fragments the city. We began with the hypothesis that there is a correspondence between the framing and cutting involved in taking a photo and the ensemble of disarticulated experiences that obtain in a megacity. In contrast to cinematic narrative, which helps us to imagine more or less integrated cities, photography offers discontinuous scenes or instances that, while they certainly may aspire to a broader representativity, always somehow separate experience from context. Rafael Argullol recently wrote that from Fritz Lang's *Metropolis* (1927) to Ridley Scott's *Blade Runner* (1982) and Wim Wenders's *Wings of Desire* (1987), the advantage of film over any other visual expression, resides in its totalizing capacity (Argullol 1994). Some films dedicated to Mexico City confirm this claim about the genre: *Esquina bajan* (1948) by Alejandro Galindo, for example, portrays a variety of journeys through the capital in many types of transportation; and *Lola* (1989) by María Novaro shows the protagonist and her daughter restoring, through extensive trips there, the areas of the city most affected by the 1985 earthquake. Photography, on the other hand, is more similar to the isolated and cumulative perceptions of the inhabitants of large cities. We cannot know the whole city, and we no longer find it possible to comprehend the whole thing. We limit ourselves to our own micropolis within the larger urban scene, and we visit only fragments of others' micropolises.

This fragmentary nature of urban experiences might seem, in a certain sense, to be overcome through travel, and yet it persists even there. The traffic jams, altercations, and fatigue that we face when traveling push us to develop new interpretations of the changing city. How do such subjective and fragmentary images differ from the global assessments and programs aimed at improving the traffic problem in Mexico City, or at controlling pol-

lution? One difference is that governmental rhetoric and programs try to concern themselves with the city as a whole. For example, the metro, which serves around five million people daily, has been expanded in order to diminish the almost three million car trips per day. However, we know the limitations and failures of public transportation. A recent survey by the Instituto Nacional de Estadística y Geografía (National Institute of Statistics and Geography) of the origins and destinations of trips taken in the metropolitan area shows to what degree urban space is privatized, or organized by private appropriation (INEGI 1994). It finds that Mexico City's residents use 3,252,000 parking spaces per day of which 4.7 percent are public, 57.2 percent are private, and 38.1 percent are in public throughways. One of the most compelling questions for us today is of how the categories of public and private are being rearranged in the thinking of those who move through the city, in the strategies and attentiveness with which we move about, and in the interpretations through which we try to understand why the city has been transformed this way.

We worked with film and still images to explore these themes.[4] We selected photos from the 1940s and 50s, when Mexico City had between 1.5 million and 2.5 million inhabitants. This was the moment that saw the beginnings of industrial expansion, massive migrations from the provinces, and residential modernization. We also reviewed photographic archives from the past ten years, and we worked with Paolo Gasparini[5] to photograph journeys through the capital and other related scenes chosen on a personal basis, though we took into account the systematic research carried out by anthropologists and sociologists of the Program in Urban Cultural Studies at the Universidad Autónoma Metropolitana. Out of all this material, we selected twelve photos from the earlier period and forty from the more recent period in order to focus our analysis on the variety of environments and experiences in the contemporary city, which contrast with the images from the past. We chose photos and films that reveal continuity with certain modes of transport (buses, cars, grocery carts) and others that mark difference (the metro, which opened in 1969; new models of automobiles).

We included images that show changes in the reasons people travel as well as the conditions under which they do so. This confrontation between the past and the present produced interesting observations. For example, the most significant change, according to the majority of the groups we studied, was the increase in the number of vehicles on the streets. One photo of a couple walking alone down a wide boulevard surrounded by trees was

interpreted by one of our interviewees as something that could happen only at night; but another one immediately added that the scene had to be old because nowadays, even at night, there would be cars parked all along the street.

We presented these fifty-two photos to ten focus groups made up of people who travel extensively through the city. We began with the hypothesis that perceptions about such travel would be more developed among those who have to move about the city on a habitual, daily basis. As for the selection criteria for the travelers, we assumed that cognitive, perceptual, and imaginary structures would differ according to the occupations that motivated their journeys. Therefore, we composed the groups according to these categories: delivery men (of food, cigarettes, batteries, and encyclopedias), street peddlers, traffic police, and taxi drivers. Given that these jobs share a lower-middle-class socioeconomic and educational profile, we also formed a group of university students who live far from their schools, and another composed of middle-aged people (thirty to fifty years old) from the upper-middle class whose positions in sales, promotion, insurance, and other jobs required them to travel frequently in the city.

We held two-hour sessions with the groups around a large table upon which the photos were displayed, and near which the video was projected. At the beginning of the sessions, we asked the members of each group to describe briefly (two to six minutes per person) a normal day of travel through the city. Later, we showed them the fifty-two photos and asked them to choose the ten that best represent the modes of travel and the meaning of that travel for the capital's residents. We suggested that they choose photos from the different periods, and we asked them to explain any historical continuities or differences they found represented in them. This exercise always generated an active dialogue among the participants about their lived experience regarding what they do when they travel through the city, what they know about the city, how they imagine that with which they are unfamiliar, how they describe different routes in the city, and how they navigate them. Our intervention was limited to making sure everyone talked and to asking an occasional question to stimulate the discussion of the photos or any debates among divergent perspectives. Finally, we asked which were the participants' favorite places in the city to travel through, which were their least favorite, and if they thought other situations related to urban journeys should have been included in the photographs.

Is it possible to group together such diverse types of travelers as if their

statements could be integrated into some global vision of Mexico City? More specifically, can the voices of six or eight people with similar occupations be blended into a single group message when they all come from different areas in the city and when their urban experiences are shaped within the different contexts of their individual work? The range of the photos chosen makes obvious the difficulty of generalizing. Only two images were chosen by eight of the ten groups: a Nacho López photo of various men pushing to board a city bus and a Paolo Gasparini photo of the Periférico full of cars while a few street peddlers walk about in the middle of this "expressway." Another image of a political protest on the Avenida Reforma, with the famous angel monument in the center, was chosen by six of the groups. The remaining forty-nine images were all chosen by some of the various groups, which indicates a wide divergence in preferences.

It must be said, however, that the discrepancies regarding which photos were more representative were diminished within each group through a process of discussion and exchange of opinions. In some cases, the decisions were taken by majority, but there was generally a sense of collaboration in reaching conclusions. When interviews are performed individually, only one person's knowledge, opinions, lexicon, style, and point of view can be assessed. Group interviews, on the other hand, produce conversation, which includes all of the aspects of an individual interview, but also much more. As Pablo Vila notes in his study of identities in the U.S.-Mexico border region, which also used group interviews based on photos, one of the advantages of the technique is that the group dynamic reenacts typical forms of interaction and elaboration found in real life: "In the collective context made possible by the group, the photo launches a social process in which the participants generally reach a kind of consensus (or at least verbalize their disagreements) about the meaning of the photograph, often based on initially contradictory interpretations of the image. As they do this, they reproduce the mechanisms of the construction of common sense in daily life, which are always collective — never individual" (Vila 1994, 29).

Why Travel Through the City?

Our selection of photos represented diverse types of journeys. Sometimes the purpose of the trip was obvious, but sometimes it was ambiguous or multiple. We wanted the visual discourse to be polysemic and more open than a typical survey or directed interview. The groups found that the photos

suggested travel to get to work, or work while traveling; travel in the hope of finding work; travel to buy and sell; travel to get information and use services (educational, banking, cultural); travel to meet with people; travel to eat or to have fun; travel to participate in political protest, sporting events, or religious ceremonies; travel to leave the city; travel to make contacts within and outside of the city.

The different groups identified and valued almost all of these kinds of journeys, although, as we will see, they used different criteria to determine which were more important. In general, the interviewees attended to the most literal meaning of travel. Some of them were puzzled by the images that alluded to more indirect or metaphorical meanings of the term, and when considering images of communications (telephones and satellite antennae, for example) asked what these had to do with the exercise.

Work-related trips figured centrally in both the selection process and in the stories it elicited. That was caused in part by the fact that the interviewees were chosen based on jobs that require travel. But it also reflects the obligatory nature of journeys taken in the middle of dense traffic, pollution, and the other urban inconveniences to which all the groups referred.

In a previous study of cultural consumption in Mexico City, Mabel Piccini and I found that the use of urban space for free time—and therefore during trips taken "for pleasure"—is restricted by the huge distances one must travel to get to a theater, a cinema, or a stadium. It is also limited by the effort required to traverse a city in which urban sprawl has grown far more rapidly than either the transportation system or cultural venues. The majority of our respondents in that study, which included fifteen hundred households that represented the general population, declared that they prefer to spend their free time at home. Even the minority who said they go out the most often—bachelors, youths, the more educated, and those with jobs that require long hours of sedentary work—did not in fact leave home very much. We observed that this retreat to domestic life was aided by the dissemination of electronic media that bring entertainment and information into the home. These media were mass-distributed in the second half of the twentieth century, the same period during which demographic and spatial expansion accelerated in the Mexican capital. While uncontrolled urban growth dismantled many parts of the city and made crossing them more difficult, radio and television linked inhabitants through information and participatory programs that make it possible to take "audiovisual jour-

neys" through daily events in the megalopolis (García Canclini and Piccini, 1993).

In the group interviews I discuss here, the participants only rarely mention the pleasure of traveling, or the pleasure trip. Some taxi drivers say, "I like cars" and "I like to walk along the street."[6] One driver enjoys above all, as he said, "that satisfaction and that sense of calm from being able to work whenever I want to." The street vendors also enjoy the entertainment they find in public spaces and in controlling their own time: "It's freer than being closed up inside a business and having to do whatever work they tell you to do." That does not mean that they are free from obligations, since it is precisely these poorer sectors, those without their own cars above all—like delivery men, who report rising the earliest in the morning (between 4 a.m. and 6 a.m.) to get to work or to take up their sales station.

For the majority, travel through the city is an exhausting obligation that they prefer to avoid whenever work does not require it. "There are probably lots of important things to enjoy, like museums, but we have the idea that being in the city means getting stressed out, tired. We prefer not to go out. We stay inside either at work or at home resting, usually watching television." In relation to the process of moving through the city, the equivalent of watching electronic media in such domestic encapsulation would be the photo of someone traveling while listening to music through headphones: "a way to distance yourself from the traffic, to relax." That scene has been so well-incorporated into contemporary life that it was described as "a very classical image."

"Going downtown," visiting "all the churches, all the old streets and houses," is more valued among those with more formal education. Still, that sort of walking and aesthetic contemplation of "the beautiful parts of the city" is associated with photos of the past and came up in stories of life from several decades ago.

In addition to "vehicular chaos," pollution is also blamed for having ruined the pleasure of traversing the city. The middle and upper classes often add migrants, street vendors, and other poorer communities to the list of culprits. "We avoid the poor neighborhoods . . . where it is impossible to find pleasant sights." That explains why they reject the photos of "the Indian woman begging for money," the children lying in a little plaza next to a sculpture. These images represent for them "the third-world" view of the country.

As opposed to the experiences that can be had at home or in neighborhoods, where choices are made according to the residents' economic level, journeys force us to deal with quite diverse sectors. Thus, urban travel reveals how divergent practices confront each other in city life, how different explanations of urban ills are imagined in a wide variety of ways. Everyone agrees that traffic is getting worse, along with disorder and danger, but they select different photos with which to identify those problems. Even when they choose the same images, they offer different interpretations of them.

Strictly speaking, none of the interpretations was held in common. The majority were disconcerted by the negative changes of recent years that have rendered the city more dangerous, more polluted, and more chaotic. One of the changes most often cited to explain these ills was the increase in migrants. From a more structural perspective, some explain, "the system has squeezed us so much that the people from the provinces have to immigrate to the city to find a way to support themselves." But various participants said that people should not travel to the big city "to seek their fortune": "The truth is that they are simply not prepared." Some saw unemployment as the consequence of la crisis económica as well as the changes in forms of coexistence brought on by people's sudden relocation to a megalopolis from rural areas or small cities, whereas others attributed it to an excess of migrants and their inability or lack of effort to adapt to a major urban center.

One of the most notable differences among the interviewees appeared between the stories of the traffic police and those of the other travelers. When the other groups discussed the factors that slow travel and cause dangers, they mentioned corruption. Some alluded to the police as inefficient, complicit, or directly responsible for assaults. To be sure, these were accounts of suspicion more than of fact: "It was a red Tsuru, and the windows were tinted," "the officers interrogated me, asking what happened, which they obviously already knew—and they knew who did it, because it was one of their friends who wasn't there with them." Although it is common for the interpretation of photos and travel stories to present a tension between the real and the imaginary, when it comes to crime and—above all—police intervention, these narratives appear to be imagined, but in such a way that the very hidden nature of the facts makes them the only way to point to the real.

For their part, the police officers present a clear, assured vision of urban order and orderly traffic. They describe their actions as precise routines

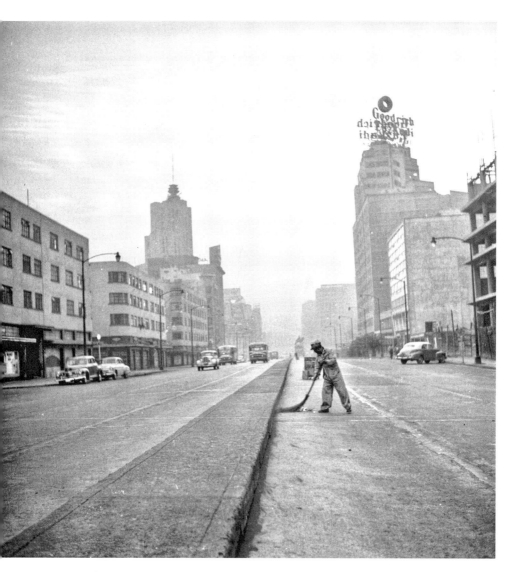

Nacho López, "Street Sweeper," Mexico, D.F., ca.1955. Photograph. Reprinted with permission from the Fondo Nacho López, Fototeca del Instituto Nacional de Antropología e Historia.

Juan Rodrigo Llaguno, "Retratos de Domingo 1990–91," 1990–91. Photograph. Reprinted with permission from the artist.

designed to make everything work: "Our job is to go out early and check the main thoroughfares, like Tlahuac, or Periférico, to prevent congestion, problems, broken-down cars." Their assignment is to ensure normality, something as simple as "that the drivers obey the traffic rules." In contrast to the other analyses, they claim that "the traffic problem is not that there are not enough streets, or that we need more transportation"; rather, "what we need is more driver education."

Just like the taxi drivers, the delivery men, and the street venders, the police see the entire city as a space through which to travel. However, the officers' notion of travel is not that of a series of complications or annoying disruptions, as for the others. It is a place where transgressions and irregularities are to be anticipated and preempted.

For this reason, the group of police chose the photos of political and sports rallies, cars parked on the sidewalk, newspaper stands that obstruct foot traffic, children stopped for "defacing" a sculpture and a public fountain, and the Periférico full of cars mixed in with street peddlers. When we asked about urban images that may have been lacking, they mentioned "mothers double- (or triple-) parking when dropping off their kids at school," vans that do the same thing, "women putting on makeup while driving or drivers reading the newspaper," "people [who] are stopped at a green light talking on their cell phones," "people walking across highways under the pedestrian bridges," "poor neighborhoods that have all the walls painted over with profanity." In sum, that which the traffic police would consider representative is that which transgresses "law and order" and "good manners."

Tactics, Transactions, and Detours

The taxi drivers, peddlers, and the upper-middle-class focus groups all speak of the impact of police corruption on traffic. The students say that "whenever you travel you hope you won't get stopped by the police." On the other hand, the police refer to violations by the taxi drivers and by "home owners, at least in Las Lomas, where they think they also own the sidewalk, parking vehicles there so that there's no room for pedestrians."

Beyond these reciprocal accusations, other comments by these groups allow for an interpretation of these behaviors as tactics employed by travelers — whether they are police or civilians — to be able to move about, park, and arrive more or less on time, in a complex megacity that sets up barriers for both people and cars. In other words, the city resists the appropriation of its spaces.

The taxi drivers run stoplights, and the police fine them on the spot. If a car or a street vender's cart cannot find an empty parking space, it uses the sidewalk. If a pedestrian is in a hurry, he or she does not bother to go the long way around to use the pedestrian bridge to cross a thoroughfare. Perhaps more than strategies, these actions should be considered tactics because, as the group dialogues suggest, they do not stem from a desire to improve traffic in general. Rather, they arise through the constant creation of small, personal solutions and transactions that attend only to immediate needs. A strategy would imply the contextualization of one's own conduct within the larger search for order in urban life, an approach that could improve things for others in similar circumstances. Tactics, in contrast, as Michel de Cer-

teau notes, are "multiform and fragmentary operations" (Certeau 1980, 15). Thus, he argues that tactics are the "triumph of space over time" and that "they do not preserve what they win" (19). However, the urban experiences that we charted show that sometimes the lessons do indeed accumulate. A particular type of citizen is being formed by the daily succession of these small tactics, a citizen who contributes to the reproduction of systemic inequalities and the legitimation of corruption.

In the more freewheeling moments of the group conversations, some participants described these tactics with great clarity. They explained them as modes of mental accommodation to adversities that are difficult to control. The threat of pollution, because of which people say "it's suicide to go running," is attenuated a bit if "we can see it this way: pollution, food, everything is some kind of toxin, and sweating it out a little is a way to detoxify. Yes, we may be ingesting some of that stuff, but what we can get rid of is what makes us feel better."

These fantasy-based interpretations are engendered in a certain way by the overly vast and complicated nature of what happens in the big city. Just as one must use detours or shortcuts to reach one's destinations during travel, living with problems that seem insuperable leads to the invention of mental tactics, "to solve" by imaginary means, to make a hostile environment "feel" inhabitable. It is less important to know how society really functions than to imagine some type of coherence that helps us live within it.

Our work with the focus groups showed that the fragmentary appropriation of space exemplified in urban journeys leads to the invention of "solutions" to traffic problems. Like Ludwig Wittgenstein's language games, such solutions are found between the real and the imaginary, between what one knows and what one supposes, between what is good for each individual and how each individual accommodates him- or herself to live in the context at hand. It is noteworthy that there were almost no references to strategic solutions. The travelers' imaginary is an imaginary of short-term tactics. What is more, the groups showed very little knowledge of what technocrats, urbanists, politicians, and journalists have been saying in recent years about the changes needed in the city. The majority of the proposals offered by the groups dealt with education and morality. They were appeals to personal responsibility.

The main demand from the police and upper-middle-class groups was "more traffic education so that everything will be more responsible and more efficient." Both groups suggested that people should live closer to

their work places. The upper-middle-class participants, who most heavily criticized the mass migrations from the provinces, invoked national solidarity: "If we only had a unified nation, if we only helped each other more, everything would be different." And then, "We are such egotists! Ay! Why should I go a day without using my car?"

Notes toward Possible Conclusions

What can we learn from this review of what ten groups of travelers in Mexico City have to say about living there? In a way, we already knew what they told us. If we compare the conversations generated by the photos with hard data about the city, measurements of its demographic and spatial growth, the multiplication and complexity of the transportation system, the difficulty of accessing public spaces, and the tendency to retreat to domestic life, then the information compiled here adds little. But if that were what we wanted to find out, our method would not have been appropriate.

Qualitative research is useful for accessing the ways in which different subjects—or groups of subjects—live these "objective" conditions, and how they construct their private worlds in relation to public structures. A vast swath of these private worlds is imaginary. That is why it reveals itself not so much through questionnaires and surveys that seek to draw general conclusions, but rather when people are shown images and invited to talk about what they see, or to use the photos as a basis from which to fantasize alternatives.

Perhaps what we have learned above all from this process is that a large part of what happens in the city, even that which most concerns us, is unknowable. One of the risks for those of us who collect information about the city is how easily we can forget that for the vast majority of people the city is an enigmatic object. In order to live there, they devise assumptions, myths, and partial interpretations drawn from various sources. With all of that they concoct versions of the real that have little to do with what the supposedly scientific explanations would say.

This distance, this disagreement, between private imaginaries and public explanations, is exaggerated in a megalopolis as difficult to comprehend as is Mexico City. That is why it would be impossible to formulate statistically representative sketches of journeys (real and imaginary) through the city by combining the routes described by focus groups (even if one were to work with one hundred or one thousand groups, rather than with ten). It would

also be impossible to depict multicultural intersections, or the manipulative stereotypes that some groups make about others in order to justify their behavior. By approaching these issues through qualitative methods, we arrive at a new level of knowledge, which Fredric Jameson briefly discussed some years ago in one of the foundational texts of postmodern thought, "Postmodernism, or the Cultural Logic of Late Capitalism" (1984).

Jameson cited Kevin Lynch's classic book, *The Image of the City* (1960), in which the author is concerned with how residents of large cities become alienated when they "are unable to map (in their minds) either their own positions or the urban totality in which they find themselves" (qtd. in Jameson 1984, 89). Lacking traditional signposts, like monuments or natural boundaries, they feel uncomfortable when they have to go to heterogeneous areas or to overly homogeneous ones, like cloverleaf junctions. Overcoming such alienation, according to Lynch, would require recovering a sense of place and constructing—or reconstructing—nodes of interrelationships capable of being held in one's memory.

The mimetic notion of correspondence between representation and reality, between maps and cities, which has been so criticized in poststructuralist thought, becomes particularly unsustainable when it comes to the imaginary relationship we all have with urban structures. What subject, group, research team, or even city manager, could ever have a view of the city as a complete whole? Actors move through the megalopolis by way of "pre-cartographic operations whose results traditionally are described as itineraries rather than as maps; diagrams organized around the still subject-centred or existential journey of the traveler, along which various significant key features are marked—oases, mountain ranges, rivers, monuments and the like." This type of itinerary is similar to "sea charts or *portulans*, where coastal features are noted for the use of Mediterranean navigators who rarely venture out into the open sea" (Jameson 1984, 90).

Nor do we who study the city have access to any global map, but perhaps the difference would be that we do have something like a limited aspiration to making such a map. Not one that could encompass everything, but rather an ensemble of navigational charts. At the same time, we need to develop methods for distinguishing "real" referents and structures from the cognitive maps that each group of urban travelers draws. We also need to understand from which positions and with which tactics they are designed. The goal is not to make an objective map of imaginaries, but rather to juxtapose imaginary itineraries, those narratives that diverse sectors build about their

journeys through the city, with the maps made by urban planners and sociologists.

We should establish the utility of these multiple types of maps for designing public policy. Which sectors devise which types of maps, and why? Why do these maps work more like travel guides that help us move through certain zones in the city and avoid others, rather than like sources of precise information? Perhaps we should also rethink what urban art might mean today. If these journeys are routes that produce a large part of subjects' (common) sense of the city, and therefore their urban culture, they ought to be central to the constitution of so-called cultural politics and the exercise of citizenship.

Obviously, we cannot limit our conclusions to only what the traveler-inhabitants tell us about these topics. Some city dwellers manifest their cultural politics and citizenship through political parties, social movements, elections, and consulting. But many others relate to urban life mainly as users of public transportation and electronic communications, of commercial and cultural centers, of sites for eating, strolling, or being entertained.

The information and interpretations regarding the ills of the city that we obtained from the travelers, as well as from other nonpolitical studies of urban culture, reveal travel maps quite different from those that appear when the population is invited to make political suggestions for solving urban problems. The photo-based interviews provide a particular type of information: an ensemble of tactics, detours, and fantasies that constitute an urban culture and a political culture. In other words, they show a logic tied to the practical: forms of imagination and resignation that manifest themselves as modes of thinking politics in the city, or the city as an object (possible or impossible) of politics and policies.

The photos, as I mentioned earlier, offer discontinuous images. But with those fragments, the photographers as well as the common travelers are able to construct multiple stories. These narratives reveal various urban cultures that are expressed through diverse types of cultural politics. In general, the interviewees are proud of antique churches and other colonial monuments in the historic city center. However, the middle and upper classes complain that the complexity of the contemporary city impedes their ability to enjoy it, and so they relegate that pleasure to the past. They also criticize other results of modernity: pollution, as well as the poor migrants who have extended urban sprawl to unbelievable distances and who have "uglied" the city with their self-built houses and temporary vending kiosks.

Pablo Ortiz Monasterio, "Y se hizo la luz," from the series *The Last City*, Mexico, D.F., 1980. Reprinted with permission from the artist.

The enormous virtual spaces between the photos allow each viewer-traveler to fill them in diverse ways. An aesthetic of discontinuity joins with the experience of urban fragmentation to facilitate a creative relation to the photos. Perhaps for this reason the travelers' narratives share very little with "objective" diagnoses about the city. They barely mention the lack of a rational plan for urban growth, which the literature on Mexico City considers key to her deficiencies. They vaguely praise "modern improvements"—the Periférico, the Viaducto, the metro—, but they see them as isolated incidents or as an echo of "foreign influences" that have "made us progress." A sense of unease predominates, caused by a city that, even as it has modernized, has also become more dangerous, polluted, and chaotic. What kind of modernity is it, when "our standard of living has risen, and yet our level of consumption has fallen"?

In the face of the difficulty of understanding these contradictions structurally, most people assign guilt to particular groups: the migrants who arrive unprepared to live in a big city, the political protests that block traffic, the excessive number of cars (although no one mentions who is responsible for that), police corruption, automobile owners who double- and triple-

park. A casuistic urban culture engenders a prepolitical culture, in which guilt is attributed to isolated groups while systemic causes are ignored.

Where there is a low level of awareness of structural problems in the city, it is logical that little attention is paid to relatively new questions requiring high levels of abstraction. Only the highly-educated groups mentioned the photos of parabolic antennae, or the billboards and newspapers in English, as symptoms of interconnection with the larger world. In a certain way their references to New York, Los Angeles, Japan, and China reveal the importance that the city's participation in globalization has for these interviewees. However, just as with their insiders' view of the city, even this international horizon is composed of random, isolated examples about which they recounted little information.

At least there is agreement that travel is central to urban space and time. We could say that this perception of the interviewees coincides with that of a number of specialists, for whom travel is now as key to urban life as is home. The city asserts itself as an indissoluble unity of residence-travel, in the sense that Walter Benjamin (2002) meant it in the early twentieth century and in the way that James Clifford has also begun considering it in his analysis of travel as an anthropological object of study (see Clifford 1992).

Doubtless, this is all particularly evident in a megalopolis, a place that seems endless, and where the long, everyday journeys recall a statement made in one of our group interviews: "It seems to me that sometimes we travel just to keep traveling."

Notes

This chapter was adapted from the second and third chapters of the author's previously published book, *Imaginarios urbanos* (1997). It was translated from the Spanish by Rebecca E. Biron.

1 Gino Germani (1911–1979) was the founder of empirical sociology in Argentina, which promoted the scientific research of social structures and relations.

2 The Chicago School was a group of scholars working in Chicago-area universities during the 1920s and 1930s. They developed an urban sociology based on their analysis of the city of Chicago and how its physical layout correlated to specific human behaviors. —Ed.

3 An extensive explanation of this research may be found in García Canclini, Castellanos, and Rosas Mantecón 1996.

4 I will limit this discussion to the photographic material. The film analysis and the

interpretation of our focus groups' reactions to the films were carried out by the coauthor of the study, Ana Rosas Mantecón.

5 Paolo Gasparini is one of the most important photographers of Latin America. He has produced work on Caracas, Havana, São Paulo, and Los Angeles.

6 Unless otherwise noted, all quotations are taken from focus group interviews conducted from 1993 to 1995. For a more detailed description of these interviews, see García Canclini, Castellanos, and Rosas Mantecón 1996.

Buenos Aires is (Latin) America, Too / Adrián Gorelik

Bernardo Verbitsky's novel *Villa Miseria también es América* (Shantytown is America, too) was published in Buenos Aires in 1957.[1] It narrates the story of a leftist student who "discovers" the shantytown hidden behind walls from the rest of the city, a result of the internal migrations prompted by Peronism. In discovering the shantytown, the student discovers America. In this novel, *America* refers to Latin America, the deep interior of the country and the continent. The shantytown was just one of many discoveries for anti-Peronist progressives after Peronism's fall. It was a fundamental discovery in Buenos Aires, because it signified the appearance of the radical other in the very core of the city. Villa Miseria can be America because Buenos Aires is not; it is a foreign (but real) body within a city that denies its very existence (thus revealing the city's own hypocrisy). It calls up that old image of "the two countries": the "true country" of the deep, authentic interior and the "false country" of the vain and superficial capital. This dichotomy, favored by the French Right and appropriated by Argentine nationalism to explain the country's ills in the 1930s, is applied to the city proper in the 1950s and assumes a progressive (and populist) stance.[2] Buenos Aires can finally establish its Latin American identity if it acknowledges this "other city" that has grown up within it, this redeeming Shantytown, the promise of a more authentic and free life. The novel's title reveals an agenda that organized the progressive imaginary for decades: setting for "European Buenos Aires" an American goal.

Our contemporary crisis in Buenos Aires can be thought in relation to

that agenda in two ways:[3] as inversion and as repetition. In the case of inversion, the signifier *Latin America* has found an opposite meaning: what was once a project now appears as a destiny. European Buenos Aires can no longer avoid the ominous presence of this human tide that daily rakes the city to rummage through her garbage or to set up makeshift tent cities in the plazas and in the doorways of shuttered shops; it can no longer avoid the growing insecurity, the need for private hired guards, and the disappearance of public space. Latin America today is the sign of collapse. But the crisis can also be envisioned as repetition because in current representations, just as in the novel, the Latin American component erupts like a discovery, revealing what we could call the primal scene in Buenos Aires: the scene of a society's shock upon recognizing the presence of the radically other. That discovery of Villa Miseria and the surprise it elicits offer two ways to look in the Latin American mirror. The mirror is fragmented, but it is also triangulated in Buenos Aires by the certainty of the city's European exceptionality and, in a less obvious but equally powerful manner, by the presence of its North American counterpart.

Buenos Aires is forever preoccupied with where and to whom it belongs, seeking models and embodiments of virtue and progress in other international cities. I trace how different stages in the city's history have founded their identity in entire continents (Buenos Aires as European, North American, or Latin American). These representations address much more than the current crisis of Buenos Aires; they also explain in more general and long-historical terms that other side of the mirror in which the city sees itself: Latin America as an idea, a project, and a destiny.

The Most European City

What was this "European city" in contrast to which Shantytown stood as the embodiment of Latin America in the 1950s—and how was this city formed? The representation of Buenos Aires as a European city is very old, at least as old as the Revolución de Mayo, when making the city more "European" came to be understood as a way to resist her Spanish heritage and, therefore, as an instrument for American emancipation. Buenos Aires, marginal to the self-absorbed Spanish-American universe in her extreme corner of the Río de la Plata, was assumed to be the most American of the region's cities because of its capacity to function as port and door for ideas, men, and European merchandise, offering the "new" continent a uniquely liberating

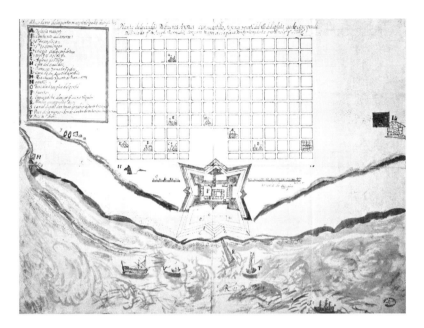

Plano lineal de la ciudad de Buenos Aires y su castillo y parte del Río de la Plata, Buenos Aires, 1708. Manuscript map. Archivo General de Indias Ref. Buenos Aires, 38.

taste of the future. Nevertheless, during the rest of the nineteenth century and into the beginning of the twentieth century, that representation lost relevance. Perhaps because other models for modernization appeared—like Domingo Faustino Sarmiento's, which opposed "frozen" Europe and preferred to introduce in Buenos Aires "the secret of North America" that Alexis de Tocqueville had revealed. Or because a too-European elite became, in the course of the modernization underway since 1880, painfully conscious of the gulf opening between European cities in which they felt at home, and the provincial chaos of Buenos Aires, invaded by exotic multitudes that did not seem to come from Europe and by bad copies of buildings imported by a new, unrefined bourgeoisie concerned with neither good sense nor good taste. In the hands of a truly existent Europe (the poor immigrants and the architectural eclecticism), Buenos Aires turned into an unrecognizable encampment. As a result, the established culture began to mythologize that "great Creole village" that had disappeared at the hands of this horrible new city—"the ugliest I have known between the second, third, and fifth order," lamented Miguel Cané (1885, 481).[4] The few modernizing reforms that were actually implemented under the pompous and deceptive name of *Hauss-*

"Gran Panorama Argentino del 1ᵉʳ Centenario de 1910," Buenos Aires, 1910.
Postcard. From Margarita Gutman, ed., *Buenos Aires 1910: Memoria del porvenir*
(Buenos Aires: Gobierno de la Ciudad de Buenos Aires, Facultad de Arquitectura,
Diseño, y Urbanismo de la Universidad de Buenos Aires, and Instituto Internacional
de Medio Ambiente y Desarrollo (IIED), 1999), 371, cat. no. 330.

mannization accomplished nothing more than to emphasize their difference
from the desired models.[5]

Although by the 1910s Buenos Aires was beginning to be identified as a
"European city," the change came about according to a peculiar equation.
Those who judged her so were the foreign visitors invited for the centenary
celebrations. They began their accounts—that genre of narratives whose
ultimate meaning lies in comparison—signaling that "the first impression
one experiences in Buenos Aires is that of arriving in a great European city"
(Huret [1911] 1988, 27). Of course, we must not dismiss these guests' op-
portunism, as the few dissenting foreigners harshly pointed out.[6] But if we
examine their less spurious motives, we see that they found an absence of
"exoticism" to be evidence of European character. These travelers noted the
absence of two elements that they had expected to find in Buenos Aires: in-
digenous traits in the population, in the Latin American manner, and monu-
mental traits of urban modernity, in the North American fashion. As we can

see, the definition of *exoticism* had changed by this time. That which the local elite saw as exotic at the end of the century became essential to the new European image in the first decades of the twentieth century: immigrants, architectural eclecticism, the human and urban scene that is key to verifying proximity to European models.

Buenos Aires is European insofar as it is not Latin American but, above all, because it is not North American either; this is the peculiar equation that arose from the celebration of the centenary, produced by travelers who came to the city eager to find a Latin counterpart to New York. If the United States had already shown that America is the future (North America's power was already evident in the early twentieth century), the emergence of Buenos Aires as a world metropolis engendered thoughts of "the future of the race" (Posada [1912] 1986, 54). The majority of the centenary visitors were from Latin Europe, where this speculative relationship between New York and Buenos Aires was constructed. It was a relation triangulated by Latin Europe with its own culture, afraid of its decline in the face of the emergence of North America or of Germany's dominance. This was the explicit preoccupation of Frenchmen such as Jules Huret or Georges Clemenceau, and of Spaniards like Adolfo Posada, but it was best expressed in terms of urban culture not by a European, but rather by a cosmopolitan Guatemalan, Enrique Gómez Carrillo.[7] He provocatively rescued Buenos Aires for his family of "retrograde loves," including Paris and Rome, "that have the audacity of being less comfortable than Chicago or Berlin" (Carrillo 1914, 45–46).[8]

Almost all the travelers' accounts flirt with existential dilemmas concerning Buenos Aires. What cities does it resemble? Does it have its own character? They thus initiated a series of comparisons that converted the city into an album of fragmentary postcards: the Avenida de Mayo can be likened to Paris, with its spacious sidewalks and terrace-lined cafes; the narrow streets of the banking district, to the city of London; Calle Florida, to Carrera de San Jerónimo in Madrid; Palermo, to the Bois de Boulogne; La Boca, to Genoa; and so on. We're treated to a paradoxical comparative system, simultaneously flattering the vanity of Buenosaireans—and they always encourage it—while further undermining Buenos Aires's fragile sense of self.

Thus, the centenary consecrated the euphemism that "Buenos Aires is the second Latin city after Paris" (Carbia 1908, 270), a city capable of matching Paris, no doubt . . . if not for "the damned straight lines" of its rectangular geometry (Carrillo 1914, 47). This is the constant complaint, from even the most fervent defenders of "the enchantments of Buenos Aires" (as Gómez

Carrillo titled his book). The "Spanish checkerboard" was already a cliché, irritating Sarmiento as much as Cané.[9] It caused dullness and monotony in the city; blocks extended without limit, always the same, reflecting the tedious regularity of the plain. And if this were the dominant impression in the nineteenth century, towards the centenary the reasons for it were strengthened even more, since the area the city occupied had grown four times larger and the authorities had plotted out the enormous empty expanse to be incorporated in direct continuity with the rigid grid. Now it was a city "that goes straight away filling up the immense playing board with cards, infinite lines and numbers" as one traveler said (Rusiñol 1911, 69), forming, as another once said, "the abhorrent American city blocks" (Carrillo 1914, 39).

This constant critique, in such a consistent tone, is particularly interesting, because Buenos Aires brings together very different images of the grid. The grid system is rejected for being too traditional, the Spanish half of the barbarity whose other half is the nature of the pampas, which adapt to it and explain it. And it is also repudiated for being too modern, like a new savagery—that of capitalist exploitation of the land, a North American trait. Both repudiations will continue to be ambiguously linked in almost all twentieth-century observations.[10] A very few attempt a defense against them, either through provocative celebration of North American modernity (like Alberto Gerchunoff, who argues that our regular blocks show that "we are the barbarians, the beautiful and robust barbarians of civilization") or through a more uncertain approach that lauds the city blocks as Creole but also, because of that, avant-garde (like Jorge Luis Borges, who responds to the two reasons for disavowal by arguing that Buenos Aires was established mythically in a square block carved out of the pampa).[11]

In any case, what the grid system shows is that at the turn of the twentieth century the morphological and social design of the city owed its shape to far more specific processes than some improbable Haussmann-like performance on the prairie. Especially because the grid blended the historical center with new lower-class suburbs, eliminating the barriers that in so many other Latin American cities foster urban and social segregation. Within a few decades the urban grid became the most accurate expression of the state's desire to integrate a conflictive and plural society; along with public education, which was key to that policy, it could be said that the repetitive city blocks of Buenos Aires were formed as an urban reassurance of broad social mobility. Thus, the "American" foundation of the city would

become one of the essential components of the "European" aspect of its public spaces.

Finally, between the mid-1930s and the mid-1940s, Buenos Aires achieves its modern form and fully assumes its "European character," which in the 1950s is taken to be common knowledge. Like no other region of the country, Buenos Aires capitalized on Argentina's phenomenal economic growth in that period. In addition, the city clearly defined its physical as well as social contours. Once the urban infrastructure had been completed, its border was marked with a modern perimeter avenue, the Avenida General Paz. What's more, the modernizing reforms of the city center were finished, with their new monuments (the Obelisk) and their new technical achievements (the subway, or the "widest avenue in the world," the Avenida Nueve de Julio). And that chaotic and heterogeneous society also crystallized in the figure of the *porteño* (Buenosairean), the crucible in which European blood acquires American citizenship. Often repeated in the self-congratulatory literature of Buenos Aires, a successful blending has taken place, and its result is a proud and self-sufficient society of unquestionably European characteristics and appearance.

First Discovery of Latin America (via Chicago)

But, curiously, the consolidation of that European *form* of Buenos Aires, which the local imaginary maintained for a good part of the century, occurred simultaneously with a second metropolitan expansion, the one that formed what is now called Greater Buenos Aires. This expansion did not involve migrants from overseas, but rather the strange "dark masses" from the interior of the country and from bordering nations, who ought to have challenged the local imaginary. If at the turn of the century half of the population of Buenos Aires was foreign and mostly European, by 1946 internal migrants made up 40 percent of the metropolitan population, and in 1960 they constituted 90 percent of the working male population and 58 percent of the working female population. However, that did not modify the city's self-image. The process that developed in those years across Latin America, described by José Luis Romero as "a rural attack on the city," was equally strong in Buenos Aires (Romero 1976, 321), but it did not have the same effect on cultural representations in Buenos Aires.

One can offer various explanations for this incongruity. First, it is the nature of the second wave of urbanization; in contrast to the other Latin

American capitals, Buenos Aires comes from a much older modernity.[12] In addition, this second expansion was relatively less explosive, with a population dynamic more similar to European cities. Note, for example, the contrast with Mexico City, the Latin American city that most paradigmatically underwent the "urban explosion" of the 1940s and 1950s. In 1940, Buenos Aires had twice the population of Mexico City; in 1960, only half. The symbolic strength of that consolidated modern form offers another explanation for the cultural resistance to new migrants in Buenos Aires, one based on the maintenance of the quality and vitality of the renovated historical center. With very slight modifications, it continues to be as much the residence of the upper classes, as it is the favored site of leisure activities for the masses. Hence, it provides a solid core of transversal recognition for all Buenosairean society, a shared "analogous city," that reunites all the postcards of local pride and reproduces them in scale for each suburban center. In this way a network of signs of urban identity is distributed across the territory of expansion in a hierarchical gradation from the center to the periphery. However, the strict maintenance of its European character produces a less positive characteristic of Buenos Aires; from the end of the 1930s, when the second expansion begins, the capital city which had been formed in the first expansion closes in on itself institutionally and culturally. It turns a blind eye to everything taking place in the new metropolitan suburbs beyond its formal borders.

Thus the specific meaning of the phrase "Greater Buenos Aires" becomes clear. Contrary to other great cities of the world, where such a designation indicates the entire metropolitan area, in Buenos Aires the term "Greater" (*Gran*) serves to designate only the "external" districts of the capital city, separated from the nucleus which had given rise to them. And Avenida General Paz becomes the material and symbolic border of the "European city," beyond which resides the majority of the new population. The population of 1940 of almost three million inhabitants in the capital city has remained constant until today, while the nine million more that have been added since then reside outside of the city limits. Therefore, one also sees how "the city" could produce that primal scene of surprise and discovery when this veiled reality erupted during the mobilization of October 17, 1945, when foreign multitudes came to the heart of the city from its outskirts, to give Peronism their popular blessing.[13] The "European city" was also disrupted by the fall of Peronism and the creation of the Villa Miseria, the interior consolidation of a fragment of that other world.

In any case, for a book like Verbitsky's *Villa Miseria también es América* to be written, a novel that locates Buenos Aires's future in this invasion of the Latin American city, two requirements had to be met. Not only did Villa Miseria need to be discovered, but urban culture had to come to terms with the very idea of the "Latin American city" that the Villa embodied, unthinkable before the mid-1940s. Significantly, that idea produced the theory of modernization that, guided by North American functionalism, was pan-Americanized in the second postwar period through a dense network of institutions (e.g., Organization of American States, Economic Commission for Latin America and the Caribbean, Inter-American Planning Society, and the Ford and Rockefeller foundations). Ironically, the "Latin American city" as a category was discovered neither in Villa Miseria nor beyond the Avenida General Paz, but rather in the sociology of Chicago.

It is often overlooked that the Latin American urban question figures centrally in the production of key categories in international sociology of the period. Consider Robert Redfield's "folk-urban continuum" or Oscar Lewis's "culture of poverty," terms the scholars coined for their research in Mexico.[14] Although their theories are conflicting, both men searched for the secrets and obstacles of "transition," that decisive link in the theory of modernization. In fact, the social sciences in Latin America were born and developed through the discussion of those categories, as well as through the policies that inspired them and the institutions that implemented them. Like the very idea of the Latin American city, they were forged in the operative tension emanating from the term *city planning*. The numerous international conferences of the 1940s revealed that the Latin American city marked an ideal point in the transition continuum, neither lagging behind, like the rest of the third world, whose urban explosion Latin America shared, nor so far ahead that it impeded "an intelligent and foresighted design" that could avoid the perils of earlier, unregulated modernization in more advanced countries (Hauser 1961, 23).[15] In the social thought of the time, governed as it was by constructivist voluntarism in planning, Latin America seemed to be ideal territory, once more the promised land for *ex novo* replication of the West.

Villa Miseria también es América must be placed in this context, together with the emergence of a form of urban planning in Buenos Aires that finds the redeeming aspect of the category of Latin American city in its potential for modernization. But the theoretical and political intensity of the urban question, the urgency implied in the expansion of the cities, brought this

fundamental cycle of Latin American thought into profound crisis. Even as the Latin American city was taken to be a laboratory for the theory of development, it did not confirm the theory. On the contrary, it actually challenged its foundations to the point of generating radically critical alternatives.

In fact, this revision started at the very beginning of the cycle, in the 1950s, in the face of certain functionalist theoretical postulates that pathologized Latin American urbanization: the concept of *over-urbanization* as the lag between the rates of urbanization and those of industrialization; *primarization* as the dominant presence of large cities in each national territory, in contrast to an ideal of homogeneous, linked urban networks; the *traditional/modern* dichotomy, as index of the weight of rural culture in the "marginal" sector of urban services. But if this critical revision sought to show the misalignments of the theory of modernization with regard to the region's path toward urbanization as development, very quickly it arrived at a complete inversion of modernizing certainties. It replaced development with dependence. This process revealed that in certain conditions, urbanization, far from being the remedy, was a sign of underdevelopment as well as a cause of its perpetuation. Each specific city had to be thought as an example of the category of Latin American city. Buenos Aires was thought of from within the new critical agenda (and this usually by the same people who had created the previous agenda).[16] The issues were the question of social housing, the problem of the periphery, and the condemnation of the state, which had once represented hope for planning, but now was stigmatized as only an agent of domination. The mystifying homogeneous representation of the city, based on the exceptionality of its public space, gave way to an equally mystifying representation of the "segregated city," that could not see any differential element in Buenos Aires with respect to the Latin American context. If, for development theory, Buenos Aires could be a prime example of early modernization in the continent, dependency theory did not really know what to do with the city as a social and urban mechanism.

Just as the initial discovery of the Latin American city came by way of Chicago, its conceptual journey also made a stop in Cuba. This was not only for reasons tied to the revolutionary imaginary, but also for other, more specific reasons found in urban theory and confirmed by the political reality of the 1970s. On the one hand, an ambitious experiment in reformist regional planning had converted Chile into a beacon of international planning, but the military coup brought this to an end.[17] On the other hand, the Cuban revolution successfully implemented the same experiment, especially through

the decentralization plan for Havana. Thus, according to these two cases, it seemed that any change in the relations between society and the land in Latin America would have to be preceded by revolutionary political change. And, more important still, it seemed that the revolution would come from the rural zones, while modern urban society would resist it.

"Cabecita negra" (Little black head), a short story by Germán Rozenmacher, was published in Buenos Aires in the 1960s. It reflected this kind of thinking, displacing the reformist accent found in Verbitsky. The contemptuous nickname that "the city" gave to the new migrant from the interior, *cabecita negra*, comes to signify an agent of rapid and profound change in the story; it attacks the conformist values of the urban middle class. The new kind of liberation represented by the Argentine peasant, the Paraguayan, or the Bolivian who migrates to the city expresses itself through a brutal confrontation that destroys any sense of commonality and turns urban public space into a battlefield. Faith shifts from the "modernizing pole" to the "traditional pole," because it is now clear that at the other end of the rural-urban continuum there will be nothing but the taming of that revolutionary energy.

In this sense, the passage from *Villa Miseria también es América* to "Cabecita negra" represents the same displacement that a notion like "culture of poverty" undergoes in urban theory. Verbitsky's book remains very close to Oscar Lewis's first formulations, which offered a sophistication of functionalist theory, although it shares functionalism's developmentalist ambitions. The novel shows that the culture of rural migrants, which in one way could seem traditional (such as the extended family), was valuable for the process of adaptation to modern life. Rozenmacher's story, on the other hand, bears the anti-modernizing disposition of a new sense of the "culture of poverty," no longer seen as an instrument of adaptation, but as an essential quality, resistant to change, that offers cultural and social alternatives to the modern city. In the 1970s there was widespread demand in Buenos Aires for a labyrinthine urban structure like that of Villa Miseria. This vision was opposed to the homogeneous city grid and paralleled the demand for picturesque landscaping in the high class "park district" at the beginning of the century. In both cases, low and high cultures remained united against the alienating uniformity of mesocratic culture.[18] The urban middle class, the proudest product of European Buenos Aires, had become (right before their very eyes) the obstacle to all change. And the failure of will toward urban reform, the decline of the historical centers, the decay of public space,

all "typical" characteristics of Latin American cities, ironically became reasons for celebration. They disguised the true character of domination. As Richard Morse, one of the most lucid theorists of Latin American populism (and one of those who best exemplified the entire cycle of urban theory, from its reformist origins to its critical inversion) maintains, Buenos Aires celebrated that "for the first time since the European Conquest, the city is not an intrusive bastion against and control center for the rural domain. The nation has invaded the city" (Morse 1992, 19).

European Interregnum (with a Detour through Miami)

Might it be that the starving multitudes traversing the streets of Buenos Aires these days are the culmination of that horrid dream? Because, having been the most European of the Latin American cities, Buenos Aires was simply the last bastion to be defeated? In any case, it is interesting to note that today almost no one is happy about it. The new climate of urban culture in the 1980s left those old paradigms in the dust. Urban thought underwent another revolution, but this time it was even more radical. Because if the 1960s inverted categories that then engaged in dialogue with each other, the shift in the 1980s brought more than just a change; it introduced a system of completely new references, a new language that did not communicate with the previous one. Incidentally, this happens rather often in Latin American culture, which seems to be constructed in geological layers, so that cultural tradition is perpetually invalidated.

It is not that the previous positions just disappeared, but rather that they were reduced to a subfield of specific studies—urban sociology—developing an esoteric jargon that lacked the power to engage with the new times. It became difficult to detect any signs of life from that buried monumental legacy, the Latin American city as a key theme in social thought. In this context, not only was no one celebrating the current invasion of the city by Latin America's "others," but the invasion could again constitute a primal scene of surprise, because the new configuration of urban thought effaced earlier premises and the principal actors.

There were new themes and disciplines, but once again the big question was modernity. Finally, after decades of Manichean debate between uncritical, celebratory views of modernity on the one hand (modernity understood as linear progress, as economic development, and as cultural homogeneity), and negative readings of it on the other, Buenos Aires could now be under-

stood, in all its complex linkage with culture, as a space of conflict, the product and motor of a "culture of blending."[19] The rapid hegemony of this new sense of the urban can be understood in the intersection of a series of paradoxical factors in Buenos Aires at the beginning of the 1980s.

One of the factors was the international height of the postmodern debate and its attention to urban thematics, as can be well seen in the overwhelming reach of Benjaminian motifs: the value of the city as modernist artifact and the value of urban culture as a document for interpreting modern life.[20] Here we find the first paradox, a sign of the disconnected periodizations of Latin American culture. Postmodernism reinstated the themes of the city and of modernity based on ignorance of what more legitimately should be called postmodernism in Latin America: the process of experimentation and debate in earlier decades that had led urban culture from full confidence in modernity to its complete rejection.

The European cities that now best embodied the new climate of urban ideas were Berlin and Barcelona, with their innovative and pluralist visions of public policy, and their recovery of public space for the democratic construction of the city and the citizenry. The second important factor for Buenos Aires, then, was the end of the dictatorship. That allowed for a novel consideration of the city as public space, the space of intersection and the production of difference on a level playing field of rules and rights (now, yes, exemplified superbly by the grid), while the real city returned to being the scene of political action and cultural life, of celebration and of protest. But here appears a second paradox: unlike the spectacular relaunching of those European cities, this new climate was expressed in Buenos Aires by the notorious material decay of the city, which inadvertently revealed that the whole cycle of modernizing expansion had ended long ago. The dismantling of the uniform discourse of planning—that had reached its final and tragic expression in the dictatorship's urban policies—revealed the wealth and the complexity of the multiple projects that Buenos Aires had come to embody, like a patchwork of truncated plans. Even as these projects finally became visible, the urban crisis gave their discovery a posthumous, epigonic tone, a kind of archaeology of our modern pasts, harboring the expectation that they would engender yet more projects, in concert with a democracy also rediscovered.

Finally, the third paradox was perhaps the most decisive for the city because it would mean the failure of that expectation. The fragmentation of the old monolithic "modern project" that connected urban culture to the

wealth of its multiple modern-European pasts coincided with a new kind of urban fragmentation: social life became more segregated as important sectors of the middle and upper classes adopted the private patterns of North American–inspired consumerism. That is to say, the discovery of the political and urban possibilities of public space occurred at the very moment in which public space suffered an attack from privatization. Two urban artifacts emblematized this privatization in a radically new way: the shopping mall and the private guard houses erected on the corners of residential neighborhoods in Greater Buenos Aires. The guard houses mark off the urban grid, interrupting the flow of an integrated public. Again the map of city blocks functions as both a material and a metaphorical incarnation of other processes. Urban fragmentation goes hand in hand with the crisis of the state that deserts its role as a guarantor of order (for which it had been harshly criticized). But in addition it is exploited by society through a process of microprivatization that consolidates the fissures as it seeks to establish pockets of well-being and security braced against the public as a whole.[21]

Let's pause for a moment to consider the urban logic of shopping malls. In Buenos Aires, the shopping center entered the scene comparatively late, in the 1980s. It was in part a result of the detour to Miami that the middle and upper classes began to make during the dictatorship, when they began to abandon the traditional Parisian reference. But, in urban terms, it arrived late because the centralized structure of Buenos Aires and the scope of her public space were not hospitable to it. The concept of the shopping mall was born in decentralized urban systems to create simulacra of the city in suburbs that lack the commercial, cultural, and civic density of traditional city centers. But when it comes to Buenos Aires, the mall settles in the center of the city, a private alternative to the intensity of the public space outside its arcades. Given that the density and complexity of social life on the street cannot be replicated, the shopping center in Buenos Aires offers only the order and security that the segmented city demands. The shopping center relies on a passive state and urban fragmentation. It is the product of a city that no longer hopes for expansion and homogenization; rather, the city now feeds on contrast and an imaginary of exclusion. In order to prosper as urban typology in Buenos Aires, the mall needs public space to be homologous to chaos and insecurity.

Second Discovery of Latin America (via Los Angeles)

In the 1980s the shopping center exemplified a group of factors that were mutually imbricated: increasingly concentrated private investments, the withdrawal of state intervention (caused as much by a lack of imagination as by a lack of control), and social and urban fragmentation. The new cycle of modernization in the 1990s synchronized those transformations of the city and the society, using them as the foundation for a new urban system. In truth, it was a Copernican revolution in Argentine democratic policy, which had heretofore focused on integration. This new urban system for the first time accepted fragmentation as a given, as the necessary condition for a modernizing leap. What's more, there was a Copernican revolution in the Peronism that had returned to power. Just as it had generated Villa Miseria in the 1940s, making possible the discovery of Buenos Aires's American promise, this second Peronism again offered America as a promise. This time, however, "America" appeared in a northern guise. The shopping center model spread across the land in a proliferation of private enclaves that no longer register notions of center and periphery; they are indifferently connected by rapid freeways. The celebration of consumerism and the private world, with the peso pegged to the dollar, saw its urban incarnation in the installation of a hypermodern network, of self-sufficient logic, suspended over the old and already fractured public structure of the city that was thus free to decay on its own.

This new urban system assumes the end of modern urban expansion. It is a true system in its urban logic, since, just like the shopping center, it does not reverse the framework of decay, but rather serves as its necessary counterpart. It is also a system with its own cultural logic, as seen in how the press of the time conjugated in all its forms the natural living/new domesticity/new workplace/complete privatization of social circuits/sophisticated consumption of equipment and technology/highway-car-gated community–mall shopping center model.[22] The obvious model was the "city with no center," Los Angeles. But what one must understand about Buenos Aires is that this new modernization by enclaves developed as conflict and tension, rather than as a system of antagonistic logics. Because, even without the vitality of old and without the political-public nourishment that had been weakened to extinction, there remained in the city an urban core built within the homogenizing parameters of "the public," that offered material

resistance. It also continued to show off its achievements in very extensive areas of downtown—those old postcard images of the "European city."

This expansive city had been built, as we have seen, from the center towards the periphery, revealing wounds, injustices, and omissions as it expanded. The post-expansive city, however, the city of post-public modernization, spread in the inverse sense: from the periphery toward the center. It installed its greatest territorial enterprises in the weakest points of the previous system. In the second half of the decade more than 60 percent of the final suburban belt had been completed with closed neighborhoods, private towns, country clubs and "environmental communities" for permanent residence, "nautical neighborhoods," and other communities. It connected them to the enclaves of financial, commercial, and touristic concentration of the "globalized" city center by means of freeways. That which in the old system was a liability, a disqualified periphery left to its fate, now became the new nucleus of meaning. In fact, this new urban system dissolved the old and degrading border between the capital and Greater Buenos Aires, because the new urban network presupposed a mobile, rhizomatic boundary. It assembled freeways and enclaves into a circuit splayed across the entire metropolitan territory.

It should be said that this new urban system never functioned fully; the inversions quickly found their limit. Some "private cities" planned during the boom for the periphery remained barely delineated in the plans of real estate agencies. The linear shopping center of Tren de la Costa was shown to be greatly oversized (sixteen kilometers of rail just for shopping and watching shoppers, in a country that had closed its productive branch rail lines). Complete zones of the traditional center where great enterprises began— enclaves attempting to replicate the success of Puerto Madero—suffered a kind of ephemeral gentrification. The best example is the neighborhood of Abasto, the old marketplace converted into a shopping center as part of an ambitious operation of the Soros group. Their plan was abandoned half-finished, a chaotic mixture of "country towers" and tenement housing, international hotels and dance clubs, shopping centers and random kiosks.[23]

The new model showed its limitations even as it was being developed. It was better able to weaken the barely recognizable characteristics of the old project than to establish its own. So when the mirage of those years passed, with the beginning of the decomposition of Argentine society, the decline was complete. Only then did society, until then excited by their provincial version of the "American way of life," begin to notice that behind the

facade of Los Angeles there lurked Latin American reality. Now there are not pockets of misery, as in Verbitsky's Villa, but rather pockets of well-being. And these have become insecure traps (they come in droves), belying the promise that once legitimized them. The Latin American continuum that surrounds those pockets of privilege now promises only violence and exclusion.

And as history always teaches — even if only to show that Marx was right — second chances come as farce. This new Latin-Americanization was accompanied by a resistance inspired, like that of the 1950s, by North America. However, this time the influence came not from Chicago, but from Miami. A new genre of protest music groups (as they were called in the 1970s) appeared in Buenos Aires. They sang of an improbable "Latin revolution," in a manner completely different from any of the traditions of resistance in Río de la Plata. They employed terms that are comprehensible only in the language of the cultural marketplace that produces MTV (see, for example, the lyrics and videos of a group called Bersuit Vergarabat).[24]

Coda: Modern and Globalized

This model, combining "North American" circuits of privilege and "Latin American" sites of decay, and crossed with the cultural logic of Latin pop, is that of the "globalized city" where all distinction between the North American, the Latin American, and the European loses relevance. Nevertheless, in the financial collapse of 2001 and 2002, the Latin American element emerged once again as a surprise. But this time it was also a threat or a disillusionment. What happened to Buenos Aires? How did it fall so low?

In 1991, Sergio Chejfec published El *aire*, a novel in which Buenos Aires appeared as a spectral landscape that controlled the movements of its afflicted protagonist. The city appeared in a fictional form that has been manifested almost literally in the real since the beginning of a generalized decomposition in December 2001: brutalized multitudes searching for bottles in the trash (in the novel, glass replaced money; in the real, paper now replaces it); squatters crowding in precarious huts on the roofs of buildings (a miserable "suburbanization" of the same decaying center, that is currently realized in cars and trucks parked on the corners); abandoned zones being invaded by weeds and undergrowth (in a second type of "suburbanization" of the center, fragmented into internal peripheries). The city of the novel was decomposing upon itself, vertiginously and routinely. At the beginning of

the brilliant 1990s, Chejfec projected the results of the decisions that were beginning to be made in Buenos Aires. Against the luminous postcard image of Puerto Madero—that powerful emblem of "global Buenos Aires"—Chejfec showed one of the possible images of failure. It isn't that he wrote a prescient novel, but rather that his fiction deciphered fragments of a reality that was already there and that most people preferred to ignore. They accepted another fiction, that of the self-representation of Buenos Aires as a mighty first world economic and cultural capital.

What Chejfec's novel shows, with meticulous exactitude, is how the fall of a city like Buenos Aires could have occurred, even with such extensive public space and with such a diverse society with a broad middle class. The existence of that middle class is one of the most relevant aspects of the current crisis, according to international opinion; this time it isn't only the same old poor who are taking to the streets. The novel shows the implacable corrosion of the city, more similar to images of abandoned areas in North American metropolises than images of typical Latin American segmentation. But, above all, the novel shows that the city's structural problems were fully present before the modernizing mirage of the 1990s, which barely served to hide them for a time and in such a way as actually to aggravate them. The crisis easily tore through the thin layer of modernization, to show that all the urban and social logics had been dislocated. Perhaps the worst thing that happened in the 1990s, between first-world delirium and North American consumerism, is that the city did not capitalize on its rush of fortune—perhaps the last—to prepare for a reasonably balanced and more equitable future. Perhaps, more than poverty itself, or more than the already abysmal social contrasts, this is Buenos Aires's most specifically Latin American trait: a triumphalist blindness that repeatedly defends superficial modernization.

By the end of the 1990s the city had undergone all the facets of its structural, urban and social collapse. A blackout for weeks in the southern fringe, for example, showed how the city of enclaves worked. Each sector was left to its own devices, between inaccessible areas and fire barricades, while the authorities clamored to proclaim in the international press that Buenos Aires would be graced with a new branch of the Guggenheim museum. The policy of marketing events showed its most pathetic face.[25] Characteristic of global planning, this idea that a city's destiny rides on the "events" that the urban global market offers had been the uniform discourse of the 1990s. However, it is entirely possible that the only genuinely beneficial event for a southern Latin American city would be to capitalize on the (small) margin of oppor-

Camera crew of Caras y Caretas, great patriotic demonstration, de Avenida de Mayo
from Perú to the Congress (detail), May 25, 1910. Photograph. From Margarita
Gutman, ed., *Buenos Aires 1910: Memoria del porvenir* (Buenos Aires: Gobierno de
la Ciudad de Buenos Aires, Facultad de Arquitectura, Diseño, y Urbanismo de la
Universidad de Buenos Aires, and Instituto Internacional de Medio Ambiente y
Desarrollo (IIED), 1999), 321, cat. no. 58.

tunity that its peripheral location (in terms of insignificance for the global
market) affords it, to try a different path of development.

Does that margin of opportunity exist? Was Latin American destiny what
impeded it? In any case, it is important to emphasize two things. The first is
the weight of representation in urban and social outcomes. By that I mean
representations about the type of city that Buenos Aires should be and about
the things that were and were not possible to make of it. The second is that
if there is some Latin American destiny, in Buenos Aires it should be as-
sociated with modernity rather than traditionalism, since it is out of this
peculiar modernity (with its generalized structures of consumption) that
our options arise. As Claude Lévi-Strauss's famous dictum in *Tristes Tropiques*
(1973) indicates, the problem of South American cities isn't, as develop-
mentalist functionalism believes, the weight of the traditional. It is, rather,
the weight of the modern.[26] With novelty as their only value, these cities

must be perpetually renewed with the same disregard that accompanied their birth, adding layers upon layers of the "latest thing," with no social and political will to repair what isn't seen, to construct solid foundations, or to prepare for the passage of time. That is the superficial modernization that Buenos Aires, with its European, North American, and global dreams, has experienced in successive waves throughout the twentieth century. It irresponsibly exhausted the sound infrastructure that it had originally set up and that provided a modern foundation for what became, ironically, a completely frustrated development. Today the collapse has shown all the flaws of the city and the society. Still, the idea of the "Latin American city" persists as a symbol of a failure that pretends to be unrelated to Buenos Aires's history, revealing a persistent pride: our conviction that Buenos Aires somehow deserved a different destiny.

Notes

This essay was translated from the Spanish by Samuel Lockhart and Rebecca E. Biron.

1 The novel won the municipal prize for literature in 1957.

2 The true country/false country dichotomy was inspired by Charles Maurras, the ideologue of Action Française. He was interested in opposing the "royal nation" of monarchical values with the "legal nation" of democratic and parliamentarian institutions. However, he expressed that opposition through a nostalgic lens that favored a rural, provincial world (where the values of the "royal nation" predominate) over the metropolitan world of the cosmopolitan capital and its solvent modernity. The Argentine essayists of the 1930s incorporated that dichotomy through analogy with the "interior/port" opposition. In *Historia de una pasión argentina* (1937), for example, Eduardo Mallea formulated the famous opposition between the "invisible country" and the "visible country." In the 1950s the notion of the two countries is taken up by the nationalist Left and applied to the interior of the city: Villa Miseria constitutes the "true" and "invisible" side of the "two cities."

3 This text was originally drafted in 2002 at the height of the financial crisis that began in 2001. For a consideration of the contemporary situation in Buenos Aires, see Gorelik 2006.

4 Miguel Cané (1851–1905) was one of the paradigmatic figures of the Generation of 1880, a loosely connected group of writers from the Argentine bourgeoisie. An author and politician, he defended the national modernizing process as a government minister and diplomat under President Julio A. Roca (1880–1886) and the urban modernization process in Buenos Aires under City Manager Torcuato de

Alvear (1880–1887). Later, however, he began to note what he considered to be the losses induced by progress and to remember with nostalgia the criollo Buenos Aires of his childhood.

5 The term *Haussmannization* refers to the late nineteenth-century universalization of the urban reform model implemented in Paris by the prefect of France's Second Empire, Georges-Eugène Haussmann (1809–1891).

6 For example, one of the foreigners who denounced this opportunism was Santiago Rusiñol, who was angered by a comparison that seemed absurd to him, given that the modern character of Buenos Aires renders it impossible to recreate there the beauty of ancient European cities (see Rusiñol 1911).

7 Jules Huret (1863–1915) was a French journalist who specialized in travel chronicles in the early twentieth century. Georges Clemenceau (1841–1929) was a French writer and politician who served two terms as president of the Council of Ministers. Adolfo Posada (1860–1944) was a Spanish writer, lawyer, and sociologist, with reformist tendencies. Enrique Gómez Carrillo (1873–1927) was a Guatemalan writer and bohemian artist who lived most of his life in Paris and made dozens of trips about which he wrote numerous chronicles. All of them traveled to Buenos Aires between 1910 and 1914, attracted by the exceptional period the city was going through. They all wrote books about their visits there.

8 I dedicated the chapter "Vislumbrando la nueva ciudad" of my book *La grilla y el parque* (1998) to the analysis of the centenary travelers' speeches.

9 Everyone who wrote about Buenos Aires at the turn of the twentieth century was inspired by North American models, European models of modernization, or by the recovery of ancient European cities. They all rejected the Spanish checkerboard model.

10 Ezequiel Martínez Estrada (1895–1964) is the representative voice of both types of rejection. See his classic works, *Radiografía de la pampa* (1933) and *La cabeza de Goliat* (1940).

11 Alberto Gerchunoff (1883–1950) wrote this Whitmanesque celebration of city blocks in "Buenos Aires metrópoli continental" ([1913] 1960, 19). Jorge Luis Borges (1899–1986) develops a *criollista* celebration of them in multiple essays and poems from the 1920s; I am referring here to his famous poem, "La fundación mítica de Buenos Aires" (1929), in which he posits that Buenos Aires was founded on one square block in his neighborhood, Palermo, which was at that time pure pampa: "a whole city block, but in the middle of the fields" (Borges 1974, 81).

12 The modernization process in Buenos Aires began in 1870, and the first metropolitan phase was finished in the 1930s. Other Latin American capitals also began modernization processes toward the end of the nineteenth century, but they were much less extensive. Thus, in the 1940s very few Latin American cities could be considered metropolises in the same way as Buenos Aires.

13 October 17, 1945, is the legendary date of the birth of popular Peronism, when the

masses that lived in the workers' neighborhoods of Greater Buenos Aires occupied the Plaza de Mayo in the heart of the city to demand the release of Colonel Perón, who had been incarcerated by political opponents who feared his growing popularity.

14 Robert Redfield (1897–1958) was a North American anthropologist and sociologist of the Chicago School. The folk-urban continuum hypothesis posits the existence of a universal civilizing process that moves from a traditional pole (the rural village) to a modern pole (the metropolis). He developed that idea in works that have become classics in the field, such as *Tepoztlán, a Mexican Village* (1930), a pioneer case study of a folk community, and *The Folk Culture of Yucatán* (1941). Oscar Lewis (1914–1970) was a North American anthropologist. His culture of poverty hypothesis argues against the idea of the continuum; he shows that rural migrants have a specific "culture" through which "the traditional" becomes an inseparable part of "the modern." *Antropología de la pobreza (Five Families)* (1961) and *Los hijos de Sánchez* ([1961] 1979) are two of his most important books.

15 A paradigmatic example of this position can be found in Hauser 1961, a publication of a symposium assembled in Santiago de Chile in 1959 and jointly sponsored by the United Nations, the Economic Commission for Latin America and the Caribbean (CEPAL), and the United Nations Educational, Scientific and Cultural Organization (UNESCO).

16 One of the best examples of this change in perspective is Jorge Enrique Hardoy, an early promoter of a Latin American network of scholars and institutions dedicated to urban studies. In 1965 he still harbored great optimism for the promises of modernizing reform: "The integrative role and the symbolic value of Brasília for Brasil, the geopolitical impact of the jungle highway in Peru, the long routes uniting the interior of Paraguay and Bolivia with the ports of Brasil and Argentina, the Pan-American Highway, the great hydroelectric projects everywhere, Venezuela's regional plan to affirm the viability of new development goals in Guayana, all show that Latin America is advancing toward new frontiers. New centers and an urban scheme that will complement the current one will no doubt appear to represent a new Latin America freed from the limits of the past, one that looks to integration for the expression of its modernization" (Hardoy [1965] 1972, 44). But by 1974 he was already showing pessimism: "The development of the capitalist system does not permit us to believe that the oppressors and the oppressed can agree on the objectives and the effectivity of national urbanization policies, nor on projects for future society, of which agrarian and urban reform processes are a part" (Hardoy and Moreno 1974, 647).

17 Since 1958, with the liberal-conservative government of Jorge Alessandri (who in 1962 created the Corporation of Agrarian Reform), but especially since 1964, with the Christian-democratic government of Eduardo Frei Montalva, Chile has developed active agrarian and urban reform policies. They reflected the state's notion of land-planning that would convert Chile into an important laboratory

for Western planning in general. The concentration of public and private institutions dedicated to planning in Santiago de Chile becomes particularly notable in the mid-1960s. It is home to the central offices of CEPAL and the Latin American Institute of Economic and Social Planning (ILPES), which offered the Courses in Regional Planning for Development that trained the principal Latin American experts under the guidance of figures from different schools of Latin American thought, such as Raúl Prebisch, José Medina Echavarría, Albert Hirschmann, Fernando Henrique Cardoso, Celso Furtado, Osvaldo Sunkel, Aníbal Quijano, and others. It is also the location of the Facultad Latinoamericana de Ciencias Sociales (FLACSO) and the Consejo Latinoamericano de Ciencias Sociales (CLACSO), with their commissions for "urban and regional development"; the Ford mission, headed by John Friedmann, and housed in the Center for Research on Urban Development (CIDU) of the Universidad Católica during the late 1960s; and the Institute for Housing, Urbanism, and Planning (IVUPLAN) of the Universidad de Chile's School of Architecture, which by 1964 had already begun offering an advanced degree program in Urban and Regional Planning.

18 In *Buenos Aires, vida cotidiana y alienación*, Juan José Sebreli explicitly opposes the labyrinthine and exceptional design in Buenos Aires of the marginal neighborhoods and of the upper classes, to the monotony of the neighborhoods (mostly) of the middle class, "in which it is as difficult to lose oneself as it is to be found" (Sebreli [1964] 2003, 79).

19 This is the phrase of Beatriz Sarlo, Bueno Aires's most acute interpreter. See, especially, Beatriz Sarlo 1988.

20 As in the rest of the world, in Buenos Aires the 1980s were marked by the rediscovery of Walter Benjamin's view of the city as a document and scenario for analyzing modernity. On the use of Benjamin in urban interpretations of modernity, see Ballent, Gorelik, and Silvestri 1993.

21 For information about the transformations in the urban culture of Buenos Aires between the mid-1970s and the end of the 1990s, see Gorelik and Silvestri 2000.

22 In the 1990s, the principal newspapers in Argentina, *La Nación* and *Clarín*, began to publish supplements titled "Country Clubs and Gated Communities" in which they exposed a true "suburban culture" associated with real estate ventures.

23 In 2006 many of those ventures were revived as part of a new "real estate boom" in Buenos Aires, although with characteristics that clearly perpetuated the fragmentation of the crisis. See Gorelik 2006.

24 Bersuit Vergaravat is an Argentine musical group that, after various years of little success, resurged in the late 1990s with a Gustavo Santaolalla production. After that, they adopted a combative style of Latino rock, with "politicized" lyrics like these: "Because in the jungle, shots ring out / They are the weapons of the poor / They are the shouts of the Latino" ("Sr. Cobranza," *Libertinaje*, Estudios Panda, 1998). This is a studied pose adopted for a global Latino audience, MTV-style, given that the Argentine tradition of politically committed song writing would

never include a call to armed uprising "in the jungle," and much, much less an appeal to the shouts of "the Latino" (identifying oneself as "Latino" is simply not a part of any Argentine cultural tradition).

25 For information about "city marketing," see Arantes 2000.

26 Lévi-Strauss argues that "the towns of the New World . . . pass from freshness to decay without ever being simply old" (1973, 95).

The Spirit of Brasília: Modernity as Experiment and Risk

James Holston

Travelers usually experience Brasília as a city removed from the rest of Brazil. This sense of separation derives in part from Brasília's great distance from the Atlantic coast, to which Brazilians have for centuries "clung like crabs," as Frei Vicente do Salvador put it (1931, 19). By road or by air, travelers must cross this distance to reach the city. They traverse a limbo, not of jungle, as outsiders sometimes imagine, but of two million square kilometers of highland *cerrado*, dry and stunted, that is the desolate Central Plateau of Brazil. At the approximate center of this flatland, Brasília comes into view as an exclamation mark on the horizon, like an idea, heroic and romantic, the acropolis of an enormous empty expanse. Once swept inside the city on its super-speedways, travelers confront a more complex separation, that of Modernist Brasília from the familiar Brazil; they encounter an entire city of detached rectangular boxes, the transparencies of a world of glass facades, automobile traffic flowing uninhibited in all directions, vast spaces seemingly empty without the social life of streets and squares, and serial order, clean, quiet, and efficient. In short, they find modernity, regulation, and progress on display.

Yet if this urbanism appears incongruously Brazilian, for those who know Brazil, Brasília's history expresses at the same time a remarkably Brazilian way of doing things. By history, I refer to the processes of building the city and structuring its society. Although their result may appear the opposite today, these processes also exemplify that knack for improvisation for which Brazil is famous. I mean that sense of invention found in so many facets of Brazilian life, from soccer and samba to telenovelas, from theories of

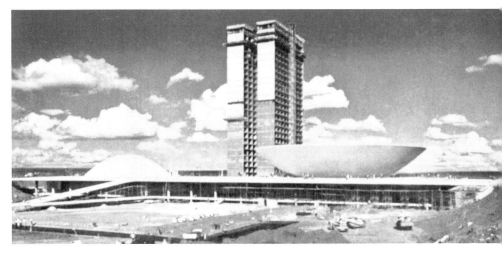

"Congress Building." Photograph. From Alfredo Wiesenthal and Gregorio Zolko, *Brasília: História, urbanismo, arquitetura, construção* (São Paulo: Acropole, 1960), 75.

modernity (such as *Antropofagia*) to everyday race mixing, from "autocon-structed" (self-built) housing in the urban peripheries to federal initiatives in the treatment of AIDS. It is improvisation by design, a desire to overcome by leaping, an instinct for the advantages of play. It is the need to be modern that views a lack of resources as an opportunity for innovation. After all, Brazilians built Brasília in just three and a half years. They turned a spot in the middle of nowhere, marked by an X on the ground, not only into an inhabitable city in record time but also into one that presented to the whole world of 1960 the most modern form of urbanism. To do so, they employed the tactics of bricolage, and they experimented in all fields. Thus, they reproduced in pioneering Brasília Brazil's distinctive style of inventing its own modernity.

In specific ways, therefore, Brasília is both radically separate from and part of the "rest of Brazil." Examples of this contradiction abound. For example, Brasília's Master Plan prohibited the development of an urban periphery for the city's poor, typical of other Brazilian cities. As the national capital, Brasília had to be different, and its planners aimed to preclude un-wanted characteristics of the rest of Brazil. Yet, as I explain later, government policy created an impoverished periphery of Satellite Cities even before the capital's inauguration in 1960, "Brazilianizing" its foundations. There-

fore both the Plano Piloto (as the privileged Modernist city is called) and the Satellite Cities constitute Brasília, which must be understood as a regional city from the beginning. The city that resulted, however, does not simply reproduce the rest of Brazil around it that planners wanted to deny. In its combination of the radically new and the familiar, Brasília remains distinct in the constellation of Brazilian cities.

This special quality derives not so much from the city's identity as a capital of capitals, but from Brasília's founding conception as an experiment in urbanism to risk something new. It is precisely this daring to embrace the modern as a field for experiment and risk that the city's pioneers called the "spirit of Brasília." This spirit of innovation structured Brasília at many levels. It motivated planners to make Brasília different, not for the sake of exoticism but to establish an arena of experimentation in which to solve important national problems. In some aspects, Brasília's experiments succeeded; in others they failed. But both successes and failures derive from the same source, as both possibilities accompany genuine experiments. If the spirit of Brasília is, therefore, that of experiment, is it not strange that this city of total design and improvisation, of innovation and contradiction, is now frozen in time? That is, the entire urban area of the Plano Piloto is legally preserved—entombed or *tombado*, as Brazilians call this preservation of patrimony—by local, national, and international layers of legal protection. If this experimental city has thus become a memorial, what memory does it record? To memorialize is never to tell the whole story. It is rather to select certain conditions that the memorializers want to preserve and ignore others. Thus, the spirit of a place—what the Romans called its *genius loci*—consists of what is both emplaced and displaced in memoriam. In these terms, what is the genius of Brasília, constructed in the backlands of Brazil in the late 1950s, and has its spirit been compromised by preservation? In what follows, I address these questions in turn.

Statecraft and Stagecraft

The Plano Piloto's basic residential units are all equal: same facade, same height, same facilities, all constructed on *pilotis* (columns), all provided with garages and constructed of the same material—which prevents the hateful differentiation of social classes; that is, all families share the same life together, the upper-echelon public functionary, the middle, and the lower.

As for the apartments themselves, some are larger and some are smaller in number of rooms. They are distributed, respectively, to families on the basis of the number of dependents they have. And because of this distribution and the nonexistence of social class discrimination, the residents of a *superquadra* are forced to live as if in the sphere of one big family, in perfect social coexistence, which results in benefits for the children who grow up, play, and study in the same environment of sincere camaraderie, friendship, and wholesome upbringing. Since Brasília is the glorious cradle of a new civilization, the children raised on the plateau will construct the Brazil of tomorrow (Novacap 1963, 15).

This description of "perfect social coexistence" comes neither from the pages of a utopian novel, nor from the new world annals of Fourierite socialism. Rather, it is taken from the periodical of the state corporation (Novacap) that planned, built, and administered Brasília—from a "report" on living conditions in the new capital three years after its inauguration. Nevertheless, it presents the fundamentally utopian premise that the design and organization of Brasília were meant to transform Brazilian society. Moreover, it does so according to conventions of utopian discourse: by an implicit comparison with and negation of existing social conditions. In this case, the subtext is the rest of Brazil, where society is perniciously stratified into social classes, where access to city services and facilities is differentially distributed by wealth and race, and where residential organization and architecture are primary markers of social standing. Brasília is put forth not merely as the antithesis of this stratification, but also as its antidote, as the "cradle of a new civilization." Furthermore, planners assume what they wish to prove, namely, that the unequal distribution of advantage that orders urban life elsewhere in Brazil is already negated in Brasília.

This thesis of negation and invention is the premise that structures Brasília's foundation. It is at the core of what Brazilians meant when they referred to the spirit or idea of Brasília, epithets widely used during the pioneering phase of the city. As such, this idea crystallizes an important paradigm of modernity. It proposes that the state, as a national government, can change society and manage the social by imposing an alternative future embodied in plans—in effect, that it can make a new people according to plan. Moreover, as a Modernist plan, this idea is millenarian. It proposes to transform an unwanted present (the rest of Brazil) by means of a future imagined as radically different. This millenarian modern exemplifies a kind of stagecraft that has come to define the statecraft of modern nation-building: modern states use

planned public works to promote new forms of collective association and personal habit that constitute their projected nation.[1]

Brasília's modernism is exemplary of this statecraft. As the city's founder, President Juscelino Kubitschek, affirms: "I have long been aware that modern architecture in Brazil is more than a mere aesthetic trend, and above all more than the projection into our culture of a universal movement. It has in fact put at our service the means with which to find the best possible solution of our city planning and housing problems. . . . It is, furthermore, a strong affirmative expression of our culture, perhaps the most original and precise expression of the creative intelligence of modern Brazil" (qtd. in Papadaki 1960, 7).

Kubitschek's "affirmative relation" between modern architecture and modern Brazil lies precisely in using the former to stage the latter, as he demonstrated so effectively in his many city-building projects. Moreover, in explaining the selection of Lúcio Costa's Modernist Master Plan for Brasília, Kubitschek justifies both the utopian and the millenarian character of this stagecraft-as-statecraft: "Owing to the need to constitute a base of radiation of a pioneering system [of development] that would bring to civilization an unrevealed universe, [Brasília] had to be, perforce, a metropolis with different characteristics that would ignore the contemporary reality and would be turned, with all of its constitutive elements, toward the future" (Kubitschek 1957, 62–63). Thus, Brasília's founders envisioned it as more than the symbol of a new age. They also intended Brasília's Modernist design and construction as the means to create that new age by transforming Brazilian society. They saw it as the means to invent a new nation for a new capital—a new nation to which this radically different city would then "logically belong," as Costa claimed (Costa 1980, 15).

This project of transformation redefines Brazilian society according to the assumptions of a particular narrative of the modern, that of the Modernist city proposed in the manifestos of CIAM (Congrès Internationaux d'Architecture Moderne). In Brasília, this model is most clearly expressed in Costa's Master Plan and in the architecture of Oscar Niemeyer, the city's principal architect. But it is also embodied in many other aspects of the city's organization. From the 1920s until the 1970s (and in many places, still today), CIAM has established a worldwide consensus among architects and planners on problems confronting the modern city. This consensus was especially shaped by the visionary architect Le Corbusier, whose writing framed its themes and whose urban design became its dominant gram-

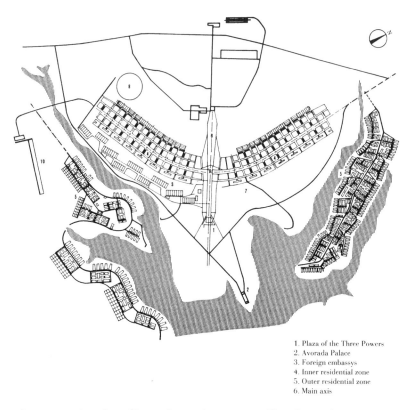

1. Plaza of the Three Powers
2. Avorada Palace
3. Foreign embassys
4. Inner residential zone
5. Outer residential zone
6. Main axis

Lúcio Costa, plan of Brasília, 1956. Drawing. From David Underwood, *Oscar Niemeyer and Brazilian Free-form Modernism* (New York: George Braziller, Inc. 1994), 72. Note that the axes of the city plan resemble a fuselage and wings.

mar. As interpreted with world-renowned clarity by Costa and Niemeyer in the 1950s, Brasília is the most complete example of CIAM tenets ever constructed.

In subsequent sections, I discuss these tenets specifically in relation to Brasília's design; here, I want to examine their reproduction in Brazil. As is universally acknowledged, the project of Brasília is a blueprint-perfect embodiment of the CIAM model city. Moreover, its design is a brilliant reproduction of Le Corbusier's version of that model.[2] The point I want to make, however, is not that Brasília is merely a copy. Rather, it is that as a Brazilian rendition of CIAM's global modernism, its copy is generative and original. Kubitschek argued precisely this point in the quotation above. Brasília is a CIAM city inserted into what was the margins of modernity in the 1950s, inserted into the Modernist ambitions of a postcolony. In this context, the

very purpose of the project was to capture the spirit of the modern by means of its likeness, its copy. It is this homeopathic relation to the model, brilliantly executed to be sure, that gives the copy its transformative power. In other words, its power resides precisely in the display of likeness. This display of an "original copy" constitutes the stagecraft that I referred to earlier as statecraft. It is the state in its theatrical form, in the sense of constructing itself by putting on spectacular public works. Under Kubitschek, Brazil showed itself to be modern by staging it. As the centers of decisive political, economic, and cultural power remained elsewhere in Brazil for at least a decade, Brasília's initial mission was above all gestural: to display modern architecture as the index of Brazil's own modernity as a new nation, establishing an elective affinity between the two.

Thus, Brasília's modernity is spectacular in the sense of being a staging of the state in its charismatic form. It is charismatic not only because Brasília is an animating center of nation-state building and state-directed modernizing and innovation. It is also charismatic because Brasília's project proposes an equation between the condition of the ruler—in the form, metonymically, of his seat, the capital—and the state of rule. It proposes, in other words, to lead the rest of Brazil into a new era by example. This charismatic notion of statecraft is an ancient proposition, as historians and anthropologists of the state have shown.[3] It depends on establishing a correspondence between the good state of the ruler (the majesty of majesty) and the good state of the realm, in which the first becomes a prerequisite of the second. This relationship is homeopathic, one of establishing a likeness between two conditions. What makes this link plausible is the display of state—its public works, as I have called them—in which the stateliness of power is itself an ordering force. With Brasília, this charismatic conception of state finds a Modernist incarnation.

Innovation by Design

Brasília was designed to mirror to the rest of Brazil the modern nation it would become. At this scale of statecraft, Brasília is a charismatic center in doubly mimetic terms. On the one hand, it conveys its aura as an animating center of the modern by embodying in its own organization the CIAM plan of a radiant future. On the other, it animates by relaying to the national realm its idea of innovation. In this radiation, Brasília is a civilizing agent, the missionary of a new sense of national space, time, and purpose,

colonizing the whole into which it has been inserted. This civilizing project is concisely represented in countless maps of Brazil produced in the 1950s and 1960s, showing the radiating network of highways that the government intended to construct between Brasília and state capitals. As a project of national development, it is a map of pure intention, since almost none of these roads existed at the time. As such, it represents the intended integration of the new nationalized space Brasília would generate.

Corresponding to this new dimension of national space, Brasília implemented a new sense of national time. To build the city in just three and a half years, Novacap instituted a regime of round-the-clock construction. This regime of hard work became known throughout Brazil as the "rhythm of Brasília," "fifty years of progress in five." Breaking with the Portuguese meter of colonialism, this was a new rhythm, defined as thirty-six hours of nation-building a day—"twelve during daylight, twelve at night, and twelve for enthusiasm." It expressed precisely the new space-time consciousness of Brasília's modernity, one that posits the possibility of accelerating time and of propelling Brazil into a radiant future.

The rhythm of Brasília thus reveals the development of a new kind of agency, confident that it can change the course of history through willful intervention, that it can abbreviate the path to the future by skipping over undesired stages of development. This Modernist agency expressed itself in a drive to innovate in all domains of Brasília's construction and organization. As I examine later, we find it not only in the city's architecture and planning, but also in its schools, hospitals, traffic system, community organization, property distribution, bureaucratic administration, music, theater, and more. We find this new sense of national agency, of rupture and innovation, concisely conveyed in newspaper and magazine advertisements of the period that celebrate the participation of Brazil's industries in the capital's construction: "Here begins a new Brazil!—Rupturita Explosives Incorporated (a pioneer in the explosives industry)"; "Brasília: the dawn of a new era—Bimetal Incorporated"; "Brasília: the decisive mark of national progress—Mercedes Benz of Brazil."[4]

Thus, Brasília's Modernism signified Brazil's emergence as a modern nation because it simultaneously broke with the colonial legacies of underdevelopment as it posited an industrial modernity. The new architecture and planning attacked the styles of the past—the Iberian baroque and the neoclassical—that constituted one of the most visible symbols of a legacy the government sought to supersede. Literally, Modernism stripped these

styles from building facades and city plans, demanding instead industrial-age building materials and an industrial aesthetic appropriate to "the new age." In planning, it privileged the automobile and the aesthetic of speed at a time when Brazil was embarking on a program of industrialization especially focused on the automobile industry. It also required centralized planning and the exercise of state power that appealed to the statist interests of the political elite.

In these terms of erasure and reinscription, the idea of Brasília proposes the possibility of an inversion in development: a radically new city would produce a new society to which it would then belong. The first premise of this inversion is that the plan for a new city can create a social order based on the values that motivate its design. The second premise projects the first as a blueprint for change in the context of national development. Both premises promised a new and modern agency of innovation for Brazil, and both motivated the building of Brasília. In what follows, I suggest that these premises generated two modes of planning and design in Brasília, and that these modes are fundamentally at odds. One is total design and master planning; the other is contingency design and improvisation. The latter is experimental by nature; the former was an experiment when tried in Brasília that soon overwhelmed and negated the other. Moreover, it engendered a set of social processes that paradoxically subverted the planners' utopian intentions.

Total Design

To create a new kind of society, Brasília redefines what its Master Plan calls the key functions of urban life, namely work, residence, recreation, and traffic. It directs this redefinition according to the tenets of the CIAM model city. CIAM manifestos call for national states to assert the priority of collective interests over private. They promote state planning over what they call the "ruthless rule of capitalism," by imposing on the chaos of existing cities a new type of urbanism based on CIAM master plans. CIAM's overarching strategy for change is totalization: its model city imposes a totality of new urban conditions that dissolves any conflict between the imagined new society and the existing one in the imposed coherence of total order. Precisely because of its emphasis on the state as supreme planning power, state-building elites of every political persuasion have embraced the CIAM model of urban development, as its phenomenal spread around the world attests.

One of the principal ways by which CIAM design achieves its totalization of city life is to organize the entire cityscape in terms of a new kind of spatial logic. It is not the only way, but I use it to illustrate both the nature of total design and one of its basic objectives: the subversion of premodern and especially baroque urbanism. Visitors to Brasília often observe that they are disoriented because the city has no street corners. Their absence is but one indication of a distinctive and radical feature of Brasília's CIAM modernity, namely, the absence of streets themselves. In place of street corners and their intersections, Brasília substitutes the traffic circle; in place of streets, high-speed avenues and residential cul-de-sacs: in place of sidewalk pedestrians, the automobile; and in place of the system of public spaces that streets traditionally support, the structure of a completely different urbanism. At the scale of an entire city, Brasília thus realizes the objective of CLAM planning to redefine the urban function of traffic. It does so by eliminating what it calls the corridor street, the street edged with continuous building facades. Although one might not imagine the importance of traffic planning in these terms, this elimination has overwhelming consequences for urbanism: it subverts the system of space-building (or solid-void) relations that structures premodern urbanism and replaces it with another.

In its critique of the cities and society of European capitalism, CIAM modernism proposed the elimination of the corridor street as a prerequisite for modern urban organization—a plan of attack Le Corbusier labeled "the death of the street" in 1929.[5] CIAM vilifies the street as a place of disease and criminality and as a structure of private property that impedes modern development. More consequentially, however, Modernist architecture attacks the street because it constitutes an architectural organization of the public and private domains of social life that it seeks to overturn.

The corridor street is the architectural context of the outdoor public life of preindustrial cities, common to both Brazil and Europe. This context is constituted in terms of a contrast between the street system of public spaces (voids) and the residential system of private buildings (solids). Traditionally, architects are trained to structure this contrast in terms of an organization of its solids and voids into figure and ground relations. Generally, in premodern urbanism, streets and squares are framed by facades built edge-to-edge and perceived as having the shape these frames make. Thus, streets and squares are spaces that have form, usually perceived as a figure of rectangular volume. This figural perception creates the impression that the continuous building facades are the interior walls of outdoor rooms, the public

rooms of the city. The street-walls are, accordingly, ornamented, and the street-rooms furnished with benches, sculpture, fountains, and so forth. The spatial principle of this urbanism is, therefore, that streets and squares are figural voids in contrast to the ground of the solids around them.

This elemental organization of solids and voids has dominated Occidental urbanism for 2,500 years. It developed its recognizable character in ancient Greece and its fullest elaboration in the baroque cities of Europe. It must suffice here to observe that in this preindustrial urbanism, both space and building are reversibly both figure and ground (Holston 1989, 101–44). Although space is consistently figural and building is ground, these relations are easily reversed to signify public monuments and civic institutions. This reversal is the key rhetorical principle of the preindustrial architectural ordering of public and private.

Modernism breaks decisively with this traditional system of architectural signification. Whereas preindustrial baroque cities (such as Ouro Prêto in Brazil) provide an order of public and private values by juxtaposing architectural conventions of repetition (ground) and exception (figure), the Modernist city (such as Brasília) is conceived as the antithesis both of this mode of representation and of its represented sociopolitical order. In the Modernist city, vast areas of continuous space without exception form the perceptual ground against which the solids of buildings emerge as sculptural figures. There is no relief from this absolute division of architectural labor: space is always treated as continuous and never as figural, buildings always as sculptural and never as background. The consequences of this total inversion are profound. By asserting the primacy of open space, volumetric clarity, pure form, and geometric abstraction, Modernism not only initiates a new vocabulary of form; more radically, it inverts the entire mode of perceiving architecture, turning it inside out—as if the figural solids of the Modernist city have been produced in the mold of the figural voids of preindustrial urbanism. Furthermore, the Modernist city negates the reversals of the traditional code by insisting on the immutability of the terms. By establishing the absolute supremacy of continuous nonfigural void, it transforms the ambivalence of baroque planning into a monolithic spatial order. Reversals are now impossible. Modernism has imposed a total and totalizing new urban order.[6]

Complementing its theory of objective change, the CIAM model also proposes a subjective transformation of existing conditions. Borrowing from other avant-garde movements of the early twentieth century, it uses tech-

niques of shock to force a subjective appropriation of the new social order inherent in its plans. These techniques emphasize decontextualization, defamiliarization, and dehistoricization. Their central premise of transformation is that the new architecture/urban design creates set pieces of radically different experience that destabilize, subvert, and then regenerate the surrounding fabric of social life. It is a viral notion of revolution, a theory of decontextualization in which the radical qualities of something totally out of context infect and colonize that which surrounds it. This something may be a single building conceived as a fragment of the total plan. Or, it may be an entire city designed as an exemplar, as in the case of Brasília. Either way, the radical fragment is supposed to create new forms of social experience, collective association, personal habit, and perception. At the same time, it is supposed to preclude those forms deemed undesirable by negating previous social and architectural expectations about urban life. As the Novacap "report" cited above asserts, "residents of a superquadra are *forced* to live as if. . . ."

Brasília's design implements the CIAM premises of objective and subjective transformation by both architectural and social means. On the one hand, its Master Plan displaces institutions traditionally centered in a private sphere of social life to a new state-sponsored public sphere of residence and work. On the other, its new architecture renders illegible the taken-for-granted representation of these institutions. Its strategy of total design is thus a double defamiliarization. As a result, for example, the functions of work and residence in Brasília lose their traditional separation when the latter is assigned on the basis of work affiliation, as it was generally until 1965 and still is in some sectors. Hence, Bank of Brazil employees reside in one superquadra, those of the Air Force Ministry in another, those of Congress in yet another, and so forth. In addition, these functions become architecturally indistinguishable as the buildings of work and residence receive similar massing and fenestration and thereby lose their traditional symbolic differentiation.

Brasília's Modernist Master Planning is a comprehensive approach to restructuring urban life precisely because it advances proposals aimed at both the public and the private domains of society. Its proposal for the private realm centers on a new type of domestic architecture and residential unit that organizes residence into homogeneous sectors, structured by a concept of "collective" dwelling. This plan is best embodied in the superquadras (self-sustainable "super blocks") of the Plano Piloto, a type called

the collective dwelling. The word "collective" refers to the sharing of common facilities, such as schools, administration buildings, social clubs, green areas, and commercial structures. As one might expect, such an experiment in living receives mixed evaluations from residents. My study of the model superquadras (South 108, for example) concluded that residents with younger children find them especially compelling (Holston 1989, 163–87). However, many other residents complain that the elimination of informal social spaces traditionally found in Brazilian homes—the copa, balcony, and veranda—defamiliarizes the superquadra apartments. Moreover, people frequently complained that their gridded glass facades negate expressions of individual status and personality in an attempt to communicate an egalitarian, rational social order. For many, the outcome of this design is both a sense of isolation inside the apartments and yet an abandonment of the superquadra's green areas.[7]

In sum, Brasília's Modernist design achieves a similar kind of defamiliarization of public and private values in both the civic and the residential realms. On the one hand, it restructures the city's public life by eliminating the street. On the other, it restructures the residential by reducing the social space of the private apartment in favor of a new type of residential collectivity in which the role of the individual is symbolically minimized. Together, these strategies constitute a profound estrangement of residential life as Brazilians know it.

These intended defamiliarizations are brutally effective. Most people who move to Brasília experience them with trauma. In fact, the first generation of inhabitants coined a special expression for this shock of total design, brasilite or "Brasília-itis." As one resident told me, "Everything in Brasília was different. It was a shock, an illusion, because you didn't understand where people lived, or shopped, or worked, or socialized." Another said, "even the tombstones are standardized." Another common instance of disorientation is the sense of exposure residents experience inside the transparent glass facades of their Modernist apartment buildings. With considerable irony. they nicknamed these glass boxes "the candango's television set"—meaning that a poor man (the candango, Brasília's pioneering construction worker) can find nightly entertainment by standing in front of an apartment block to watch the interior drama of middle-class life revealed on the big screen of the illuminated facade. In response to this perceived assault on their privacy, which some link to the moralizing gaze of a new state-sponsored public sphere, residents resist by putting up every kind of visual barrier—curtains, blinds,

potted plants, even birdcages. Yet the sense, if not the fact, of transparency remains. Thus, Brasília's Modernism also works its intended subversion at an intimate scale of daily life. Harmonized in plan and elevation, Brasília's total design created a radically new world, giving it a form that possessed its own agenda of social change.

Contingency Design

I suggested earlier that the project of Brasília generated two modes of design and planning. Although both were experimental and innovative, they were fundamentally at odds. One is Modernist total design. As I have shown, this mode attempts to overcome the contingency of modern experience by totalizing it, that is, by fixing the present as a totally conceived plan based on an imagined future. This kind of design is always already preserved by the very completeness of the plans themselves, which have a statute-like character as a set of instructions. In the case of Brasília, Costa's Master Plan actually became law with the inauguration of the capital. Establishing the city's inaugural legal and administrative organization, its first Organic Law declared that "any alteration in the Plano Piloto . . . depends on authorization in federal law."[8]

The second mode of design and planning is based on contingency itself. It improvises and experiments as a means of dealing with the uncertainty of present conditions. Contingency design works with plans that are always incomplete. Its means are suggested by present possibilities for an alternative future, not by an imagined and already scripted future. It is a mode of design based on imperfect knowledge, incomplete control, and lack of resources, which incorporates ongoing conflict and contradiction as constitutive elements. In this sense, it has a significant insurgent aspect. I will illustrate contingency planning with three examples from the construction period of Brasília. The first concerns the worker himself as bricoleur; the second, the contrast between the totally regulated construction zone and the market city that developed on its fringes; and the third, the development of illegal settlements as a reaction to the government's planned occupation.

In late 1956, Novacap divided the area of the future federal district into two zones of planned but temporary occupation based on a spatial organization of work. One zone was reserved for construction camps that would build the city and one for commercial establishments that would provide services and supplies to the work force. The need to build Brasília quickly

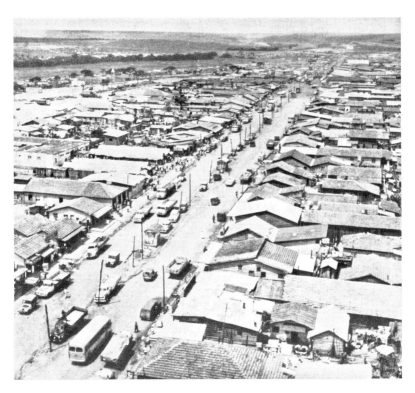

"Bird's-eye view of the 'Nucleo Bandeirante' (1960)." Photograph. From Alfredo Wiesenthal and Gregorio Zolko, Brasília: História, urbanismo, arquitetura, construção (São Paulo: Acropole, 1960), 114.

and the lack of skilled labor created a work regime of improvisation and ingenuity in both zones. In this regime, Brasília's workers became famous as *quebra-galhos* (trouble-shooters, handymen), a type of bricoleur ready to tackle any job with great ingenuity but limited resources; or, as one candango joked, "ready to undertake tasks for which he has not been sufficiently prepared." Moreover, the shortage of skilled laborers meant that unskilled workers could move into a category of skilled labor and higher pay with relative ease. Nearly every candango I interviewed told the same story of unlimited hours of work, rapid advancement based on audacity, and learning on the job.[9]

As Novacap was constructing the Plano Piloto to accommodate the government and its civil servants transferred from Rio de Janeiro, it wanted to preclude the possibility that this labor force might take root in shanties on the site. Therefore, with state-like authority and its own security force,

Novacap strictly controlled access to and accommodations within the construction zone. However, if the construction zone was marshaled like a boot camp, Novacap established a commercial zone for private initiative at its edge that grew as its opposite under a laissez-faire policy. This site became known as the Free City (Cidade Livre), though officially called the Provisional Pioneer Nucleus or Núcleo Bandeirante. The government encouraged entrepreneurs to supply the construction effort at their own risk and profit, and, after the city's inauguration, to become its commercial and service population. To that end, it offered entrepreneurs two incentives: free land and no taxes for four years. The combination of laissez-faire governance and temporary wooden buildings turned the Free City into a veritable frontier town of abundant cash and ambition. However, Novacap's commercial contracts stipulated that at the end of the four-year period it had the right to raze the entire city to the ground. With a turn of phrase still famous in the Free City, the president of Novacap declared, "In April 1960, I will send the tractors to flatten everything."

Thus, in classic imperial fashion, Novacap created a kind of bazaar at the gates of its noncommercial capital. On the one hand, those whom it recruited for jobs in construction were billeted in regimented camps as the work crews of a public building project. On the other, those recruited for their capital investments in all activities except construction populated the Free City and dominated its capitalist economy. It was called a free city precisely because it grew in an area free of regulations that applied elsewhere. In contrast to the construction zone, it was immediately accessible to all: to those just off the bus, to those awaiting documentation for construction work, to those rags-to-riches dreamers seeking their frontier El Dorado, to those whose husbands and fathers were laboring in the camps. All could enter the Free City freely to find a place to live and work—freely meaning, of course, in accordance with individual means. The Free City was thus a capitalist city, organized around contingency and risk, on the fringes of a totally planned economy.

Another crucial difference between the Free City and the construction zone was that the latter was overwhelmingly male and occupied mostly by men who lived in barracks without families. Ultimately, the consequences of this difference fundamentally altered the planned organization of the federal district. The two encampments for Novacap employees were exceptions, as both officials and manual workers had the privilege of family residence. As a result, 89 percent of Novacap officials and 82 percent of its workers

brought their families to Brasília by 1959. For the rest of the almost 17,000 men lodged in the private sector construction camps, 91 percent lived without families, although 34 percent of them were married. In all, there were only about 1,450 families in these camps, mostly those of the managers and a few skilled workers.[10] To be sure, the rest of the married workers were not less likely to want to live with their families. For them, there were only two options: to rent accommodations in the Free City for their families, or to build unauthorized dwellings for them somewhere in the countryside around the construction camps.

Of the two, the latter became the more common, and, after 1958, the only viable option. The tenuous balance between housing supply and demand in the Free City ruptured that year, when a massive influx of drought victims from the northeast of Brazil overwhelmed the limited supply of accommodations. Rents and overcrowding soared. Both migrants and speculators responded by building huge numbers of unauthorized shacks. Rather than allow this uncontrolled growth, Novacap prohibited additional expansion of the Free City after December 1959. It even attempted to slow migration by erecting what turned out to be an ineffective police cordon around the city. As a result of this housing crisis, workers who wanted to bring families to Brasília had little choice but to become squatters by seizing land on which to build illegal houses. Most seizures were multifamily occupations. The larger ones were called *vilas*, the most important being Vila Sara Kubitschek (named after the president's wife), Vila Amaury, Vila Planalto, and Vila do IAPI.[11] Improvised by candangos to lodge their families, these illegal *vilas* were so important in the settlement of the federal district that by May 1959 they contained over 28 percent of its population. Moreover, as we will see, these insurgent settlements soon became legalized as precisely the kind of a poor periphery around the Plano Piloto that the Master Plan prohibited (as in Article 17).

The candangos were not the only ones to risk illegal settlement in response to the government's planned occupation. In this regard, the fate of Novacap's officials is especially significant. These administrators, architects, and engineers were the supreme commanders in Brasília. They formed an elite cadre of pioneers, zealously dedicated to its spirit as a mission of national development. Nevertheless, although they combined nearly absolute power, they lacked an essential component. According to the state's plan to transfer the federal bureaucracy—elaborated by the Grupo de Trabalho de Brasília (GTB) in Rio de Janeiro—Novacap officials had no predetermined

rights to reside in the city, as most had been recruited for the preinaugural construction and not for the postinaugural bureaucracy. Thus, they found themselves without inaugural rights to the city they built and ruled and to which 89 percent had already brought families.

In August 1958, however, a "corrective measure" presented itself. The Popular Housing Foundation completed five hundred row houses located between W-3 and W-4 in the South Wing, based on a Niemeyer design. In the GTB's original distribution plan, these houses were designated for lower-echelon functionaries (e.g., drivers, janitors, typists) transferred with large families. Although their design expresses a middle-class social organization, these row houses were thus intended as *casas populares* (popular-class houses) for the lower-income residents. Indeed, at their inaugural ceremonies in August, President Kubitschek affirmed that "what we call popular houses in other places, housing for people of few resources, in Brasília constitute palaces contested for by all the residents and workers as a prize for their efforts" (Novacap 1960, 148). In fact, so prized were these completed houses that five hundred of Novacap's elite families immediately and illegitimately occupied all of them, usurping transferee rights. Ultimately, no one disputed Novacap's usurpation. There was, in any case, no one to evict them.

This "official seizure" had profound consequences for Brasília's social structure. It forced the GTB to scuttle its planned social stratification of residence in which the superquadras in the 100–300 bands were reserved for middle- and upper-echelon officials, and the W-3 houses and 400 band superquadras for those in the lower ranks. With the W-3 houses occupied, the GTB had to change its housing assignments and distribution criteria. Instead of a stratified distribution, it had to adopt an egalitarian one based on criteria of need and a pool of recipients now including all levels of functionaries. Out of this distribution emerged the famous superquadra blocks of Brasília's postinaugural years in which the upper and lower classes lived side by side. This distribution lasted only five years, until the government sold the apartments on the open market. Ironically, however, through an unintended concordance of contingencies, the initial distribution created a radical social structure more in keeping with the one originally envisioned by the utopian architects.[12]

Brazilianization

Built Brasília thus resulted from the interaction of both modes of planning: the total and totalizing, the contingent and insurgent. In most cases, however, the former soon overwhelmed the latter. I will use the example of the illegal periphery to demonstrate. The government planned to recruit a labor force to build the capital, but to deny it residential rights in the city it built for the civil servants from Rio. By 1958, however, it became clear that many workers intended to remain and that almost 30 percent of them had already rebelled against their planned exclusion by becoming squatters in illegal settlements. Yet the government did not incorporate the candangos into the Plano Piloto, even though it was nearly empty at inauguration. The government found this solution unacceptable because inclusion would have violated the preconceived plan for Brasília's "essential purpose [to be] an administrative city with an absolute predominance of the interests of public servants" (Ministry of Justice 1959, 9). Rather, under mounting pressure of the candango rebellion, and in contradiction of the Master Plan, the administration decided to create legal satellite cities, in which candangos of modest means would have the right to acquire lots and to which Novacap would remove all squatters. In rapid succession, the government founded Taguatinga (1958), Sobradinho (1960), and Gama (1960), and legalized the permanent status of the Free City in situ under the name Núcleo Bandeirante (1961). In authorizing the creation of these satellite cities, the government was in each case giving legal foundation to what had in fact already been usurped: the initially denied residential rights that candangos appropriated by forming squatter settlements. Thus, Brasília's legal periphery has a subversive origin in land seizures and contingency planning.

To remain faithful to their model, the planners could not let the legal periphery develop autonomously. They had to counter contingency, in other words, by organizing the periphery on the model of the center. To do so, they adopted what we might call a strategy of retotalization, especially with regard to the periphery's urban planning, political-administrative structure, and recruitment of settlers. That model had two principal objectives: to keep civil servants in the center and others in the periphery, and to maintain a "climate of tranquility" that eliminated the turbulence of political mobilization (Ministry of Justice 1959, 9). Given these objectives, the planners had little choice but to use the mechanisms of social stratification and repres-

sion that are constitutive of the rest of Brazil they sought to exclude. First, they devised a recruitment policy that preselected who would go to either the center or the periphery and that would give bureaucrats preferential access to the Plano Piloto. Second, in organizing administrative relations between center and periphery, planners denied the satellite cities political representation. Through this combination of political subordination and preferential recruitment, of disenfranchisement and disprivilege, planners created a dual social order that was both legally and spatially segregated. Ironically, it was this stratification and repression and not the illegal actions of the squatters that more profoundly Brazilianized Brasília.

As we might guess, the reiteration of the orders of the center in the periphery created similar housing problems there. These problems led, inevitably, to new land seizures and to the formation of new illegal peripheries—in the plural because now each satellite spawned its own fringe of illegal settlements. Moreover, by the same processes, some of these seizures were legitimated, leading to the creation of yet additional satellite cities. These cycles of rebellion and legitimation, illegal action and legalization, contingency planning and retotalization continue to this day. A striking illustration of the perpetuation of Brasília's contradictory development is that, even today, the Plano Piloto remains more than half empty while only containing 14 percent of the Federal District's total population. This comparison strongly suggests that the government continues to expand the legal periphery rather than incorporate poor migrants into the Plano Piloto.[13]

When we consider the Plano Piloto itself, the terms of its Brazilianization are somewhat different. Especially among the first generation, residents tried two strategies to overcome their sense of estrangement in Brasília's new world. Some tried to reassert the familiar values and conventions of a more heterogeneous outdoor public urbanity. For example, in a few of the local commercial sectors of the South Wing, residents rejected the lack of street life by repudiating the antistreet design. They put store entrances back on the curb rather than on the proposed superquadra (nonstreet) side of the buildings. In so doing, they tried to reconstitute the life of the market street where it had been architecturally and legally denied.

However, their success was limited. In the absence of a continuous system of streets and sidewalks, the front/back reversals were isolated. In any case, the government precluded this "deformation" of the Master Plan when it later built the local commercial sectors of the North Wing. Similarly, residents rejected the transparency of glass facades not merely by putting up

barriers but by demanding an architecture of opaque walls and balconies in later superquadras.

Most accepted privatization, however, as the means to create new and more selective social groupings. An example of this second strategy is that rather than try to reform the Master Plan, many among Brasília's elite (including city planners and officials) rejected the residential concept of the superquadra altogether. They moved out of their Plano Piloto apartments and created their own neighborhoods of individual houses and private clubs on the other side of the lake. In so doing, they contradicted Article 20 of the Master Plan, which stipulated that the lake area remain free of "residential neighborhoods." The existence of these elite neighborhoods repudiates the aims of the Master Plan to achieve social change by instituting a *new* type of residential organization. Whereas the superquadra concretizes a set of egalitarian prescriptions, especially through standardization, the houses of these elite neighborhoods often compete with each other in ostentation, using a bricolage of historical styles. While significant in its own right as a counterstyle, this display fractures every tenet of the Modernist aesthetic and social program of the Master Plan. By building exclusive neighborhoods and clubs, these elites contradicted the intentions of Brasília's residential organization. Without their support, important aspects of its proposed collective structure collapsed.

Entombment

We have seen that the history of Brasília's development is one of interaction between its total and contingent planning. Mostly, however, the total overwhelmed the contingent, as planners insist on reiterating the original model in the face of insurgent developments. In a few cases, such as the front/back reversal of stores and the settlement of the periphery, contingency planning made lasting changes to the Master Plan. However, even these insurgent alternatives were retotalized as planners either neutralized their significance by isolating them (the first case) or subsumed them into the whole by organizing their development according to original principles and objectives (the second).

With these conclusions in mind, we can return to a question posed at the beginning: if the spirit of Brasília is that of innovation, experiment, and risk, is this insistence on totalizing the contingent—that is, on perpetuating one experimental moment at the expense of all others—a betrayal of that

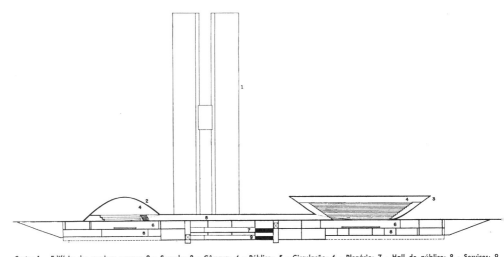

Corte: 1 - Edifício dos serviços anexos; 2 - Senado; 3 - Câmara; 4 - Público; 5 - Circulação; 6 - Plenário; 7 - Hall do público; 8 - Serviços; 9 Hall para Senadores e Deputados
Section: 1 - Buildings for administrative services; 2 - Senate; 3 - House of Representatives; 4 - Public; 5 - Circulation; 6 - Plenary; 7 - Hall fo the public; 8 - Service areas; 9 - Hall for Senators and Representatives

"Plan for Congress Building." From Alfredo Wiesenthal and Gregorio Zolko, *Brasília: História, urbanismo, arquitetura, construção* (São Paulo: Acropole, 1960), 75.

spirit? Even though planners may think they are furthering the project of Brasília through this insistence, are they misguided in imposing one model that was experimental in the 1950s but that now prevents subsequent generations of Brazilians from using Brasília as their field of experimentation? After all, the spirit of Brasília inspired Costa's and Niemeyer's particular expressions of it and, therefore, predates them. If so, then the idea of Brasília cannot be subsumed and completed by those particular embodiments. Must it not, as well, continue to inspire others?

Brasília is today preserved by various levels of law. What is "entombed" is the original urban conception of Costa's Master Plan from 1957, including the Plano Piloto and the lake districts but not the periphery. Indeed, Brasília was born preserved when the Master Plan became law with the city's inauguration (Article 38 of Law 3751, April 1960). Since then, it has been protected by three additional levels of law. In 1987, the local government of the federal district regulated Article 38 through Decree 10,829, giving that article new specificity and application. Also in 1987, Brasília received unprecedented international protection: the United Nations Educational, Scientific and Cultural Organization (UNESCO) guaranteed its preservation by inscribing the Plano Piloto (including the lake districts) in its List of

World Cultural and Natural Heritage. It is the largest urban area in the world and the only contemporary living city so preserved. Moreover, it is one of the few twentieth-century sites selected for the list, along with Auschwitz, Hiroshima's Peace Memorial, and the Bauhaus sites at Weimar and Dessau. Finally, the Brazilian federal government declared Brasília *tombada* in 1990, inscribing it in the *Book of Historical Preservation* (entry 532), an inscription regulated by acts of the Secretariat of National Historical and Artistic Patrimony (SPHN) and the Brazilian Institute of Cultural Patrimony (IBPC). In the words of the official publication of the IBPC, Brasília's preservation means that "any alteration in the height of buildings, in the layout of roads, avenues, and lots, in the use and function of lots, in the unbuilt green areas, within the perimeter preserved, should, on principle, be avoided. Necessary alterations should be profoundly studied and carefully executed to guarantee the preservation of the essential characteristics of the Plano Piloto and its quality of life" (IBPC 1992, 10). To disagree, one could reasonably argue that the exceptional "quality of life" of Brasília is rooted in a history of extraordinary inequality and stratification (exceptional even by Brazilian standards), that it is based on exclusive privileges, and that it costs the nation an inordinate amount to maintain for the benefit of a half-empty Plano Piloto in relation to an increasingly populous and poor periphery. One could claim that legislation that fixes such a quality of life is but a means to preserve the privilege of elites at the expense of others—indeed, that it establishes a tyranny of elites through law and planning councils, and that it empowers a gerontocracy of founders to maintain their vision while depriving younger generations of citizens the opportunity to define their own. One could argue the pros and cons of these assertions at great length with respect to Brasília, without necessarily reaching a completely satisfactory conclusion.

I prefer to conclude by noting that there is no mention in the pronouncements about Brasília's preservation of what is to my mind the most important of its "essential characteristics," namely, its spirit of invention. If that spirit is essential, and if preservation is intended to protect the essential, then at the very least *tumbamento* (official preservation status) should preserve Brasília as a field of experimentation, indeed of continuous innovation. It should preserve the city as a special place in Brazil where that kind of risk is possible. Freezing Brasília at one moment betrays that spirit and turns it into a ghost.

This suggestion does not in any way mean "letting market forces take over" from government planning in Brasília. Though privatizing certain

Oscar Niemeyer, Ministries under construction, 1958–60, Brasília. Photograph by
Marcel Gautherot. Copyright by Instituto Moreira Salles, São Paulo.

urban issues would be an important experiment, "the market" can never be a blanket solution to urban problems. Rather, my suggestion means sponsoring controlled experiments in urbanism in all aspects, from housing to governance to transportation, that will out of necessity respond to Costa's Master Plan but that may also depart from it in considering new problems. In this way, planners could preserve many aspects of the CIAM Modernist city, while allowing Brasília to become a city layered with other kinds of urbanisms. In fact, what makes cities like Rome, Paris, and New York most interesting is that they are not based on one model but are layered with the visions of each generation that lived them. This juxtaposition makes visible the vitality of city life as debates about urbanism itself. The density of this record produces cities rich in *experience* and rewards those who know them. The vast and empty spaces of Brasília need to contain such juxtapositions, whose frisson is the best means, not only to nurture the founding idea of Brasília as experiment, but also to perpetuate the importance of its initial experiment, its Costa/Niemeyer/CIAM Modernist urbanism.

At the very least, memorializing Brasília must mean re-presenting its premises as they developed through both total and contingent/insurgent modes of design. Presenting that dialogue between the modes of Brasília's design is a challenge worthy of a memorial to the real history of the city. It would also provide an important educational project for all concerned with urbanism. As it is now, Brasília's preservation tells only part of the story, that of the elite planners and architects but not that of the workers who built the city and who rebelled against their exclusion. It also neglects the story of the officials who developed new but not architectural proposals for urban life. And it preserves an exaggerated, state-sponsored, social and spatial stratification.

Notes

This essay was originally published in *Brazil: Body and Soul*, copyright 2001 by The Solomon R. Guggenheim Museum, New York.

1 For an extensive discussion of this Modernist political and planning project, see my study of Brasília from 1989, *The Modernist City*, on which I rely for various passages of this essay. This study was based on several years of fieldwork in Brasília.

2 See Holston (1989, 31–58) for proof and discussion of the Le Corbusian derivation.

3 For example, see Quentin Skinner 1989 for an analysis of the conceptual foundations of the modern European state, in part inspired by Geertz 1980.

4 These citations come from media material in the personal archive of the author.

5 Le Corbusier proclaimed the death of the street in an article first published in the French syndicalist newspaper L'Intransigeant in 1929. A slightly different and expanded version was republished in the syndicalist review Plans 5 (May 1931). This version is reprinted in Le Corbusier's Radiant City. [This note originally appeared in Holston 1989, 327 n. 1. — Ed.]

6 Although I argue that Modernist urban planning is antithetical to baroque planning in theory, and eliminates it in practice, some observers suggest that Niemeyer's architecture has a baroque aspect. In particular, they point to the curving and "lyrical" lines of his massing and to the iconic quality of some of his forms. The cathedral in Brasília is a good example of the latter, readily recognizable as a "crown of thorns" or "two hands in prayer," as many people describe it. I would only argue that in theory all Modernist buildings are figural and that most baroque buildings are not iconic. That some of Niemeyer's are especially iconic says more about their ability to communicate quickly and effectively as "one-liners" than about any deeper baroque sensibility.

7 The reduction of family social space and expression of individuality is consistent with Modernist objectives to reduce the role of private apartments in the lives of residents and, correspondingly, to encourage the use of collective facilities. As Le Corbusier argued, "The problem was no longer that of the family cell itself, but that of the group; it was no longer that of the individual lot but that of development" (Le Corbusier 1957, 16).

8 As in Article 38. The first Organic Law of Brasília, Law 3751 of April 13, 1960, is also known as the Lei Santiago Dantas after its principal sponsor in Congress.

9 I should also stress that the need to build Brasília at breakneck speed also created serious job hazards. The combination of exceptionally long work hours, deadline pressures, and lack of adequate training made work-related accidents and deaths progressively more common.

10 These and subsequent demographic data come from the Instituto Brasileiro de Geografia e Estatistica's Censo Experimental de Brasília (1959). It was officially called the Experimental Census because, like so much in Brasília, it was designed to test new methods and concepts that would be developed as national guidelines.

11 That these land seizures were of the only viable places of residence near the construction sites for poor families is indicated in the demographic profile of the only vila surveyed in the 1959 census: over 99 percent of the population of Vila Amaury lived in family households, the highest incidence of family residence in any of the new settlements in the federal district and comparable only to that of the preexisting cities of Planaltima (97 percent) and Brazlândia (100 percent). (IBGE 1959, 103).

12 In addition to Novacap, other federal institutions had the task of constructing

the superquadras. The officials of these institutes were, like Novacap's elite, dedicated pioneers who were deprived of postinaugural residential rights. However, they had much less power. After the inauguration, they continued to live in the wooden shacks of the construction camps, while the transferred civil servants got the apartments they had built. Finally, they too carried out an illegal occupation to gain what they thought they deserved. In a dramatic raid, Instituto de Pensão e Aposentadoria dos Servidores Estaduais (IPASE) officials seized the last apartment blocks the institutes would build in Brasília, just before they were distributed to others.

13 The Plano Piloto was planned for a maximum population of 500,000. As of 1996, the date of the most recent findings, it had a population of 199,000. If we include the lake districts, we add another 54,000 residents, for a total that is still just half of Brasília's planned population. Moreover, the demographic imbalance between center and periphery has only worsened with time. At inauguration, the Plano Piloto had 48 percent of the total district population, and the periphery (both satellite cities and rural settlements) had 52 percent. In 1970, the distribution was 29 percent to 71 percent; in 1980, 25 percent to 75 percent; in 1990, 16 percent to 84 percent; and in 1996, 14 percent to 86 percent (IBGE 1996).

PART 2 / STREET SIGNS

City, Art, Politics / Nelly Richard

During the military dictatorship of General Augusto Pinochet (1973–1989), a Chilean artist took to the streets to lay crosses on the pavement. She thus inaugurated a complex mission to subvert signs. Lotty Rosenfeld's project culminated in her September 2002 video installation in Santiago de Chile, *Point of Order* (*Moción de orden*). Rosenfeld's work serves beautifully as the basis of a reconsideration of city, art, and politics. As aesthetic performance, it opens windows onto disconformity, windows onto the critical imagination that art is capable of creating, even in the capitalist structure of the globalized city.

Throughout seventeen long years of dictatorship, Santiago de Chile was controlled by a repressive military order. In the 1980s, a group of Chilean artists, united under the name of Escena de Avanzada (the Cutting-edge Scene), developed a series of urban events, or "art-actions," to reuse the term of the German artist Wolf Vostell.[1] These art-actions in the city were meant to disturb the rigid urban social order that, under militarism, had rendered the citizens passive. The art-actions were also intended to generate disruptive effects in the daily routines and social conventions of the city. Rosenfeld's work forms part of this movement in Chilean art. It actively interrogates the relations among urban landscape, the social quotidian, and the artistic happening; it inserts itself between the opposed forces of urban regimentation and critical and aesthetic disorder.

Rosenfeld was a member of the CADA group (Colectivo Acciones de Arte—the Art Action Collective) that deployed a form of street art in the 1980s.[2] This street art differed from that of the Ramona Parra Brigades which, during the days of the Popular Unity party of Salvador Allende, figu-

ratively retold revolutionary epics by painting the walls of the city.[3] Whereas the representational muralism of the Ramona Parra Brigades thematized revolution in expressive-referential, or testimonial, terms, the urban actions of the CADA group in the 1980s spoke in more situational or interventionist terms. The art-actions of the CADA group and of Rosenfeld did not draw from politics as if it were the source of an iconographic repository of meta-signifieds (the People, Revolution, Identity, etc.) that were somehow external to the artwork.[4] Rather, the art-actions, through the micro-politics of "happenings," sought a live (and, hence, mobile, in progress) articulation of artistic contingency and of the web of social intersubjectivity.

In 1979, Rosenfeld began her piece entitled *Una milla de cruces en el pavimento* (A mile of crosses on the road).[5] The work consisted of altering the perforated lines that divide the street into lanes, by crossing those marks with a white stripe (a cloth strip). The stripes' insolent, perpendicular orientation was superimposed upon the vertical line that "normally" imposes order for the flow of traffic. With this bold and contentious, yet minimalist gesture, a Chilean artist and subject of dictatorship occupied the prohibited space of the street. She transgressed the boundaries between marks, territory, and vigilance with which authoritarianism controlled both physical space and life in the city.

Rosenfeld's placement of the crosses in the middle of the street, out in the open and in public space, called attention to the fact that, in those years of military repression, art had become increasingly self-referential, secluding itself through processes of institutionalization and absorbing itself with the contemplative rites of official museography. But Rosenfeld did not want only to expand the mechanics of artistic production through her engagement with the work of social exteriority and the dynamics of collective management. The artist wanted, in addition, to invite everyday passersby to critically restructure their schema of daily experiences according to the libertarian impulse expressed by the surprising conceptual alterations with which she was designing art in the city. In other words, her work sought to provoke an anonymous spectator (virtually anyone) to question the daily teachings that ensure the servility of subjects trapped in a framework of official codes.

The lines on the road indicate the directionality of a double-entendre of order, that is, of both structure and command, going ahead in the linear sense, following a path preordained by authoritative control. Rosenfeld converted the straight lines on the road—signals created to guide movement

in a forced direction—into a metaphor for everything that, in the name of order, dictated the norms for tradition, disciplining the mind, subjugating bodies to a matrix of effects that spoke the coercive language of a militarized nation. The act of transgressing the subsystem of transit lines in a completely regimented country went far beyond the mere surface of the roads. Rosenfeld's gesture exposed authoritarianism's forms of power. In a fragment of a conversation recorded in 1980, Severo Sarduy notes the way in which Rosenfeld gets at the heart of signification:

> The work of Lotty Rosenfeld is a subversion of a formal code that constitutes the sublevel on which the entire mechanism of civilization rests: the semantics, that is to say, the system of signals, the code of signs that governs not only urban circulation, but all possible circulation of goods and of women that, of course, have been assimilated by the present civilization to consumer goods and above all, money. The alteration, then, of the foundation of urban signaling, even the entire system of exchange, be it linguistic, economic, bankerly, or cultural, seems to me to operate exactly there, in the generative center of communication, in the center of misunderstanding. (Brito 1986, 43)

Thus, by altering a simple stretch of the daily traffic flow through an apparently discreet and thus far inoffensive gesture, Rosenfeld's piece subversively called attention to the relation between communicative systems, reproductive techniques of social order and the uniformation of docile subjects.

The first dimension of Rosenfeld's crosses in the 1980s dealt, then, with breaking the linearity of a repressive system, with materially twisting its direction. By crossing over the verticality of order with an insurgent, horizontal rebellion, she rejected the imposition of an authoritarian path. But a second dimension of this same work, a dimension that transcended the immediate limits of the Chilean dictatorship, introduced a new, rebelliously creative relationship with signs and codes, and it did so from within the perspective of art. Instead of being fixed and invariable (like the relation already drawn up by the social order) this new understanding of signs would be plural and multiplicative. The "+" sign that the artist marks upon the pavement is the operator of addition, but also of multiplication: seen from a different angle, it is an "×." Under military authoritarianism, Rosenfeld's "+" sign articulated the multiplicative plurality of open meanings that art must maintain in suspense and contradiction if it is to defy totalitarianism's ownership of unique truths. The "+" sign, the symbol of sums and products, was the

form of the art chosen by a woman seeking to defy the economy of deduction and subtraction in Chile, where totalitarian seclusion and a regime of fear led to death and disappearances.[6]

More than twenty years later, Rosenfeld produced *Point of Order*. This time her work returns to crossing urban supports, aesthetic streams, and political contingency. More than a single work of art, *Point of Order* is "a coordinated program of intervention in public, artistic, political and economic spaces and places" (Rojas 2002, 7). The program is divided into two parts. The first part consists of three video installations exhibited simultaneously in September 2002 in the National Museum of the Arts (Museo Nacional de Bellas Artes), the Museum of Contemporary Art (Museo de Arte Contemporáneo) and the Gabriela Mistral Gallery (Galería Gabriela Mistral) in Santiago. These installations juxtapose television images of international current affairs, other visual sources, and rows of crawling ants projected on the walls. The second part is composed of a series of projections in the city of these same lines of ants that invade different public and state foundations such as the metro, the Palace of the Treasury, the Telefónica building, the copper Codelco building, and the Civil Identification Service.

The Video Installations: Junction and Disassembly

The video-installations of *Point of Order* select and manipulate informative materials that travel through the networks of global communication and global media services. The work subjects these familiar images (already seen and archived by mass audiences) to a *shock treatment* that shatters them into multisemantic and multi-ideological intersections (crosses). The work mixes images of Alberto Fujimori looking to Nestor Zerpa, snipers in Bosnia, Commander Chávez crossing out lists, Abimael Guzmán in jail, George Bush vacationing after the attack on the World Trade Center towers, Chilean political prisoners, Mohammed Ali in front of an accusing committee, the 2001–2002 looting in Argentina, and others. All of these texts are simultaneously mixed with images of the first Chilean silent film, *El Húsar de la muerte*,[7] and with a fragment of James Joyce's *Ulysses* (1922).

The work generates an explosive dialogue between fragments of news reports that belong to different and sometimes opposing latitudes: the Soviet Union, the United States, Cuba, Afghanistan, Korea, Latin America, and elsewhere. These conflicts receive, nevertheless, the same communicative treatment on the television screens that audiovisual globalization uses to

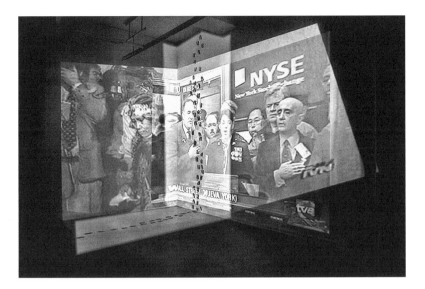

Lotty Rosenfeld, *Moción de orden*, 2002. Installation. Printed with the artist's permission.

indifferently balance and process all international current events. Rosenfeld denounces this acritical mass of flat images (that neither make shadows nor leave traces) that news media circulate full-time, at full speed, with no reflective pause. The video installation disrupts the flat simultaneity of these media images through visual and auditory resources that highlight dissonance. This juxtaposition deepens the conflicts and the antagonism of voices in dissimilar materials. It highlights the deceptions produced by the image. It emphasizes perceptive ruptures and conceptual shifts. Shock techniques—like gaps, intermittence, and sudden visual jolts—produce a critical destabilization of the senses that places the spectator in the condition of risky discomfort when confronting the image.

Displacing the relation between images and the gaze, this art frustrates the placid representation of the "other" as the accommodating stereotype of diversity that cultivates the relativist pluralism of multiculturalism. Rosenfeld's work plays with the imbalances of vision, division, and disorientation among the planes of representation. The dislocation of the gaze that her art provokes refutes the anesthetized script disseminated by the globalization of information media. As Rosenfeld's viewers experience the images separated from their original packaging within the familiar (and therefore invisible) conventions of "news," they necessarily disengage from their con-

ventional roles as consumers of audio-visual media. Thus, they confront the real alterity of difference. This experience resists the meaningless streaming of newsworthy visibility. It repudiates the system of representation in which even wars are seen as just one more product of the entertainment industry.

Rosenfeld's multimedia technology disrupts the apparent instantaneity and simultaneity of news in the globalized present with voices that come from elsewhere, voices usually submerged in oblivion (Mapuche voices, indigenous voices). They recall a long Latin American history of scorn and humiliation over which colonialism, neocolonialism, and postcolonialism have been superimposed. Rosenfeld includes the image of an official reading a testament of the distribution of goods and land during the Spanish conquest (the testament of La Quintrala). This image is crossed with other images of today's Magellanic ocean, showing oil rigs at sea. These images expose postindustrial voracity, multinational capitalism's insatiable search for riches, ratified by a hymn accompanying the images: the anthem played during the reopening of the New York Stock Exchange after the attacks of September 11, and the dubbed voice of George W. Bush shouting to the world, "¿Pueden oírme?" ("Can you/they hear me?"). This was when the American Empire decided to rearrange the world to serve a new, murderous binarism: "us" vs. "them." Rosenfeld's work reveals how the search for gold during the conquest continues today in oil ventures in the Tierra del Fuego. It also makes plain the structures of economic power that subterraneously (via petroleum) support the architecture of the new clash of civilizations declared by the United States. Reflecting the various velocities of peripheral postmodernity, rebellious signs of colonized memory appear in this work along with indices of hypercapitalism's triumphant planetary expansion.

However, the ants that cross the oil platforms and the images of the New York Stock Exchange in Rosenfeld's work intrude upon the economic operations of multinational capitalism. The ants' frenzy, Rosenfeld's metaphor for proliferation, frustrates the calculation of the numerative and the quantitative. These ants show how art and its conceptual poetics, with their excess of meanings, upset the equations negotiated among value, capital, and market. As Sergio Rojas writes, "The image of a marine oil rig near the south of Chile, in which we see lines of ants moving across the center of the heliport on the platform, this has an imposing material and economic reality, nevertheless the artist manages to make it enter into the ambiguous environment of art's significance. This also demands of the artist a great unfolding of technical and economic resources, only, unlike what occurs

with the oil rig, these resources now yield sense. The platform enters art as a sign in a system whose limits are powerfully uncertain" (Rojas 2002, 33). The surplus of the aesthetic metaphor, as much as the ambiguity created by its vague and shifting meanings, subverts the capitalist order of signs. The image of oil tankers symbolically condenses the expert rationality of contemporary economic and political technologies, and it carries them toward the shores of the powerfully indeterminate.

The Ants: Aligning, Disorganizing

In one of the sequences of *Point of Order*, the rows of ants cross lines on pavement, recalling the piece Rosenfeld initiated under the military regime in the 1980s. This citation of memory weaves together the present and the past, moving from the markedly authoritarian order of yesteryear (the dictatorship) toward today's resignation to a different order (the democratic transition). The Chilean Transition, begun in 1989, sought to normalize the social and political situation by developing a "democracy through agreement" (*democracia de los acuerdos*). It privileged two ways of effecting a national integration to Order and the homogenization of Order. The first appealed to consensus using a rhetoric of moderation meant to avoid ideological polarization and to generate a collective understanding of democratic realism's benefits for all. The second relied on the free market as the regulator of the neoliberal economy that disciplines behavior and subjectivities at the same time that it offers the spectacle of pluralistic tastes and styles.

In effect, in one of Rosenfeld's referential analogies, the ants' organized transit evokes these control mechanisms. The disciplined rows of ants in *Point of Order* speak of both consensus and economic productivity, the concepts deployed by democratic realism in order to rehomogenize the social and which integrate Chilean subjectivities into a passive system of moderation and resignation. However, in Rosenfeld's artwork, a finger abruptly interrupts the ants' trajectory. This intrusion generates a dispersive explosion that alters the gray course of programmatic neutrality (at least until a new *Point of Order* comes to reorganize the ranks). The ants' dispersive explosion exacerbates the tension between integration into order and the disintegration of order; that is, the tension between system, rupture, and dislocation.

One possible reading of the work—influenced by the new vocabulary of Paolo Virno, Michael Hardt, and Antonio Negri—would consist of detecting

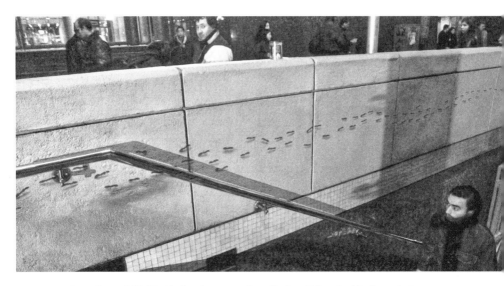

Lotty Rosenfeld, *Moción de orden*, 2002. Installation. Printed with the artist's permission.

in the transitory metaphor of the ants an evocation of the disorder of the multitudinous: a rebellious force of the multitudes that breaks the traditional political mold (the mold that seeks to contain the category of "the people" within a scheme of controllable representation). The deterritorializing movement of the streams of ants that come and go, that escape, that disappear and reappear, reminds us of "desertion, exodus, nomadism" as oblique strategies of resistance to traditional hierarchies (Hardt and Negri 2002, 201). According to Diamela Eltit (2002), when entering and leaving the museum, the ant colony, whose "anxious search for the hollow reminds us of penal flight . . . seems to fulfill the aspiration to break decrees and to thus disorganize the rigidity of a speech that is collected and perpetuates itself in the deliberate obsession of museography. . . . The work of Lotty Rosenfeld moves like this . . . until it finds a hole it can hide in. Its 'passage' can also be read as 'a protest march' . . . that transforms the official categories and indicates that art must be thought of as an 'anthill' in permanent turmoil" (63). The ants evoke two modes of social behavior: the ordering of uniform procession, on the one hand, and the expansive disorder of the multitudinous, on the other. The aesthetic performance itself, however, introduces the alternative of escape. It makes "the disorder occur aesthetically as dissemination, as scattering, as the emergence of a now-uncontrollable many,

as the dispersal of singularities, and therefore as intensification of context" in the "production of an alternative political space" (Rojas 2002, 21).

The itinerant multiplication of the ants' journeys inserts itself into the mobile segments of cultural institutions and the social urban network. It engages the same problematics of discipline and transgression that Rosenfeld's work had masterfully defined twenty years ago. But now, the work has shifted. Whereas it once stressed the polarization of "+" and "−," still caught in binarism with its perpendicular layout, now it performs transversality and dissemination. The artwork projects an undulatory multiplicity, the routes of bifurcation and branching that the ants follow in order to imperceptibly corrode the microtextures of domination. In the piece, this delirium of ants quietly infiltrates oblique fissures in the emblems of state power (the Palace of the Treasury), of exchange markets (the New York Stock Exchange), of bureaucratic controls (the Civil Identification Archive), of capitalist exploitation (the oil platforms), of official art institutions (the museums), and of communicative imperialism (the Edificio Cooperativo, or CTC building). This art's counterdiscourse relies on itinerancy and dispersion in order to exercise a highly mobile, tactical locality, which changes its targets as needed. Thus art accesses all social sites, yet never lets itself be territorialized by the imposition of fixed meaning. There are so many ants, their routes so unpredictable, and their game so small and interstitial, that they cannot be controlled by the machinery of domination. As opposed to the infinitely large scale of the capitalist machine, the infinitely small scale of the ant world bets on art to win the game, by multiplying—invasively and evasively—its disturbing presence in the centers of power. As Gilles Deleuze puts it, "The great ruptures, the great oppositions, always are negotiable; but the small fissure, the imperceptible ruptures that come from the south, those are not" (Deleuze and Parnet [1977] 2007, 131).

The multi-spatiality of Rosenfeld's work resists any single reading, any attempt to limit it within only one system of artistic inscription. In order to maximize the points of contact, this art passes through the interior of cultural institutions. It does not stop in them, but rather crosses them. It passes through these institutions (museums and galleries), not allowing itself to be intimidated by the boundaries of demarcation and official definitions of artistic legitimacy. On the one hand, the ants that come and go at the edges of the work infiltrate the cracks in these institutions. On the other hand, they spread throughout the city, infecting different segments of urban life with their metaphors of the reconcentration of power and of the rebellious

Lotty Rosenfeld, *Moción de orden*, 2002. Installation. Printed with the artist's permission.

expression of desire. The ants that escape, seeking a way out of confinement, are the metaphor of an art that creates fissures and new grooves out of its utopian desire to elude sedimentation and codification.

Rosenfeld's work converts a seemingly inoffensive part of daily life into spectacle. Her parades of ants, by the singularity of their size and their unusual location, alert us to something we cannot quite pin down, since nothing directs our reading of the image toward a predictable or entirely de-codable meaning. The ants in the city offer a tenuous, half-articulated inter-vention. They play with the indeterminacy of a gesture that connotes nothing specifically artistic because it lacks the legitimating frame of a museum or a gallery. As with Rosenfeld's crosses of thirty years ago, *Point of Order* rejects the protected enclosures of institutional art, and runs the risk of reaching out to any spectator at all. This is an art of the streets.

Art sets out here to produce a slight alteration of urban vision that subtly troubles the disposition of the real, a disturbance of the gaze that intro-duces the unknown into the known. It introduces ambiguity of meaning as the ants incarnate the metaphor of order and disorder. Appealing to contin-gency and the randomness of the gaze as the scenic materials of a network of urban intersubjectivity that art also recreates subversively, *Point of Order* seeks to subject the passerby to an alteration, small or great, in the regu-

larity of everyday order. It wants this window of incomprehension to upset that which has become naturalized through habit and convention. The ants parade between the limited spaces of system-art (the Museo Nacional de Bellas Artes, the Museo de Arte Contemporáneo and the Galería Gabriela Mistral) and the unlimited space of the city. The discontinuous segmentation of the rows of ants that perforate walls and floors helps this art produce intervals, cuts, and interruptions in the apparently continuous urban surface. Even as that surface pretends to seal the connections between technology, power, and the marketplace, making us think that the totality of power is indisputable, critical art uses the insignificant, the heterogeneous, and the dissident to break apart those hegemonic blocks.

Moving from place to place and circulating incessantly, the undulatory proliferation of ants escapes the disciplinary logic of unitary power. Critical art, the art of opposition, must look everywhere for ways to crack the system; it must explore multiple escape routes. That is why Rosenfeld's critical art is located in the intersections (at the crossings) where the interruption of regimentation and unidirectional movement produces a dispersive release of mutating meanings.

Notes

This essay was translated from the Spanish by Samuel Lockhart and Rebecca E. Biron.

1 In 1977, the Galería Epoca of Santiago de Chile exhibited works by the German artist Wolf Vostell. His concepts of "found life" and "experience workers" profoundly influenced the discourse of the Colectivo Acciones de Arte group, of which Rosenfeld was a member. Those concepts suggest that art's strength consists of stimulating in each viewer or participant—almost anonymously—a self-conscious awareness of his or her ways of living that would then allow him or her to creatively reprocess forms of individual and social experience.

2 For a documentary investigation of the CADA group, which consisted of Diamela Eltit, Raúl Zurita, Fernando Balcells, Sergio Castillo, and Rosenfeld, see Neustadt 2001.

3 The Ramona Parra Brigades of muralists were linked to the Communist Party (Juventudes Comunistas), and originated as propagandistic organizations in support of Salvador Allende's 1958 and 1964 electoral campaigns. Later they illustrated for the *Unidad Popular*.

4 Reflecting upon the relation between "art" and "politics," Sergio Rojas notes: "We should not take for granted that politics is something that is available to be "the-

matized" by art. We fall into this error when we simply interrogate a work in regards to what is said or proposed about politics (as if the work were only the support of an already-answered message), or when we suppose immediately that the work could have some impact on political contingency" (Rojas 2002, 4).

5 For a detailed reading of the operations inscribed in the work of Rosenfeld, see essays by María Eugenia Brito, Diamela Eltit, Gonzalo Muñoz, Nelly Richard, and Raúl Zurita in Brito 1986.

6 Of the murderous terror spread by Augusto Pinochet's military regime, the mass political disappearances of leftist militants and supporters of the Unidad Popular government constitute one of the worst moments in all of Chile's national history. Even today the details and final destiny of those disappeared bodies remain shrouded in uncertainty. Because of that, the figure of death-in-suspense (the undead, or unfinished death and incomplete mourning) traumatically haunts public memory even in the postdictatorship period.

7 *El Húsar de la Muerta* was made in 1925 by Pedro Sienna. It is the only feature-length film of the Chilean silent film period that is still available today.

The Writing on the Wall: Urban Cultural Studies and the Power of Aesthetics

Marcy Schwartz

The vibrancy of the urban world has complex multisensory dimensions. While this essay will focus on the interactions of verbal and visual urban expressions, the sonorous, kinetic, architectural, and material aspects of the urban world also participate in those expressions. Cities' structures, with all the noise and movement that surround and emanate from them, create visual horizons (it's no accident that photography originated in the city) and generate verbal products, both oral and written. Latin American urban development has often been considered a "lettered" phenomenon, as Angel Rama (1984) elaborates; however a visual dimension informs much of its written production, frequently intersects with it, and sometimes supercedes it. The semiotic coparticipation—even competition—of visual and verbal designs reminds readers and spectators of the fundamental role of aesthetics in urban representation and experience. Like Michel de Certeau's walkers in the city, those who decipher a city's cultural products as readers or spectators engage with and help construct city space. The investigation of urban public space particularly benefits from considering the aesthetics of language and visual images in the construction and use of those spaces.

Recent debates within and about cultural studies expose the unresolved disciplinary, political, and philosophical dilemmas in working with cultural materials. Roundtable discussions, panels at academic conferences, and columns in journals devoted to the place of literature and art within the panorama of "high" and "low" or popular cultural spheres have yet to resolve the definition and categorization of what falls under the rubric of "cultural

studies."[1] The use, value, and experience of urban space involves a mingling, sometimes even a bombardment, of a wide range of expressive culture, resulting in an inseparability of the supposed high and low realms to the extent that these categories become, I believe, obsolete or irrelevant. Part of the controversy in situating cultural products within their sociopolitical contexts, which has become the hallmark of cultural studies, concerns the contested and often discounted place of aesthetics in interdisciplinary approaches. This essay shifts the focus to the role of aesthetics in urban art and writing in order to rediscover the dynamics of verbal and visual art in the experience of the urban in Latin America.

When cultural studies ignores the subjective and symbolic dimensions of cultural products, it leaves gaps in interpretation as well as in sociohistoric grounding. I draw on recent work in cultural studies on urban space to contextualize examples from art and literature whose verbal and visual interactions suggest a dialogic aesthetics of the urban imagination. The political possibilities of public art by Liliana Porter and fiction by Julio Cortázar reassert the potency of aesthetics within the experience of city space and the politics of culture.

The heated discussion, critique, and defense of cultural studies has debated the materials studied and also scrutinized the methodologies applied to them. Among the shifts and tensions in these reconsiderations are a focus on popular culture and a delegitimation of "art." The cultural critics Néstor García Canclini and Beatriz Sarlo are two key figures whose work helps frame the struggle to define cultural studies and the debates over the place of art in Latin America. García Canclini's vast interdisciplinary focus, mostly grounded in sociology and anthropology but more recently focused on communications and mass media, occasionally takes art into account but mostly dismisses it. His theory of the hybrid proposes more fluid and less dichotomized notions of the modern and the traditional and questions the local and the cosmopolitan, demonstrating a confluence of these categories rather than their previously rigid separation. While his work has been key to a new understanding of urban space (such as the coexistence of historical monuments with commercial culture) and the dynamics of consumer culture in Latin America, he often relies on a false division between art and the supposedly more politicized immediacy of popular culture. For example, he identifies one of the circuits of cultural development "la cultura de élites," defined as the realm that "abarca las obras representativas de las clases altas y medias con mayor nivel educativo. . . . No es conocido ni apro-

piado por el conjunto de cada sociedad" (encompasses the representative works of middle and upper classes with greater education. . . . This level is not known or appropriated by the whole society) (1995a, 32–33).[2] It is not unusual for cultural studies to be wary of visual art and literature, considering them "privileged" and therefore warranting less attention. García Canclini, despite brief moments of championing visual media in urban contexts (graffiti, photography, video, painting), largely neglects art and literature in his theories on hybridity and multimedia communications.[3] Patrimony and canonicity make high art suspect, and according to John Beverley, cultural studies privileges the autonomous creativity in the sphere of consumer or popular culture that does not depend on being authorized by high culture. To the contrary, if it is authorized by high culture, it becomes denatured and loses its oppositional force (Beverley 1999, 123). Some critics still accuse cultural studies practitioners, despite their focus on popular and consumer culture, of not being far enough to the Left. In effect, by celebrating the consumer market, cultural studies may only serve to confirm the neoliberal economic policies of the past decade.[4] Tensions continue surrounding the place of art and the definition of *aesthetics* in relation to consumer and popular cultural production.

Sarlo, along with many other literary critics, contests this dismissal of the subjective and aesthetic field within cultural studies. She defends art and literature as essential expressions whose aesthetics grow out of and engage with politics and society. Although she finds García Canclini's theory of the hybrid convincing, she finds it "is not able to cover a wide enough field, and is attractive only with regard to well-chosen examples" (Sarlo 1997a, 86). In a discussion on the intersections of literary criticism and cultural studies, she expresses concern that ignoring aesthetic value leaves unresolved the relationship between artistic expression and society's symbolic dimension (Sarlo 1999). What she calls "la sociología de la cultura" definitely "ha operado como un ácido frente al esencialismo [y al] elitismo" (worked like acid to undo essentialism and elitism) (1994, 154). However, even if cultural sociology "logra desalojar una idea bobalincona de desinterés y sacerdocio estético, al mismo tiempo evacúa rápidamente el análisis de las resistencias propiamente estéticas que producen la densidad semántica y formal del arte" (manages to unseat a frivolous sense of disinterest and sacredness within aesthetics, at the same time it rapidly empties analysis of the properly aesthetic resistances that constitute art's semantic and formal density) (1994, 155–56). Attention to aesthetics in studying urban cultural production and

reception reveals fundamental aspects of a society's symbolic values. Compositional strategies, discursive registers, linguistic innovations, parodic critiques, and challenges to aesthetic traditions in visual art and literature respond—beyond social class association and consumer behavior—to the society's political, environmental, and institutional dramas.

Latin American urban expression, such as Cortázar's fiction and Porter's public art, highlights the integration of the aesthetic and sociopolitical dimensions of cultural products. Lois Parkinson Zamora, in her reexamination of interdisciplinarity and pedagogy, questions the "unnecessary disciplinary divisions that currently characterize the academic study of the arts" and calls for a more direct integration of art in literary studies (1999, 389). Her launching of interartistic study offers a far-reaching *ars critica combinatoria* for Latin American culture in particular. She identifies the limits of verbal and visual meaning in order to propose a mode of analysis that moves beyond an isolated medium or mode of expression. She states that interartistic criticism serves to "elucidate the work of one artist in terms of another, to weigh the expressive potential of one medium in terms of another, and to compare cultural constructions of the image in their visual and verbal media" (1999, 413). These kinds of analyses insist on the intersection of an array of interdisciplinary modes that includes the artistic and aesthetic with the market and consumer, analyses that expand the sometimes rigid limits of market reception and consumer-based studies.[5]

In fact, studies such as García Canclini's *Consumidores y ciudadanos* examine consumer culture but avoid direct discussions of art. Through the analysis of mass participation in local arts festivals, sociological attitudes on multilingualism, and access to information technology, García Canclini studies how identities are negotiated in increasingly multicultural and global contexts. Mentions of literature lead to dismissive reductionisms such as "fundamentalismo macondista" (Macondistic fundamentalism) regarding magic realism. While a number of the essays are centered around cinema, film as an art form becomes swallowed up by the "redes globalizadas de producción y circulación simbólicas" (globalized networks of symbolic production and circulation) and by the multimedia policies of each country (1995a, 108, 128). García Canclini ignores examples of canonical literature repackaged in popular productions for mass consumption. In the domain of popular music alone one could consider examples such as the lyrics to Josefito Fernández's ageless "Guantanamera" from José Martí's *Versos sencillos*, Nicolás Guillén's poem "Tengo" performed by Conjunto Céspedes, and Chico Buarque's and

Caetano Veloso's interpretations of poetry in song.[6] Lisandro Meza's valle-nato "Canción de una muerte anunciada" pays homage to Gabriel García Márquez's novel *Crónica de una muerte anunciada*, and the novelist himself has referred to his best-known work, *Cien años de soledad* (*One Hundred Years of Solitude*), as a 450-page vallenato (Wade 2000, 137).

While cultural studies often categorizes visual art and literature as suspiciously high brow, "street art" does captivate cultural studies practitioners because it represents an aesthetic middle world that mediates between high and low cultures. This is art that challenges the aesthetic institutionalization of national monuments and museum exhibits. Visual manifestations for public consumption, such as graffiti, banners in demonstrations, and murals, play an important role in cultures now recognized as hybrid because these materials coexist with neon signs and modern architecture, and intersect with transportation systems and urban planning projects. This is art exploding into public space that is spontaneous, sometimes risky, unlawful, and aggressive.

Graffiti, a medium that inscribes the city itself, pertains to what García Canclini calls today's "perishable, transient, and evanescent" visual culture (1993, 442). This is art that challenges the static confines of a museum collection or the presumed fixity of the printed word in literature. Cortázar's short story "Graffiti," from the collection *Queremos Tanto a Glenda* (1980) brings together street art and literature in an intense urban drama.[7] "Graffiti" demonstrates the limitations of a rigid classification of certain cultural products—literature, in particular—as "elite" and therefore not pertinent. In fact, "Graffiti" accomplishes what much of cultural studies suggests only hybrid popular manifestations can: it subverts the dominant codes governing expression to reveal significant elements of urban social and political reality as part of the overt resistance to censorship and repression under dictatorship.

"Graffiti" tells the story of anonymous communication between a man and a woman through drawings on walls in an unnamed city under a repressive political regime. The two characters exchange drawings on the dangerous space of public walls until the woman is arrested and tortured by the police. After a long "silence," or lapse in their visual communication, she lets him know what happened to her before she takes refuge in "la más completa oscuridad" (the most complete darkness): "Viste el óvalo naranja y las manchas violetas de donde parecía saltar una cara tumefacta, un ojo colgando, una boca aplastada a puñetazos" (You saw the orange oval and

the violet splotches where a swollen face seemed to leap out, a hanging eye, a mouth smashed with fists [1983, 38]) (1994, 2:400).

Cortázar dedicates his story to Antoni Tàpies, the Catalan painter, and a description of one of the character's drawings in the story is reminiscent of Tàpies's industrial textures: "Lo había hecho con tizas rojas y azules en una puerta de garaje, aprovechando la textura de las maderas carcomidas y las cabezas de los clavos" (She had done it in red and blue chalk on a garage door, taking advantage of the worm-eaten wood and the nail heads [1983, 35]) (1994, 2:398). Several published editions of the story have exploited the writer's recognition of Tàpies's "pintura matérica" (matter painting)[8] by overlaying the printed text on a background that exposes "aquellos aspectos más humildes y abandonados de la realidad inmediata, tales como los graffiti callejeros, objetos de desecho y otros . . . [para] reevaluar esos objetos condenados socialmente al desuso" (those most humble and abandoned aspects of immediate reality, such as street graffiti, discarded objects . . . to reevaluate those objects socially condemned to disuse) (Borja-Villel 1992, 23–24).[9] Thus art is pushed into the public domain, imitating and becoming public space. Like Tàpies's paintings, the drawings in Cortázar's story try to defy, and clearly denounce the violence of everyday life and of authoritarian regimes—repression under Francisco Franco in Catalunya for Tàpies, surveillance and disappearances during the Argentine Proceso that Cortázar observed from afar. The violence evident in the colors, detached body parts, and disconnected shapes on the walls, parallels the psychic and physical violence done to the public.[10] Public walls that serve as canvases further expose the dilemma of artistic expression under censorship. Cortázar's fictitious graffiti exposes violence and censorship on public walls, while Tàpies and other "matter" painters (see Borja-Villel 1992) convert the space of their canvases into public plazas for exposing political and sociocultural aggression.[11] Both Tàpies and Cortázar simultaneously challenge the traditional models of signification in their respective media and the political structures they embody.

Art critics have linked Tàpies's work along with other matter painters' work to graffiti. The aesthetics and the politics of graffiti corresponded to both the resistance and the emphasis on the primitive in Tàpies's work.[12] The huge size of his canvases in the matter paintings also suggests street art dimensions. In *Culturas híbridas*, García Canclini similarly recognizes the spatial and political elements of graffiti's aesthetic:

Jean-Pierre Vorlet, untitled photograph, ca. 1984. Michel Fresson carbon print, reprinted with artist's permission.

Una escritura territorial de la ciudad, destinada a afirmar la presencia y hasta la posesión sobre un barrio. . . . Su trazo manual, espontáneo, se opone estructuralmente a las leyendas políticas o publicitarias 'bien' pintadas o impresas, y desafía esos lenguajes institucionalizados cuando los altera. (1990, 314)

A territorial writing of the city designed to assert presence in, and even possession of, a neighborhood. . . . Its manual, spontaneous design is structurally opposed to 'well'-painted or printed political or advertising legends and challenges those institutionalized languages when it alters them. (1995b, 249)

Cortázar's story challenges institutional (in this case, the military regime's) language and control through intimate visual communication. As Anne Wilkes Tucker notes in her comments on Brassaï's experiments with graffiti, graffiti is an art form that "attracts those who harbor something for which society can be reproached, and those whose impulses can no longer be repressed" (1999, 95). Brassaï describes graffiti as "la parole y redevenait action," verbal art that takes words and turns them into action (1993, 7). He insists that carving, writing, and painting on walls is not vandalism but rather instinctual survival (1993, 18). The characters in Cortázar's story choose arbitrary walls (a garage, a gray wall), not to occupy and claim their neighborhood, but to frame the alienation and repression they work under. The whitewashing trucks antiseptically obliterate the drawings, but when the man dares to write the words, "A mí también me duele" (It hurts me, too) along with one of the drawings, "la policía en persona la hizo desaparecer" ("The police themselves made it disappear) (Cortázar 1994, 2:397; 1983, 34).[13]

This subtle reference to *desaparecidos*, or the disappeared, is part of this story's political grammar. Addressing the reader in the second person is another of Cortázar's politicizing strategies in "Graffiti." In speaking to "you," the story implicates the reader, immediately assigning "you" a position in the dangerous artistic exchange. The narration pulls the readers into the story as potential victims of repression and potential resisters through art and solidarity. The narrator's gender remains uncertain through most of the story. Other than one verb in the first line of the story (*supongo*), the first person is withheld until the very end, when the narration ultimately reveals that it is the female protagonist who narrates:

Ya sé, ya sé, ¿pero qué otra cosa hubiera podido dibujarte? ¿Qué mensaje hubiera tenido sentido ahora? De alguna manera tenía que decirte adiós y a la vez pedirte que siguieras. (1994, 2:400)

I know, I know, but what else could I have sketched for you? What message would have made any sense now? In some way I had to say farewell to you and at the same time ask you to continue. (1983, 38)

This delay in gender identification prolongs the suspense and the open-ended relationship with the reader. Finally protected by "la más completa oscuridad," the narrator tragically asserts herself and calls out from the other side of disappearance and silence.

The temporary, precarious, and tragic nature of the fictitious drawings in Cortázar's "Graffiti" has both political and aesthetic messages about contemporary urban expression in its verbal and symbolic content. As ethnographic material, "Graffiti" is paradoxical: imagined pictures and silenced communication. The crisis of the image in this story underscores the need to reassess the role of literature. Alberto Moreiras positions literature under the umbrella of cultural studies and considers it subaltern. Reassigning literature this new subaltern function, according to Moreiras, "endows it with a forceful irruptive potential" (2001, 13). It is art's irruptive force, through its political content along with its linguistic or visual gestures, that challenges semiotic order and proposes alternative structures of behavior.

Porter's public art offers its own urban immediacy. Her mosaic series from 1994, *Alice: The Way Out*, is installed along the train platforms of the Fiftieth Street Interborough Rapid Transit (IRT) subway station in New York City. Two images frame each side of the platform (north- and south-bound) just at the edge of the wall that separates the platform from the entrance to the station. The four murals represent characters from Lewis Carroll's *Alice's Adventures in Wonderland*, specifically Alice, the Mad Hatter, the Queen of Hearts, and the Rabbit. The murals' placement along the subway platform highlights the movement already incorporated in their medium and design, and further connects them to the commuters and travelers who become their spectators.

The murals' incorporation of movement, both in their content and from the angle of the spectator, underscores the urbanity of these images. Porter inserts Alice and company into the classic nineteenth-century flâneuristic gaze. They evoke a preindustrial story (despite Carroll's writing in the height

Liliana Porter, *Alice: The Way Out*. Mosaic mural located at Fiftieth Street subway station, 1, 2 lines. Commissioned in 1994 and owned by MTA Arts for Transit. Reprinted with permission.

of English Victorian industrialization) where magic happens without any reliance on machines, rendering them doubly campy in their transposed context. The modernizing mechanism of urban rapid transit that frames them makes them simultaneously contemporary and anachronistic. Their physical location along the platforms of the IRT forces a postmodern self-consciousness of their perception. Just as Cortázar's story directly addresses the reader via second-person pronouns, Porter's murals impinge on and animate the viewers. As Rosalind Krauss reminds us, the wall as art's recognized and codified exhibition space has had a major role in structuring aesthetic discourse since the nineteenth century. If the salon, gallery, or museum began to offer walls as continuous surfaces for the exchange between artists, patrons, and viewers, then the walls of the underground transport network only exaggerate that continuity. According to Krauss, "aesthetic discourse resolves itself around a representation of the very space that grounds it institutionally" (1989, 288). While Malcolm Miles finds that much of the art in public transportation systems relates more "to the static spaces of stations than the ephemeral experiences of movement" (1997, 132), Porter's murals resist being bounded by the confines of their setting. In medium and mes-

sage, *Alice: The Way Out* ventures boldly into the complexities of movement. Porter exploits the incorporation of the transit system's public exhibition space into the murals to capitalize on movement, perspective and the intertextual relationship to travel.

The silhouetted figures "drawn" in blue with red highlights against the contrasting white background are positioned in movement, perhaps on their way out, skipping, hopping, jumping, or running with a bold and youthful gait. One of the murals pictures the Mad Hatter in the foreground, coattails flying as he runs after the Rabbit. The angular perspective on him from the bottom corner—leaning into his stride, knees bent, feet cut out of the picture—emphasizes his movement. As in a crowded subway scene, we see shoulders and coats and hats from behind but feet tend to be beneath our sight lines. The movement in these mosaic images is not motorized or mechanical, since the figures propel themselves without vehicles or transport systems. Nevertheless, they comment on the locomotion of mass transit as they intersect with the travelers who end up framing and entering their scenes.

A brief consideration of Porter's mosaics in their context of commuting and perceptual psychology illuminates the role of visual expression in urban experience. The medium chosen requires distance for viewing, and the murals' colors and composition not only accommodate that distance but also incorporate how to access the works given the movement of the subway.[14] The murals account for the fact that they will not only be viewed straight on from a standing position, as in a gallery, but from various angles and rates of movement. They are constructed for what E. H. Gombrich calls the "elusiveness of vision." Many viewers will experience the murals only peripherally, and according to Gombrich, "peripheral vision is extremely sketchy in the perception of shapes and colors but very responsive to movement" (1974, 206). Porter relies on stark color contrasts and large shapes so that viewers may grasp the images even while moving and through peripheral vision.

Travel and movement have become commonplaces of urban life, and recent studies that track the experience of urban movement in Latin America go beyond the demographics of regional migration and begin to consider the everyday practice of urban dislocations. One example is the study of travel in Mexico City and the urban imaginary by García Canclini and his collaborators Alejandro Castellanos and Ana Rosas Mantecón, documented in their book, *La ciudad de los viajeros*. The team presented participating groups with

photographs and film clips of streetscapes, highway labyrinths, and scenes of public transportation that frequently included street art. These examples of photographic documentation chronicle urban life through its intersection with art. The movement that these images capture—streetcars passing, demonstrators marching, workers commuting, lovers meeting—triggered responses from the participants regarding their own experiences of moving through city space. The images used in the study were pulled out of context, fragmented and isolated from their original works, but reintegrated into a sociopsychological consideration of commuting and intra-urban travel in the megalopolis. Their insistence on movement and newly configured fluidity is inconsistent with the static confines of a museum collection or the presumed fixity of the printed word.

One of the images from *Alice: The Way Out* merits particular attention in this exploration of writing on the walls because it turns the wall into a page and the pictorial representations into a book. Porter positions Alice grabbing the right edge of one of the murals where it curls up into a turning page. The Rabbit stands back, apprehensive; perhaps this is the way out, or a way leading deeper into the book's mysteries and the city's underground passages.[15] Here the visual catches up to the verbal intertext, transforming the ceramic tiles into paper, wordlessly writing a page, and inviting the spectator/traveler into its subsequent tales. Porter's work is known for her ironic quoting from literary texts, such as work by Jorge Luis Borges, intermixed with icons of popular culture.[16] Often she teases at collage, graphically reproducing shreds of text, their textures, and their shadows as if they were pasted onto the canvas. She isolates fragments of verbal text within the conventions of visual art. On the subway murals, however, she inverts this practice, making pages out of tiles such that literature can be read from a moving subway car in which Alice and the Rabbit, along with contemporary commuters, travel among its pages.

Porter's murals at the Fiftieth Street station are part of the Metropolitan Transit Authority's project called Arts for Transit, begun in the 1980s to clean up and beautify the subway spaces.[17] The Federal Transit Authority wants "good design and art" to help revitalize urban neighborhoods, "make patrons feel welcome," and ultimately "create liveable cities" (quoted in Miles 1997, 144, 146). In an essay on New York City, Malcolm Miles calls it "a city worthy of narration." The essay is accompanied by a photograph of a graffiti-covered subway car whose caption identifies it as "the very icon of 1970's New York" (52). This image is precisely what Arts for Tran-

Liliana Porter, *Alice: The Way Out*. Mosaic mural located at Fiftieth Street subway station, 1, 2 lines. Commissioned in 1994 and owned by MTA Arts for Transit. Reprinted with permission.

sit combats.[18] Miles bemoans the "clean up" of the last quarter of the century, mourning the loss of rough textures, grit, and pungency, and embraces the city in 2003 as it readjusts to the hard times of the current economy and post-September 11 terror.[19] Porter's mosaics may replace graffiti, but they inscribe the city with more stories by visually narrating on walls and through movement along with throngs of passengers who foreground and frame these images. Porter's mosaic murals feature not only the intersection of urban transportation and art (incorporating the people who move within and use the subway and the station's architecture) but also the integration among urban space, art, and literature. Carroll's wit, inventiveness, and playfulness do much more than brighten up the dim underground. As visual icons of verbal satire and metadiscursiveness, the figures of Alice and her gang underscore the written nature of urban space.[20] Porter's murals are both testimony to and invitations into the city as a narrative experience.

Writing, reading, painting, and moving in urban space are all practices of the city that contribute to its discourse, its grammar, its sociospatial functioning. Cortázar's "Graffiti" and Porter's *Alice: The Way Out* inscribe the

urban, and help write the city's text while they simultaneously contest it. As Certeau writes, "The language of power is in itself 'urbanizing,' but the city is left prey to contradictory movements that counterbalance and combine themselves outside the reach of panoptic power" (1984, 95). The communicating artists in "Graffiti" resist the censorship and state control of urban public space, while Alice and her companions in the mosaic murals skip off the tracks, outside the cars, resist the linearity of the system, and turn the station into a book, its walls into pages to be ventured into, turned, and read.

These two examples of urban expression illustrate—ekphrastically in the case of Cortázar's story and concretely in the case of Porter's murals—new and challenging dimensions of writing the city. A published verbal text that dramatizes a prohibitive, illegal, visual form of expression and a non-verbal visual text that animates a literary classic point out the hybrid and multi-textual nature of urban space in Latin American culture. The intertextual, interartistic relationships between Tàpies and Cortázar in the case of the short story "Graffiti," and between Porter and Carroll in the mosaics, further exploit the textualization of the city's spatial dimension. These works go beyond exemplifying the rich possibilities of a culture's aesthetic and symbolic elements through verbal and visual expression. They inscribe city space, affect the urban imagination and insist on an active engagement on the part of the reader/viewer. These texts mesh what is often considered "elite" or "high" literature with popular street expression, challenging the boundaries that supposedly distinguish them.

According to W. J. T. Mitchell, "all art is public art" (1990a, 4). Inquiries into public art have been defined traditionally by the "relation of beauty to bureaucracy" (2), and many critics would like to see public art spur more debate, generate critique, take on the structures of power and patronage that help inaugurate them. More than decoration and embellishment, art in public space should motivate "the activation in their users of a *reflective civilized consciousness*; of their being in a place shaped both to specific uses—learning, healing, debate, diplomacy, etc.—and to those general purposes beyond immediate utility, of the human project, which include the contemplation of matters of value, the pursuit of happiness, and a sense of well-being" (emphasis added; Gooding 1998, 19–20). To what extent critical messages and political opposition can be conveyed in public art depends not only on the artist but also on the mechanisms of funding, patronage, and

civic planning at a given site. Therefore, public art, or visual expression in public places (particularly in cities), is built on a paradox of opposition, wrestling between the freedom of aesthetic expression and the institutional and financial apparatuses of urban planning. While Mitchell locates public art outside the realm of galleries and museums, he cannot help but note this paradox. Although it appears to be independent of those institutional physical structures, public art "makes its way in the larger sphere of publicity—billboards, bumper stickers, postcards, and posters—yet it also seems, to use a loaded word, 'destined' to return to the gallery and museum" (1991, 438). Clearly the examples highlighted in this essay reflect the hybrid stories of their production—literary culture and its conventions in the case of Cortázar's text and the official financial backing of an urban arts institution in the case of Porter's mosaics—along with their *ars combinatoria* of the verbal and the visual.

Both texts considered here, as they underscore the paradoxes of urban institutionalization, have important implications for public space in the urban realm. Even García Canclini admits this potential, when he states that "los discursos literarios, artísticos y massmediáticos, además de documentos del imaginario compensatorio, sirven para registrar los dramas de la ciudad, de lo que en ella se pierde y se transforma" (literary, artistic and mass-media discourses not only document compensatory imagination, but also serve to register the city's dramas, what in the city is lost and transformed) (1995a, 78). The transformation of garage walls into canvases defies censorship, denounces political violence, and helps recuperate some of the loss; the transformation of underground passageways into fantastic adventures stretches the confines of industrial structures and incorporates the commuters into its movement. Porter's murals and Cortázar's story bypass the false dichotomy between "elite" and "popular" culture by initiating new uses for urban space. They question who controls urban spatial functions and propose their own rules about who may enter and interact with it. "Graffiti" identifies the consequences of infringement of those controls, and *Alice: The Way Out* blends literary figures into the commuting crowds. Cortázar's and Porter's works, in their reliance on both visual and verbal signs to a degree that puts the visual at the service of the verbal or vice versa, exemplify the opportunities for a productive synthesis, not only among different media, but also between the aesthetics and the politics of cultural production.

Notes

1 Both PMLA and *Journal of Latin American Cultural Studies* have hosted a variety of views concerning the evolution of cultural studies as a practice. Special issues of the journals devoted to the topic, numerous panels at academic conferences, and even scholarly books (Moreiras 2001, for example) have taken on these controversies as academic enterprises in their own right.

2 Translations are mine unless otherwise indicated.

3 Few readers are aware that García Canclini's first book, *Cortázar, una antropología poética* (1968), proposes a structuralist anthropological discussion of Cortázar's short fiction. His article in *South Atlantic Quarterly* on aesthetic theory surprisingly recognizes the political potential for art. He frames the discussion in his usual examples of museology and indigenous craft production but finally arrives at contemporary Latin American visual art, defending it against the "ahistorical metaphysics of a present without substance" and also against indigenistic nostalgia (1993, 442–43). Encompassing both "high" and "low" cultural manifestations, here he delivers a more fully interdisciplinary message than he usually allows.

4 "If hybridization is seen as coextensive with the market, consumer choice, and possessive individualism, then despite [García] Canclini's own protestations that his work is intended as a contribution to reformulating the project of the left, there is a sense in which it is also, in principle, compatible with globalization and neoliberal hegemony" (Beverley 1999, 129). Alberto Moreiras concurs, and in his discussion of hybridity (through which he critiques not only García Canclini's *Hybrid Cultures* but the impact of García Canclini's and others' work in this realm) notes that "the political force of hybridity . . . remains to a large extent contained within hegemonic politics." He goes as far as to call hybridity "a sort of ideological cover for capitalist reterritorialization" (2001, 264, 267).

5 Zamora's chapter in Boris Muñoz's and Silvia Spitta's volume on urban writing (2003) provides another example of how the visual and verbal intersect in Latin American urban culture.

6 See César Braga-Pinto's discussion of both Buarque and Veloso and their insertion into the literary canon: "It is well known that one of the peculiarities of Brazilian pop culture is that, at least since the 1960s, popular songs have enjoyed the status of literature. . . . What has characterized canonical popular music production in the last thirty years is precisely its relative mobility between high culture, on the one hand, and popular culture and mass production, on the other" (2000, 103).

7 This work was published in translation as *We Love Glenda So Much and Other Tales* in 1983.

8 The Barcelona branch of the Galerie Maeght's catalogue prints the story in a typewriter font over a reproduction of a Tàpies earthy, wall-like texture (Cortázar 1979). Another version appears in an art journal in Costa Rica, *Graphiti*, which

prints the story on a two-page spread, including a photograph of Cortázar and interspersed with drawings by the artist Otto Apuy (Cortázar 1993). Still another example, a limited edition from Switzerland, prints the story translated into French followed by twelve color photographs by Jean-Pierre Vorlet taken "of different walls from all over the world" (Cortázar 1984, n.p.).

9 The implementation and representation of materials and surfaces traditionally considered anti-aesthetic or even unseemly is fundamental to graffiti. Brassaï, for example, "believed that the rawness of the images was derived as much from the rough-hewn qualities of the deteriorating walls into which the graffiti were typically chiseled as from the crude qualities of the drawings themselves" (Tucker 1999, 94). Tàpies's urban primitivism furthers this collaboration of materials and design by restoring, uncovering, or breaking through the "walls" of contemporary urban existence: "Tàpies llegaba para abrir, en aquella tradición tan extendida, no una ventana tradicional, sino una brecha en el muro" (Tàpies came to open up, in a long-standing tradition, not a traditional window, but a break through the wall) (Guilbaut 1992, 33).

10 Tàpies's canvases present equally disturbing, potentially brutal images in their textures, such as scratches, boot marks, indentations, and gashes.

11 See W. J. T. Mitchell's "The Violence of Public Art" for a discussion of the associations between public art and violence. Here he considers the frequent vandalism suffered by public art as well as representations of violence in public art, stating that rather than an abstract notion of violence, public art seems "encoded" with violence in its very practice and conception (1990b, 888). He outlines three forms of violence in public images, all of which coincide with "Graffiti": the image suffering demolition (in the story, the whitewashing of graffiti by the police), the image as a weapon (in the story's case, an act of resistance), and the image representing violence (the last drawing in the protagonists' exchange, which depicts a face after a beating).

12 Tàpies himself refers to prehistoric drawings and African masks along with the mention of graffiti in what for him were essential connections between modernity and primitivism (from *Por un arte moderno y progresista*; qtd. in Borja-Villel 1992, 23–24).

13 Brassaï considers the complicated role of those hired to erase or deface graffiti, and photographs the rather hieroglyphic results of black spray paint or brush strokes covering the graffiti artists' words (Brassaï 1993, 20).

14 Gombrich discusses mosaics in his treatment of still images captured by the moving eye: "The medium does not permit smooth transitions and makes it impossible to show objects smaller than the smallest tessera at the disposal of the craftsman. Go too near and you will no longer see what you are meant to see but rather individual patches" (1974, 191).

15 It is interesting to note that the original title of Carroll's book was "Alice's Adventures Underground" (1960, 44 n. 7).

16 A recent retrospective exhibition of Porter's work was titled, "Liliana Porter: Fotografía y ficción." In the catalogue of the same name, many of the essays refer to the literary associations in her work, such as those to Borges and Carroll. The essay by Mercedes MacDonnell, "The Sphinx's Suicide: Literature, Dream and Enigma in Liliana Porter's Photographs," discusses Porter's reliance on images and citations from Borges, her affinity with Wallace Stevens, and her Alice motif (MacDonnell 2003, 203–5). MacDonnell notes the dream-like unreality Porter achieves in her photographs of everyday objects, rendering them enigmatic and offering the viewer an experience of both irony and vertigo: "Porter puts the viewer in a state similar to that which a certain English girl named Alice might have experienced. . . . It is curiosity that leads Alice to chase the rabbit, the same curiosity that leads the viewer of Porter's pieces" (203).

17 In 1981 the MTA established a program of refurbishment for the subway system. The Arts for Transit office emerged in 1985 to coordinate the installation of permanent art and the organization of periodic exhibits and performances, with funds totaling 1 percent of the station upgrading costs (in accordance with the Percent for Art policy for public works). See Miles 1997, chap. 6.

18 In the process of securing permission to reproduce photographs of Porter's murals for this book, I noticed some very telling hesitation on the part of permissions-desk staff at the Arts for Transit office. When I explained that the article was about graffiti, red flags went up and a much more concerned investigation into exactly what I was doing ensued. I was quite surprised to find that my chapter here might cause some controversy, but came to understand why Cortazar's story, indirectly, provoked a new response. I thank the Arts for Transit office for their consideration, which included a careful reading of a draft of this chapter, and for granting permission to reproduce these images.

19 "Urbanism isn't always pretty. But the broken porticoes and cracked pavements, the walls of garbage and zaftig rats, the constant recall, ironically or otherwise, of the city that scared us and made us–this is the stuff of true New York stories" (Miles 1997, 53).

20 MacDonnell finds that the objects, toys, and images that Porter portrays are "representing their own representation. . . . In Porter's work, the viewer looks at looking and, at the same time, is looked at" (MacDonnell 2003, 203).

Miami Remake / *José Quiroga*

Surfaces tended to dissolve here.
—Joan Didion, *Miami*

In the 1980s, Miami stopped being the comic interlude of a narrative that took place elsewhere, and was able to muster a narrative arc of its own. The narrative could lead to other sites, and other histories, because there was something about Miami that was never quite anchored, rooted, native-born; a "foreignness" was affixed to every description of the city as a whole. This was not simply the foreignness of an ethnic enclave that changes certain city zones, but rather the decisive intervention of the foreign within the very structure of the city. And what was interesting in the 1980s was precisely that the more "foreign" the city became, the more "American" it was. It was an American city because it was a foreign city, because something of the new borders of America was being played out there—very visibly in terms of bodies, but also behind everybody's back in terms of the real estate deals, the money that changed hands as fast as it could be acquired. Visitors to Miami from the literary or the filmic worlds approached it as a kind of mystery waiting to be deciphered, with a somewhat difficult foreignness that needed to be curtailed by a decisively external intervention that could explain it for native consumption, where *native* refers to the broader United States. Brian De Palma's film *Scarface* (1983), with a script by Oliver Stone, as well as Joan Didion's *Miami* (1987) tried to decipher this relation between the visible and the invisible at a particular juncture in the city's history. Their

works bracket the decade of the 1980s from two different angles: *Scarface* is the moral parable of a subject corrupted by a system, while Didion explores a system corrupted by causes too complex to mention in one sentence. *Scarface* decisively registered a changing perception of the American dream, and its afterlife as a cult film for the hip-hop generation only heightened the sense of irony the future was to have against those previously unquestioned ideals of upward mobility, sacrifice, and freedom that had always been the mantra of the Cuban exiles. Didion's book-length essay engages the loss of those ideals by trying to decipher the codes of a site that has become an enigma. And at the center of both Didion's and Stone's tales, the very foreignness of the city called *Miami* turns the political narrative upside down: from uplift to consumption; from the social model of the melting pot to the dystopian horrors of not keeping the borders securely locked in order for a "domesticated" difference to blossom, with economic prosperity for all.

For Cubans—those quintessential and paradigmatic newcomers who are the protagonists of these narratives, Miami had already become a code of its own well before the 1980s. It offered a middle-class success story advertised in the *Diario Las Américas*, or even *El Sol de Hialeah*, as a way of lending epistemological reality to the varied events of a social life replete with religious feasts, national commemorations (Cuban and U.S.), anniversaries, debutante balls, and civic functions. Miami was the beacon of freedom for those Cubans who left the island in the 1960s, and then again for those who left during the Mariel exodus that serves as the backdrop to *Scarface*. And one could argue that even *Scarface* and *Miami* did not make a dent in that perception decades later, when the community argued that the child Elián González should remain in the immigrant center of the Cuban enclave.[1]

But when Miami became something other than a temporary city for transient immigrants in the 1980s, the difference was palpable and significant. The city by then had a narrative and a history—with a sense of continuity all of its own.[2] The written word created what Benedict Anderson has termed an "imagined community," one bound by certain "commonalities of feeling," or affect. For Cuban exiles before 1980, the Miami narrative was invested principally in the return (to the island), but it never lost sight of recording what happened in the meantime, and of controlling how *la lucha* or "the struggle" was represented as something bigger than just simply the opposition to a dictatorship. The U.S. government supported, even created, this narrative of the model immigrant community for the benefit of Cubans on the island, and for the benefit of all Latin Americans.[3] And that model nar-

"Colony Hotel, South Beach, Miami." Photograph. Copyright Ciudad/City: Territorio para la innovación. Bilbao, Spain. Printed with permission.

rative was meant to show that Cubans, under a different system, could be much more prosperous and successful.

In the 1960s and 1970s money flowed through Miami, and government largesse was not simply the result of aid to those "refugees" who actually exported much of the internal opposition the Cuban Revolution encountered during its first decade. It was also money that influenced political positions and controlled, surveyed, and regimented political action. The Miami community was living in a very specific circumstance within very specific times— a Communist revolution and an alliance with the U.S.S.R. in the midst of the Cold War—and the situation demanded close surveillance on all sides. From the 1960s on, espionage undercut identity: Cuban Americans were not

simply an opposition, but a violent opposition fashioned, elaborated, and then betrayed in the U.S.-led Bay of Pigs invasion. Espionage rendered identity performative: exemplary tales of Cuban loyalty were always contingent, always partial, always the subject of some higher power pulling the strings in one way or another.[4] Cubans lived the American dream but they also were the first minority to underscore the contingency behind the sense of agency. If they understood how they were welcomed with open arms, at the same time (and since the Bay of Pigs), they could also understand that this privileged status would end in some form of betrayal the moment their interests might fail to coincide with those of the U.S. government. For while the government and the media created the narrative, they also provided the means to undercut it. Cubans were hard-working, but they were also crazy; they escaped Communism but they knew nothing of how politics was carried out; they established networks of mutual aid and support, but these were also seen as relics of some prepolitical time when rabid passions ruled. Thus, there were no tears shed in the broader community for Cubans' lost lives, lost property, sense of oppression, or victimization. In the 1980s the pain of Cuban exile became the tale told by an idiot (to borrow from Shakespeare); it was a perverse thread that bred the idea that something was out of joint, something sinister.

1

I am working with an Anti-Castro group. . . . I am an organizer,
and I get a lot of political contributions. — Tony Montana, *Scarface*

"How do you construct the history of this place?" Joan Didion asks in *Miami*, her account of her visits there in the early 1980s. Brian De Palma's *Scarface* impertinently asked the same question. The California rootlessness that Didion explored in her collection of essays *The White Album* (1979) is not an issue here, for *Miami* is no narrative of an east-west passage. The narrative here is compressed to a short flight from Havana or Managua to Miami. This compression accounts for the sense that there had been no time for history—that the swamp spontaneously became a city, while the aquifer on which it rests still rendered it a kind of lacustral, floating entity.

Between *Scarface* and *Miami* a new history would be constructed for the city as well as for Cuban Americans. These two cultural products of the 1980s registered the broader community's fascination with the city as an alien

entity, and they in turn cemented the transformation of Miami into a *site*. Didion and De Palma and Stone came to look at the city and endeavored to give cultural meaning and density to what had been a rather sleepy town in a context that was also producing other cultural artifacts related to Miami: the television series *Miami Vice*, the rise of the Gloria and Emilio Estefan empire, the transformation of Miami Beach into a hip urban enclave, David Rieff's book *Going to Miami: Exiles, Tourists, and Refugees in the New America* (1987), John Sayles's novel *Los Gusanos*, and so on. But De Palma (with Stone) and Didion provide the bookends to this period in two opposite and opposing ways. One, a film that became an instant classic of excess at all levels: heightened violence, epic length, cocaine politics, over-the-top acting. The other, a work of serious literature by a member of the literary establishment—an essay that purported to deal with the situation of the city in the dispassionate manner of one who was not privy to the disputes at hand. As befitted a city poised between the modern tale of survival and the postmodern tale of culture, a film and an essay became the decisive interventions of outsiders, who were now forced to deal with an American city they could not recognize as such.

Neither Didion, nor Stone and De Palma had affective links to the city in which they decided to place their tales, and both felt the angry retribution of the community they chose to represent. Didion wanted to capture what she felt was the grounding element in the Central American wars—their point of origin—while *Scarface* was a film about the American dream and its intersection with foreign policy. The two narratives were projected onto what had been a model immigrant enclave—a situation that soon changed partly because of the Didion-Stone-De Palma intervention, but mostly because of Cuban exiles' complicity in the Central American wars of the 1980s. The Central American situation was in many ways the proxy for what a failed Bay of Pigs invasion never delivered, just as Miami and the Cubans became the proxy for U.S. battles fought elsewhere.

Sidney Lumet convinced Stone to reconsider his rejection of an update to a Howard Hawks film, and to transform it into a piece on contemporary Miami. The classic gangster film from the 1930s was called *Scarface: The Shame of a Nation*, and it was loosely based on Al Capone's career. Instead of Al Capone, the new film would have a Cuban character, and it would explore the drug milieu.[5] Stone, at the time battling his own addiction to cocaine, was instantly sold on the idea.[6] Stone, however, did not simply create a tale of addiction; he imbued it with a political mission and message. He felt he

could trace an arc between Miami, El Salvador, and Nicaragua. At first he did not understand his own intuition, but "years later the threads came together because of the connection between coke and the contra trade." Drugs were financing political operations, while at the same time those same drugs took their toll on U.S. citizens. For De Palma, who at that point was interested in filming a remake of *The Treasure of the Sierra Madre* with cocaine trafficking at the center, the material instantly made sense: "It was sort of a modern metaphor for Sierra Madre, where cocaine becomes gold and it's the American dream gone crazy. You have this product that you can turn into millions of dollars, but in the process you destroy your life." In fact, De Palma admitted to his total disconnection with the question of Cuba or of Cuban cocaine trafficking, and was much more interested in focusing on the characters themselves: "I knew nothing about the Cuban cocaine trade at all. I knew nothing about dealing in an epic, dramatic movie with all kinds of elaborate, exotic character types. *Scarface* is basically about the relationship of a series of characters over a period of time, a saga, and I had never made a movie like that in my career."

Of course, Stone did create the saga of an immigrant who becomes corrupted by the American dream, and De Palma filmed it in a way that turned the predictable realism found in gangster films into an exercise in mannered excess. As Tony Montana becomes more and more involved in the drug trade, the film visually leaves aside the immigrant narrative in order to focus on the deadpan visions of one who needs more elaborate sets, wardrobes, and guns in order to compensate for the lack of "affect" felt after consuming gram after gram of cocaine. At the same time, De Palma and Stone do not simply give us the account of the corruption of the American dream, but point out that the dream itself is a corrupting influence—the real crime in itself, one which prevents people from fitting into a socialist state (Cuba) that insists on fashioning a different kind of utopia. Tony was a political "undesirable" in Cuba, but he is also a political undesirable in the United States, and thus is placed in a detention camp. There, a drug dealer named Frank López recruits him to murder a Castro loyalist who had joined the Mariel exodus. The detention camp is already a kind of insular space away from the island— a version of Cuba in a different territory where Cuban debts still need to be settled and paid in spite of the political history that has placed these characters on "this" side of the ninety miles that separate the island from the United States. This is the defining moment when Tony's undesirability becomes individualized. He becomes an undesirable element everywhere,

in all political systems, and under two different flags. As he begins his ascent within the hierarchies of Miami's cocaine underworld, other versions of the American dream (most notably, his family's) become corrupted by Tony's example, to varying degrees. Tony corrupts his sister Gina, but not his mother, who throws him out of the house for his involvement in the drug trade. And his friendship with his best buddy, Manny, also suffers as Tony attempts, like his mother, to separate two worlds that he does not want to bring in contact with each other: his family's pursuit of freedom and economic security, and the drug trade that offers a shortcut to the attainment of that dream. Ultimately, what Stone wants to expose is the way in which cocaine corrupts the narrative of uplift. If wealth and power are the ultimate goals, the immigrant tale loses the purity of sanctified narrative, for there are no clear and definitive borders to corruption.

Scarface becomes, then, the mirror for what happens when the ordered separation between different realms is shown to be an illusion unsustainable at this point in time. Cocaine crosses all borders; it becomes the one significant phantom proxy for a city in the liminal space between north and south, where all politics seem international, defying geographical as well as psychic boundaries. Cocaine substitutes for political opposition, and then it trumps politics. At the outset of the film, Tony Montana expresses his notion that political opposition could render him different from the others in the internment camp, but we soon realize that the agenda of politics is but a minor chapter in a bigger agenda that is ruled by cocaine. In other words, as a political story, Scarface becomes a morality tale, representing the drug trade as the result of the absence of politics. No political stance can be taken by Scarface, once the cocaine trade comes into the picture. To have remade the original Scarface in the context of the Mariel exodus would have entailed placing blame either on the system that produced Tony Montana (Cuba) or on the system that corrupted him (the United States). Instead, cocaine manages to circulate around the film in order to crush all other possible meanings. The Cuban story is not universalized, but the corrupting influence of cocaine surely can be. This is the allure that beckons through De Palma's gaudy stylization placed upon a city that in itself seems to beckon other people's projections and other people's ideas. Stone and De Palma turned cocaine into a signifier that could move beyond politics while at the same time giving a significant twist to the tale of the model immigrant community. Cocaine corrupts political agency, but it also corrupts political ideology. And in this case, it corrupts the history of the model community that

left Cuba because of its political opposition to a regime. Political opposition in itself is flattened, rendered a useless nostalgic memento when the transition from politics to cocaine leads to a narrative of no return, similar to the chemical process that turns coca into cocaine. This is the most important political narrative in the film, and it is precisely what turns the film into an important historical object in the representations of Miami, as well as in the histories of the Cuban community within it.

The use of cocaine and the drug wars to represent political opposition to the Cuban Revolution altered exile politics. Model immigrants or model exiles, no matter their origin, never quite continue being models after the original situation that spawned their exile has lost its urgency. But the shift from politics to drugs registered in these cultural products about Cuban exiles per se is also symptomatic of broader changes in exile politics happening at more or less the same time, with consequences that are still felt today. Conflicting loyalties dominate both politics and representations of identity among postrevolutionary Cubans. As María Cristina García humorously recalls, there was a popular joke circulated in Miami during the 1960s: "If you put two Cubans in a room with a political problem to solve, they would come up with three organizations" (1996, 130–31). Cubans themselves joked about the *industria de la revolución* that created organized factions whenever and wherever Cubans settled. Some of these organizations were on the U.S. government payroll, like the Cuban Revolutionary Council. The Junta Revolucionaria de Liberación Nacional, on the other hand, tried to organize yet another, failed, invasion (García 1996, 131), while the Asociación de Magistrados Cubanos en el Exilio went as far as organizing a government in exile. Still another revolutionary group set off from Puerto Rico on an invasion of Cuba but were intercepted by a British destroyer in the Bahamas. In the early years of Cubans' encounters with Miami, the political narrative defined the community. There were even attempts to organize exile organizations among themselves, as in the far-ranging plan devised by Jose "Pepín" Bosch of the Bacardi rum company, who polled more than 75,000 exiles and asked them to choose the leaders of a new exile government that would make a common front to topple the revolution.

These groups modeled themselves on the very same notion of struggle that Fidel Castro had himself copied partly from José Martí. At least since the early nineteenth century, there has been a long tradition of Cubans escaping to the United States and organizing themselves in order to bring change to despotic Cuban regimes, and the Cuban bourgeoisie who collaborated in

this venture were simply following historical example. The failure of these attempts was due in no small part to U.S. interference, but also to the collectivized nature that the Cuban Revolution almost instantly assumed, with massive educational, medical, and social programs that became the public face of an increasingly politically and economically repressive regime. It was clear by the early 1970s that Cuba had become "Sovietized" and that no change could be expected from within, for the moment. The United States had cornered itself into a losing position, while the Cuban exiles were debating violently as to the direction that la lucha would take. From 1973 to 1976, more than one hundred bombs exploded in the Miami area (García 1996, 141). And when Cuba was sending troops to Africa in 1976, the exiles exploded a bomb at the Cuban mission at the United Nations and attempted to kidnap the Cuban consul in Mérida, Mexico. Exiles exploded a bomb at the Cubana Airlines office in Panama, and they executed the infamous bombing of a Cuban jet after it left Barbados, killing all seventy-three passengers on board. None of these activities could have taken place without a well-trained force of mercenaries that had initially been on the U.S. government payroll. The exiled Cubans were so effective that the Chilean state police hired them to kill the Chilean ambassador Orlando Letelier in Washington. And let us recall that three of the Watergate burglars—Bernard Barker, Virgilio González, and Eugenio Martínez—turned out to be Cuban exiles that had some sort of relationship with the U.S. Central Intelligence Agency (García 1996, 141–43).

This is the kind of violence (mostly political and, according to the George W. Bush doctrine, terrorist) that the producer Martin Bregman had in mind when he decided to sponsor the update to the classic *Scarface*. But even then, the effects of the violent context of the 1970s entered a new stage with the start of the Ronald Reagan administration. Cuban exiles decided to take the struggle out of Miami and directly to Washington. After the two sides faced each other in the Mariel exodus, the Cuban American National Foundation (CANF) was established by Jorge Mas Canosa in 1981—perhaps one of the more successful organizations any exile or immigrant group has created in the United States. It launched a political action committee, the Free Cuba PAC, modeled after Jewish lobbying groups, and it argued successfully for the creation of Radio Martí and then for TV Martí.

The sheer visibility of the CANF already spoke of important changes that had taken place in the Cuban American community. People no longer risked their lives trying to invade Cuba from the keys in the Bahamas. The CANF

was successful because it had a financial base, and that financial base spoke of a realistic understanding that policies and politics regarding Cuba originated in Washington and not in Miami or in Havana. It was time for Cuban Americans to decisively join the U.S. political system in order to achieve any degree of success. The CANF pressured the U.S. government to maintain, and even tighten, the embargo against Cuba, while at the same time it urged the Cuban exiles on the radical Right to support its positions in spite of the fact that political discourse in Florida was losing its militancy overall. The model community attempted to regain some of the political luster that it had lost with its internal squabbles, and it understood that it had to appeal to Washington as the guarantor of its demands. Going to Washington represented a step in the "right" direction. But at the same time it entailed a loss of independence. Washington had committed to not attacking Cuba after the missile crisis, and the federal government consistently impeded attempts at invasion.

Political espionage, and not cocaine, was paramount in Miami's exile community. This became evident with the fracas that ensued in the summer of 1982, when De Palma wanted to move to South Florida to start shooting *Scarface* in October. The city commissioner Demetrio Pérez Jr. threatened to ban De Palma's shooting in Miami unless he turned Tony Montana into a communist spy sent by Fidel Castro to undermine Cuban and U.S. society. This confrontation occurred in a context in which political, social, and ethnic minorities were increasingly sensitive to the treatment given to them by mainstream Hollywood films that cast a sensationalist eye on the "hidden life" of their communities. Minorities were being represented, but—as with *Cruising* (1980), a film in which Pacino plays a detective who goes undercover in order to explore the male gay leather scene—sensibilities were heightened due to negative representations. With *Scarface*, the final agreement was that a minimum amount of footage would be shot in South Florida while the official shooting location would be Los Angeles. Also, the film was screened early for Cuban American leaders, who ultimately tagged the film with a disclaimer. Visually, the Miami seen in *Scarface* is a composite of different migrant communities and scenarios. The internment camp under the freeway where Tony Montana is first seen was staged under the Santa Monica and Harbor freeways, and the extras (many of whom actually spoke only Spanish) were presumably Central Americans, and not Cubans, given the fact that Mexicans are far more numerous in California. Tony Montana's Little Havana sidewalk cafeteria was actually shot in Little Tokyo, with the

production changing the storefront signs and billboards from Japanese to Spanish. Tony's mansion in Coral Gables was actually an estate near Santa Barbara once owned by the German writer Thomas Mann, and another home in California also served as the villa for the Bolivian drug lord Alejandro Sosa.

Tony Montana is placed at a curious juncture in the life of the city, precisely when the exemplary narrative of exile has become unglued, and the question of espionage starts morphing into the issue of drugs. The injunction against filming in Miami actually rendered the whole situation much more abstract. The injunction not to film—which in many ways meant "you cannot see" or "you cannot represent"—is the first step in what would be the prime narrative of Miami: a city that is neither known nor unknown, but rather a canvas, a projection, a kind of abstract topography.

With Hollywood's narrative line about Cubans in Miami so clearly developed, there is really nothing left to chance in *Scarface*. Consequently, in fashioning its injunction against this project in particular, the community relegated itself to a secondary status in the representation of its own tale. From now on, Cubans forfeited their own representation for the sake of allowing or not allowing others to represent them. Surveillance became not simply something that could be done internally and in order to decide who belonged and who did not belong to the community, but rather, it was conducted externally, determining how the community would be represented via those others who came to fashion a morality tale out of the community's history. Cubans' symbolic capital suffered as a result, for *Scarface* turned narrative and personal history into culture, and thus cemented what would later be called the "Latin Americanization" of Miami. Now only outsiders were capable of connecting the dots that turned political capital into a product for popular consumption, with Cubans left to be the subjects represented, as well as to police those representations. As a result of *Scarface*, and in order to resist the negative stereotypes in American media at this time, Cubans founded in Miami Facts about Cuban Exiles (FACE) in 1982: "Like the NAACP [National Association for the Advancement of Colored People], LULAC [League of United Latin American Citizens], and other minority rights groups, FACE's goal was to educate Americans about the emigré community through conferences and publications and to celebrate Cubans' accomplishments" (García 1996, 78). Prior to the founding of FACE, there was already a desperate situation produced by the bad publicity surrounding Cuban exiles. Over time, and as a result of processes that came to the forefront during the *Scar-*

face production, Cubans became the minority that it was politically correct to defy. They constituted a minority with political power and money, which had seemingly ransacked a whole city and was threatening sacrosanct American values by exercising undue influence upon a government in Washington that had been, after all, freely elected by the people and for the people.

2

To spend time in Miami is to acquire a certain fluency in cognitive dissonance.
—Joan Didion, *Miami*

Joan Didion walks hallways so empty that the reader can feel the vibrations of her high-heel pumps on the floor: "I recall walking one October evening through the marble lobby of what was then the Pavillon Hotel. . . . I could hear my heels clicking on the marble. I could hear the young woman in the black taffeta dinner dress drumming her lacquered fingernails on the table at which she sat. It occurred to me that she and I might be the only people in the great empty skyline itself" (1987, 28). She goes one evening to a "virtually empty restaurant on top of a virtually empty condominium off Biscayne Boulevard" (37). In this world, women dress "in silk shirts and Chanel necklaces and Charles Jourdain suede pumps" (33), and the narrator is our intermediary in the running tensions between Anglos and Cubans living side by side and interacting in one city that was actually two separate cities. Here, Miami becomes a sort of double-headed entity living at the breaking point of dialectics, where "surfaces tended to dissolve" and one always had to watch out for "the unloosing of furies still only provisionally contained" (36, 147). These furies—with their undercurrent of Greek drama, of unresolved family disputes—are ethnic, racial, and class-related, but more importantly, they are the result of an interplay of secret and very public political narratives. Assuming a persona in line with the city itself, Didion presents herself as the female enigma arriving at the enigmatic city itself. The image is all the more apt in that Miami is a city where one does not walk to places, nor encounter large groups of people; it is a place where the absence of collective meeting places or of collective sites of gathering is all the more significant. The city, she says, is not exactly "an American city as American cities have until recently been understood," but rather "a tropical capital: long on rumor, short on memory, overbuilt on the chimera of runaway money." For Didion, the

dialectical tale allows the different elements to coincide, to live side by side, touching and not touching each other.

Miami moves back and forth in time, because time itself is one of the undercurrents to the tale. The book provides a quite vague sense of the order of experience. Readers cannot really track Didion's moves, because she erases them all the time, distancing her text from the genre of travel narrative. She does not reconstruct the itinerary of her journeys, and the reader has very little access to the nature of her encounters with the city. She describes, "the time I began spending time there" and "my first visits to Miami" (26–27), not about the time she lived there, because Miami is opposed to California, the other movable platform in terms of her lived experience. The subject here is a filter that does not so much mobilize circumstance, as see in it a mystery waiting to be deciphered.

This perception of time as something "spent" is also related to the geographical dispersal of empire, which is also partly Didion's theme: Miami as the spatial shorthand for a history of interventions, invasions, and wrongful policies. Thus, the sense of time turns Miami into a place where one can write the history of the American empire in the twentieth century. It starts in Woodlawn Cemetery, where the empire buried some of its dead, and this very concrete space is disaggregated into memoranda, government notes, history consumed within the paper trail of empire. Didion remarks on how newspapers from Bogotá are read during the airline flight into the city, and she constructs a web that links Washington, Santiago, Havana, and Managua. The crisscrossing of space that pertains to travel literature is not the point here, but rather the disjunction between the perceptible, the epistemological, and then the ontological quality of things. Even this space is purely geographical, a space of interiority paradoxically created by the U.S. press accounts of the Central American wars, the Cuban connection, and Miami.

There is no map for the city in Didion's book other than the map of a political history. As such, her work is not about a physical map but rather a psychic one. One need not map a city in which one is constantly located on a grid, in which one is constantly measured by coordinates, from northeast to southwest, with avenues intersecting streets. Didion's city is built on unstable soil, and it was so particularly during the Reagan years, when the encounter between Latin America, the Contras, and Washington was taking place there. No literature has read the spaces where Didion walks—

these spaces are not "literary"; they have no history. There is a contemporary feel to her historical sources. She gathers this history from newspaper clippings and interviews; it is composed of memoranda, pieces of paper that bureaucracy leaves behind. The sources are neither antique nor illustrious, for Miami is built in this semi-solid aquifer that, to Didion, resembles a movable platform.

"Time spent" in Miami is a composite. Didion reads the newspaper most every day; she goes to a Miami Dolphins' game with her husband and Gene Miller, a *Miami Herald* editor; she speaks with Bernardo Benes at his house in Biscayne Bay one afternoon; and she heeds the warnings of her friends: "On my first visits to Miami I was always being told that there were places I should not go. There were things I should and should not do" (39). The city was a place, but a place through which ran a network: "Nothing about Miami was exactly fixed, or hard. Hard consonants were missing from the local speech patterns, in English as well as in Spanish. Local money tended to move on hydraulic verbs: when it was not being washed it was being diverted, or channeled through Mexico, or turned off in Washington" (31–32). These networks have other nodes: Havana, Managua, Grenada, among others. From the vantage point of insular Miami, however, the rest of the world is equally insular, those islands where the other continent and the tropical nightmares could be visualized as a panorama.

Miami was born out of the strange effects of class. Didion understands this particularly in terms of language—it was certainly uncanny to feel that the other language was not confined to the periphery, but rather was present at the highest levels of civic life. Didion famously remarked that in Los Angeles Spanish was the language one could hear as if in a whisper, while one could not avoid hearing Spanish in Miami for it was screamed, shouted, in the most fashionable places. Ultimately, the presence of this language in these settings accounted for the sense of strangeness and dissolution that Didion felt in the city. The cognitive dissonance that produces transparent relationships between site, history, and language had suffered a severe blow in this process. Miami could allow for a different understanding of U.S. history on two fronts: it could conceivably recast U.S. history in a different language, and it could allow for a different history to be told—not along an east-west axis, but rather on a north-south one.

Didion's book, in many ways, is about the loss of historical certainties caused by the transformation of a country into an empire. In the present tense of empire there is no past other than nostalgic imperial memoranda.

There is no tragedy in U.S. interventions in its neighboring countries to the south, but also no resolution in *Miami* to the problems expressed by this situation. And the mirror which reflects the subject can only give back its own distortion at this particular moment in time. Cubans were part of a narrative, and they seemed to control its effects, but they were also, partly, those who had been fooled into believing that the history of empire could be malleable, and could be transformed at will. They had illusions, those Cubans, and the sense of betrayal they felt turned them into one more casualty of the transformation of government into empire. Framed in this manner, their very real accomplishments were those of precocious children who still could not understand the true meaning of what they could only imagine as a deep sense of loss.

3

That there was in Miami under the Reagan administration 'nothing' going on was something said to me by many exiles, virtually all of whom spoke as if this 'nothing,' . . . might be only temporary suspension, an intermission of uncertain duration in an otherwise familiar production. —Joan Didion, *Miami*

For a community that can never quite shake off the notion of its own transitoriness, everything is a moment of suspension unless it is a "definitive" moment—like the Bay of Pigs, the Mariel exodus, the *balsero* crisis in the 1990s,[7] the legal disputes over the child Elián González, or Fidel Castro's relinquishing of power to his brother Raúl as a result of illness. The time between these moments is, thus, empty time, the space of psychoanalytic work where nothing seems to be going on though something definitely is. *Scarface* and *Miami* signal the turn from the politics of the Cold War to cocaine politics, but they also propel the narrative toward the time when Miami ceases to be a Cuban city and becomes instead the "Latin" city par excellence. One recalls with nostalgia the gruesome scene that takes place in Miami Beach where Tony Montana is sent to pick up cocaine (called "yeyo" in the movie) from a Colombian couple and ends up witnessing his buddy Angel's dismemberment with a chainsaw inside a hotel bathroom, while Manny and his other buddy Chi Chi wait outside in a convertible, taking in the scene of a Miami Beach that has not yet become the gay design mecca it will be in the 1990s. That was one of those moments when "nothing" was going on, but when one could anticipate the future. The Miami Beach pictured here is

still a relatively laid back space, with rest homes for old people and small hotels with porches and rocking chairs. The outside space is in marked contrast with the kinds of changes we are witnessing inside the hotel room: the Colombian drug cartel acting within this relatively serene space. In the coming decade, this was all to change, as Miami Beach became the flashy hotspot with the constructed blandness of fashion photo shoots.

The Reagan years fashioned Miami into a place that one knew little about, but about which one knew everything there was to know, without even reading about it. This was a history of politics and intrigue, notably different from the story told in George Yúdice's *The Expediency of Culture: Uses of Culture in the Global Era*. Yúdice argues that corporate sponsorships in the age of globalization have now occupied the space left empty by the narratives of espionage and cocaine in Miami. Politics and illegality have given way to an amorphous "culture industry," that allows Yúdice to understand Miami as the city of record deals and of other consumer products that blend culture and merchandising. This new image of Miami sells an idea of culture that is really all about commerce. In this new Miami, the polemics of *Scarface* take a back seat to the kind of "cool" that *Scarface* represents for the hip-hop world. The realm of the political is confined to the presence of the Cuban American community and its distaste for the revolution and Fidel Castro. Thus, one can sense the end of the "Cubanization" of Miami, as the new Latin American "feel" of Miami begins to free the city from its provincial obsession with Fidel.

The new metamorphosis of the city began with *Scarface* and *Miami*, two accounts of the city in the 1980s. Cubans and Cuban Americans served as a backdrop to these projects. They were the point of origin for the "Latin Americanization" of Miami. But at the same time, they mark the end of the representation of the model community. This ending took place during that time when "nothing happened," when the Colombian cartel and the Contra wars led to the banking crises in Argentina and Mexico, and later to the influx of Venezuelan middle and professional classes. The two projects stand on related sides of the cultural field: the film registers the narrative of corruption that develops when the American dream is shown to be contingent upon politics; the essay registers the loss of language with which one could explain history as well as the present.

Both *Scarface* and *Miami* are part of a broader canvas, and perhaps the most important message they communicate is that only those foreign to Miami can connect the dots in order to assemble a coherent image of the city. For

"Calle Gervasio, Malecón, Habana." Photograph. Copyright Ciudad/City: Territorio para la innovación. Bilbao, Spain. Printed with permission.

all views created from within the city give us a partial account of what actually takes place there. Even if this is true of many cities and many locales, with Miami the only privileged position is that of outsider, for insiders are always already perceived as being *biased*. In a sense, *Miami* and *Scarface* both represent the devolution of the city: the fact that from now on only the outsider could be within the community but at the same time dispassionate about it, in order to be able to read it "correctly." No native intellectual is entrusted to this work—or rather, the native intellectuals were consigned, if not to the category of local color, at least to the place reserved for one of the sides of a warring dispute. The internationalization or even Latin Americanization of Miami was predicated not only on the Cuban histories of the Cold War, but also on the loss of status of the model community, on the fact that it could not be trusted to recount its own narrative, and that from now on Cubans would be in the position of either validating what was said about them, or approving the message for external consumption. In deference to their historical prestige and anteriority, Cubans now became the community that one could write about, while repeating the story that Miami was a "copy" of Havana, or that Cubans had "recreated" their native land in the

United States. These statements are true only to the extent that they signal Miami as a product to be consumed—even if at your own peril, for Tony Montana's tale was also a morality tale about consumption run amok.

In this narrative, the cultural consumption of Miami from now on would repeat a given script with a total disregard for what the script actually meant. Miami, for the Cubans who settled there in the early 1960s, was never meant to be a copy of Havana. It was never intended to provide a symmetrical counterpoint to Havana; it certainly did not build itself a Malecón seawall, nor is there a Morro Castle made of foam. For real simulacra one must go north, to Walt Disney World, and gawk at the carbon copies assembled there from major cities in the world. The relationship between Miami and Havana is not one of mimicry, but one of *translation*. In Walter Benjamin's words, "all translation is only a somewhat provisional way of coming to terms with the foreignness of languages" (Benjamin 1968, 75). Translation renders language as foreign, because "any language is a place of exile." The relationship between the translated text and the original renders them both creations of exile—temporary borrowings that uncover the nature of the original by changing it forever. Hence the sense of disappointment Cubans from the island experience when they visit a Miami that they have known only as a sort of imaginary construction. They expect a copy of Havana, and it takes them a while to understand that the sense of copy is not at all in the landscape, or in the layout, but in the mental geography that constructed Miami.[8] Looked at from the point of view of Benjamin's notion of translation, the original loses its privileged place, for the mechanics have to be found in the internal landscape, in the "inner eye," in the uncovering of the mechanism of the original, instead of the aping of the original itself. This was, ultimately, *Scarface*'s triumph: the remake is a totally different thing.

Notes

1 In November 1999, Elián González, his mother, Elizabeth Brotons, and others left Cuba for the United States on a makeshift raft. Elián was rescued at sea by two fishermen, and was then handed over to the U.S. Coast Guard, who released the child to his paternal great uncle, Lázaro González. The father, in Cuba, was joined by Cuban authorities in demanding that the child be returned to Cuba. The case dominated news media for the first six months of 2000, and polarized public opinion in Miami. Cuban exiles overwhelmingly supported the child's relatives in the United States, though Attorney General Janet Reno ordered the return of Elián to

his father. On April 22, 2000, agents stormed the Miami house in Little Havana where Elián lived with his relatives, seized the child, and took him to his father, who was waiting for him in Washington, D.C.

2 The story of this change has been rendered before, most notably in María Cristina García's *Havana USA* (1996), but much work still needs to be done in collections and archives, and a much broader notion of literary discourse needs to be deployed here—discourse that would include early literary journals (such as *Alacrán Azul* in the early 1960s, for example) but also the small, sometimes ephemeral newspapers that for three decades connected the loose ends of the Cuban exile population, not only in Miami, but also in Puerto Rico, New York, Santo Domingo, and Caracas.

3 See María de los Angeles Torres (1999) and the insightful study by José Cobas and Jorge Duany (1995).

4 I discuss this more broadly in my essay "Espionage and Identity," which is included in *Cuban Palimpsests* (2005). There I argue about the effects of espionage on a city like Miami, where very vocal antirevolutionary statements are sometimes performed by those who are later revealed to be acting as agents of the Cuban government, collecting information on its opposition. In this context, performative markers of identity at times become suspect. The long history of espionage that has taken place in Miami since the early 1960s is definitely inscribed within the city's long history of conspiratorial narratives.

5 The main character in *Scarface* is Tony Camonte, a name that Stone and De Palma transformed into Tony Montana. Both films chronicle the rise of Tony Camonte / Tony Montana from petty thief to a leader of organized crime. The secondary plots are also similar, in that both Tonys desire their boss's girlfriend, and they both have sisters whom they zealously protect. Both films end in a massive shootout scene, though in the *Scarface* from 1932 censors demanded that the audience see Camonte's death at the hands of justice, a tacked-on ending which the director, Howard Hawks, actually refused to direct, but which was inserted in the film anyway. Stone's and De Palma's version has no such ending with overtones of justice and morality. In their film, justice does not kill Tony Montana; excess kills him.

6 This information, and quotes by Oliver Stone and Brian De Palma that follow, can be found at www.briandepalma.net/scarface, accessed March 10, 2007.

7 Given the harsh economic conditions brought about by the end of Soviet subsidies in the early 1990s, many Cubans expressed their disenchantment with the government by becoming *balseros*—those who boarded makeshift boats (*balsas*) to leave Cuba—to take advantage of the preferential treatment given to Cuban refugees in the United States under the Cuban Adjustment Act. The Cuban government prevented its citizens from leaving the island and aggressively pursued balseros. The tense situation between the balseros and the Cuban government produced citizen riots on August 5, 1994, on the Malecón in Havana, with the result that the government lifted all restrictions against leaving the country. It is estimated that at that point over thirty thousand Cubans left on rafts. President Bill Clinton then ordered

the U.S. Coast Guard to detain them in Guantánamo. They were finally admitted into the United States in 1995.

8 Iván de la Nuez is right in dislodging the question of outer representation from the question of Miami (1998, 138). He focuses more on the internal representation of Miami, and so he calls the city a kind of emblem for an attempt to conquer time, not space.

The Jew in the City: Buenos Aires in Jewish Fiction

Amy Kaminsky

Insofar as globalized capital increasingly bypasses the nation state but still needs the material fact of workers on the ground and corporate headquarters in the skyscrapers, the city persists. Exactly which metropolises make it onto the list of "global cities" is determined by the extent to which global economic processes are densely located there. In Saskia Sassen's account, the obvious cast of global characters (financial centers like New York, London, Paris, and Tokyo) is joined by São Paulo, Mexico City, Bangkok, and Taipei. But if the father of the global city is what seems like deracinated economic power and its necessities, its mother is invention, and she is very much rooted in the nation. Janet Abu-Lughod sees beyond the power relations of production, dispersal, and consumption of goods, services, and information when she defines global cities as "gigantic urbanized places that currently occupy hegemonic positions in the spatial structure, aesthetics, economy, changing demography, contentious politics, and evolving cultural meanings of [their nation's] history" (Abu-Lughod 1999, 1). As a sociologist, Abu-Lughod takes us closer to the cultural economy in characterizing the global city as "the built environment [whose] human occupants endow [it] with symbolic significance" (5). Her definition makes it possible to include Buenos Aires in the list of global cities as a site whose contribution to the global economy (a term I use in this instance in its broadest meaning) is less financial than textual. Buenos Aires fits Abu-Lughod's criteria, but the sociologist, still working in the realm of the tangible, omits two key interrelated elements in her description of the global city that are critical in the case of this Latin American metropolis. First, she disregards the imagined

city, whose space is more metaphoric than literal, produced in the mind by narrative formations; second, she ignores the meaning-makers whose experience of the city is purely narrative. What sets the global city apart from other built human environments is not just that it is occupied by people who endow it with symbolic meaning, but that it itself occupies the minds and the texts of people beyond its borders who also participate in the creation of its symbolic meanings. Buenos Aires is a global city because it has successfully insisted on its presence on the world stage. The global city persists not only through economic structures, new and old, but also, as Abu-Lughod suggests, through symbolic systems. It exports not only products but meanings, and those that Buenos Aires exports are primarily meanings of itself.

It is a commonplace in Latin America that Argentina is obsessed with producing, performing, and projecting a Eurocentric national identity. More precisely, this has been the aspiration of the *porteño* cultural and political elite.[1] Their desire for Buenos Aires to be admitted to the company of civilized nations has required that it can claim to be an equal of the capitals of Europe. (That this obsession is perceived as Argentine rather than just porteño shows just how successful the city has been in claiming that it is the nation.) For their part, most Europeans and North Americans oscillate in their perception of Argentina between the myth of the exotic South American landscape, onto which Argentina is mapped, and their peculiar familiarity with Buenos Aires, the "gigantic urbanized place" that signifies and—in certain contexts subsumes—Argentina.

Because the global city is also "built" by writers and their words, the city can be experienced and "endowed with symbolic significance" from a distance. The global city is knowable and known beyond its official limits. In fact, the idea of "city limits" is a little absurd in the context of the global city. The imprecision of just what is included in what we denominate a metropolitan area suggests that the city strains against its official boundaries, pushing itself into what we might fruitfully think of as an imagined geography—not the city and its suburbs, but the city and its stories. Outsiders have access to the symbolic meanings of the city and participate in the construction of the city as symbolic space by means of the narratives produced from within the city, and—as importantly—by the stories told about it from beyond its borders. In fact, among the characteristics global cities share is their life in the imaginary of the rest of the world.

Globalization enables its cities to increasingly occupy imaginative space for those who have little or no direct, lived knowledge of them. In the case of

Buenos Aires, being seen means being validated and is therefore especially important to the ever-fraught process of identity formation. Unlike New York, London, and Paris, whose presence in the global imaginary rests in large part on the political, cultural, and economic hegemony of the nations they represent, and which seem to have entered the world imaginary as a byproduct of their creative aesthetic, political, and economic energy, Buenos Aires has striven to cultivate a narrative of itself that comes from elsewhere, a narrative designed for its own use, as well as for the consumption of those places on whom it would model itself. Buenos Aires manufactures, for itself, a narrative of a city that is cosmopolitan, European, white, sophisticated, stylish; but it needs to see that self reflected back as such. Buenos Aires is, in part, what observers say it is because Buenos Aires cares about what they have to say about it.

But why should Europe and the United States bother to imagine Buenos Aires at all? I believe that the appeal of Buenos Aires to the industrialized North has rested on the fascination with the uncanny other.[2] Contemplation of this other, which is simultaneously familiar and different, provides a pleasurable refraction of the subject's own reality. The global city holds an appeal to the cultural imaginary of people who do not experience it directly, insofar as it functions as a mirror, an uncanny other by which the self can be known. In the case of Buenos Aires, the city serves as a screen onto which Europeans and North Americans project both desire and fear as they recognize themselves in their foreign other. To invoke another metaphor, Buenos Aires offers a hook of familiarity baited with difference that attracts the attention of those it would have gaze upon it. Moreover, one of the markers of Buenos Aires as a global city is its diverse population, a result of internal and international migration that has historically drawn people to it. Every global city has its own constellation of identifying characteristics, and each speaks through them to specific, historically determined populations. Blacks in the 1920s were drawn to New York and Chicago for the blossoming of African American creativity there, and not only for economic and political reasons. Hippies flocked to the relative social leniency of San Francisco in the 1960s and were followed by gays in the 1970s. The tired, poor, huddled masses of Europe, yearning to breathe free made their way to "America," but specifically to New York, where immigrant enclaves made the unfamiliar less so, and where, they believed, poverty, exhaustion, and persecution could be escaped or overcome. Tales of streets paved with gold are fantasies of urban space. To the extent that Buenos Aires attracted European immigrants as the

"other America," it established links that fomented an imagined Argentina among particular populations within Europe. Jewish immigration to Argentina created the Jewish rendering of this phenomenon.

The wandering Jew of European legend often wanders into cities, but many Jews were drawn to Buenos Aires indirectly, their immigration elicited to colonize wilderness recently wrested from Argentina's indigenous population. It was facilitated by the Jewish Colonization Association, whose goal it was to recreate Zion in Argentina's rural areas. Nevertheless, a variety of factors sent many of the subsequent generations of Argentinean Jews to Buenos Aires. As Gisela Heffes (1999) points out, the poor quality of the soil, the restrictions on inheritance of the land, the value that these immigrants placed on education for their children, and those children's own desire to make a life for themselves sent many to Buenos Aires. As it was forbidden in much of Europe to own property, it is not surprising that so many Jews became urban folk, and the dream of a Zion on the pampas that drew large numbers of Jews to Argentina dissipated for the majority. Currently, more than half of Latin America's Jews live in Argentina, the vast majority of them in the capital. As a result, Buenos Aires holds a place in the Jewish imaginary throughout the diaspora, and Argentina is perceived by gentiles as well as Jews as a place marked by Jewishness.

In the early years of Argentina's self-civilizing mission, Eastern European Jews were implicitly excluded from that nation's ranks of desirable immigrants. Only in 1881 did immigration practice change to include them, when President Julio A. Roca named a special agent to recruit Russian Jews to settle in Argentina. Eight years later, on August 14, 1889, the German ship *Wesser* landed in Buenos Aires harbor with 824 Eastern European Jews on board. They were transported to the countryside, where, intent on establishing themselves in the rural economy, they nevertheless found themselves in such appallingly harsh conditions that many of them fell ill and died of malnutrition that first year. Sixty-one of their children perished that winter. The following year, Dr. Wilhelm Lowenthal, who was invited to Argentina to share his technological expertise in agricultural matters, visited the province of Santa Fe, where he found that ravaged settlement of Jews. Horrified by their tragedy, Lowenthal convinced the Jewish philanthropist Baron Maurice von Hirsch to finance the Jewish Colonization Association to help immigrant Jews obtain land and cope with their new surroundings. The eventual massive influx of Jews, many of whom eventually made their way to the cities, together with later immigrants whose original destination was the

capital, meant that Buenos Aires would become recognizably European in large part because of its Jews.

Fully welcome neither in Europe nor in Argentina, Jews nonetheless bear the mark of urban, urbane Europe. This is the case in Dominique Bona's novel from 1984, *Argentina*. This banal book, because it is so cliché ridden, is a useful text for looking at how early twentieth-century Buenos Aires appeared in the French popular imagination even as recently as the 1980s, when Argentina was struggling to emerge from a brutal period of political repression. France itself was caught up in the effects of the Dirty War,[3] in particular, the kidnapping by security forces of Alice Domon and Leonie Duquet, two French nuns who had been working in Argentina. Nevertheless, Bona sets her novel in the Buenos Aires of the first part of the century, when its reputation was that of a city of the fabulously wealthy, punctuated by an underworld of dreary brothels and the (short-lived) misery of the newly arrived immigrant, with excursions to the vast oligarchical estates of the pampas, and brief references to the wilds of the north and of Patagonia. One of the central characters, Léon Goldberg, a successful businessman, is a thoroughly assimilated Jew with a daughter who barely acknowledges her Jewish heritage. Goldberg, who has made his fortune exporting beef, is unconnected to the Jewish community of Buenos Aires. He represents commercial success, and his identity as a Jew is wholly contained in that stereotype.

Bona's Buenos Aires easily absorbs and assimilates this wealthy Jew. Already married to a Catholic woman even before emigrating, and widowed before the novel's action begins, Goldberg is part of the porteño landscape. His Jewishness is fulfilled in this novel by his being a shrewd and wealthy businessman who pampers his assimilated daughter. Recognizably Jewish himself, he has no visible ties to the Jewish community. In fact, no such community appears to exist in *Argentina*. In his daughter's generation, Jewishness will dissolve completely and effortlessly into the porteño brew.

With *Carlota Fainberg* (1999), Antonio Muñoz Molina creates a Spanish version of Argentine Jewishness that resonates with Bona's. His porteño Jew is similarly perceived as part of what makes Buenos Aires the slightly exotic, but also familiar, place that it is. Like Bona's Goldberg, Muñoz Molina's Isaac Fainberg is a successful businessman. He is also the elderly, and presumably lecherous, husband of the sultry title character. Fainberg's presence in the text is filtered through layers of narration, and it is, ultimately, incidental to the plot if not to the texture and ambiance of the novel. Mar-

celo Abengoa, the novel's provincial Spaniard, who has been fabulously seduced by Carlota, finds Buenos Aires compelling because of its fascinating racial blending, which for him means the mixture of Christians and Jews. Carlota herself may well not be Jewish, but Abengoa's obsession with her is fueled by his perception of her cultural overabundance. Not quite a sign of conventional urbanity, Carlota's presumptive Jewishness is a marker of the sexual exotic. Jewish Buenos Aires in the writing of non-Jews from the out-side (here exemplified by the Spanish Muñoz Molina and the French Bona) plays on stereotypes, and Jews in these texts are written primarily in relation to the gentile world.

For non-Jewish observers like Bona and Muñoz Molina, the Jew is a famil-iar other, easily transplanted onto Argentine soil, and fully assimilated into European gentile meaning systems: in Bona, the stereotypically successful businessman; in Muñoz Molina, the exotic object of desire. Buenos Aires's very meaning is produced through what for Abengoa is the title character's oxymoronic name: the sufficiently Hispanic "Carlota" literally, if surpris-ingly, married to the unmistakably Jewish, Eastern European "Fainberg." In its familiar difference, the Jewish aspect of Buenos Aires is part and parcel of the city's core identity in these texts. In contrast, the Jewish writers I will discuss encounter an internal difference in the Jewish presence in Buenos Aires. More attuned to the uneasiness with which Buenos Aires—a city that learned its anti-Semitism from Europe—has absorbed its Jewish popula-tion, they recognize that the city itself has been resistant to the Jewish pres-ence there. From the *Semana Trágica* (Tragic Week) of January 1919, when the violent repression of workers demanding their rights turned into a murder-ous attack on Jewish businesses, synagogues, and individuals, to the bomb-ing of the Argentine-Israelite Mutual Aid (AMIA) building that destroyed irreplaceable documents and artifacts and took the lives of more than eighty people in 1994, Buenos Aires has known anti-Semitic violence.[4]

For the non-Argentine Jewish writers Sholem Aleichem, Judith Katz, and Isaac Bashevis Singer, Buenos Aires is not the place of easy Jewish assimila-tion that it is in Bona and Muñoz Molina. Rather, it emblematizes the Jew as outsider and dallies with the Jew as outlaw. Moreover, Jewish writers from outside have often been drawn to the edgy question of the Argentine Jewish underworld, unlike Argentine Jewish writers, who historically have tried to demonstrate that the Jews of Argentina are model citizens.[5] With different objectives, and no need to prove themselves worthy to Argentine society,

Sholem Aleichem, Katz, and Singer have drawn their stories from the shady side of Argentine Jewish history.

This is not to say that the story of Jewish criminality has been totally absent from Argentine Jewish literature. César Tiempo's *Clara Béter, versos de una . . .* (1927), originally published under the name of the eponymous fictional Jewish prostitute, is perhaps emblematic of respectable Jews' ambivalent acknowledgement of the porteño Jewish underworld. Only after it went through five editions was the true author's identity revealed. César Tiempo, already a pseudonym—a playful translation of Israel Zeitlin—further distanced himself from authorship by attributing the poems to their speaker. In addition, his title coyly suppresses the sexually scandalous nature of the putative author in favor of an ellipsis. Tiempo's ambivalence in the face of his representation of a Jewish prostitute is symptomatic of the reluctance of the Jews of the period to be associated with activities that gave local anti-Semites a fertile ground for their anti-Jewish propaganda and potential violence. Nor did they want to advertise the already too visible world of the Zvi Migdal and the *caftens*[6]—the Jewish face of organized crime in Buenos Aires. As Leonardo Senkman points out, the initial readers of *Versos de una . . .* , including the also-pseudonymous prologuist of the text, even chose to ignore the Russian-Jewish origins of the poems' speaker (Senkman 1983, 169). Senkman also argues that the invented Jewish prostitute, Clara Béter, had little in common with the real-life Jewish prostitutes bought and sold by the Zvi Migdal.

Although Argentine Jews were reluctant to advertise Jewish participation in Buenos Aires organized crime, by 1909 Jews in Europe were already familiar with the outlaw Jews of Buenos Aires. People knew enough about the operations of the Zvi Migdal so that Sholem Aleichem, writing in Yiddish, could rely on their notoriety in "The Man from Buenos Aires" (Sholem Aleichem 1983). In this short story, two Jewish men share a train compartment in Eastern Europe, and in the intimacy and anonymity of travel the title character tells about his rise from poverty as a supplier of a highly profitable, though never named, commodity. Although the man from Buenos Aires never says quite what his valuable merchandise is, the name of the city in the story's title is a sign of the traffic in women. The man's comments about bribing the police, blackmailing his boss, and his rough and tumble upbringing supply more clues, but the city itself signifies Jewish trade in women's bodies.[7]

Decades later two more Jewish writers from the outside, Isaac Bashevis Singer and Judith Katz, were both drawn to the outlaw Jews of Buenos Aires who captured the attention of Sholem Aleichem. These immigrants flourished in the early twentieth century, a time when Jewish immigration to Buenos Aires was at its peak and when Jews in Europe were in crisis due to pogroms, secularization, and political upheaval. As for Sholem Aleichem, the name of the city is a potent signifier in Katz's *The Escape Artist* (1997) and Singer's *Scum* (1991), but the place itself remains phantasmagoric. Singer's novel actually takes place in Warsaw. Buenos Aires is evoked and recalled, but it is never a site of the novel's action. Judith Katz's Buenos Aires, however, is a city of real streets and neighborhoods. Yet notwithstanding the fact that her novel is grounded in historical accounts and the physical spaces of Buenos Aires, Katz takes those as a starting point for the creation of the imaginary spaces of the Jewish brothel.

In both *Scum* and *The Escape Artist*, Buenos Aires is necessarily linked and implicitly compared to the vibrant and endangered Jewish life in Warsaw, and the Jews of Poland are the standard of Jewish authenticity in these novels.[8] The protagonist of *The Escape Artist*, an adolescent from Warsaw named Sofia Teitelbaum, is deceived, drugged, cajoled, and threatened, and winds up in a Buenos Aires brothel, eventually to be rescued by Hankus, another young woman who has escaped the pogroms of Poland by dressing as a man and becoming adept at juggling, acrobatics, and disguise. Hankus transfigures reality, not least with the transformation of her own female body into the masculine persona she cultivates. Moreover, the spectacle of Hankus's magic tricks and juggling turns the everyday city into a space of fantasy.

The Escape Artist begins with the grounding of Sofia's "real" life in Warsaw and Hankus's travels through rural Poland after surviving the massacre that destroyed her village and killed her family. Singer's *Scum* is the tale of Max Barabander, a shady character who returns to Warsaw after his son's death in Buenos Aires. In an inversion of the conventional immigration narrative, Singer sets the action entirely in Poland, while Buenos Aires is a site of memory. In both *Scum* and *The Escape Artist* the travel between Warsaw and Buenos Aires is essential to the weave of the textual cloth. It is a difficult and long voyage, unimaginable for some characters in both novels, but undertaken multiple times by others. In these texts, Buenos Aires and Warsaw are among the major cities, all connected by tales of migration, on a Jewish map of the world. The characters displaced from the Polish city and installed in the Argentine capital long for the familiar sounds, smells, and tastes of

home. Street names and even house numbers trigger the return of memo-ries. Yet there is a notable difference between women and men in these texts in their feelings about the transatlantic crossing. The men who make the re-turn trip (Max in *Scum*; Tutsik Goldenberg, the brother of the madam in *The Escape Artist*; and Sholem Aleichem's train traveler) rhapsodize over the food, the smells, and the Jewish feel of the place. In contrast, the prostitute Sarah from *The Escape Artist*, who accompanies Tutsik in his shopping trip for a new woman to install in Madam Perle's bordello, can get pleasure from nothing but from the drugs to which she is addicted. Madam Perle herself has no desire to make that return trip, at least not until she can return for good, with her respectability restored. Instead, she recreates Poland in Buenos Aires, running her brothel by familiar, if somewhat revised, Jewish law and commentary.

The Jews of *The Escape Artist* and *Scum* live in Buenos Aires, but they are never truly of it. In marked contrast with the thrust of Jewish writing in Argentina set in the same period, neither Katz's characters nor Singer's aspire to assimilation into the greater Argentine society. The former's madam and the latter's gangster pimp long for respectability and legitima-tion within the Jewish community, which in turn has recreated the familiar institutions of Eastern Europe in Buenos Aires: synagogues, burial societies, theaters. The assimilation assumed by Muñoz Molina's Abengoa, for whom porteña women are exotic and racially mixed, is not an alternative for the characters by Singer and Katz.

Of course by the 1990s, when Muñoz Molina's novel takes place, many Jews have intermarried and assimilated, changing the meaning of Jewish Argentineity. Katz and Singer, however, choose to set their novels in the period of Argentine Jewish history that allows them to tell stories of as yet unassimilated Jews. Muñoz Molina's Buenos Aires, unlike theirs, is a pre-dominantly gentile culture thoroughly permeated by the trace of Jewish presence for the Spaniards who work out their own concerns in the space of the Argentine, postcolonial other.

For Muñoz Molina's Abengoa, Buenos Aires's difference from Spain is not only palpable, it is Jewish. In *Scum*, in contrast, the Polish characters whom Max meets in Warsaw confuse Argentina with Spain. Even Max, who explains that Argentina is an entirely different country, confuses the two nations when he refers to Argentinean women as "Spanish." Abengoa's Buenos Aires is marked by Jewishness; for Max, and for Katz's characters, being Jewish means living precariously on the margins there.

Sexual desire is a key element in constructing otherness in *Scum* and *The Escape Artist*, as well as in *Carlota Fainberg*. In this last work, Jews, sex, and the city are a potent mixture, painfully desired and ultimately frustrated. The sexual desire exhibited by Carlota amazes Abengoa, and he is a willing victim of an updated version of the romantic, and somewhat anti-Semitic, figure of the passionate Jewess. In *Argentina*, the protagonist's desire for the half-Jewish Sarah is instead displaced onto her marriageability. Jean is attracted by Sarah's asexual coolness, as well as by her father's fortune. In the end Jean marries Sarah, but his sexual needs are met by Mandoline, a French prostitute who offers not the excitement of difference but rather the comfort of the familiar.

In *Scum* and *The Escape Artist*, the conjunction of Jew, sex, and the city is a key to exploring the sordid side of the self. All the characters are Jews, and many trade in sex; in the absence of the exotic other we are left with the unsavory world of prostitution. Sex between men and women is stripped of its mystery, and women are bereft of the power to inflame the male characters' desire. Max is desperate to reanimate his desire for sex, and Tutsik is decidedly uninterested in the women he procures for his sister's brothel. The sexual predators in these novels are not seductive Jewesses, out to lure gentile men, but rather Jewish men who entice young women to leave their families in Eastern Europe and accompany them to Buenos Aires, the enforcers who make sure they do not escape, and their clients. Exoticism is drained from the conjunction of Jewish women and sex. In Singer's and Katz's novels the whole sexual economy of prostitution is Jewish, and neither the prostitutes nor the procurers ever expect to become Argentinean. Their status as Jewish outsiders is compounded by their marginality as criminals. This is in distinct contrast to Muñoz Molina, for whom Buenos Aires is exotic precisely insofar as it is Jewish, and Jewishness is constitutive of Argentineity. For Singer and Katz, Jewish marginality, and therefore specificity, afford some purchase on the distant city that is Buenos Aires.

The worlds of both *The Escape Artist* and *Scum* are familiarly Jewish, unfamiliarly the underworld. The unthinkable is possible in Buenos Aires because it is so distant from the European center of world Jewry. In Buenos Aires Jews can be sexual outlaws, women can be criminal entrepreneurs, and common crooks can aspire to social acceptance. When Singer's characters move from their center of gravity in Poland, they begin to lose some of their most fundamental characteristics. This is true of Katz's characters as well, but her women are able to develop parts of themselves that never would have

emerged in Poland. In Warsaw, Singer's formidable Reyzl is not able to go into business on her own without a man's support. Similarly, Katz's even more extraordinary Madam Perle does not become an entrepreneur until she reaches Buenos Aires, where she assumes sexual, economic, and religious control. Not only are Tutsik and her other male helpers subordinate to her, but she wears kippa and tallit (skullcap and prayer shawl) and reads the Torah, assuming the religious responsibilities exclusive to Jewish men of her day.

In distant Buenos Aires, both Max and Perle engage in wealth-producing activity that causes them to be ostracized by the good Jews of the somewhat phantasmagoric city, but that they hope will gain them respectability in the real world of Europe. For Perle, a parodic respectability is possible; she lands herself a rabbi and we last see her on her marriage journey back to Europe. Max, instead, returns to Warsaw and fulfills his nightmare of winding up in prison, just as he is about to become respectable in Jewish Buenos Aires itself. Max's almost legitimate status in Buenos Aires, however, has no currency in the real world of Warsaw.

In both Scum and The Escape Artist, Argentine criminality is a central theme, but so is the way Argentina promises redemption. In Scum, Max is on the brink of this social redemption in Buenos Aires itself, whereas in The Escape Artist, Sofia and Hankus rescue themselves in a fantastic, imagined pampas. The rural Argentina in which The Escape Artist ends is, ultimately, as unreal as the memoryscape Buenos Aires in Scum. In the end, the two women disappear into a mythic terrain, leaving the narrow, gritty Argentina of the Buenos Aires underworld behind in favor of a magical and ephemeral Argentina that is more the setting of a fable than the locale of a realist novel.

Buenos Aires is the Jewish elsewhere of all of these texts, whether written by Jews or gentiles. Singer's Max and Muñoz Molina's Abengoa return to their respective European realities, while Katz's Sofia and Hankus retreat to the even more fantastically imagined pampas. The first half of Carlota Fainberg, like all of Scum and "The Man from Buenos Aires," takes place in another locale altogether. Buenos Aires is an elsewhere that holds great meaning for those characters who tell about it, but who are not there at the moment of telling and who, moreover, will never go back. For Max, storytelling turns into fantasizing, which in turn becomes lying. His own narrative, and the desire he expresses in it, is a web he cannot escape. Buenos Aires becomes real in the act of telling, but it is also falsified, fictionalized, and forever estranged from the teller.

For Muñoz Molina's Abengoa, Jewishness is what makes Buenos Aires an exotic elsewhere. In Bona, Jewishness is not only stereotyped but precariously on the verge of disappearance via assimilation. Yet however dissimilar *Carlota Fainberg* and *Argentina* may be, they share the assumption that Argentineity incorporates Jewishness. In contrast, Singer's *Scum* and Katz's *The Escape Artist* represent Jewishness as outside the imagined community of Buenos Aires. In these novels, Jewish identity and culture are neither the mark of the exotic nor a deracinated stereotype, but rather the foothold of sameness that makes Buenos Aires not totally foreign territory. Buenos Aires, neither fully fantasy nor fully real, remains a potent site for the Jewish narrative of its own otherness.

In contrast, Buenos Aires is fully present in the writing of Argentine Jews who claim the city, as well as the rural colonies established by Baron von Hirsch, as their own. Particularly in the first generations, Jewish writers often expressed their title to Argentineity, and it could be argued that all Jewish writing in Argentina is in dialogue with Alberto Gerchunoff, whose *Los gauchos judíos* (*The Jewish Gauchos of the Pampas*) (1910) represents a yearning for and claim to acceptance. Gerchunoff's text was an exercise in persuading both Jews and gentiles that Jews could be real Argentines, and that the nation itself desired such assimilation. According to the vast majority of critics of Argentine Jewish literature, most Jewish writers in Argentina engage on some level with Gerchunoff's ur-text, either aligning themselves with his assimilationist fantasy, or exposing its underside, showing in their texts that Argentina is always resistant to its Jewish citizens and that such resistance necessarily marks the Jewish experience in and of Argentina.[9] Surely, an author who paraded the Jewish underworld around for all the world to see would undermine the assimilationist project on the one hand and set off the anti-Semite on the other.

Moreover, the Jewish outlaws, largely absent from these Argentine-produced fictions, do not engage in this foundational problematic themselves in texts by outsiders like Katz and Singer, who themselves have no particular interest in Jewish assimilation into Argentine society. In their narratives the characters' great desire is, rather, to be accepted by the legitimate Jewish community. Repugnant as they are to legitimate society, none trouble themselves with their acceptance by the culture at large. As represented by Katz and Singer, and as implied in Sholem Aleichem's work, the outlaw characters are sufficiently alienated from Argentine culture to be pulled instead toward the home country. They are little interested in Argentina, except as a

place where they have the freedom to ply their trade—which they do entirely in the city. In Katz, the two runaway women, one victimized by the Jewish trade in bodies, and the other her rescuer, are required to leave the city if they are to survive. In an almost farcical rewriting of Gerchunoff, Sofia and Hankus escape from Buenos Aires to become pampas performers, doing stunts, riding and roping better than the Jewish gauchos among whom they settle. It is a frothy ending to a novel of trauma. The struggle in this novel is not with becoming Argentine while remaining Jewish; that possibility, which so wracks Jewish Argentine writers, is the simple happy ending for Sofia and Hankus. The lesbian couple earns acceptance because they are both productive and entertaining.

In Jewish Argentina represented from within, however, unconventional sexuality is not so neatly absorbed. Any suggestion of defiance of sexual normativity challenges conventional Jewish identity and makes Jews vulnerable to charges of deviance in the larger culture. In the documentary *Susana* (Muñoz 1980), an Argentine Jewish lesbian ultimately leaves for Israel in the face of her community's homophobia. The feature film *Esperando al Mesías* (Waiting for the Messiah) (Burman 2001), follows the protagonist, a young Jewish man named Ariel, as he tests the waters of assimilation in part by leaving his sweet, family-oriented, uncomplicatedly heterosexual Jewish girlfriend in favor of an independent, gentile, bisexual woman who represents the temptations of life in the city in a globalized, post-dictatorship, economically ruined Buenos Aires where it seems that money is to be made in the new media and video technology. In the end Ariel returns to his old neighborhood and his former sweetheart, having found his bisexual girlfriend a little too rich for his blood.

Not all Jewish writers in Argentina deal with Jewish issues, of course. David Viñas writes primarily about broad social and political concerns. Even his *En la semana trágica* (During the tragic week) from 1966, whose historical referent is a traumatic moment in Jewish Argentine history, casts only the briefest glance at a Jewish character. Angélica Gorodischer's work is largely science fiction–fantasy, a genre that eschews the realism of the novel of the immigrant experience. Yet she has written at least one short story that reimagines the era of the Jewish settlers. Jorge Goldenberg's play *Relevo 1923* (Relay 1923) from 1975, could have, but does not, feature Jewish characters, insofar as it takes as its theme the anarchist movement, in which Jews played a large part. On the other hand, his play *Krinsky* is about Jewish identity.[10] The absence of Jewish themes or characters in Alejandra Pizarnik's

work, for example, does not preclude a Jewish sensibility, according to some of her readers (e.g., Senkman 1983). Moreover, as Edna Aizenberg (2002) convincingly argues, some Jewish writers come to write about Jewishness not through a sense of identity, but as a result of textual ties—specifically through Borges, who authorizes Jewish text and lore as the stuff of literature. In sum, to attempt to reduce Jewish writing in Argentina to any single theme or approach is not only futile, it is an exercise in essentialism that only proves how limited of an approach it is.

There remains, of course, a considerable amount of fiction by Jewish writers who are concerned with the question of a porteño Jewish identity. The protagonist of Sylvia Plager's *Mujeres pudorosas* (Chaste women) (1993), for example, is a novelist trying to write a narrative about a Jewish woman much like herself. In her quest to write both the particular and the universal, Plager's protagonist, Graciela, faces the conundrum of the contemporary Argentine Jewish writer of her community's identity. If her novel is to deal with broader issues in Argentina, it will lose its Jewishness, but if it is set in the Jewish world of Buenos Aires, it will be too claustrophobic.

The Jewish Argentine difference-in-similarity that plagues Graciela is also present, in a particularly grim way, during the period of the military dictatorships of the 1970s and 1980s. A number of Jewish survivors of the Argentine secret prisons and torture centers have written about these places. Some of them refer to the clandestine prisons as concentration camps, with all the baggage that term carries, and each writes the experience in different relationship to being Jewish. Jacobo Timmerman (1981) focuses on his Jewishness as constitutive of his imprisonment, while Alicia Partnoy (1986) seems somewhat taken aback by the guards' and torturers' emphasis on this piece of her identity that seemed much less important to her than it did to them. The paramilitary thugs who kidnap the protagonist of Alicia Kozameh's *Pasos bajo agua* (*Steps under Water*) from 1987 spray-paint swastikas on the wall of her apartment in the only specifically anti-Semitic reference in her arrest, beatings, and torture. In *Una sola muerte numerosa* (*A Single Numberless Death*), Nora Strejilevich composes a novelized account that lies somewhere in between the insistence on Jewishness in Timmerman and the almost incidental acknowledgement of it in Partnoy and Kozameh. Strejilevich sets her autobiographical protagonist in the context of her Jewish immigrant family history, including the first generation experience in one of the Jewish Colonization Association colonies and her own upbringing in Jewish Buenos Aires.

Pedro Orgambide's *Buenos Aires: La novela* (2001) interweaves several narrative strands to trace the history of the city from its founding to the late 1980s. Among them are the stories of Martín Tobler, the son of Russian Jewish immigrants, and Sarita, Rosita, and, later, Gabriel Gutman. Tobler's story begins with the Semana Trágica and continues beyond the time that he enlists to fight in the Spanish Civil War, never to return. Rosita Gutman helps a young Jewish prostitute escape to one of the Jewish colonies in Entre Ríos, and Gabriel, a journalist, gets caught up in Peronist politics in the 1950s and later in the 1970s, when he becomes a witness to the Dirty War. Buenos Aires may be most marked by its Jewishness by the fact that its writers simply include Jews as part of the porteño landscape, with Jews as one immigrant group among many. Jewish Argentine history is part of the history of the nation, but it retains its distinctiveness, not least because others insist on maintaining its difference.

In *Todas las máscaras* (All the masks) (1997), Natalia Kohen writes stories that include Jews in the social mix of the city. "Los amigos" is an allegory of assimilation, in which three elderly men, each representing one of Buenos Aires's immigrant groups (Jewish, Italian, Spanish), decide to live together in the Buenos Aires neighborhood of Villa Crespo, but later marry and separate. Rodolfo E. Fogwill's *Vivir afuera* (Living outside) (1999) maps the liminal spaces of post-dictatorial Buenos Aires through three central characters, who represent the margins of contemporary porteño society. But whereas the marginality of the two gentile characters is determined by their illegal activities, the third is always already marginal as a Jew. The condition of exile is inextricably connected symbolically to the Jew, so even though the majority of political exiles during the Dirty War were gentiles, this Jewish character is called upon to represent the paradigmatic Argentine exile. His Jewishness is recognizably Argentinean; that is, he can represent a kind of displacement and marginalization that the reader recognizes as belonging to the Argentine experience. At the same time, Jewish identity means marginality, or not quite belonging. In the Argentinean symbolic order, the Jew is always inside and outside, marked by his troubled membership in the nation. The slippage between Argentine and porteño here is also telling. The urbanization of Argentine identity, the collapsing of "Argentina" into "Buenos Aires," also has Jewish resonance. The Jew's historical association with the migration out from the Jewish Colonization Association settlements to the capital is part of the myth of Jewish Argentina, linked to the Jewish presence in urban spaces and urban professions.

Jews are part of the texture and color of Argentine culture, and because they have the same kind of shorthand meaning that other recognizable immigrant groups do — similar in form if not in content, Jewish characters give depth to the texts of Argentine writers. Gentile writers who take advantage of this Jewish presence do not concern themselves with the questions of Jewish identity that fuel so much Jewish writing in Argentina. Even Borges — whose interpellation of Jewishness is not determined by the author's penchant for scenes of local color, but rather by his abiding interest in Jewish mysticism, Jewish thought, and Jewish lore — does not concern himself with the interiority of Jews' struggling to be both Argentine and Jewish.

Borges is the most obvious example of an Argentine writer fascinated by Jewishness. His professed European, cosmopolitan sympathies and desires can make us think that his fascination with Judaism is also rooted in his Eurotropism. A number of his fictions may well suggest this, but others deal with a very porteño Jewish world. In "Emma Zunz" (1949) the title character's father is an Argentinean Jewish success story, and she weaves her revenge drama in the very specific geography of Buenos Aires. Even more striking in this regard is "La muerte y la brújula" ("Death and the Compass") (1944), in which comprehension of Jewish temporality is the key to understanding porteño space. Only when the detective protagonist suddenly remembers that the Jewish day begins at sundown does he discover the key to reading the map of the city being drawn by the killer, thus solving the puzzle of where the final murder will take place. The irony is that the murder he predicts is his own; the killer fully expected that his pursuer would have that knowledge, that is, that Jewish practice would have entered into porteño consciousness sufficiently that a smart and insightful gentile porteño would have access to and be able to use that knowledge.

In an inverse process, Emma Zunz's revenge requires her to step outside the small circle of Jewish society, but that step also takes her beyond the larger Argentine world. She finds a foreigner, neither Jewish nor Argentine, to take her virginity so she can make her case of rape within the Jewish world and to the Argentine authorities. The cultural assumption that she is a nice Jewish girl makes her story credible; there is a general understanding of legitimate porteño Jewish culture as one that protects and educates its daughters. Like the knowledge of Jewish time-reckoning available to the thoughtful detective in "Death and the Compass," this plot device suggests that things Jewish are enough a part of Buenos Aires to be used as figures or concepts on which the plot may turn. This suggests a considerably high

level of integration of Jewish culture into Argentine culture, but it does not attend to the cost of that assimilation—because of the extent to which it is not complete—for Jews themselves.

Emma Zunz has access to an anonymous sailor as her instrument of revenge precisely because Buenos Aires has long been a global city, a site of migration and international trade. Literary texts like "Emma Zunz" afford affective meaning to the theories of the global city, as understood from the perspective of critical social science with which I began this chapter. To conclude, I return to Saskia Sassen's account of globalization, which has so much to do with the materiality of global capitalism and so little to do overtly with problems of identity and literary representations. Yet Sassen's commentary resonates with the problematic of Jewish history and geography as it plays out in the imagined spaces of literary texts. In "The Global City: Strategic Site / New Frontier," she asserts that "globalization is also a process that produces differentiation; only the alignment of differences is of a very different kind from that associated with such differentiating notions as national character, national culture, national society" (Sassen 2000, 92). The Jew in the global city short-circuits the easy homogeneity of nation; but, as Abu-Lughod notes, globalization is inextricably linked to ideas of the nation (1999, 1). Because they both cross-cut the nation, Jewish differentiation and globalization both trigger national anxieties.

Sassen goes on to argue that dispersal and centralization are both in play in globalization. *Dispersal* and *centralization*, terms that reflect and refract the creation and perpetuation of differences within nations and differences across them, resonate as well with the problematic of Jewish otherness. The nature of Jewish difference, which produces and is produced, not by national character, national culture, or national society, but in and as cultural identity, occurs as well in and across nations. The dynamic of dispersal and centralization and the process of differentiation are the story of the Jew in the city, in this city, in the city of dispersal and otherness and migration.

Notes

1 Porteño, the adjective used to denote that which is of Buenos Aires, is part and parcel of the identity of Buenos Aires as a global city. Buenos Aires is the port, the site of transit for people and goods in and out of Argentina.

2 See my forthcoming book, *Argentina: Stories for a Nation*, for a fuller discussion of the uncanny other. The discussion that follows of works by Judith Katz, Isaac

Bashevis Singer, Dominique Bona, Sholem Aleichem, and Antonio Muñoz Molina is also indebted to the research I did for that book.

3 The Argentine military dictatorship of 1976–1983 waged a campaign of state terror against suspected dissidents in which as many as thirty thousand people were kidnapped, tortured, and, for the majority, killed. This "Dirty War" gave rise to the use of *disappear* as a transitive verb and to the phrase *los desaparecidos*, the disappeared.

4 According to different reports, eighty-five or eighty-six people died in the bombing of the AMIA building in Buenos Aires. The attack was traced to financing by the Iranian government, abetted by local police and government leaders who were bribed to look the other way.

5 The most obvious example from this second category is Alberto Gerchunoff (1883–1949), whose *Los gauchos judíos* (*The Jewish Gauchos of the Pampas*) (1910) describes the bumpy journey from the shtetl to the Pampas.

6 Their name apparently derives from the long, caftan-like garments worn by Hungarian Jewish pimps in Rio de Janeiro brothels.

7 See Guy 1991 for a history of Argentine prostitution. Nora Glickman (2000) argues that the actual number of Jews engaged in the traffic in women was exaggerated by a public happy to have a Jewish scapegoat onto whom the blame for moral decay and criminality could be pinned.

8 Singer grew up on the Warsaw street he writes about in *Scum*; Katz knows Poland as she knows Buenos Aires, from the outsider's knowledge that comes from brief visits, stories heard and read, and a good dose of research.

9 See, for example, Senkman 1983, Sosnowski 1987, and Lindstrom 1989.

10 I am indebted to David William Foster's study of Goldenberg (1993) for this insight.

PART 3 / TRAFFIC

On Maps and Malls / Hugo Achugar

The turn of the twenty-first century has seen a change in temporality. As with previous surges or accelerations of modernities, this change reflects more than just velocity. It implies a transformation, as Andreas Huyssen puts it, "in the relation between past, present, and future" (1995, 7). Of course, this relationship has been problematic for a very long time, at least in certain Latin American countries. However, the question of temporal relationship, or sequence, is more relevant today than ever. The future may well seem more uncertain here than in other parts of the world, but there are also— as Marcelo Viñar and Maren Ulrikensen (1993) put it—"breaks in memory" provoked as much by recent dictatorships as by several centuries of repeated historical traumas. This fractured memory, the rethinking of time, and a current sense of generalized amnesia accompanied by an obsession with memory are reformulating our relationship to space, especially to space that is charged with history, or the "realms of memory" (Nora 1997).

The relationship between trauma and memory, or between traumatic memory and mourning, often leads to the reconfiguration of specific spaces and temporalities. Jacques Leenhardt calls this "a cartography that articulates space and time according to a new model."[1] In the case of Latin America, a fractured relationship between past, present, and future marks multiple spaces. These spaces, articulated by fractures in temporal connections, may be located at the supra-national, regional level or on the much smaller scale of cities, neighborhoods, and buildings. Insofar as they are emblems of rupture rather than depositories of memory, the spatio-temporal nodes in which temporal change is expressed do not possess the same char-

acteristics as Pierre Nora's "realms of memory." In some cases they can be thought of as the superimposition of a new map over an old one. In other cases, the marks of rupture can be found in the very structure or architecture of a building.

In the context of Uruguay, or at least of the Uruguayan area on the northern shore of the Río de la Plata, any history of space and violence, of national imaginaries and urban imaginaries, or of places that are emblematic of the nation as well as of historical forms of violence, would have to begin well before the founding of Montevideo in 1729. Such a history might look to the moment when Juan Díaz de Solís disembarked on the northern side of the river that the Europeans had barely begun to include in their maps, or even earlier, with the signing of the Treaty of Tordesillas in 1494.[2]

The abstract border imposed by that treaty at the end of the fifteenth century, marked onto a map that was barely sketched out, of territories never visited by those who drew the lines, revealed an utter indifference to the presence of preexisting ethnic groups and cultural communities. This method of mapping separated indigenous nations.[3] The border between the Spanish and the Portuguese empires marked, from its beginning, the political and cultural history of the region that would later become Uruguay. Independent of its political implications, the Treaty of Tordesillas activated an imperial distribution of commercial rights as well as rights to exploit the American territories yet to be conquered by the period's European powers. In this sense, the imposition of Spanish and Portuguese economic interests perpetrated an inaugural violence expressed through political cartography.

Pope Alexander VI's geometric violence would be partially corrected, or atoned for,[4] as late as 1991, with the Treaty of Asunción that laid the foundations for Mercosur. Therefore, that originary violence can be understood as a "big bang" that spawned the nation-states of Argentina and Brazil, and later, successively, the Banda Oriental and the República Oriental del Uruguay. But even if we were to discount this original symbolic violence, we would still find other violent scenes that mark the beginning of Montevideo, if not the country itself, and that are directly related to the present.

The supposed ingestion of Juan Díaz de Solís by the original inhabitants of this area of South America constitutes one of the first such scenes that shaped today's Uruguayan imaginary. The extreme violence of cannibalism became a constitutive violence that still permeates the national imaginary. Though both denied and latent, this story's revealing force retains its influence to the present day.[5]

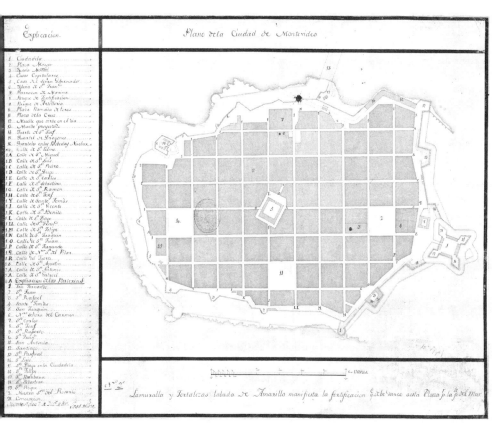

Plano de la ciudad de Montevideo, Santiago y San Felipe de Montevideo, 1811.
Manuscript map. Reprinted with permission from the Archivo del Servicio
Historico Militar (Madrid, Spain). Ref. no 6–324, hoja 3/pb.12–35.

The very founding of Montevideo around 1729 represents another of
these violent scenes. The Portuguese presence in Colonia del Sacramento as
of the end of the seventeenth century forced Spain to establish the fort of
Montevideo at the beginning of the eighteenth century in order to block Por-
tuguese advances onto territory that was supposedly reserved for Spain. Al-
though Montevideo itself represented the Spanish response to a Portuguese
threat, the Spaniards later violently expelled the Portuguese from Colonia.

Rivalry and commercial battles between the ports of Montevideo and
Buenos Aires shaped the relationship between these two cities well into the
twentieth century. The competition continues to this day, as seen in the halt-
ing pace of the negotiations over the boundaries of the Río de la Plata and

the dredging of shipping canals in that river as well as in the Uruguay River.[6] The natural border between Argentina and the historically contested border between Brazil and Uruguay feed the self-image of a region that is thought to play the role of a boundary state. This imaginary is also supported by the fact that late in the nineteenth century the border was transformed into a "purple land" where the different geopolitical actors confronted each other and engaged in battle (Hudson 1980).

The Treaty of Asunción from 1991, the basis for Mercosur, seemed to put an end to that founding version of Uruguayan history and introduce a new one: the story of a Uruguay that renounces its role as the violent border, or buffer zone, between its large neighbor states in order to take on the role of a country that champions communication and administrative neutrality. In this sense, Uruguayan territory no longer serves to separate, but to communicate. Thus, the country ceases being a site of combat and becomes a place of transit. It loses its function as "border or battle field" and acquires the identity of a democratic Eden where, according to the Latinobarómetro of 2006, 77 percent of Uruguayans support democracy.[7] This is the largest percentage among Latin American countries.

However, that self-perception and discourse obscure certain facts that complicate and contradict the Edenic image. It might be better to say that they prefer to "forget" those facts. Indeed, rather than concealment and forgetting, perhaps the more accurate terms would be *masking* or *disguise*. This disguise began in 1985 with the circulation of the idea of the "democratic restoration." The discourse of restoration assumed that the years of the "civil-military process" (the euphemism used to refer to the Uruguayan dictatorship of 1973–1985, which followed a military takeover of the government) represented an anomaly that should be forgotten and that did not deserve to receive attention from the citizenry. The discourse of restoration also implied that the violence of the 1960s had subverted the Uruguayan paradise established by José Batlle y Ordoñez's government in the early twentieth century. That image of paradise reached its height of popularity in the first years of the 1950s, when the slogan "Como el Uruguay no hay" (There's nothing like Uruguay) seemed to reflect a definitive "reality" in the Uruguayan imaginary.

The discourse of democratic restoration argued that the Uruguayan dictatorship had indeed forced a violent break in the self-satisfied national imaginary, but that this rupture was exceptional. However, in spite of the ardent desire of restoration discourse, the repercussions and consequences

of said rupture did not end with the return of democracy in March 1985. They actually continue to this day. The topics of the violation of human rights, as well as the increasing criminalization of Uruguayan society (Rico 2004), are still on the agenda of the Uruguayan post-dictatorship. Moreover, Uruguay's complacent and self-satisfied imaginary has been complicated by Mercosur's regional integration, a process that altered the country's geopolitical and economic role at the same time that transformations in media, technology, and politics were leading to today's globalized new world order. But the regional integration of Mercosur is above all a territorial rearrangement in the service of new rules for commerce, or the international marketplace. Just as the Treaty of Tordesillas drew a dividing line that helped the Spanish and Portuguese empires pursue their colonial commercial enterprises, the new Treaty of Asunción was intended to facilitate the imposition of the new global, or globalized, market conditions on this region. It can be argued that the violence of regional and world reorganization, along with the irruptions of different modernities and of the political violence that accompanies them, have introduced—and also contaminated—the very articulation of a new cartographic model,[8] a new relationship between time and space. Real, territorial space and the space of the Uruguayan imaginary (self-perceptions, self-representations) have been marked by violence since their beginning. In this sense, historical trauma can be registered and read in the "geological layers" of official memory as much as of subterranean or latent memory.

Up to now, my discussion has dealt with cartographic modifications and forms of violence that, though silenced, endure. In the pages that follow I will consider the transformation of memory, space, and time in one particular site: Montevideo's Punta Carretas Shopping Center, a former jail that has been turned into a mall.

A Mall for Prisoners, or How Piranesi Became a Shopping Center

In his *Confessions of an English Opium Eater* of 1821, Thomas de Quincy described a striking architectural fantasy:

Many years ago, when I was looking over [Giovanni Battista] Piranesi's *Antiquities of Rome*, Mr. Coleridge, who was standing by, described to me a set of plates by that artist, called his "Dreams," and which recorded the scenery of his visions during the delirium of a fever. Some of them

(I describe only from memory of Mr. Coleridge's account) represented vast Gothic halls, on the floor of which stood all sorts of engines and machinery, wheels, pulleys, levers, catapults, &c. &c. expressive of enormous power put forth, and resistance overcome. Creeping along the sides of the walls, you perceived a staircase; and upon it, groping his way upwards, was Piranesi himself. . . . But raise your eyes, and behold a second flight of stairs still higher, upon which again Piranesi is perceived, by this time standing on the very brink of an abyss . . . again . . . a still more aerial flight of stairs is beheld . . . and so on, until the unfinished stairs are lost in the upper gloom of the hall. With the same power of endless growth and self-reproduction did my architecture proceed in dreams. (qtd. in MacDonald 1979, 10)

The drawings of *Carceri d'invenzione* described by de Quincey have sparked the imaginations of writers and architects ever since Piranesi published his first versions of them in 1750. De Quincey's interpretation is highly subjective (MacDonald 1979). He locates Piranesi's work in the atemporality of dream and delirium. The erasure of temporality (remember that de Quincey claimed to be hearing about these images while perusing a text about Roman antiquity) and the imposition of a productive delirium indicate a very particular subjectivity. De Quincey's maneuver here prefigures that of Juan Carlos Lopez, the main architect for the Punta Carretas Shopping Center in Montevideo.

It is hard to imagine that those architects did not have Piranesi's images in mind. In fact, they refer directly to Piranesi, consciously or not, within a postmodern aesthetic. Numerous aspects of the building evoke Piranesi: the excessive proportions of the enormous walls, the play of escalators, the preservation of the original entryway to the former Punta Carretas prison as a space lacking any practical use for the commercial needs of the site, the multiplication of aspects of the main atrium in the secondary atria, the play among contrasting perspectives, and the relationship between human figures and architectural space.

There are differences, as well. For example, light floods the structure, and the atria are not gothic. However, the preservation of the old jail entrance underscores a fundamental correspondence between the architects' reading of Piranesi and de Quincey's reading. De Quincey's gaze removes temporality from Piranesi's jails, transforming it into dream. The architects' gaze is rooted in the present, focused on the architectural project assigned to them, trained on the temporality of the market. The meeting of this gaze

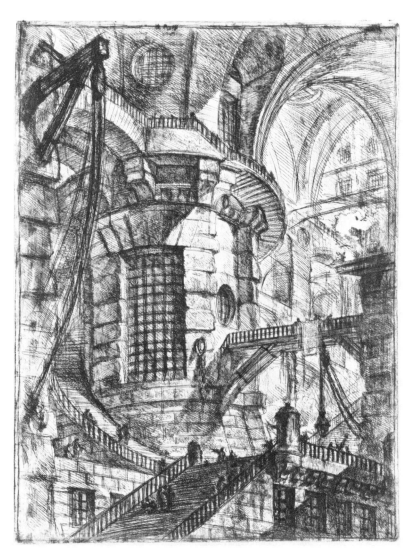

Giovanni Battista Piranesi, "The Round Tower" from *Carceri d'invenzione*, ca. 1745–50, published 1753. Printed with permission from the Hood Museum of Art, Dartmouth College, Hanover, New Hampshire.

Interior view of Punta Carretas, 2007. Photograph by Hugo Achugar.

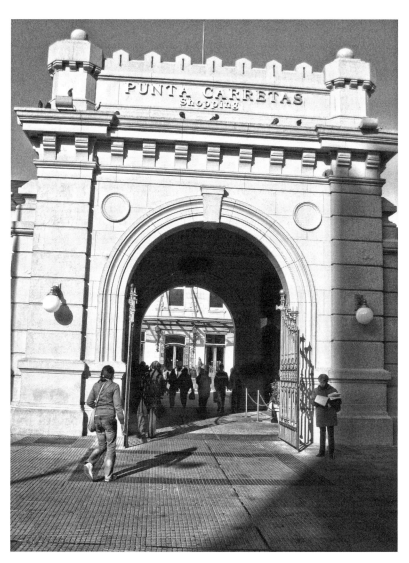

Main entrance to the Punta Carretas Shopping Center, featuring the original arch of the former jail entrance, 2007. Photograph by Hugo Achugar.

of the present with a space full of memory produces a scene written over by different logics in which none disappears completely:

> "I was impressed when I first entered this place that had been a jail," Juan Carlos López remembered, "because there were three levels with over-looks onto the central plaza, and I said to myself: this is a mall, a mall for prisoners, and that particular thought stayed with me." . . . "At first we wanted to preserve a lot of things," added Estela Porada, "but necessity required us to demolish certain sections; and for the functional benefit of the shopping center, we decided to preserve the spirit of the place, but without letting that preservation go to such extremes so as to be an obstacle to the development of the final project."[9]

It is difficult to resist the temptation to conclude that the "spirit" they tried to preserve in the interest of the shopping center's "functional benefit" was that of a "mall for prisoners." But the architects' decisions, perhaps unconsciously, have to do with more than demolition and preservation. They entail the construction of new ways to normalize violence and social exclusion. They relate to forgetting and memory. Above all, they reflect the way in which Uruguayan society in those years processed the topic of political violence and the violation of human rights.[10]

As Alejandro Solomianski points out, "The clean and controlled (in every sense) space inside the Punta Carretas Shopping Center, as in all malls, has no place for the 'undesirable' elements of the postmodern city. Not only are there no delinquents, homeless people, beggars, or garbage inside the Center, but the very coordinates of space and time are altered in more than one way" (Solomianski 2003, 176). The mere fact that malls are found in every city in the world blurs markers of local particularity, and therefore of local memory. "To this universality of the shopping center we might add its 'indifferent relationship to the city that surrounds it,' in which not only does one lose a 'sense of orientation within the mall,' but 'the city's geography also disappears completely'" (Solomianski 2003, 176, quoting Sarlo 2001a, 12). Time, too, ceases to flow because of this break with the natural (or at least somewhat less artificial) exterior space. Beatriz Sarlo writes, "There is no distinction between day and night. Time does not pass, or at least what time does pass is also a time without qualities" (Sarlo 2001a, 12).

Time does in fact pass in shopping centers, but it is the time of the market, the time of consumption. In this sense, centers of consumption offer a particular articulation of time and space. As Ignasi de Solá Morales puts

it when proposing that these places be seen as containers, we are dealing with spaces that "are not always public, nor are they exactly private": "They are spaces of exchange, delivery, and distribution of the goods that constitute the multiple types of consumption in our highly ritualized societies. A museum, a stadium, a shopping mall, an opera theater, a theme park, a historic building open to visitors, a tourist center: they are all containers. They are not transparently open, but rather closed sites where the 'generalized separation' discussed by Guy Debord in *Sociedad del Espectáculo* [2002] is the basic premise" (Solá Morales 1996, 8). According to Sarlo and Solá Morales, among many others, the space of the shopping center in general conflicts with the city in the same way that Solá Morales argues that "container spaces" impose separation:

> Separation from reality in order to create a space of pure representation. Physical separation that denies permeability, transitivity, transparency. The maximum artificiality produced by an enclosed, surrounded, protected place. An artificiality of climate, organization, control. An artificiality of interior space, always interior even when there is no roof, produced by architectural tricks that can be multiple, changeable, ephemeral, etc., but that are always enclosed within the rigid embrace of the container.
>
> There is a unification of space that precedes all processes of artificial diversification and that also stems from the essential condition of separation to which I have been referring. Nothing is as changeable as the seasonal displays of the shops in a mall, yet nothing so rigid, controlled, separated, selective and homogenous as these temples of consumption, whose proliferation on the peripheries of every large city in the world constitutes one of the most powerful and determinant architectural and metropolitan phenomena of the last twenty years.
>
> But the same argument applies to other sites of distribution and consumption because museums work in exactly the same way today, in spite of their apparent opposition to the banality of large commercial centers. (Solá Morales 1996, 8)

The Punta Carretas Shopping Center, however, engages in a different dialogue with the city. In the first place, it is not isolated on the city's periphery, but rather completely integrated into the neighborhood where it is located. Also, it does not present the same artificiality of other shopping centers and malls because it was a pre-existing building that was "adapted" or "reformed" toward a new use. The Punta Carretas Shopping Center presents

other variations on the generalized or transnational model of the archetypical shopping center, according to Agustín Noriega.[11] For example, the food court on the upper level takes advantage of its ocean view, integrating it into the decor. Also, the pedestrian access offers an especially notable break with typical malls' disorienting and enclosed circulation patterns; at the same time, it establishes a point of contact with the surrounding neighborhood and its history.[12]

In the face of the building's weighty history, though, these details do not configure a message very different from that emitting from the configuration of any shopping center as a postmodern space. In fact, they actually reinforce the "amnesia without which the smooth advancement of its business would be impossible" insofar as "history abounds with meaning that the mall has no interest in conserving" (Sarlo 2001a, 14). In this sense, the thick prison walls, still standing and partially integrated into the Punta Carretas Shopping Center, emphasize the separation of the mall from the city. The noteworthy cross-pieces of the pedestrian area, opening to Ellauri Street ironically and unconsciously, symbolize the difference between the pedestrian—who has theatrically controlled access, in the sense that the old prison bars remain, but now have a welcoming function—and the motorist—who has free and natural access (Solomianski 2003).

Nevertheless, the fact that the Shopping Center finds itself surrounded by a church, houses, and condominium buildings as well as traditional neighborhood shops, rather than being remotely located at the city's margins, means that its isolation from–or tension with—the city is expressed in a special way. In the course of its history, the Punta Carretas Prison, opened in 1910, established an urban relationship with the rest of the city without major complications, except, as we shall see, for the prison breaks of 1931 and 1971.

In the shopping center of today, dictatorial power has been converted into commercial power. The former rigid prison discipline is attenuated, at limited times, so that the saleswomen and custodians are granted small opportunities to become consumers themselves, or at least to imagine that possibility. Indeed, the memory that has been definitively erased is not the memory of power, but rather the memory of resistance to power. In the case of the Punta Carretas Shopping Center, this erasure is not just a question of the subordination of the building's historic identity to commercial needs. The material traces of certain acts of resistance to power have actually been eliminated. In 1931, seven anarchists and three other prisoners escaped

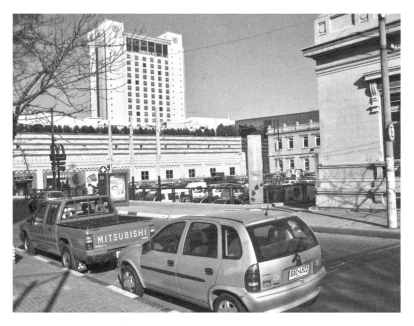

View of Punta Carretas from the church, 2007. Photograph by Hugo Achugar.

through a tunnel dug from outside into the jail. On September 8, 1971, in a prison break that was highly significant in the history of Uruguay before the 1973 dictatorship, 111 Tupamaro guerrillas escaped through a tunnel dug from the inside to the outside. Moreover, as Luis Costa Bonino suggests, the prison and the Tupamaros' escape are linked with the onset of President Jorge Pacheco Areco's authoritarianism and, later, the *golpe de estado* (military coup) in 1973: "The beginning of military prominence would come in the last months of Pacheco Areco's rule. On September 9, 1971, in re-action to the mass escape of Tupamaro militants from the Punta Carretas Prison, President Pacheco charged the armed forces with the responsibility for the anti-guerrilla effort. At the same time, the Junta of the Joint Chiefs of the three armed forces was established, as well as the Joint Military Staff. These significant decisions passed relatively unnoticed in the midst of the enthusiasm over the electoral campaign" (Costa Bonino 1995, 185). According-ing to Eleuterio Fernández Huidobro, one of the Tupamaros involved in the 1971 escape and now a national senator, the two tunnels dug for the two big prison breaks crossed each other: He describes the moment of discovery: "Suddenly the sign is illuminated for all to see: 'Here cross the paths of two generations, two ideologies, and a single destiny: freedom.' Just past the

sign, the intersection with the anarchists' tunnel. My eyes will never forget the marks made by their tools, quite visible, clear, meeting ours in the top of the vault" (Fernández Huidobro 1990, 1:141). These signs, traces of struggle and of a non-mercantilistic conception of human solidarity, have been completely eliminated by the dizzying excavation for the shopping center. The "generalized separation" (Guy Debord, qtd. in Solá Morales 1996, 8) imposed by the Punta Carretas Shopping Center is no longer that of the prison as panopticon, but rather that of the market. The ritualization of the market tries to disguise the generalized separation imposed by political repression.

Disguising History, or How to Create Forgetfulness

It is no accident that in recent years the most common locations for Uruguayan social confrontation have been the port of Montevideo, the nearly abandoned construction site of a bridge between Colonia and Buenos Aires, the construction site of a new building for the Carrasco airport, incarceration centers that have seen repeated insurrections and hunger strikes, and the installation points for surveillance cameras in various key zones of the capital.

Nor is it any accident that the post-dictatorship period rehearses certain recurrent themes: the revision of national history, the problem of the disappeared, reform of the penal code, changes in the role of the army and the police, security on the beaches of the most prestigious resorts and spas. In addition, private security services have seen the largest increase in jobs of all types of business. These themes, places, people, and businesses relate directly to a few clear issues: Uruguay's role within Mercosur, the transformation of state security forces under democratization, and the "place" (both symbolic and concrete) of current and historical violence. Contemporary Uruguayan society and government are deeply invested, both economically and psychologically, in transportation and communications infrastructure as well as in security. This investment is expressed in architectural terms and symbolized in newly significant geopolitical and physical sites of meaning.

The port of Montevideo, the various beaches (Punta del Este, in particular), and traffic between Argentina, Brazil, and Uruguay offer particular ways of experiencing danger, violence, and especially the threat that the new regional and world order represent for the country. The new national project of reform is designed to support this new world order, and it is promulgated by

contemporary, hegemonic, modernizing discourse. Beaches, ports, bridges, and highways manifest the hopes and fears produced by the border. These hopes and fears run through Uruguayan history, given the nation's role as a buffer zone between Argentina and Brazil. The ambivalence of the border, as the place of advantage and well as of predatory invasion, explains the contradictory and complicated regulation of movement. It also explains the rigorous control over people, commerce, and symbols that has so preoccupied the different post-dictatorship governments.

Media coverage shows that this obsession with security and the control of violence and criminality bedevils various private sectors as much as it does the state. Such obsession is part of a larger debate in which it is absolutely necessary to erase violence from the public stage in order to realize the ideal Uruguay. The first step toward the erasure of political violence as well as common crime was the attempt to normalize the dictatorship's legacy by rearranging history and managing public memory.[13]

However, the obsession with security and the erasure of violence during the post-dictatorship period cannot block the effect of the new temporality imposed by the contemporary market. In a way, both obsession and erasure are part of the transformations that accompany the globalized present. But on the other hand, Uruguayan temporality has its own rhythm. At the end of the twentieth century, Montevideo seemed trapped in time even though certain changes were already afoot. The city's residents began to see parades of transvestites, homosexuals, and lesbians on Gay Pride Day. The old, abandoned movie theaters that had been converted into evangelical churches or parking lots are now seeing the proliferation of micro-cinema complexes that testify to the film industry's "renaissance" at the local level. New bookstores and museums are opening, and a sculpture park was built around the government center. Not only does every year see more people in attendance at the Iemanjá festivals on Montevideo's beaches, but Afro-Uruguayans are organizing into associations like "Mundo Afro" that seek to reconstruct their history.

In spite of all of that activity, the transformation continues to be uneven, creating many Montevideos and multiple temporalities. These parallel Montevideos share only the same space and the same historical moment. While the city still sees trash recycling carts pulled by horses, and the number of shantytowns or slums grows, in the past decade this same city has also seen the proliferation of cell phones and has begun to navigate the electronic space of MTV. Thus, in the newest films and videos, whether Uru-

guayan or foreign, the city appears as a stage for new artistic expression that tries to adjust to a slow modernity by tapping into the speed of the Internet and the virtual space of television.

Uruguayan modernity, as various political groups call it, is not only a peripheral modernity, but rather also and more importantly a modernity that manifests no major break with the particularly slow rhythm that hegemonic discourse defends as an expression of democratic Uruguay's maturity and responsibility. This modernity distinguishes Uruguay from the turbulent "banana republics" of Latin America. The absence of violence or criminality forms part of this imaginary. The Uruguayan solution to human rights violations during the dictatorship is another example of the "deceleration" proper to Uruguayan society. Four years after the reinstitution of democracy, in order to block amnesty for human rights violators, the country held a referendum against the *Ley de Caducidad* of 1989, which had imposed a statute of limitations on prosecutions for such crimes. The strength of the referendum campaign exceeded that of traditional political proceedings. It did take place in the streets, but there was also a whole series of both "high" and "low" cultural effects. Testimonials, historical revisions, and socio-political analyses shared the stage with carnival groups, plastic arts, plays, and a series of historical novels that dealt with dictatorship and human rights violations. This surge in cultural production implied a rereading of traditional history and opened up new discussions of Uruguay's future as a nation.

Simultaneous with the fight for the referendum, the closure of the old Punta Carretas Prison was finalized, and its transformation into the Punta Carretas Shopping Center was begun. Obviously, the referendum debate about the *Ley de Caducidad* upstaged the discussion about the future of the Punta Carretas Prison. The prison's fate seemed relevant only to the neighborhood's residents, a few former political prisoners, investors in the shopping center, and President Julio María Sanguinetti Coirolo's government. It was of particular interest, however, to Dr. Antonio Marchesano, then minister of the interior in charge of the Punta Carretas Prison and also President Sanguinetti's legal associate, who would later form part of the investment group that built the new shopping center.

According to both Agustín Noriega and Alejandro Solomianski (2003), the debate involved two lines of argument. On the one hand, there was a desire to reappropriate a property that by late 1989, after having served as a prison for eighty years, was valued at several million dollars. On the other hand, there was significant discussion about the future and function of the

architectural structure itself. This second topic, whether couched in terms of architectural heritage, the need for educational and cultural spaces, or the importance of housing for the homeless (Solomianski 2003, citing Noriega), entailed a debate about public memory. It concerned the "break in memory" that the dictatorship had imposed on Uruguayan society.

Today's hegemonic discourse that rearranges Uruguayan public memory was developed and consolidated between the first mention of transforming the Punta Carretas Prison in early 1989, and the opening of the Punta Carretas Shopping Center on July 14, 1994. That discourse represents the country as a nonviolent, democratic community. It links itself to a project that proposes to transform Uruguay's economy into a service economy specializing in tourism, communications, and finance. The changes introduced by the Treaty of Asunción define Uruguay's new geopolitical role in the region, and the concomitant discourse holds that Uruguay enjoys the continent's lowest level of economic inequality, on a par with Denmark or Belgium. There is no criminal, economic, or social violence as in other Latin American countries, including Argentina. Uruguay is a small but refined country. It possesses no significant mineral riches, but boasts a high literacy rate and a five hundred-kilometer coastline full of safe and serene beaches. Sparsely populated, Uruguay is not a very powerful market, but it is quiet. It is completely digitalized, it does not suffer from ethnic conflicts, and it has one of the lowest (if not the lowest) poverty rates in the region. The former guerillas and their allies in the Frente Amplio enjoyed parliamentary representation at the time of the construction of the Punta Carretas Shopping Center.[14] They made up the democratic opposition even though for some people's taste it was still — and this adjective is key to the Uruguayan situation — "nostalgic."[15]

Successive ministries of tourism and the economy, as well as financial institutions, have tried to export this image of Uruguay as Eden. They base this promotion on a defense of Uruguay's exceptionalism and its status as a refuge from the criminal violence and economic fluctuations of Mercosur's two big players, Argentina and Brazil. The Edenic image, however, disguises some undermining facts, beginning with the so-called democratic restoration, whose discourse denied that the Uruguayan dictatorship had introduced a fundamental break in the self-satisfied national imaginary. Other examples from this supposed restoration process include the "Gelman case,"[16] current efforts to find a legal solution to the problem of "the disappeared," the criminalization of Uruguayan society (Rico 2004), the trials in 2006 of various members of the military who were involved in torture, and

the trial of ex-President Juan María Bordaberry for his participation in the *golpe de estado* of 1973.

The Punta Carretas Shopping Center exemplifies the project to transform Uruguay into a new Eden. As a "safe" space in which the violence of old has been eradicated, it reflects the modernizing and pacifying discourse that promotes a friendlier image of the country as well as a new historical function for a modern Uruguay. Unlike other commercial centers in Montevideo (and in all of Uruguay), Punta Carretas speaks with particular eloquence to how the organized and legitimated violence of the market displaces and then substitutes both political and criminal violence. History has been erased, destroyed, and reconstructed here in a way that favors the goals of political discourse and market logic, which seek to impose certain representations on the whole country.

Palimpsests/Arcades/Hotels

Piranesi's baroque imagination could not have conceived of the transformation of his jails into shopping centers. The "mini-cities with glass ceilings, with marble hallways extending the length of buildings whose owners had shared business interests," along whose corridors "were the most elegant shops," that Walter Benjamin describes at the beginning of *The Arcades Project* (2002) did not yet exist. But neither would Benjamin have been able to imagine, with the complete triumph of the panopticon, that Piranesian jails could end up being anachronistic metaphors for the descendents of his "arcades."

It is possible to trace the genealogy of today's shopping malls, which have multiplied in Latin America as well as other regions of the planet, through the galleries (arcades) that Benjamin described early in the twentieth century. Market and architecture, business and technology, are united in Benjamin's vision of the galleries. But what is really at play here is the "space of the market," a modern market that requires modern technologies. In the case of the galleries, it requires iron.

Benjamin analyzes the technological changes that accompanied the development of the modern market: ironworks, but also the first forms of urban transport systems, photography, and daguerreotypes. In more than one sense, Benjamin considers the upsurge of modernity, the market, and the changes that affect daily human life as much as architecture and urban-

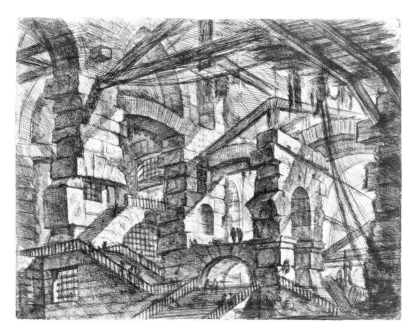

Giovanni Battista Piranesi, "The Gothic Arch" from *Carceri d'invenzione*, ca. 1745–50, published 1753. Printed with permission from the Hood Museum of Art, Dartmouth College, Hanover, New Hampshire.

ism. The machinery of modernity modifies not only transportation, but also art, leisure, and individual rambling. However, more than Benjamin's archaeological work, the twenty-first-century reader notes that his *Arcades* essays describe the moment of modernity's irruption—the *frisson nouveau*, a term that Victor Hugo attributes to Charles Baudelaire in a letter from October 6, 1859 (Pichois 1973, 188). Both Baudelaire and Benjamin register the new, that which severs relations with the past, which carries no historical charge, and which looks only to the future. Of course there is a difference: Baudelaire lived that moment while Benjamin analyzes it from a vantage point closer to the century that sees, if not a new wave of modernity, then at least an acceleration. Perhaps that is why Benjamin recurs to the image of the angel gazing with horror on the past as a pile of ruins.

I want to focus on the centrality of the temporal dimension in both Baudelaire's and Benjamin's descriptions of the market and the modern city as new spaces. This temporality simultaneously destroys and builds, constitutes and displaces, locations, identities, stories, behaviors, and values. It

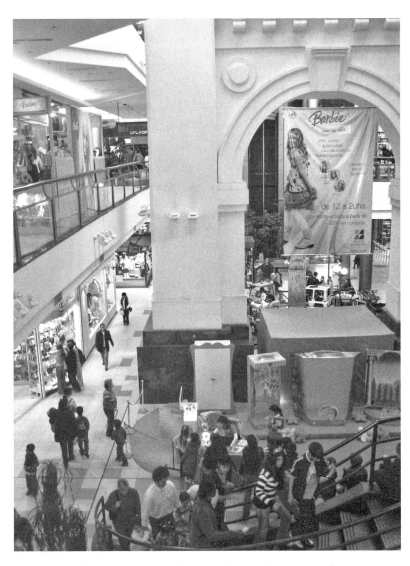

Interior view of a Punta Carretas arch, 2007. Photograph by Hugo Achugar.

relates to a particular experience of space. It changes artistic as well as mundane perceptions and symbolizations. Even more, it alters the very experience of modernity and modernity's effects on displacement and velocities. It redefines contemporaneity.

In this sense, we can read the Punta Carretas Shopping Center as an updated version of Piranesi's images as well as of Benjamin's arcades. That is, we can understand it as a perverse form in which the inexorable machinery of the market reveals its ability to swallow up every type of space. In the shopping center, it is not the state, but rather the logic of the market that produces discipline and control (as imagined by Jeremy Bentham and analyzed by Michel Foucault). Discipline and control create a regulated space in which the old, messy market of the plaza comes under the gaze of the shopping center as panopticon. It is a perverse form, if not of the contemporary prison, then of exclusion and the violent imposition of collective forgetting. It also updates Parisian arcades to complement Uruguay's late-twentieth-century traumatized modernity.

The thousands of people who, every weekend, traverse those unconsciously Piranesian spaces of the Punta Carretas Shopping Center, with its endless escalators disappearing into a mechanical simulacrum of the infinite, resemble the characters that overwhelm the second engraving of *Carceri*. They are similar in that these thousands of people moving through the corridors of the too brightly-lit atria, hands stuffed in their pockets, gawking at the mirages of a cornucopia of goods that they cannot afford to buy, are the contemporary expression of oppression. The shopping center, as a paradigmatic market space, determines the existence of two types of consumers: those who are "successful consumers" and the others, "failed consumers" (Bauman 2005). The latter are prisoners of a new kind. They are not incarcerated, but they are actively excluded. They are citizens of the state, but they are denied citizenship in this mini-city, or this mini-state, of the shopping center (García Canclini 1995).

The presence of security guards (although their presence is not unique to the Punta Carretas Shopping Center) reinforces the idea of monitored space, or of the panopticon. The "inhabitants" of a prison reside there against their will; while no one is physically forced to walk through a shopping center, both situations involve a type of control that discriminates and establishes limits on individual freedoms. In the one case it is the weight of the law, and in the other case it is the weight of the market. In both cases, however, there

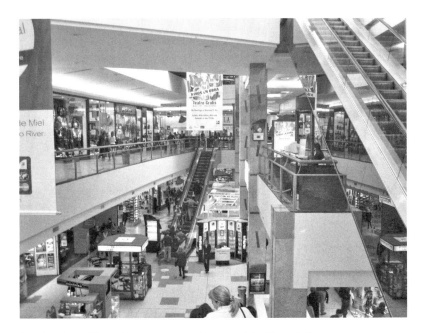

Interior view of Punta Carretas, 2007. Photograph by Hugo Achugar.

are always some whose desires and liberties are kept from being realized, while others "guard" or "supervise" and have the power to punish. It is true that not all citizens are prisoners and not all shoppers at Punta Carretas are "failed consumers," but the parallel between prisoners and failed consumers holds insofar as for both populations the force of the law or of the market punishes those who do not meet their respective requirements for full citizenship.

The shopping center also controls even the "successful consumers." It imposes equally on everyone a kind of forgetting, a form of impossible desire. The memory of absence substitutes for other memories, for the satisfaction of other desires. This is like the situation facing the diminutive figures in Piranesi's engravings. Perhaps, though, another dimension of the Punta Carretas Shopping Center's offerings exceeds Piranesi's vision on a different scale. I am referring to events like the Liza Minelli concert that took place in 1995 in one of the center's open-air parking lots under a torrential rain. Minelli's appearance, as with those of Plácido Domingo and José Carreras in the same space before her (along with other events that continue to this day), is a particularly absurd aspect of the attempt to erase the site's serious

history. Notably, this part of the project was not facilitated by the state, but rather entirely by the market.

An even greater irony, however, is that the formerly obligatory dormitory of the Punta Carretas Prison has been replaced by a recent addition to the shopping center: a Sheraton hotel. It seems that the global marketplace has won. Hotels, and not only five-star hotels like the Sheraton, beautifully represent all that characterizes globalization: migration, non-stop traffic, the flow of information and people (Appadurai 1996). Hotels, like borders, ports, beaches, bridges, and shopping centers, are sites of transit and passage. Therefore, they are ideal sites of control and order, at once a place of movement and parentheses, or pause.

Today the Punta Carretas Shopping Center, more than a "safe" space, is a metaphor. In this metaphoric space, memory has been partially demolished. I write "partially" because, in spite of the power that sustains it and the defeated resistance to it, the center has not completely erased its own memory of place and history. Remember that one of the architects saw the original building as a "mall for prisoners." In that sense, the shopping center architects' postmodern citation of Piranesi's *Carceri* reveals the palimpsestic nature of this site of memory. Even if the shopping center is an unwilling site of memory that celebrates the powers that made it possible, it also registers the traces of resistance. Even when it seems conquered by market logic, that resistance works to keep the gangrene of forgetfulness from infecting absolutely everything.

Conclusion

The change in Punta Carretas Prison's identity and function took place in a territory charged with memory, in a space criss-crossed with history. The transformation reveals that the relationship between space and memory is never innocent. It shows how market forces operate on materiality, and in this case, in a specific space whose history will not be completely erased.

Memory and market seem to be antagonistic concepts. The "memory of the market" sounds like an oxymoron. However, the *space* of the market— whether it be a plaza, a mall, or a department store—can certainly be related to memory. In that sense, maps and terrains, plazas or marketplaces, are always marked by time and by historical or collective memory. The accelerations of temporality become especially visible when a particular space—a

map, a region, a city, or a building—is configured by social or historical trauma. Such is the case of the symbolic, political, and economic reconfiguration of the Punta Carretas Shopping Center and of present-day Uruguay.

Notes

This essay was translated from the Spanish by Rebecca E. Biron.

1 Jacques Leenhardt, "Arte do Mercosul," 1999–2000, http://www.joycelarronda .com.br/1bienal/CritEsp.htm. This website describes the Biennial of Mercosur, a series of art exhibitions that featured works by artists belonging to the Common Market of the South.

2 In 1493, after learning of Christopher Columbus's "discoveries," Spain's King Ferdinand and Queen Isabella sought the Pope's support for their conquest of the New World. They hoped to block Portugal's claims as well as those of future rivals. In order to help the Spanish rulers, Pope Alexander VI, who was a Spaniard by birth, issued a Papal bull establishing a line of demarcation that stretched, from pole to pole, 100 leagues (about 500 kilometers), ending to the west of the Cape Verde islands. The Treaty of Tordesillas that was signed on June 7, 1494, by Spain and Portugal was meant to resolve the conflict over the land "found" by Columbus and other fifteenth-century explorers. However, the line of demarcation ran 370 leagues (about 1,600 kilometers) west of Cape Verde. Pope Julius II confirmed the agreement in 1506. In spite of Pope Alexander VI's geometry and the confirmation of the Treaty in 1506, the border that it established would not remain fixed. It continued to be moved according to the interests of Portugal, and later Brazil.

3 I use the term *nation* here with its contemporary meaning, to refer to indigenous groups as equivalent to developed, European, national communities.

4 Naturally, reparations did not take into account the pre-Columbian indigenous nations that were absorbed into the nation-states created in the nineteenth century. This topic merits much more discussion than I have space for here.

5 I am referring here, for example, to the widely publicized plane crash in 1972 involving Uruguayan rugby players and their supposed cannibalism as a form of survival. One can also point to the more symbolic aspect of contemporary Uruguay's endogamic society.

6 Over the past two years, Argentina and Uruguay have argued before the International Court of The Hague, as well as in other international and regional institutions, over the establishment of a Finnish pulp mill on the Uruguayan shore of Río Uruguay. This has led to mounting confrontations between diplomats and in the media. It has resulted in the "friendly" closure of international bridges connecting both countries by local environmental organizations in Argentina. With

the support of many other countries, Uruguay has rejected accusations that its plan will cause pollution.

7 Latinobarómetro is an annual public opinion survey that involves eighteen Latin American countries, representing more than 400 million inhabitants. Latino-barómetro, "Press Report 2006," online data bank, http://www.latinobarometro .org.

8 Jacques Leenhardt, "Arte do Mercosul," http://www.joycelarronda.com.br/ 1bienal/CritEsp.htm.

9 "Arquitectura and Diseño," weekly supplement to El Cronista (Buenos Aires), July 20, 1994; quoted in Solomianski 2003, 249.

10 One might make a similar argument about the transformation of the former Breakwater prison of South Africa's Cabo City into the hotel called Breakwater Lodge and the University of Cabo's School of Business Administration. In doing so, however, it would be important to study the differences between the Uruguayan and South African political processes, as well as the difference between the mall and the hotel.

11 Noriega's manuscript, "Estudios generales sobre el Penal-Shopping," is quoted in Solomianski 2003. My discussion of Noriega is based on the portions of his work that are reproduced in Solomianski 2003.

12 This section of my essay relies heavily on Solomianski 2003.

13 Specifically, I am referring here to the Ley de la Caducidad Punitiva del Estado and the referendum to defeat that law in 1989. The law gave the government permission not to prosecute those who had carried out torture, murder, and disappearances for the dictatorship. I discuss this issue later in the chapter.

14 The Frente Amplio is a left-wing Uruguayan political party. It was founded in 1971 as a coalition of historical parties on the Left.

15 A little more than ten years later, that same opposition would win the national election and would control parliament with a commanding majority.

16 The "Gelman case" refers to the kidnapping and disappearance of María Claudia García and her husband, Marcelo Gelman. Their daughter, born in captivity in Uruguay and adopted by the family of a Uruguyan policeman, has requested that Uruguayan courts reopen the investigation into her mother's death.

Culture-Based Urban Development in Rio de Janeiro / *George Yúdice*

With few exceptions, Latin American cities of all sizes, but especially mega-cities, have deteriorated quite rapidly since the so-called lost decade of the 1980s. Dozens of deadly prison riots have taken place since the mid-1980s (see "Motines y revueltas" 2005), and by 2006 organized crime had taken over entire areas of São Paulo and Rio de Janeiro. Class- and race-based residential segregation is worse than ever, and a foreboding sense of insecurity prevails. No doubt the media's penchant for sensational crime stories contributes significantly to the anxiety, even in relatively small and safe cities like San José, Costa Rica. But the legacies of the lost decade—reduction of public spending for social services, privatization and concomitant decreases in tax revenues, and the loss of employment opportunities—characterize the region as a whole.

In this context, several culture-based urban development projects have emerged. They are of two types: lavish investment in cultural infrastructure (revitalization of heritage sites, particularly in colonial city centers, and construction of high-profile museums) and community-based development of creative resources to deal with exclusion, marginalization, and lack of opportunities. In this chapter, I review critically a proposal to build a Guggenheim museum in the downtown port area of Rio de Janeiro. Then I examine several local networks and cultural groups that are seeking to transform Rio, neighborhood by neighborhood, harnessing the creativity of local residents as well as professionals and celebrities who participate in their networks.

In the spring of 2003, Rio de Janeiro city authorities signed a contract with the Solomon R. Guggenheim Foundation to build a Guggenheim museum

designed by Jean Nouvel. The Rio Guggenheim would equal in spectacularity the landmark buildings of Frank Lloyd Wright's Solomon R. Guggenheim Museum in New York (1959) and Frank Gehry's Guggenheim Museum Bilbao (1997).

Designed to occupy the four-hundred-meter-long Mauá pier in the port area at the edge of downtown Rio, the museum complex would begin with an enormous white wall, eighty-two meters long by thirty-eight meters high. The government's official description of it reads like the usual hard-branding strategy of global arts–and entertainment-led urban regeneration, a concept which Graeme Evans (2003) has discussed in depth:

> An enormous, luminous canvas hovers over the entrance. That immense wall is a powerful urban sign that can be seen from the highway and the piers. Erected at the edge of the museum's footprint, the canvas plays a symbolic and significant role. Like a sign, it is seen from the elevated highway, like a tall and narrow line, with the Guggenheim logo at the top. From the Praça Mauá, it emerges like a strange object that augurs the programming of the museum in a subtle play of white on white. From the pier, the canvas softens the view of the city, especially the elevated highway, and buffers the traffic's din. Symbolically, the white rectangle is usually understood as a virgin canvas, on which one's perceptions become memories, a figure of the psyche. (Prefeitura da Cidade do Rio de Janeiro 2002)

At the other end of the pier, the museum complex ends with a cylindrical concrete tower, topped by a roof restaurant with a cloud-like canopy. Between the white wall and the tower, a row of pavilions, some of them submerged in the bay, reference a sunken rain forest and presumably evoke the lost city of Atlantis (Nouvel 2003).

According to César Maia, Rio de Janeiro's then mayor and most assiduous promoter of the project, it was to be the centerpiece of "the renewal of [the city's] historic center through the rehabilitation of the port area, and its economic development." The obvious precedent was the Bilbao Guggenheim, which became a must-see icon and dramatically increased tourism and revenues. "As in all great cities of the world," Maia argued, "investments in urban resources make a city unique and increase the value of the existing public patrimony. The value of that investment will ultimately be greater than the original investments."[1]

The port area, deteriorated over the years and a site for prostitution and

crime, nevertheless is one of the main historical areas of Rio, with a dozen cultural institutions within a short radius. Advocates argued that the Rio Guggenheim would stimulate investment not only in that specific location, with a concomitant rise in property values and therefore a higher tax base for the city government, which would enable increased spending on social services. But, they hastened to add, it would also stimulate investment in the already existing cultural institutions (e.g., the Museu Histórico Nacional, the Museo Nacional de Bellas Artes, the Museu da República, the Museus de Castro Maya, and the Imperial Palace [Paço Imperial]) as well as important landmarks in Rio's historical heritage, like the Mosteiro São Bento.

Additionally, Maia and other advocates, such as Augusto Ivan de Freitas Pinheiro, the urbanism director of the Instituto Municipal de Urbanismo Pereira Passos, reasoned that development of the port area, with the Rio Guggenheim as the magnet of investment, would reintegrate the city. By attracting all social classes, it would reverse the trend toward segregation represented by the upscale neighborhoods of the Zona Sul (Copacabana, Ipanema, Leblón, and Gâvea) and especially by Barra da Tijuca, on the outskirts of Rio, where most capital investment had migrated in recent years.

Despite all of the benefits presented by the mayor and the feasibility study (Prefeitura da Cidade do Rio de Janeiro 2002), a judge, convinced by a groundswell of opposition, declared the contract unconstitutional. The primary reason for the decision was that the mayor had committed the city to a ten-year period of payments to the Guggenheim Foundation, which exceeded the terms for fiscal obligations of the 2003 budget. The judge also based his decision on the impropriety, in his view, of holding the city subject to New York state law in its contractual obligations, since all services in the cultural sector are also subject to Brazilian national law. Additionally, he argued that although the city originally agreed to make its payments to the Guggenheim Foundation in local currency, the final wording in the contract committed it to pay in U.S. currency. The judge concluded that "in truth, when you read the wording carefully, you get the impression that the city signed a contract taking advantage if its status as a public entity but for matters for which it does not have the authority" ("Justiça barra Guggenheim" 2003).

One month later, the Rio de Janeiro Supreme Court preliminarily ratified the judge's decision and ordered the city to withhold the first payment installment to Jean Nouvel, who was to receive $12 million for his work on the project ("Justiça do Rio veta construção do Museu Guggenheim" 2003). Two

months later, the project was definitively halted when the supreme court suspended the contract. The justices also observed that although the mayor committed to $130 million for the construction of the museum, Thomas Krens, the director of the Guggenheim Foundation, had raised the price tag to $210 million (France Presse 2003). Actually, Krens and other members of the Guggenheim team had over time mentioned construction costs that ranged from $200 million to $240 million, and some of the critics calculated that it could exceed $300 million.

While there were important supporters, like the architect Agácio Gil Borsoi, interested in Rio's architectural heritage, they were overwhelmed by the opponents, who succeeded in getting the municipal assembly to investigate the negotiations. Public debate was quite spirited and media coverage widespread. Aside from the price tag, which most opponents considered obscene in a city marked by a 35 percent poverty rate, criticisms focused on the sources of the funds to pay for the museum, the potential effect on the other cultural institutions of the city, the difficulty of accessing the museum for lower-income residents, a general suspicion that the mayor's declarations and accounting were not entirely honest, and the lack of public and professional discussion and input in the formulation of the project.

The Congress of Brazilian Architects convened on May 3, 2003. After much discussion, the Congress voted to demand that the city rescind the contract with the Guggenheim Foundation; that all such projects be open to discussion, particularly with professionals in the field and with representatives of the communities involved; and that, once formulated, all such projects be opened to a public call for proposals. Among the reasons cited for these demands was that the project was likely to have cost overruns not foreseen in the contract or the feasibility report. Also cited was the fact that city has numerous cultural centers and museums and major urban icons recognized nationally and internationally, many of which are in need of funding that under the recently legislated cultural-incentive laws would otherwise be channeled to the Guggenheim. The Congress gave as an example the then-current "International Exhibition Rio Architecture" that occupied thirty-five establishments with more than forty exhibits (Andrade 2003).

The claims made in the feasibility report that the new Guggenheim would spur development of the port area in such a way that it would bring millions of tourists and thousands of workers in need of jobs, were seen as convenient and predictable arguments characteristic of such documents, but they were contradicted by numerous local organizations, workers unions, other

cultural institutions in the area, specialists in cultural tourism, and cultural management programs at the Federal University of Rio de Janeiro. In the first place, despite arguments about public impact, the Guggenheim administration and Rio government and business authorities had not circulated a plan that detailed the specifics of what benefits the museum would bring, nor who would be the beneficiaries—local residents or the upper and middle classes who would visit, would work there, and own property whose value would rise.

Moreover, critics pointed out that the so-called private investment to be raised through cultural incentives provided by Brazil's generous tax incentive laws would have negative consequences for other cultural institutions. Partly modeled after U.S. tax deductions for contributions to nonprofit organizations, the tax incentive laws in Brazil mainly benefit large corporations and banks, or corporations with good connections, which generally open their own cultural foundations, to which they pass their tax-incentivized contributions, usually to support "cultural marketing." Edemar Cid Ferreira, then president of the Brazil-U.S. Council and of the Associação Brasil +500, who began negotiations with the Guggenheim Foundation to get the project started,[2] is famous for having raised the tens of millions of dollars necessary for São Paulo's Quincentenary Exhibition. A selection from that exhibition, "Body and Soul," was presented at the New York Guggenheim museum in great part to grease the wheels of the deal—at the cost of $8 million to Brazil for sponsoring the exhibition.[3] As one critic remarked, the arrival of the Guggenheim at Rio's port would be only the latest in a historical series of transfers of capital from Brazil to the North since the arrival of the Portuguese, the Dutch, the English, and so on.

Museum directors in Brazil have been quite critical of the cultural tax incentives, because they facilitate privatization by banks and other large corporations. They do not lead to institution building, nor are they sensitive to the socio-cultural and aesthetic aspects of art. Parulo Sérgio Duarte, the director of the Fundação Iberê Camargo, criticized the $40 million spent on the "Brazil 500 Years" exhibition because it did not add even one work to the collections of the museums to which it circulated. Moreover, Duarte is critical of institutions, like the Associação Brasil +500 years, that sponsor temporary exhibitions and deduct 100 percent of their contribution. For Duarte, this is an "inexplicable distortion," especially when contributions for acquisitions are eligible only for a 70-percent deduction. Even these deductions are quite high and "corporations do not really disburse funds but

simply decide for the government what to do with the money owed in taxes as a means to exhibit their logos."[4] Paulo Herkenhoff, the curator of the twenty-fourth São Paulo Biennial in 1999 and the current director of the Museo Nacional de Bellas Artes in Rio de Janeiro, criticized the decision of the then-president Fernando Henrique Cardoso to entrust a banker—Edmar Cid Ferreira—with the major commemoration activity of Brazil's celebration of its five hundred years (Hirszman 2004).[5]

While the Rio Guggenheim would have introduced to the city a state-of-the-art building and a menu of services not offered by any other institution, critics argued that the public funds spent on this project alone would have been enough to sustain all other cultural institutions in the city for at least a decade. According to Teixeira Coelho, just the amount spent on the Rio Guggenheim feasibility study ($2 million) would have covered half the expense of constructing a new building and relocating the Museu de Arte Contemporânea to downtown São Paulo, a project that he directed until March 2002 (personal communication with Coelho). The amount budgeted for the Rio Guggenheim's collection alone—$12 million per year, as demanded by the Guggenheim Foundation—was more than 250 times larger than the entire operational budget—$45,000—of the City Historical Museum of Rio de Janeiro.

For many critics the revenues to be generated by the Rio Guggenheim and other franchise museums are part of the Guggenheim Foundation's strategy to overcome its economic crisis. The funds would make up for the huge deficit gap that not even the board member Peter Lewis's gifts of $77 million over twelve years could fully cover (Rosebaum 2003).[6] The Rio Guggenheim's projected annual operating budget was estimated at $23.8 million. This included almost $1 million for the Guggenheim's curatorial fees; $3 million for expenses related to partnership arrangements with the Guggenheim network (New York, Bilbao, Berlin, and Venice), the Hermitage Museum in Saint Petersburg, the Kunsthistorisches Museum of Vienna, and the Center for Art and Media in Karlsruhe, Germany, brokered by the Guggenheim Foundation for the sharing and rotation of works for exhibitions; $9 million for exhibitions (to be raised by corporate use of the Lei Rouanet cultural tax incentive law); and $8 million to $12 million in direct subsidies for which the Rio municipal government would be responsible. There was also a one-time charge of $20 million for use of the Guggenheim trademark.

But whether or not the Guggenheim's economic crisis is the ultimate reason behind the push to "McGuggenize" (McNeill 2000), the question to ask

from a "culture and development" perspective is whether the Rio Guggenheim, even under the best of circumstances, could be capable of bringing about citizen development. That is, could it facilitate the creation of public spaces, or provide opportunities to tap and channel creativity to serve individual and collective needs and to find solutions to social problems like urban segregation, racism, classism, and educational deficits? How many jobs would be created and would they be sustainable? The Rio Guggenheim project made some nods in this direction; it claimed that there would be a significant increase in employment in the area and proposed that it could reverse the segregation brought about by the development of elite neighborhoods like Barra da Tijuca, but there is little precedent among Guggenheim projects for addressing social concerns. While the Bilbao Guggenheim was successful in contributing to Bilbao's regeneration, its project was a top-down, business-centered development scheme.

According to the Bilbao revitalization plan, local political and business leaders, concerned about Bilbao's fraying post-industrial infrastructure as well as the city's reputation for terrorism, sought to revitalize it by investing in cultural infrastructure that would attract tourists and lay the foundation for an economic complex of service, information, and culture industries. By investing in a museum stamped with Frank Gehry's stylistic grandiosity, city leaders provided the magnet that would attract those activities that "give life," to use Manuel Castells's words: "Alongside technological innovation there has mushroomed an extraordinary urban activity . . . fortifying the social fabric of bars, restaurants, chance encounters on the street, etc. that give life to a place." Enhancing the quality of life in this way enables a city to attract and retain the innovators indispensable to the new "creative economy" (Castells 2000). "Knowledge, culture, art . . . will help catapult Bilbao to the short list of world capitals," claimed Alfonso Martínez Cearra, the head of Bilbao Metrópoli 30, a network of government officials, businessmen, educators, nonprofit directors, and media executives who spearheaded the city's development (Jacobs 1997, 14).

Unlike the Rio Guggenheim, the Bilbao museum was part of an integral strategy to transform Bilbao itself into an advanced service economy. "The availability of the factors of production, the existence of an adequate network of infrastructures, the possibility of access to the reception and diffusion of information, as well as other aspects linked with technological conditions, are factors of the metropolitan area that condition the location of advanced services. Nevertheless, there are others no less important, such

as the existence of an agreeable environment, an adequate formative offer, availability of qualified and diversified manpower, cultural and leisure offer, and so on."[7] Whether or not the revitalization plan was more rhetoric than strategy in terms of cultural development, at least Bilbao included such priorities as the following: cultural and recreational information to contribute to "greater cultural formation"; promotion of an educational system "with a greater presence of culture in the study plans and complementary activities, open to the interchange of international experiences"; promotion of "active participation in cultural dissemination and coordination of the different public initiatives that allow [the city] to convert Metropolitan Bilbao in [sic] a focal point of cultural creativity"; and links to the culture industries.[8]

Yet while the Bilbao revitalization plan established a dialogue with a wide range of business and institutional actors (which the Rio project did not), and a useful set of networked urban interlocutors (Ruhr, Lille, Lyon, Nantes, Newcastle, and Rotterdam in Europe; Austin, Baltimore, Cleveland, Detroit, Pittsburgh, San Francisco, Seattle, and Silicon Valley in the United States), it did not include a wider dialogue with civil society organizations in the planning stages. It may have held to the principles of promoting the so-called creative industries (valorized by the protection of copyright and other intellectual property rights) for economic purposes, but it did not include all of the elements that Charles Landry and Franco Bianchini (1995) lay out in their approach to "creative cities."

Landry and Bianchini identify a "creative milieu" constituted by a combination of "hard" infrastructure (buildings, technologies, institutions, and transportation and communications networks), and "soft" infrastructure defined as "the system of associative structures and social networks, connections and human interactions, that underpins and encourages the flow of ideas between individuals and institutions" (Landry and Bianchini 1995, 133). The idea of soft infrastructure implies that networks are never simply technological, nor industrial clusters simply institutional or economic. Rather they have a symbiotic relationship with communities, linking the physical and interpersonal. Hence, creativity and innovation are not only essential to the development of new products and services, but also to the development of a dynamic city or region. But such "dynamism" should be measured by the contribution that innovation and creativity make in redistributing wealth, both by building infrastructure that leads to greater human capital—schools, libraries, skills-training programs, hospitals, and so forth—and creating jobs that lead to greater social mobility. In this regard, the

creative cities model has been quite limited, mostly to urban clusters and to gentrification initiatives that relegate lower-wage earners, minorities, and immigrants to congested areas further from their workplaces.

Landry and Bianchini also promote collaboration as an important element of the city dynamic. For them, the necessity of collaboration is evident when one considers the network of actors and institutions, the need to move away from binary thinking in social problem solving, the mixing of people and the desire to harness the many talents any group of people possesses, and the need for the acceptance of radicals and outsiders to bring in change (Landry and Bianchini 1995, 134). Because administrative bureaucracies can stifle creative innovation, Landry and Bianchini offer a series of strategies for transforming them: integrated thinking and boundary blurring, thinking organically instead of mechanistically, creating cooperative space, and reassessing and evaluating what counts as success. One of their valorized strategies of collaboration involves public-private partnerships, which can diversify the sources of funding and presumably get greater input from society at large. Yet quite often the involvement of public agencies and some civil society organizations provides the legitimacy for projects that serve the interests of private enterprise with little accountability to the electorate. These arrangements are even more problematic in areas where there is already little accountability or where clientelistic relations may mitigate accountability. Moreover, citizen collaboration often does not include the poorest residents, who may be the ones most affected.

From the vantage point of Latin American cities, it is striking that there have been a number of urban development projects (for example, the Pelourinho in Salvador da Bahia, Puerto Madero and Palermo Viejo in Buenos Aires, and the Jorge Vergara Center in Guadalajara) that have opted for the marriage of capitalism and culture. Certainly, in these post-9/11 times of violent intercultural violence and intolerance, the optimism of cities like Paris, London, and Amsterdam has frayed. Yet new creative initiatives responsive to citizen welfare have emerged in beleaguered circumstances, such as in Bogotá (under the leadership of Mayors Antanas Mockus and Enrique Peñalosa), Medellín (under the leadership of Mayor Sergio Fajardo) and Rio de Janeiro (in the Favela-Bairro Program and other projects). Against considerable odds, projects emerge to undo centuries of disrespect, particularly for the poor. These projects seek to remedy the segregation wrought by middle classes seeking protection from organized crime as well as the poor behind security systems that turn urban life into societies of control. Under such

circumstances, the poor are excluded from the exercise of citizenship, and consequently they sometimes invade the shielded space of privilege.

In his book *Cidade Partida* (The divided city) (1994), Zuenir Ventura paints the picture of Rio as a city composed of two separate parts: that of the rich, particularly the *Zona Sul*, and that of the poor, the *favelas* (slums) and the outlying areas of the north and west. Contrary to what many *cariocas* (residents of Rio de Janeiro) have registered in their memory of the city, there was always a division between the haves and the have-nots. If the golden years of the 1950s, of bossa nova, are remembered so nostalgically in the current period of record violence,[9] it is because the tarnished parts were banished from the view of the middle and upper classes. As Ventura writes: "In truth, during this century, from the reforms initiated by Pereira Passos [1903–1906] up to the plans of [Donat-Alfred] Agache [1926–1930] and [Constantinos A.] Doxiadis [1964–1965], the option [for the elites of the city] was always one of separation, if not a more outright segregation. The city was civilized and modernized by expelling its second-class citizens to the local hillsides and the outlying areas" (1994, 13).

An even stronger indictment of the violence and poverty in Rio is Arnoldo Jabor's article "As favelas do Rio são países estrangeiros" (Rio's favelas are foreign countries) from 1995. He begins by stating that "all the plans against violence and poverty in the city are vitiated by an ideology of exclusion." His point is that it is too late to repair that exclusion, or at least, that it is not up to the elites to carry out that work of reparation. The reason for this is that the white middle classes (*população branquinha*) have not shown a real ability to live side by side with the darker denizens of the favelas and *suburbios*.[10] According to Jabor, "what disturbs the elite of the Zona Sul is not the mugger. It is the walker (passeante), a poor flâneur. Dark flâneurs in sandals and shorts clog the streets of the Zona Sul. They can feel the fear of the middle classes and they parade with style. The white cariocas take umbrage, as if they were the only native city dwellers."

By the late 1980s and early 1990s, the exclusion could no longer be managed. Additionally, the emergence of powerful narco-trafficking gangs in this period provided employment for poor black youth excluded from the formal job market. Violence broke out in spectacular incidents in the 1990s. One of these incidents—the massacre of twenty-one residents of Vigário Geral on August 30, 1993—led the journalist Zuenir Ventura to climb the hillside favelas to understand the violence and to seek solutions. The local narco-traffickers had killed four police officers who sought to steal a drug

shipment. A large police battalion entered the favela the next day and shot indiscriminately at the people gathered in the central plaza. In the place of the massacre, the Casa da Paz (House of Peace) was subsequently built, a kind of memorial community center, which to this day is the center of a citizenship movement within the favela.

For Ventura, the separation of classes, which presumably enabled the good life of the Zona Sul in the golden years of the 1950s, turned out to be the nightmare of the middle and upper classes in the 1980s and 1990s. His point is that this policy of apartheid was not only disastrous from a humanitarian and moral point of view, it turned out to be a disaster from the standpoint of efficacy in administering the city. The policy boomeranged on the elites:

> The *barbarians* are the great source of malaise at this century's end. The [policy of] exclusion turned out to be the greatest social problem. There seemed to be no problems so long as all we heard were the sounds of samba coming from the favelas. But now we also hear gunshots. This is not a civil war, as some mistakenly think, but a postmodern, economic war, which depends on the laws of the market as much as on the arts of war. We are dealing here with a kind of commerce. That is why there is no magic solution within sight. It's obvious that the advance guard—the drug traffickers who practice the barbarities—have to be destroyed in an implacable show of force. But to exterminate them is easier than to dismantle the economic circuit that sustains them and whose center of gravity—production and consumption—is not in the favelas themselves. (Ventura 1994, 14)

The point of Ventura's book, however, is that the two parts of the city can be reconnected. And it is for this purpose that he undertakes to become the flâneur of the barbarians' territory, to discover, of course, that they are no more barbarian than his own neighbors. Indeed, the favelas have also become fertile ground for the emergence of social movements, with strong roots in cultural activism, that seek to give poor youth an alternative to becoming cannon fodder for the narco-traffickers or easy targets for the police. But before detailing this different kind of urban cultural development, I would like to give a brief profile of the favelas.

About 25 percent of Rio's population resides in about six hundred favelas (Oliveira 2000). Although the favelas have existed since the late nineteenth century,[11] particularly after abolition in 1888, the problem that the favelas

now pose (or, that elite society poses to them) worsened after the end of the military dictatorship that held power from 1964 to 1984. By the 1990s, it had become obvious that favelas could not be eradicated and elites would have to continue to rub shoulders with the poor on the streets. Mayors César Maia (1993–1996 and 2001–2004) and Luiz Paulo Conde (1997–2000) sought to integrate them into the formal city. The Favela-Bairro (favela-neighborhood) Program was implemented by the Secretaria da Habitação (Municipal Housing Secretariat) to provide basic infrastructure and hygiene, such as electricity, potable water, garbage disposal, and social integration projects like skills training centers, kindergartens, sports facilities, and community centers (Segre 2004).

As if following in Ventura's footsteps, they sought to erase the dividing line (the "cidade partida") between morro (unpaved hillside shantytowns) and asfalto (the paved sidewalks of the middle and upper middle class neighborhoods of the South Zone of Rio: Copacabana, Ipanema, Leblon, and Gâvea). The program also sought to understand the communal and aesthetic value of the bairros (neighborhoods) and rid them of the stigma of ghetto-hood. Contrary to the utter absence of any strategy for linking the Rio Guggenheim with low-income urban development, Favela-Bairro worked with a number of highly esteemed local architects and firms to find solutions in conjunction with community input. Instead of seeking to eliminate favelas, they studied the complexity of informality, the spatial logics and structures of the preexisting neighborhoods. They discerned modes of community and designed projects that adapted to their topographic and ecological structures, as well as respected the local cultural and symbolic systems. Ongoing dialogue with the communities was standard procedure, and that dialogue extended to the creation of complex networks of heterogeneous actors. While successful to a degree in linking favelas with surrounding neighborhoods, the project could not eliminate violence, in large part due to the commanding presence of narco-trafficking gangs (Segre 2004).

The logics of collaboration, consultation, complex networking among heterogeneous actors, and valuing the cultural systems of the community have been put into practice by the Grupo Cultural Afro Reggae (GCAR), an ensemble of fusion bands, theater and circus acts, and mentors to favela youth. The GCAR came into being in 1993. Like various other citizen initiatives, it aimed at countering the violence that racked Rio de Janeiro at the beginning of the 1990s.[12] In the final months of 1992 and again in the winter of 1993, youths from the outlying favelas launched a series of arrastões

(looting rampages) that was opportunistically overdramatized by the media, sending the middle classes into panic. But it was the brutal violence against the poor that immediately prompted the formation of a "citizen action initiative" known as Viva Rio.[13] On July, 23, 1993, eight street children were murdered by a "social cleansing" death squad made up of off-duty police in front of the Candelária Church at the major intersection of Rio's downtown avenues. A month later, the aforementioned massacre in Vigário Geral took place.

The community movement of Vigário Geral, which arose in response to these acts of violence, was formed to analyze what had happened, to demand justice, and to develop ways of enhancing citizenship values and access to social services. The group also took on the task of demonstrating to the rest of the city that "the people who live in shanty towns are honest; that we exist, that we can also be intellectual, that we can also produce culture" (Colombo 1996). The challenge before the people of Vigário Geral was to capture the public realm, to counteract negative stereotypes of favela residents that legitimized abusive police invasions with their own empowering spectacle. The group decided to transform the "house of war" in which the family of eight had been murdered into the Casa da Paz.

The massacre in Vigário Geral provided GCAR's coordinator, José Júnior, with a mission not to change youth culture but rather to use music and dance to attract its members to a "new ethical and moral field"; rather than claim the moral high ground, he sought to instill recognition and affirmation of these youths' "beauty and positivity" (Roque 2001, 62). Júnior sought to institutionalize the GCAR as a nongovernmental organization (NGO) in order to expand activities from cultural self-esteem to the provision of social services. To do this he needed support, which he got from Viva Rio and by forming a dense network of connections with local and international NGOs, human rights organizations, politicians, newspaper reporters, writers, academics, and entertainment celebrities. At the heart of Júnior's initiative was the idea that music, as the practice that best characterizes fusion or sampling, could serve as the platform through which favela youth would be able to dialogue with their own community and the rest of society. Although Júnior may not have thought of it at first, the musical practice of GCAR was to become the polyglossia of sociability that he imparted to these youths.[14]

After much success in establishing peace in the favelas in which GCAR worked, and in taking the Afro Reggae band to stardom (they produced two CDs with Universal Records, performed at Carnegie Hall, and produced an

award-winning film, *Favela Rising* [Zimablist and Mochary 2005]), Júnior expanded their work to consciousness-raising with the police. This action might be understood as a Favela-Bairro intervention in reverse: a favela dweller crossing over to the other side to reform it for the sake of survival. Júnior and several Afro Reggae band members took their practice of collaboration in music-making to the Belo Horizonte police department to bridge the gap between the police and poor youth through cultural activities involving theater, music, percussion, graffiti, and circus. To this end, GCAR partnered with the Center for Studies on Public Security and Citizenship at the Universidade Candido Mendes, as well as with Luiz Eduardo Soares, the former secretary for security in the Lula government, and Elizabeth Leeds, the director of a police and security initiative sponsored by the Ford Foundation.[15]

Luiz Eduardo Soares, briefly the secretary of security at both state and national levels and a collaborator in the Youth and Police Project, advocated the elimination of narco-trafficking gangs and the larger forces that support them. He has also advocated policies that established links between the various sectors of society. Using the cidade partida metaphor, his idea is that the role of culture is to promote the "symbolic relinking between all that is divided and separated." He recognized that rap music in Brazil was one of the means by which the events of everyday life, often unconnected, are brought together in music, like putting a jigsaw puzzle together (Soares, Hill, and Athayde 2005, 148). This symbolic connection is a major piece of his idea of security, and is consistent with new international research and practice:

> The subjective dimension is a relevant part of public security . . . not only because people suffer in connection with what they experience in the immediate domain of criminal acts, but also because their interior experience, inseparable from culture, intrudes into the practical world and generates events in various different ways. This does not mean . . . that a good security policy can be reduced to dealing with people's subjective concerns . . . that a security policy should be merely a communication policy. However, it does mean that a true security policy must include a communication policy. Moreover, it should include a cultural policy. Eliminating prejudices and combating racism (in society, police departments and all the institutions of the criminal justice system) are indispensable initiatives for promoting security.
>
> Security means stable expectations, positively and widely shared. . . .

In other words, security is confidence. Confidence in others, in society, in State institutions. Shared expectations: here we are in the realm of inter-subjectivity, where culture is woven. (Soares, Hill, and Athayde 2005, 185–86)

This need to establish a subjective and cultural sense of stability has led Soares to collaborate with cultural activists in Rio's favelas, from the Afro Reggae band, to MV Bill, one of the best known rappers, and Celso Athayde, his producer and record label executive. Together they co-authored *Cabeça de porco*,[16] from which the preceding quotation is taken. The book gathers together interviews with petty drug traffickers in nine Brazilian cities to get an understanding of why they got into the drug traffic. One of the discoveries is that many of them would prefer to do something else, particularly because of the sense of insecurity in that way of life. But it is also the sense of inse-curity in a society in which they are suspects and have no chance of getting decent employment that leads them to a life of petty crime. Athayde, more-over, is, like Júnior, the catalyst of an artistic project within Rio's favelas, Central Unica das Favelas (CUFA), which translates more or less as Central Factory of the Favelas. It has eight video and filmmaking production units and residents borrow the equipment to make films about their reality. CUFA has opened up both audiovisual space and debate, and mobilized its music and media connections to get one of its films distributed in the largest com-mercial network in Brazil.

A major point of reflection in *Cabeça de porco* is the difficulty, even impos-sibility in most cases, of blacks and whites overcoming their separation to truly commune, and not just occupy the same physical space. The authors give their own collaboration and friendship as an example of transcending the cidade partida. They are all, like GCAR, and Rubem César Fernandes, creators of social networks whose participants seek to establish security in a very volatile social climate. And within those networks they seek to circulate their texts, their *tecidos* or weavings, throughout the media on TV, radio, and Internet blogs. Their cultural work and the networks they have created may not eliminate the root causes of violence—such as the economic and politi-cal interests that enable the drug and arms traffic—but they do maintain hope and plant the seeds that may blossom into action later on.

The work of GCAR, Fernandes, Soares, CUFA, and other similar projects makes it obvious that urban development is not limited to revitalization, infrastructure, and hygiene. It also involves values and culture, but not nec-

essarily of the type that motivates the Guggenheim franchise, although it is conceivable that in certain contexts, the two might work together. Given the Guggenheim Foundation's priorities, as evidenced in their museum franchise projects, such collaboration seems unlikely at the moment.

When Rio de Janeiro turned out to be a dead end for the Guggenheim, it continued to consider other cities, and has now signed a contract with the Guadalajara Cultural Capital Foundation to build a museum in the Huentintán Gully in Mexico. Enrique Norten (Mexico's response to Gehry), Jean Nouvel, Rem Koolhaas, and Norman Foster, designed a 180-meter tower that seems suspended over a 600-meter-deep *barranca* or gully. The project consists of six primary elements: the tower, the sunken gallery, the programmed bridge, the excavation, the platform, and the barranca itself. Its description evokes similar reactions to that of Nouvel's Rio Guggenheim museum:

> From the far reaches of Guadalajara, the tower of the project is seen floating at the edge of the city; a lighthouse that provides the first indication of the barranca. As one begins to approach this beacon from the Avenida de Independencia, the volume appears to be sitting on the horizon line, terminating the avenue itself and acting as the physical edge of the city. As one moves closer to the building site, however, the avenue begins slope downward; carving into the earth. At the end of this carving, the tower hovers above, held aloft by a single structural bridge. From this vantage point, the tower above and the two walls of carved earth on each side create the last urban plaza for the city of Guadalajara and a framed view to the barranca beyond.[17]

This project is part of what seems like a megalomaniacal will to transform Guadalajara into a super-acropolis for the global era. Jorge Vergara, who has made millions selling vitamin beverages to peasants, promoted this mega-center of 240 hectares (about 593 acres) in size, with designs by an all-star team: Toyo Ito (a museum), Zaha Hadid (a hotel), Jean Nouvel (a business center), Daniel Libeskind (a university complex), Carmen Pinós (a fair hall), Philip Johnson (a children's museum), Thom Mayne (a 6,250-seat, open-air, multi-use *palenque* or arena), and TEN Arquitectos, Enrique Norten's firm (a convention center and the master plan). In theory, this mega-center will catapult Guadalajara into a global limelight.[18]

Again, with this project we see all of the promises of economic devel-

opment (image, branding, jobs, tourism, competitiveness in services, and so on), with a potent dash of vanity, and none of the initiatives that would move this project in the direction of cultural development. And as in Rio, criticism comes from directors of museums and cultural institutions who consider the costs (similar to those of the Rio museum) exorbitant and not oriented toward high-quality art collections or linkages to the community. Carlos Ashida, director of the Carrillo Gil Museum in Mexico City, whose annual budget of $1 million is a tiny fraction of what it would cost to operate the Guadalajara Guggenheim, observed that while recent Guggenheim exhibitions ("The Art of the Motorcycle" and "Giorgio Armani") attracted massive audiences, their artistic legacy is quite slim. He added that rather than a mega-structure, it would be more interesting and effective to "create a network of medium size institutions steeped in the interests of our own artistic community, thus providing a mechanism for cultural support" (Marcin 2005).

One of the most positive outcomes of the Guggenheim's expansion is the generating of creativity among its opponents, but few have sought to harness the potential of culture-based infrastructural development for socio-cultural development. We are dealing with two worlds that are almost incommensurable: on the one hand, developers who commission celebrity architects, and on the other hand, local activists who seek to empower communities. Aside from turning a large profit, the former have the same ambitions as the patrons of yore: attaining their own celebrity and historical importance. In this regard, the César Maias (Rio Guggenheim) and Jorge Vergaras (Guadalajara Guggenheim and JV Center) of urban development are quite different from the producers and executives of record labels, such as those who have collaborated with the Afro Reggae band, MV Bill, and others to enable their celebrity for the purposes of profit and social activism. An example is André Midani, who recently retired from his position as president of international music at Time Warner, in order to return to Rio, where he had worked in the 1960s and 1970s, to help raise funds for Viva Rio, the citizen action initiative against violence. He has also teamed up with another Viva Rio project, Viva Favela, to develop the musical, industrial, and economic potential of Rio's numerous community radio stations.[19] Midani has clearly taken a step away from celebrity charity and instead has involved himself in sustainable development strategies with a network of other actors interested in enabling social well-being among Rio's majority.

Midani's work in Rio shows that it is possible for major executives to involve themselves in culture-based urban development. Developers may be a breed apart, but it might be possible to find intermediaries like Júnior, Soares, and even Midani to establish the links that would make it possible to nudge architectural and large infrastructural development projects in the direction of socio-cultural development. One such attempt is the "creative cities" initiatives that I briefly discussed earlier. They seek to develop the creative potential of citizens and turn significant profits by promoting the so-called creative industries: in addition to the traditional culture industries (publishing, recording, film, radio, and others) they include architecture, design, publicity, television; that is, all those industries that profit from the sale or licensing of copyright. The problem with this model is that it has generally emerged and been promoted from an exclusively market-oriented perspective. The so-called creative class described by Richard Florida (2002) may be interested in diversity, but it is limited to consumption of that diversity (as in cuisine, clothing design, and music) and is segregated by the high price of housing from the classes that provide that "diversity." Florida (2005) has acknowledged that neo-liberal policies, increased inequality, and anti-immigrant attitudes are some of the reasons why American cities are in decline. The same could be said, with a few exceptions, for cities around the world. Moreover, Florida has also acknowledged that his earlier focus on a highly-skilled creative class is ultimately limited, especially in providing solutions for today's divided cities. Low-skilled workers add value and help propel the economy (Florida 2005, 266); hence, investment in the creative infrastructure must be conceived broadly, with "massive increases in spending—from both the private and public sectors—in the arts, culture, and all forms of innovation and creativity" (250).

Franco Bianchini has become quite critical of the way in which the recommendations made in *Creative City* (Landry and Bianchini 1995) were implemented by creative-industries advocates interested exclusively in the economic dimension of culture. Bianchini and Landry intended for creativity to be harnessed to work out the problems of the contemporary city, not only for economic development. Bianchini's (2004) recent advocacy of intercultural and transcultural policies, as well as investment in and harnessing of local cultural resources, is a welcome corrective and is very much in line with the work of Favela Bairro, Viva Rio, Viva Favela, GCAR, CUFA, and others. It is time for high-profile, culture-based urban development projects like the Guggenheim franchises to find common cause with those who are seek-

ing to solve urban problems. Social concerns that go beyond the motives of profit and celebrity are required, as are the skills of intermediaries like Fernandes, Júnior, and Midani.

Notes

All translations are my own unless otherwise indicated.

1 Solomon R. Guggenheim Foundation, "Agreement Signed for a New Guggenheim Museum in Rio De Janeiro," press release, April 30, 2003, http://www.guggenheim.org.

2 Solomon R. Guggenheim Foundation, "Guggenheim Foundation to Undertake Feasibility Study in Brazil," press release, November 10, 2000, http://www.guggenheim.org.

3 The Rio municipal government's own report on the project, "Museu Guggenheim renovação do Rio: A cidade decide," stated self-servingly and without consulting the Brazilian artistic community about the advisability of a Guggenheim museum, that the "Body and Soul" exhibition strengthened the bond between that artistic community and the Guggenheim Foundation (Prefeitura da Cidade do Rio de Janeiro 2002). My reading of this document leads me to the conclusion that the exhibition, quite lucrative for the Guggenheim Foundation, was a persuasive gambit on the part of Ferreira and the Rio mayor. See also Fioravante 2001.

4 Paula Braga, "Desafios para museus de arte no Brasil no século XXI [resumo]," *Fórum permanente*, October 17, 2004, http://www.forumpermanente.org.

5 Ferreira was subsequently brought up on charges of tax evasion, fraud, and other mishandling of bank and client funds, resulting in the bankruptcy of his Banco Santos. His embezzelment was estimated at $1 billion (Costa 2005).

6 In 2002, Lewis gave the Guggenheim $12 million to cover the losses stemming from the decline in admission revenues due to 9/11 and from the general trend in cuts in foundation, corporate, and individual contributions. Lewis's gift came in the aftermath of the closing of the SoHo branch in downtown Manhattan and the Las Vegas Guggenheim, which closed after a brief fifteen months. Lewis resigned from the board in 2005, frustrated that the Guggenheim director, Krens, had not curbed spending. At his resignation, Lewis's gifts to the Guggenheim amounted to $77 million (Vogel 2005).

7 Bilbao-Metropoli 30, "Revitalization Plan for Metropolitan Bilbao," 1996–2000. http://www.bm30.es/plan/pri_uk.html.

8 Ibid.

9 Historically, most violence has been confined to the favelas, but new patterns of violence have emerged in 2006 and 2007 in São Paulo and Rio de Janeiro. Orchestrated as if part of war strategy, the mid-May 2006 São Paulo attacks were in part revenge for the government's decision to isolate leaders of the Primeiro Comando

da Capital (PCC) in maximum security prisons in order to divide and thus control organized crime. The toll was 251 attacks, including rebellions in 73 prisons, the Centro de Detenção Provisória, and 9 public jails in the capital city of São Paulo. By the end of 2006, the number of buses burned tripled to 350 and the number of dead nearly doubled to over 200. In Rio, just as a major wave of tourism was expected for spectacular New Year's Eve celebrations, narco-trafficking gangs called for a series of attacks on buses, police garrisons, and other places as a warning to the new governor, Sérgio Cabral, and in retaliation for the attacks by private militias composed of off duty police who extort money from favela residents as payment for each narco-traffic leader they kill. The violence was stepped up in mid-January 2007 as the Mercosul summit was about to take place, requiring the military to police the highways from the airport to the downtown area where the political leaders met. Violence flared up again in mid-February in shootouts between narco-traffickers and militias.

10 Historically, most cariocas actually believed the opposite, as in the myth of Rio as the city of conviviality, where residents of the luxury high rises and the favelas live literally side by side. With the spillover of violence into the city at large, Rio middle classes now experience even the "noble" areas of the city in much the same way as do the bunkered elites in São Paulo.

11 The term *favela* derives from the name given to the first hillside shantytown created by the soldiers who in 1897 returned to Rio from the war in the northeastern town of Canudos against the messianic movement led by Antônio Conselheiro, and about which the noted author Euclides da Cunha wrote his foundational documentary novel, *Os sertões (Rebellion in the Backlands)* (1902).

12 Much of this history of GCAR is in my book *The Expediency of Culture* (2003). See especially chapter 4, "The Funkification of Rio," and chapter 5, "Parlaying Culture into Social Justice."

13 Rubem César Fernandes, director of the Instituto de Estudos da Religião (ISER) and a major civil society activist and theorist, became coordinator of the "citizen action initiative." He was instrumental in bringing together a complex network of union officials, religious leaders, business executives, community organizers, newspaper and television directors, journalists, and other non-governmental organization leaders. Fernandes has characterized Viva Rio as "a bridge on which diverse sectors of the citizenry can meet with the private sector and the state" (Personal communication, ISER, Rio de Janeiro, August, 6, 1996). Over the years, Viva Rio has expanded to encompass education for low-income residents, community development, public security (including training for police officers), human rights, environmental improvement, sports, and community action. See the Viva Rio website, http://www.vivario.org.br.

14 The phrase "polyglots of sociability" was coined by Rubem César Fernandes, coordinator of Viva Rio. In *Private but Public* (1994), Fernandes advocates for the development of the communication skills (the ability to communicate with

communities with very different ethos) required for bringing about effective so-
cial change. Such polyglots of sociability can mediate between diverse sectors
of civil society, enabling them to meet and work together, and they encourage
the development of professionalism. Fernandes's efforts are aimed at creating a
multiplier's effects in "third sector" initiatives, that is, working with the "fluid
language of values," developing the "art of translation" of those values "beyond
cosmopolitan circuits" where rights and other conceptual categories can be too
abstract (Fernandes 1994). José Júnior is one of the best incarnations of such a
polyglot and he has prepared several members of GCAR to take an active role in
negotiations with multiple communities. As I will discuss, this is what the group
is doing with the Youth and the Police Project.

15 For a detailed account of the Youth and the Police Project, see Ramos 2006.

16 In the vernacular of Rio's favelas, *cabeça de porco* (a pig's head) means problems
without solutions, or confusion.

17 "Guggenheim Museum Guadalajara, Guadalajara, Jalisco. Mexico. 2004," *Noticias
arquitectura.info* (online newsletter), http://www.noticiasarquitectura.info.

18 See the plan on the Ten Arquitectos website (http://www.ten-arquitectos.com).

19 Viva Favela is dedicated to fostering social inclusion and constructing a culture of
peace and solidarity for the benefit of Rio's low-income residents.

Latin American Megacities: The New Urban Formlessness

Nelson Brissac Peixoto

How have Latin American cities responded to the impact of globalization? Even as the international flow of capital, with its increasing velocity, has carved out a new strategic role for large metropolises, it also produces massive changes in their economic base, their spatial organization, and their social structures. As evidenced by São Paulo or Mexico City, the emergence of the megacity brings with it a new understanding of space. A well-established topic within urban studies, this new configuration is characterized by functional connections established across vast territorial expanses. It also, however, results in significant discontinuity in patterns of land use. The social and functional hierarchies of the megacities are intertwined with one another in terms of space, organized in both controlled and improvised ways. Surprising new modes of using space continually appear on the urban scene.

///// The large Latin American cities have become battlefields. A war is being waged for the occupation of entire urban areas, and for control over infrastructure and public spaces. These cities have become archipelagos of modernized enclaves with their corporate towers, shopping centers, and exclusive condominiums. These enclaves are surrounded by large abandoned areas, undefined lots occupied by itinerant populations. In this conflictive landscape, modern buildings find themselves surrounded by new urban practices. Street vendors take over the roadways, favelas sprout up in the spaces between highways, and homeless groups install themselves under

the viaducts. Those who collect paper and industrial waste carve out an alternative economy of recycling. Entire populations invade abandoned estates and vacant land at the city's edges. Like a boundless sea, they spread out everywhere, flooding interstitial space.

These macro-urban phenomena distill the same dynamic processes that characterize Latin America more generally. The concentration of globalized activities forms internationalized spaces in the heart of the region's cities. Large-scale reurbanization projects bring with them large-scale reconstruction. But, in tandem with corporate development projects, informally constituted territories also emerge, engendering new spatial and social configurations. Dynamic and nomadic social elements occupy the interstices of urban space, forging new relationships and unforeseeable events, transcending the demarcations drawn by maps and city planning. These new urban conditions, continuously reforming and disseminating themselves, do not obey the formal design of the cities' economy or infrastructure. They are dynamic, complex topographies, in which local conditions are molded to globalized space, producing liminal zones and new territories. How can we grasp this new topography? How can we map the globalization of Latin American metropolises?

My consideration of the new urban informal/formlessness is centered primarily on São Paulo, but the dynamics I discuss also pertain to other large Latin American cities that experienced an unprecedented process of de-industrialization from the 1980s to the beginning of the twenty-first century. I take as emblematic the effects of de-industrialization on one specific part of the urban landscape, an area southeast of São Paulo's principal business districts, where steel factories once dominated the economic, infrastructural, social, and residential character of an area encompassing forty-two urban blocks. Steel production ended there, which was predictable enough for the transnational companies; but it seemed sudden to the area's residents and workers.

This area, along with its relationship to government-sponsored revitalization projects in other sectors of the city, provides a fertile source of information about how informally constituted social groups re-occupy and re-appropriate "abandoned" urban spaces. It allows us to assess the value to the local residents of these collaborations, and offers conclusions regarding the more abstract critical function of seeing spontaneous urban appropriations and collective art forms as positive aesthetic interventions into urban design rather than only as reactive survival mechanisms.

///// No man's land. The growth of the global market introduces a discontinuity into national urban systems, leading to the emergence of new types of transnational interdependence (Sassen 1991). New concentrations arise at certain sites, the result of the mobility of capital and its territorial dispersal. In this terminal landscape, modern structures share space with basic survival tactics. Real war machines traverse these urban deserts, with their troops mounted on buses and overloaded trains. Street peddlers' tents invade the sidewalks. People camp out at intersections, or under the overpasses. Budget shopping centers appear in the financial districts. This shift in the geography of economic activities implies new relations among the various components of each particular place.

To the degree that the larger service industries develop vast multinational contacts with special geographic and institutional connections, it is possible to create globalized spaces within these cities. This process generates a profound urban restructuring. Significant reurbanization projects are developing heretofore underpopulated or marginal areas for business and residential purposes, promoting large-scale reconstruction of the cities. The spatial design is being constantly reconfigured, with the formation of new and highly unstable territorializations (Soja 1990).

These areas, now part of a global real-estate market, become settings for large-scale urban redevelopment projects that require significant appropriations of public resources and urban space. The alteration of scale, with its concomitant brutal verticalization, creation of large complexes with autonomous infrastructures, and urbanization of entire regions, is indicative of a new stage in the restructuring of metropolitan spatiality. This blend of strategies depends on the flexibility of legal systems to facilitate development, all of which leads to the increased privatization of urban space. The role of public administration becomes that of the strategist for the implementation of the goals of private, international enterprises. As this dynamic causes profound transformations in Latin American metropolises, the megacity introduces new spatial forms. They represent a combination of, on the one hand, functional connections established in vast extensions of territories, and on the other hand, discontinuity in the patterns of land use (Castells 1999).

Express transit lanes and new real estate or commercial enterprises appear in enclaves that are disconnected to the old urban grid. This process radically fragments the old image of large urban areas as unified entities. Multiple, modernized centers emerge—residential condominiums, corpo-

rate buildings, shopping centers, and store fronts—that are periodically repeated along principal avenues. This is a complete reworking of the urban geography of cities, and its implications can be understood only on a grand scale. Distant spaces are brought closer together as they become more accessible. Other, nearby spaces, are made more distant by being made inaccessible. The perception of space comes to be determined by velocity, rendering useless the pedestrian knowledge typical of traditional, local configurations. The old public spaces, now inaccessible, lose their meaning and their use-value. They become a literal no man's land.

Certain pockets of space, occupied by solid structures and rigid programs, remain in the urban landscape. Activities are reorganized into islands connected to one another across still densely built areas that are then occupied by new economic and social arrangements. The most extreme forms of modernization live alongside the new urban conditions—informal, transitory, clandestine—generated by global integration. Other aspects of spatial and social restructuration result from deindustrialization. The reorganization of metropolitan spatiality, in order to adjust to the exigencies of globalized capital, necessarily passes through divestment. This process is a sequential combination of dissolution and reconstruction.

Deindustrialization produces "vague space" (*terrain vague*) (Solá-Morales 1995). These undefined and insecure areas embody the oscillations, the instability, of the urban network. Apparently devoid of activity, these spaces exist outside of productive structures and circuits in the cities, reminiscent of the diverse operations of reconfiguration on more complex scales in Latin America at large. The speed of the transformations of urban space contrasts to the material inertia of the manufacturing world. There is a proliferation of industrial sites transformed into dumps, and demolition areas converted into parking lots. The built environment remains; it continues to take up space, but it is now converted into an obstacle. Its amorphous ruins resist change. Degeneration and collapse are the motors of this new process.

Such a metropolitan dynamic obstructs all sense of spatial continuity. There are only shapes arranged in proximity to one another, and they share no proportions or limits. In this space dominated by chaos and turbulence, each locale has lost its place in the urban whole. These fractured spaces always refer to somewhere else. Empty spaces testify to abandonment. The interstice is the paradigm of the contemporary Latin American metropole.

"Vague territory" refers to areas dominated by an entropic dynamic. This force overtakes all the intervals between the points in space, abolishes dis-

tances, and causes a slow dissolution into the undifferentiated. It poses the question of limits, of context. Vague territory erodes the difference between interior and exterior, the fixed and the mobile; it dissolves the boundaries we typically rely on in order to perceive anything at all. It creates soft sites, unlimited and indistinct. Thus, the urban impact of globalization takes one of its most paradoxical forms in Latin America's cities.

The deactivation of urban territories, together with the peripherization of the areas along major transport routes, produces empty space with informal and undefined uses: the zone (Krauss and Bois 1997). These interstitial spaces expand continuously, invading neighboring areas. Anything can happen in the zone, a never-ending encroachment of indistinction. That is where formlessness happens. Here, emptiness takes over everything, as if a whirlwind were occupying urban space. Ironically, it is as if the fixity of space below this entropic rigidity were blocking the possibility of establishing any precise patterns above it. The city always seeks to combat entropic proliferation even as it generates it.

A city is basically a space delineated, compartmentalized, by a grid of roads and functions. But the metropolis generates its own opposites: highways, urban deserts, temporary settlements, huge favelas, entire areas occupied by street vendors. These forms of spatiality extend themselves infinitely, with no points of reference. Everything is distributed according to relations of speed and slowness between flowing elements, like musical compositions played continuously in unlimited variations. Heterogeneous and mismatched elements form fluid combinations (Deleuze and Guattari 1980).

These formless mixtures leak, spill, and flow into all empty spaces. The nomad—the homeless person, the street peddler, the slum dweller, the migrant—operates in these spaces hidden from the city. The nomad occupies land through dislocation, by way of trajectories that distribute people and objects throughout open, undefined spaces like vacant lots, abandoned public places, the alleys between buildings, or the voids created by the introduction of infrastructure. The nomad's actions are dictated by the necessities of individual survival. He instrumentalizes everything around him: a homeless person uses the sink at the gas station, the street peddler takes a stretch of sidewalk for himself, the slum dweller occupies open areas between highways and viaducts and pirates electricity from the live, public cables.

/ / / / / Such discontinuous and variable urban structures render any kind of mapping extremely problematic. How does one apply cartography to this ge-

Arte/Cidade, "Electricity Pole with Hundreds of Pirate Connections" (Cidade Tiradentes, Zona Leste), ca. 2002. Photograph. Printed with the permission of Arte/Cidade.

ometry of mutating economic activities, undefined land use, an ever-shifting informal economy, and abrupt migrations of the population? The urban configuration undergoes constant change in part because of the consecutive establishments of new transportation systems that are seldom coordinated with one another. These profound ruptures in the urban and social cloth, followed by the improvised and self-organized occupations of the remaining areas, generate a diffuse terrain, stripped of clear markers of the divisions and uses of space. By escaping the structuring mechanisms of the large new corporate enclaves, these activities and forms of occupation produce fluid and ever-mutating arrangements.

The long view of space delineated by monuments, radiuses, or borders depends on fixed distances in relation to inert references, a centralized perspective. But the new urban situation offers just the opposite: close proximity combined with the inability to see anymore. There are no references in this scene of continuous change in orientation. Observation is always in

motion. Space is no longer visual; there is no horizon, no perspective, no limit, outline, or center. There is no intermediate distance. We are always on the inside, in the middle. The new reality parallels the experience of a naval fleet: one does not travel from one point to the next. Rather, one takes up all the space of any given point. It is no longer a question of crossing an ocean or a continent, but rather of a kind of displacement with no destination in space or time. The goal is to occupy open space, like a whirlwind that can appear anywhere at all. Geographic location loses all relevance. It is now a question of the turbulent filling in of space, of occupying it at all points (Virilio 1984).

A different type of perception asserts itself here. Astronomy invented a standard for locating positions when one loses spatial reference: the observation of the stars. That establishes fixed points of reference. Here, however, the observer is always moving, with no stable reference points. It is no longer possible to pass through space like a sailor with an astronomical map. Rather, one now moves like a nomad or like an atomic submarine, with no fixed points. We have lost a stable sense of scale. There is no longer any way to measure things according to their place in a given dimension. References no longer have a visual model that could orient an immobile external observer. Now we have multiple relative measurements, as many as there are observers in motion. We follow routes with no destination and no endpoint through non-delineated spaces. There are only differences of speed — accelerations and decelerations. Given this superimposition and displacement of scale, it is necessary to make new connections between locations that seem isolated and disconnected from one another (Deleuze and Guattari 1980).

Space that has been stripped of delimitations cannot be mapped. The borders drawn by administrative districts or by roads and railways are incapable of containing these imperceptible flows. As primarily relations of proximity and distance, they are being created independently from any planning system. As such, these are non-locatable relations. Their emergence as well as their dissolution depends on gradual, small-scale adjustments in the ballasts of urban perception. The territory of the urban thus comes to be the critical distance between situations.

The metropolis establishes itself as an infinitely expanding field, well beyond any individual experience. No visual scheme can contain it. No sequencing is adequate to it. There is no continuity in the urban cloth. No sutures can mend it, no technical device can unify it. Its dimensions completely escape individual human experience. It offers a large-scale intrinsic

contradiction: the observer's perspective is presumed to be panoptic, able to grasp abstract forms, but at the same time the patterns reveal themselves only partially. The key aspect of cartography is its fusion of the real and the abstract. The map introduces the idea of a "seeing" that comprehends more than any single point of view could capture. Mapping comes to be the first image of a landscape that cannot be directly perceived by the eye. It is a non-ocular perception.

Optical equipment, argues Paul Virilio, radically alters our geographic perception. It projects an image of the world that is not normally available to us. The amplification of both near and far destroys our understanding of distance and dimension. Complete perception of a situation can only be achieved through the use of instruments. Through instrumental observation, we move from vision to visualization. We are now at an immeasurable remove from that which we normally know through experience. Abstract, two-dimensional representations replace topographical maps; topographical memory gives way to a geometric optic.

Understanding new scales that escape our vision requires a new approach. Large spaces are related to a kind of vision that purposefully avoids reading in terms of gestalt-like, all-embracing forms. Rather than the immediate perception of an image, this mode of perceiving seeks parameters within which totality is configured on the basis of the collection of information, where heterogeneity and indeterminacy are constitutive. This approach heralds the most contemporary methods of understanding the mapping process, methods based on the intensive and critical exploration of multiple types of information.

The problem of measuring such large dimensions could be put this way: what map could represent this dissemination, these unforeseen movements? The challenge lies in apprehending the relation between the local and the global. How does one move from one scale to the other? Perhaps one could begin with an intensive exploration of unique locales and elite neighborhoods, private places whose exclusivity lends a global dimension to the mapping. By way of shorter or longer extensions, this flow could build the world one place at a time (Serres 1994). Places are always local and precise. It is impossible to comprehend vast expanses in any other way. Only through juxtaposition, through the comparison of one thing to another, through gradual and progressive linkages, can ever larger areas be reached. The same tissue connects neighboring places and also distributes them far

away. These criss-crossing paths produce a field that grows by way of unexpected expansions and extensions.

Think of an atlas designed by this interlinking, by continuous connections and inclusions that stretch further and further all the time. Distances are replaced by new proximities, redistributed according to new connections. These proximities somehow imitate the real landscape, but they also permit new passageways, new interactions. Even the bird's eye view is spatial; it presupposes a privileged point of view and stable references. We need maps that allow for rapid change as much as for slower, more profound, geological changes. Instead of a classic architecture linked to fixed, heavy solids, we need a map of journeys that could account for areas undergoing convulsions and continual transformations. A new cartography emerges out of this unfolding, a new space forms itself out of these unexpected new connections.

///// We are dealing with the limits of figuration, the human mind's inability to represent the enormous forces of nature and the metropole (Jameson 1984). Our imagination has trouble comprehending the organization of production and of space, the web of power and control. We still lack the technology of perception necessary to confront these new spatial dimensions. These disconcerting spaces render useless the old language of volume. The new mutation of space exceeds the human body's ability to orient itself, to perceptively organize the space around it and cognitively map its position in the external world. Charles Baudelaire's descriptions of Paris only hinted at this situation, in which new urban technology transcends all the old habits of corporal perception. All the efforts to map the city according to experience on the street—the Benjaminian drift, or the situationists' affective itineraries—pointed to the hope for a renovation in perception. In a universe constructed and developed by late capitalism, however, there is no place for such a renovation.

The legibility of the urban landscape has always relied on imagination, on the capacity to evoke a strong image in the mind of the observer. It assumes visual reference, the sensorial domination of space by way of experience and ocular observation (Lynch 1960). But the current configuration impedes our mental mapping of the urban landscape. Our cities no longer permit us to hold a locale in our imaginations, as if we had an accurate image that fit neatly into the whole of the urban cloth. The individual subject's phenome-

nological experience no longer coincides with the place where it happens. These structural coordinates are no longer accessible to immediate, lived experience. Nor do people even recognize them. This results in the collapse of the kind of experience assumed in those artistic works that sought a reordering of urban space along with its apprehension by the passing observer.

The periodic transformations of the parameters of our experience and perception of space and time, accelerated by developments in technology, transportation, and communications, force us to reevaluate how we represent the world. When it becomes evident that we lack appropriate methods of representing change in space-time dimensions, we see an increase in criticisms of the map as a totalizing tool intent on the homogenization of differences (Harvey 1990).

The new dimensions of the globalized world require a new cartography. It has to account for dynamics, flux, permanent and variable reconfigurations. Aerial perspectives redefined visual culture and aided in establishing a universal rhetoric. But they also maintained a certain affinity with maps. They respected the requirements of legible space. Non-visualizable space-time, on the contrary, exposes the limits of conventional mapping. It demands new procedures that take into account the complexity and indeterminacy of urban space. It requires approaches that activate the generative connections between new events and configurations.

/ / / / / All this poses the question of how to establish principles for detecting the emergence of these new urban conditions. How can we recognize the new types of the largely informal/formless occupation of urban space, and the practices created by its economic and social agents? We need a method that questions existing urban regulations and that reveals the dynamic configurations obscured by centralized urban planning as well as by large urban development projects. We have to grasp this new dimension by conceiving of pure substance and function, distancing ourselves from the forms that they may take, ignoring all formal distinctions. We have to identify an operational set of markers and zones, meaningless and non-representative traces and stains. This approach works by deconstructing given realities and meanings, and by constructing unexpected intersections and improbable continuities. It displays the power relations proper to each configuration, the power to affect and to be affected. Societies are webs of alliances, irreducible to any structure. These alliances weave loose, transverse networks, forming unstable systems in perpetual disequilibrium (Deleuze 1986). They reflect

the notion of a field rather than a form. A field consists only of vectors. It is the opposite of structure, which is defined by a combination of positions. It proceeds by way of variation, expansion, conquest. The question is no longer one of organization, but rather of composition. We face a world crossed over with formless elements of relative velocities, infinite segments of an impalpable substance that participates in various connections. This amorphous, informal space is occupied more by events than by forms (Deleuze and Guattari 1980).

Along with rigidly structured urban development projects, formless territories appear where new spatial and social arrangements are made. Changing, nomadic elements fill in the gaps. They provoke new relationships and unforeseeable events that entirely escape all planning and structuration. These interstices permanently reconfigure the urban pattern. Each informal strategy—the occupation of land by the homeless, street vendors, slums or favelas, the appearance of centers of unauthorized activities that appropriate buildings or infrastructure—redirects the region toward adjustment-by-accumulation with other local sectors. This juxtaposition composes a heterogeneous space in continual variation.

This is a new, formless definition of the informal, the result of the prevalence of combined and superimposed types of information, of uncertain, heterogeneous conditions, and of open parameters (Gausa et al. 2001). The situation allows the use of intermediate, unstable, and provisional spaces. It allows for the identification of experimental territories in which to explore the conditions of the new city. It is a new type of space, one of mobility and communication, ironically made possible by the power of large infrastructural systems.

We need an urbanistic repertoire that we can use to explore the consequences of the emergence of these new configurations. Approaches designed for this process would transgress the limits established by the structured and zoned uses of space in order to see the urban in terms of patterns of interaction in a permeable and open terrain. They would free the city from rigid structures and understand it as a dynamic web of relations (Königs 1999; Versteegh 1997). They would adopt instruments of recombination that allow for nonhierarchical and heterogeneous spaces. They would engender changing and contingent influences and affiliations that resist static order. Vast residual spaces could be activated by programmatic innovation, technology, and events (Kipnis 1993). These strategies would provoke largely unforeseen processes, impervious to direct control. They would make possible

the mapping of the formlessness, the dynamism, and the intensity of large fields.

Is urbanism as we know it capable of inventing and implementing on a scale required for the demographic and spatial development of cities? Pervasive urbanization has altered the urban condition beyond all recognition. Therefore, a new urbanism is needed here, one capable of expanding notions, denying borders, discovering innumerable compositions. It must manipulate infrastructure in order to facilitate permanent intensification and diversification, and irrigate the cities with potential. We need a critical mass for urban renewal (Koolhaas 1995). The megascale makes possible programmatic hybridizations, proximities, frictions, and superimpositions. Only this scale can support a huge proliferation of events in a single area. Only this scale can allow for the unexpected. This vision defines the city more as a pattern of events than a collection of objects.

How can we grasp the extraordinary and unprecedented evolution occurring in contemporary metropolises? How can we understand these new urban conditions at the same time that they are emerging? New urban phenomena create heterogeneous spatialities with a variety of uses. Economic activities and informal modes of the occupation of space, apparently chaotic, actually just operate according to a different logic, predominantly based on self-organization. Infrastructural systems house new uses, mobile rather than static, that alter the nature of public space. Highly unstable processes create zones that are inhabited by shifting forces. These situations illustrate the large-scale efficiency of systems and agents that are typically considered marginal and informal. This relation between territorial alteration and self-organization offers us a new panorama in which innovation and change derive from nonplanned, nonregulated processes (Koolhaas et al. 2000). Thus, it is necessary to develop new modes of observation and of action on the basis of instability, of dynamic landscapes occupied by multiple processes and agents. We need a critique of urbanism's central fallacy: that the city expresses itself through its physical form, through its objects. The city is, rather, foremost a field of moving forces and continuous organization.

///// In the conflicted landscape of the megacity, new urban practices proliferate. Unauthorized populations insert themselves into dynamic processes and develop new strategies for inhabiting and working in the global city. Those who have no access to the new manifestations of the global economy and who produce other modes of social participation and residence in

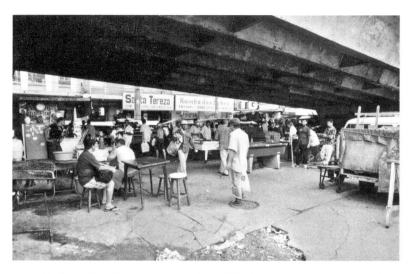

Arte/Cidade, "Informal Commerce, Outdoor Billiards" (Rua Rangel Pestana, Brás, Zona Leste), ca. 2002. Photograph. Printed with the permission of Arte/Cidade.

the city remain far from the investment and power centers. These new social actors suffer the extreme results of global capitalism: absolute mobility, total availability. They live according to flux: recycling, informal distribution, provisional residence. They constitute a new economy and a new modality of regional occupation (Hardt and Negri 2000). Objects, vehicles, venders' stalls, all comprise the architecture of precarious dwellings. These accouterments of dislocation and temporary settlements become instruments of survival in critical urban situations. They are collapsible, portable riggings improvised out of the most diverse materials and methods. They represent techniques for getting around fences and rules, for occupying empty lots or heavily trafficked areas, for providing both housing and circulation.

Thus, contemporary urban nomads develop mechanisms that permit the homeless to survive and to transform their living conditions. A nomadic politics consists of the development of procedures and tools to promote self-reliance in this state of constant change. That is what creates the new urban condition, the city-in-flux. It is all a question of logistics and of the means of economic survival in the city: collecting, saving, transporting, exchanging, selling, protecting.

The city is compartmentalized by capital and work. But movement continually threatens these rigid divisions. Fluid processes leak across lines, reconfiguring the urban scene in new ways. Homeless populations, those

engaged in informal commerce, those who collect garbage, are the agents of the flows that erode established urban structures. We must equip those populations for the struggle over intermediate spaces, the undefined gaps between residential and commercial enclaves, the large architectonic structures that dominate the urban landscape.

The metropolitan nomads work against those urban policies and real estate ventures that control the exclusionary structure of the city (Deutsche 1996). By way of their dislocations, they constitute dynamic sites-in-motion that spread, like a liquid stain, throughout old industrial areas, beside the huge highways, in empty lots abandoned by real estate speculation. Like an expanding, occupying force, they work in the interstices, redesigning the metropoli. Their displacements create an amorphous, informal space, transforming the urban terrain into a zone.

These operations are tools for resisting urban restructuring. They make visible the relations between the "redesignation" and relocation of people. They facilitate the occupation of space by the homeless. They attack the urban image of coherence based on exclusion. For example, the homeless person is typically presented as someone who blocks the free flow of traffic. But the traffic itself responds with a new role; it corresponds more to the needs of the excluded, whose actions are in fact based on movement and the transgression of boundaries, whether they be geopolitical, social, public, or private. Like the homeless person, traffic also seeks to create zones that open space in the gaps between the city's structures.

The itineraries of those with no place to call home provide a different way to organize and perceive space. They move in continually diverging lines, zigzagging, creating passageways between spaces, altering the shape of the urban terrain. These trajectories move between points, indifferent to the norms of contiguity and distance. They take over territory through densification and intensification. These tactics distribute them throughout open and undefined spaces, spreading in all directions. They subordinate habitat to movement; they adapt interiority to exteriority. These imperceptible, interstitial movements create space in the fissures, but without relying on form or architecture.

The populations taken up by this dynamic of formlessness transcend the traditional spatial limits established by social exclusion. They invade the whole city. They infiltrate the holes in the urban cloth, the cracks in buildings, all interstitial spaces. They inhabit the folds and fissures of the city. This is a reconquest of the urban, an uprising against administrative rules

and exclusionary capitalistic urbanization. It is urban guerrilla warfare. Its agents advance at night and retreat during the day. They skirt obstacles but still enter through slits and holes. They constantly reinvent new economies and tactics of occupation. Their attacks consist of besieging and invading spaces, cutting off old lines of communication, and establishing escape routes.

Another example of this nomadic invasion is the way in which urban space is entirely taken up by street vendors. Their dense mass of stalls violates all the established limits, obscuring the urban design and rendering invisible the few remaining landmarks. They preclude all other activities by impeding access to the majority of buildings and urban facilities in their chosen locations. These stalls, covered in plastic, offer a seemingly infinite variety of cheap clothing, faux products, and disposable utensils. How are these products made and obtained? How do they circulate? Multiple circuits keep weaving themselves together in continual variations. Everything is all mixed together in absolute indistinction. It seems impossible to discern any pattern of organization or movement in the midst of such chaos. With a rising tide of indifferentiation, little by little the informal street economy takes over neighboring areas.

This expansion relies on small contacts between infinitely subdividing spaces, like the linkage between one sidewalk and another. The field keeps expanding, but no one is in charge of it, and no one plans it. Like a liquid, it slowly seeps out in all directions. In a whirlwind motion, it sucks everything in its path into one vast, limitless, vague space. Informal, formless occupation dilutes all distinctions and borders, making it impossible to trace the contours of this fluid world by focusing on stable elements. These itineraries have no outline. They do not establish borders. They create a moving configuration, radically void of formal structure. This liquefied architecture and urbanism can be understood only through the concept of flow.

This is the manifestation of the history and identity of those agents who are excluded from the formal economy and from other types of citizenship. It is a portrait of the informal economy, with its creative force and its resisting role in the face of a globalized economy. How does such a large part of the population live off of this market, and how is it integrated into the city?

Massive architectonic structures take up all available space, but the people add so many levels to them that they can, for example, actually increase the height of a viaduct. Additional levels, with balconies and stairs

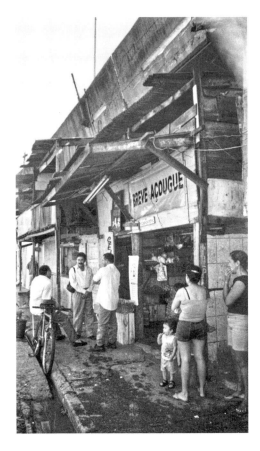

Arte/Cidade, "Houses and Shops Built under a Viaduct" (Viaduto da Vila Prudente), ca. 2002. Photograph. Printed with the permission of Arte/Cidade.

that descend directly to the street, are built onto the concrete structure. Dwellings with porches, food stands, and bars, install themselves next to the viaduct's columns. Illegal connections pirate electricity. The original purpose of the electrical equipment, to provide power to the railways, comes to coexist with another, slower, usage—that of small-scale connections. The city scene juxtaposes architectonic elements, the restricted circulation of goods, and pedestrian traffic. As long as new, corporate, urban development projects continue to be implemented, subverting legislation and appropriating entire areas of the city, the excluded population will continue to take over whatever remains of urban space. Could this be the end of urbanism?

///// Globalization, argues Rem Koolhaas, allows for the emergence of cities that maintain their existence and productivity in spite of an almost total lack of infrastructure. These deficiencies generate ingenious and criti-

cal alternatives able to guarantee the efficacy of informal or illegal strategies. Globalization provides a wide array of new opportunities to operate outside of traditional regulatory systems. Perhaps an intensely material, decentralized, and crowded use of the city can be instructive for the development of even more types of urbanism.

The informal market adapts the transit infrastructure in order to extract from it the most uses possible. Different levels of economic activity, with their ever-increasing interactions and institutionalizations, develop in the interstitial spaces of transit infrastructure. Formless urbanism follows a different and more efficient logic than that imposed by the formal streets, bridges, and viaducts. In this urbanism, parts of the infrastructure become a kind of real estate vulnerable to the redirection of its original purpose. The movement toward "vague space" indicates the collapse of the formal transit system planning. Streets lead to barriers and impasses that control isolated areas. Highways become access roads to local sectors. The dysfunctional elements of the urban traffic system, which currently impede movement, are recuperated as if they were planned interstices.

In the global city, infrastructure is implemented to serve new, restructured, business centers. The facilities that at first are integrated in a totalizing fashion become more and more competitive and local. Even the new infrastructure, aimed at urban renovation and sponsored by formal city planners, builds enclaves rather than networks. It no longer meets needs, but rather has become dominant urbanism's strategic weapon. For example, a new metro system is installed in a certain area just to make another area seem outdated and overcrowded. But the infrastructure can also be used, programmatically, to serve different processes, to maximize existing resources, to envision infinite intensifications and diversifications, interruptions and redistributions. This new kind of urbanism looks to irrigate cities with potential, to accommodate processes that refuse to be crystallized into definitive forms.

This process heralds a new tendency to appropriate toward new ends an urban infrastructure that was originally planned to link distant locales and to organize modern enclaves. Certain portions of that infrastructure begin to be utilized for new arrangements, reconfiguring the city on a grand scale and according to an informal/formless dynamic. Can global urban change create a new type of urban evolution different from that of the corporate enclaves? Local measures such as the work of the trash collectors, the architecture of the homeless, the exchange network among street peddlers, and the

various appropriations of urban infrastructure, clearly engage larger urban systems by developing relationships between multiple scales and sites. These ever-mutating links create an irreducible structural instability. The resulting interstitial spaces point to the power of reconfiguring the city on a global scale. In this sense, shouldn't we think of the Latin American megacity as the vanguard of a new kind of urbanity?

Note

This essay was translated from the Portuguese by Rebecca E. Biron.

Bibliography

Abu-Lughod, Janet. 1999. *New York, Chicago, Los Angeles: America's Global Cities.* Minneapolis: University of Minnesota Press.

Achugar, Hugo. 1998. "Leones, Cazadores e historiadores." In Castro-Gómez and Mendieta, *Teorías sin disciplina,* 271–85.

Aizenberg, Edna. 2002. *Books and Bombs in Buenos Aires: Borges, Gerchunoff, and Argentine-Jewish Writing.* Hanover: University Press of New England.

Almandoz, Arturo, ed. 2002. *Planning Latin America's Capital Cities, 1850–1950.* London: Routledge.

Anderson, Benedict. 1991. *Imagined Communities: Reflections on the Origin and Spread of Nationalism.* London: Verso.

Andrade, Carlos Fernando de Souza Leão. 2003. "Decisões do XVII Congresso Brasileiro de Arquitetos." *Vitruvius, Arquitextos,* May 6. http://www.vitruvius.com.br/arquitextos/arq036/arq036_01.asp.

Appadurai, Arjun. 1996. *Modernity at Large: Cultural Dimensions of Globalization.* Minneapolis: University of Minnesota Press.

Arantes, Otília Fiori. 2000. "Pasen y vean . . . Imagen y city marketing en las nuevas estrategias urbanas." *Punto de Vista,* no. 66 (April): 16–19.

Argullol, Rafael. 1994. "A cidade-turbilhao." *Revista do Patrimonio Histórico e Artístico Nacional* 23: 59–68.

Armus, Diego, ed. 1990. *Mundo urbano y cultura popular: Estudios de historia social argentina.* Buenos Aires: Editorial Sudamericana.

Bachelard, Gaston. 1958. *La Poétique de l'Espace.* Paris: Presses Universitaires de France.

Ballent, Anahi, Adrián Gorelik, and Graciela Silvestri. 1993. "Las metrópolis de Benjamin." *Punto de Vista,* no. 45 (April): 19–27.

Bauman, Zygmunt. 2005. *Vidas desperdiciadas: La modernidad y sus parias.* Buenos Aires: Paidos.

Benjamin, Walter. 1968. *Illuminations*. Edited by Hannah Arendt. Translated by Harry Zohn. New York: Schocken Books.

———. 1983. *Charles Baudelaire: A Lyric Poet in the Era of High Capitalism*. Translated by Harry Zohn. London: Verso.

———. 2002. *The Arcades Project*. Translated by Howard Eiland and Kevin McLaughlin. Cambridge, Mass: Harvard University Press.

Béter, Clara. 1926. *Versos de una. . . .* Buenos Aires: Editorial Claridad.

Beverley, John. 1999. *Subalternity and Representation: Arguments in Cultural Theory*. Durham, N.C.: Duke University Press.

Bianchini, Franco. 2004. "A Crisis in Urban Creativity? Reflections on the Cultural Impacts of Globalisation, and on the Potential of Urban Cultural Policies." Paper presented at "The Age of the City: The Challenges for Creative Cites" symposium, Osaka, February 7–10. Available online at http://www.artfactories.net.

Biron, Rebecca E. 2003. "Marvel, Monster, Myth: The Modern City in Latin American Literature." In Lejeune, *Cruelty and Utopia*, 118–33.

Bona, Dominique. 1984. *Argentina*. Paris: Mercure de France.

Bononi, Aldo. 1992. "La machina metrópoli." Paper presented at "The Renaissance of the City in Europe" symposium, Florence, December 6–8.

Borges, Jorge Luis. 1974. *Obras completas*. Buenos Aires: Emecé.

Borja-Villel, Manuel J. 1992. "Comunicación sobre el muro." In Tàpies, *Comunicació sobre el mur*, 13–31.

Braga-Pinto, César. 2000. "How to Organize a Movement: Caetano Veloso's Tropical Path." *Studies in Latin American Popular Culture* 19: 103–12.

Brassaï. 1993. *Graffiti*. Paris: Flammarion.

———. 1999. *Brassaï: The Eye of Paris*. Edited by Anne Wilkes Tucker, with Richard Howard and Avis Berman. Houston: Museum of Fine Arts.

Brito, Gustavo A., and Isolda Maur. 1990. *Ciudad y marginación: Un enfoque sobre la segregación espacial en Buenos Aires y su región metropolitana*. Buenos Aires: Fundación de Investigaciones Sociales y Políticas.

Brito, María Eugenia. 1986. *Desacato: Sobre la obra de Lotty Rosenfeld*. Santiago, Chile: F. Zegers.

Burman, Daniel, director. 2001. *Esperando al mesías*. Argentina/Italy: Diego Dubcovsky.

Caldeira, Teresa P. R. 1996. "Fortified Enclaves: The New Urban Segregation." *Public Culture* 8: 303–28.

———. 2000. *City of Walls: Crime, Segregation, and Citizenship in São Paulo*. Berkeley: University of California Press.

Calvino, Italo. [1972] 1998. *Las ciudades invisibles*. Translated by Aurora Bernárdez. Madrid: Ediciones Siruela.

Campra, Rosalva. 1994. "La ciudad en el discurso literario." *SyC* 5 (May): 19–39.

Cané, Miguel. 1885. "Carta al Intendente Torcuato de Alvear desde Viena." In Adrián Beccar Varela, *Torcuato de Alvear: Primer Intendente municipal de la Ciudad de Buenos Aires*, 481. Buenos Aires: Kraft, 1926.

Carbia, Rómulo. 1908. "El alma nuestra." *Nosotros* 3, no. 16–17 (November–December): 270.

Carrillo, E. Gómez. 1914. *El encanto de Buenos Aires*. Madrid: Perlado, Páez y Cía.

Carroll, Lewis. 1960. *The Annotated Alice: "Alice's Adventures in Wonderland" and "Through the Looking Glass."* Introduction and notes by Martin Gardner. New York: Bramhall House.

Castells, Manuel. 1977. *The Urban Question*. Cambridge, Mass.: MIT Press.

———. 1999. *A sociedade em rede*. São Paulo: Paz e Terra.

———. 2000. "La ciudad de la nueva economía." *La factoría* 12 (June–September). http://www.revistalafactoria.eu.

Castro-Gómez, Santiago, and Eduardo Mendieta, eds. 1998. *Teorías sin disciplina: latinoamericanismo, poscolonialidad y globalización en debate*. Mexico: Miguel Angel Porrúa.

Castro-Klarén, Sara. 2006. "Review: *The Latin American Cultural Studies Reader.*" *Modern Language Notes* 121, no. 2: 465–72.

Centro de Estudios Históricos de Obras Públicas y Urbanismo. 1997. *La Ciudad Hispanoamericana: El sueño de un orden*. Madrid: Centro de Estudios Históricos de Obras Públicas y Urbanismo.

Certeau, Michel de. 1980. *L'invention du quotidian*. Paris: Union Général d'Editions.

———. 1984. *The Practice of Everyday Life*. Translated by Steven F. Rendall. Berkeley: University of California Press.

Chejfec, Sergio. 1991. *El aire*. Buenos Aires: Alfaguara.

Clifford, James. 1992. "Traveling Cultures." In *Cultural Studies*, edited by Lawrence Grossberg, Cary Nelson, and Paula Treicher, 96–112. New York and London: Routledge.

Cobas, José, and Jorge Duany. 1995. *Los cubanos en Puerto Rico: Economía étnica e identidad cultural*. San Juan: Editorial de la Universidad de Puerto Rico.

Colombo, Paola. 1996. "The Exile of Caio Ferraz in the U.S." *Brazzil*, June. http://www.brazzil.com.

Cortázar, Julio. 1979. "Grafitti." In *Tàpies: desembre 78-gener 79*, n.p. Barcelona: Galerie Maeght.

———. 1983. *We Love Glenda So Much and Other Tales*. Translated by Gregory Rabassa. New York: Knopf.

———. 1984. *Graffiti*. Translated by Laure Guille-Bataillon. Photography by Jean-Pierre Vorlet. Lausanne: Galerie Porfolio.

———. 1993. "Grafitti." *Graphiti* 4:4–5.

———. 1994. *Cuentos completos*. 2 vol. Madrid: Alfaguara.

Costa, Lúcio. 1980. "Razões da nova arquitetura." *Artem em Revista* 4: 15–23.

Costa, Vivian. 2005. "Decretada falência do Banco Santos." *Jornal do Brasil*, September 21, A19.

Costa Bonino, Luis. 1995. *La crisis del sistema político uruguayo*. Montevideo: Fundación de Cultura Universitaria.

Costantini, Humberto. 1990. "La rapsodia de Raquel Liberman" (excerpt). In *Cien*

años de narrativa judeoargentina 1889–1989, edited by Ricardo Feierstein, 193–202. Buenos Aires: Milá.

Davis, Diane E. 1994. *Urban Leviathan: Mexico City in the Twentieth Century*. Philadelphia: Temple University Press.

Davis, Mike. 1998. *Ecology of Fear: Los Angeles and the Imagination of Disaster*. New York: Metropolitan Books.

———. 2000. *Magical Urbanism: Latinos Reinvent the U.S. City*. London: Verso.

———. 2006. *Planet of Slums*. London: Verso.

de la Nuez, Iván. 1998. *La balsa perpetua, soledad y conexiones de la cultura cubana*. Barcelona: Editorial Casiopea.

De Palma, Brian, director. 1983. *Scarface*. United States: Universal Pictures.

Deleuze, Gilles, ed. 1986. *Foucault*. Paris: Minuit.

———. 1996. *Conversaciones*. Madrid: Pretextos.

Deleuze, Gilles, and Felix Guattari. 1980. *Mille Plateaux*. Paris: Minuit.

Deleuze, Gilles, and Claire Parnet. [1977] 2007. *Dialogues II*. Translated by Hugh Tomlinson and Barbara Habberjam. New York: Columbia University Press.

Deutsche, Rosalyn. 1996. *Evictions: Art and Spatial Politics*. Cambridge, Mass.: MIT Press.

DiAntonio, Robert, and Nora Glickman, eds. 1993. *Tradition and Innovation: Reflections on Latin American Jewish Writing*. Albany: SUNY Press.

Didion, Joan. 1979. *The White Album*. New York: Noonday.

———. 1987. *Miami*. New York: Simon and Schuster.

do Salvador, Frei Vicente. 1931. *História do Brasil, 1500–1627*. São Paulo: Companhia Melhoramentos.

Eltit, Diamela. 2002. "Arde Troya." In Rosenfeld, *Lotty Rosenfeld: Moción de orden*, 48–72.

Evans, Graeme. 2003. "Hard-Branding the Cultural City—From Prado to Prada." *International Journal of Urban and Regional Research* 27, no. 2 (June): 417–40.

Feijoó, María del Carmen, and Hilda María Herzer, eds. 1991. *Las mujeres y la vida de las ciudades*. Buenos Aires: Grupo Editor Latinoamericano.

Fernandes, Rubem César. 1994. *Private but Public: The Third Sector in Latin America*. Washington: Civicus and Network Cultures-Asia.

Fernández Huidobro, Eleuterio. 1990. *La fuga de Punta Carretas*. 2 vols. Montevideo: Túpac Amaru Editorial.

Filc, Judith. 2003. "Textos y fronteras urbanas: Palabra e identidad en la Buenos Aires contemporánea." *Revista Iberoamericana* 69, no. 202 (January–March): 183–97.

Fioravante, Celso. 2001. "Booty And Soul: Possibility of a Guggenheim Museum Branch in Rio de Janeiro." *ArtForum*, February, 48.

Flores, Susana M. 1993. *Construcción del espacio urbano: Socialización, privatización*. Buenos Aires: Centro Editor de América Latina.

Flores Galindo, Alberto. 1991. *La ciudad sumergida: Aristocracia y plebe en Lima, 1760–1830*. Lima: Editorial Horizonte.

Florida, Richard. 2002. *The Rise of the Creative Class, and How It's Transforming Work, Leisure, Community and Everyday Life*. New York: Perseus Books.

——. 2005. *The Flight of the Creative Class: The New Global Competition for Talent*. New York: HarperCollins.

Fogwill, Rodolfo E. 1999. *Vivir afuera*. Buenos Aires: Sudamericana.

"Forum." 1997. PMLA 112, no. 2: 257–86.

Foster, David William. 1993. "Krinsky: A Play of Argentine Ethnic Identity." In "Argentine-Jewish Writing: Critical Essays," edited by Nora Glickman. Special issue, *Modern Jewish Studies* 8, no. 4: 19–23.

——. 1998. *Buenos Aires: Perspectives on the City and Cultural Production*. Gainesville: University Press of Florida.

——. 2002. *Mexico City in Contemporary Mexican Cinema*. Austin: University of Texas Press.

Foucault, Michel. [1966] 1970. *The Order of Things: An Archaeology of the Human Sciences*. New York: Random House.

——. 1977. *Discipline and Punish: The Birth of the Prison*. New York: Pantheon.

——. 1994. *Vigilar y castigar*. Madrid: Visor.

France Presse, no Rio. 2003. "Justiça do Rio suspende contrato com arquiteto responsável pelo Guggenheim." *Folha de São Paulo*, August 26. http://www1.Folha.uol.com.br.

Franco, Jean. 2002. *The Decline and Fall of the Lettered City: Latin America in the Cold War*. Cambridge, Mass.: Harvard University Press.

García, María Cristina. 1996. *Havana USA: Cuban Exiles and Cuban Americans in South Florida, 1959–1994*. Berkeley: University of California Press.

García Canclini, Néstor. 1968. *Cortázar, una antropología poética*. Buenos Aires: Nova.

——. 1990. *Culturas híbridas: Estrategias para entrar y salir de la modernidad*. Mexico: Grijalbo.

——. 1993. "Memory and Innovation in the Theory of Art." *South Atlantic Quarterly* 19, no. 3: 423–43.

——. 1994. "Los estudios culturales de los 80 a los 90: Perspectivas antropológicos y sociológicos en América Latina." In *Posmodernidad en la periferia: Enfoques latino-americanos de la nueva teoría cultural*, edited by Hermann Herlinghaus and Monika Walter, 111–33. Berlin: Langer Verlag.

——. 1995a. *Consumidores y ciudadanos: Conflictos multiculturales de la globalización*. México: Grijalbo.

——. 1995b. *Hybrid Cultures: Strategies for Entering and Leaving Modernity*. Translated by Christopher L. Chiappari and Silvia L. López. Minneapolis: Minnesota University Press.

——. 1997. *Imaginarios urbanos*. Buenos Aires: Eudeba.

——. 2004. "Cultural Studies from the 1980s to the 1990s: Anthropological and Sociological Perspectives in Latin America." In Sarto, Ríos, and Trigo, *The Latin American Cultural Studies Reader*, 329–46.

García Canclini, Néstor, Alejandro Castellanos, and Ana Rosas Mantecón. 1996. *La ciudad de los viajeros: Travesías e imaginarios urbanos; México, 1940–2000*. México: Grijalbo.

García Canclini, Néstor, and Mabel Piccini. 1993. "Culturas de ciudad de México: Símbolos colectivos y usos del espacio urbano." In *El consumo cultural en México*, edited by García Canclini and González Sánchez, 43–85. México: Consejo Nacional para la Cultura y las Artes.

Gasparini, Graziano. 1991. "The Spanish-American Grid Plan, an Urban Bureaucratic Form." *The New City-Foundations* 1 (fall): 6–33.

Gausa, Manuel, ed. 2001. *Diccionario Metápolis de Arquitectura Avanzada*. Barcelona: Actar.

Geertz, Clifford. 1980. *Negara: The Theatre State in Nineteenth-Century Bali*. Princeton: Princeton University Press.

Generalitat Valencia. 1992. *La ciudad iberoamericana*. Valencia: Artes Gráficas Soler.

Gerchunoff, Alberto. 1910. *Los gauchos judíos*. La Plata: Talleres Gráficos Joaquín Sesé.

———. [1913] 1960. "Buenos Aires metrópoli continental." In *Buenos Aires, la metrópoli de mañana*, 13–30. Buenos Aires: Cuadernos de Buenos Aires.

Gilbert, Alan. 1994. *The Latin American City*. London: Latin America Bureau.

———, ed. 1996. *The Mega-city in Latin America*. Tokyo: United Nations University Press.

———. 1998. "World Cities and the Urban Future: The View from Latin America." In Lo and Yeung, *Globalization and the World of Large Cities*, 174–202.

Glickman, Nora. 2000. *The Jewish White Slave Trade and the Untold Story of Raquel Liberman*. New York: Garland.

Goldenberg, Jorge. 1975. *Relevo 1923*. Havana: Casa de las Américas.

———. 1984. *Krinsky*. Buenos Aires: Ediciones de Arte Gaglianone. Translated as *Krinsky* in *Argentine Jewish Theater: A Critical Anthology*. edited and translated by Nora Glickman and Gloria Waldman. Lewisburg, Penn.: Bucknell University Press, 1996.

Gombrich, E. H. 1974. "Standards of Truth: The Arrested Image and the Moving Eye." In *The Language of Images*, edited by W. J. T. Mitchell, 181–217. Chicago: University of Chicago Press.

Gooding, Mel. 1998. "Public: Art: Space." In *Public: Art: Space: A Decade of Public Art Commissions Agency, 1987–97*, 13–20. London: Merrell Holberton.

Gorelik, Adrián. 1998. *La grilla y el parque: Espacio público y cultura urbana en Buenos Aires, 1887–1936*. Buenos Aires: Editorial de la Universidad Nacional de Quilmes.

———. 2004. "Imaginarios urbanos e imaginación urbana: Para un recorrido por los lugares comunes de los estudios culturales urbanos." In *bifurcaciones* 1 (summer). www.bifurcaciones.cl/001/Gorelik.htm.

———. 2006. "Modelo para armar: Buenos Aires, de la crisis al boom." *Punto de Vista*, no. 84 (April): 33–39.

Gorelik, Adrián, and Graciela Silvestri. 2000. "Ciudad y cultura urbana, 1976–1999: El

fin de la expansión." In *Buenos Aires, historia de cuatro siglos*, 2nd ed., edited by José Luis Romero and Luis Alberto Romero, 461–99. Buenos Aires: Altamira.

Gorodischer, Angélica. 1991. "Camera Obscura." Translated by Diana Vélez. *Latin American Literary Review* 19, no. 37: 96–105.

Gottdiener, M., and Alexadros Lagopoulos, eds. 1986. *The City and the Sign: An Introduction to Urban Semiotics.* New York: Columbia University Press.

Guilbaut, Serge. 1992. "Materias de reflexión: Los muros de Antoni Tàpies." In *Tàpies, Comunicació sobre el mur*, 33–46.

Gutman, Margarita and Jorge Enrique Hardoy, eds. 1992. *Buenos Aires: Historia urbana del Area Metropolitana.* Madrid: Editorial Mapfre.

Guy, Donna J. 1991. *Sex and Danger in Buenos Aires: Prostitution, Family, and Nation in Argentina.* Lincoln: University of Nebraska Press.

Hardoy, Jorge Enrique. [1965] 1972. "El rol de la urbanización en la modernización de América Latina." In *Las ciudades en América Latina. Seis ensayos sobre la urbanización contemporánea*, 33–48. Buenos Aires: Piados.

———. 1975. *Urbanization in Latin America: Approaches and Issues.* Garden City, N.Y.: Anchor Press.

———. 1997. "Las ciudades de América Latina a partir de 1900." In Centro de Estudios Históricos de Obras Públicas y Urbanismo, *La Ciudad Hispanoamericana: El sueño de un orden*, 267–274.

Hardoy, Jorge Enrique, and Oscar Moreno. 1974. "Tendencias y alternativas de la reforma urbana." *Desarrollo Económico* 52 (January–May): 627–47.

Hardoy, Jorge E., and Richard Morse. 1988. *Repensando la ciudad de América Latina.* Buenos Aires: Grupo Editor Latinoamericano. Published in English as *Rethinking the Latin American City.* Baltimore: John Hopkins University Press, 1992.

Hardt, Michael, and Antonio Negri. 2000. *Empire.* Boston: Harvard University Press.

———. 2002. *Imperio.* Buenos Aires: Paidos.

Harvey, David. 1990. *The Condition of Postmodernity.* Cambridge: Blackwell.

Hauser, Philip, ed. 1961. *La urbanización en América Latina.* Buenos Aires: Solar.

Heck, Marina, ed. 1993. *Grandes metrópolis de América latina.* São Paulo: Fundação Memorial da América Latina: Fondo de Cultura Económica.

Heffes, Gisela, ed. 1999. *Judíos, argentinos, escritores.* Buenos Aires: Ediciones Atril.

Hirszman, Maria. 2004. "Os museus na pauta do dia: Crises e desafios." *O Estado de São Paulo*, September 4. http://forumpermanente.incubadora.fapesp.br.

Hoberman, Louisa Schell, and Susan Migden Socolow, eds. 1986. *Cities and Society in Colonial Latin America.* Albuquerque: University of New Mexico Press.

Holston, James. 1989. *The Modernist City: An Anthropological Critique of Brasília.* Chicago: University of Chicago Press.

Homero Villa, Raúl. 2000. *Barrio-Logos: Space and Place in Urban Chicano Literature and Culture.* Austin: University of Texas Press.

Hudson, W. H. 1980. *La tierra purpúrea: Allá lejos y hace tiempo.* Translated by Idea Vilariño. Caracas, Venezuela: Biblioteca Ayacucho.

Huret, Jules. [1911] 1988. *De Buenos Aires al Gran Chaco*. Buenos Aires: Hyspamérica.

Huyssen, Andreas. 1995. *Twilight Memories: Marking Time in a Culture of Amnesia*. N.Y.: Routledge.

Instituto Brasileiro de Geografia e Estatistica (IBGE). 1959. *Censo Experimental de Brasília*. Rio de Janeiro.

Instituto Brasileiro do Patrimônio Cultural (IBPC). 1992. Special issue, *Patrimônio Cultural*, November-December.

Instituto Nacional de Estadística y Geografía (INEGI). 1994. *Encuesta de origen y destino de los viajes de los residentes del Área Metropolitana de la ciudad de México*. Mexico City: Instituto Nacional de Estadística y Geografía.

Jabor, Arnoldo. 1995. "As favelas do Rio são países estrangeiros." *Folha de São Paulo*, May 30, V10.

Jacobs, Karrie. 1997. "Capital Improvements." *Guggenheim Magazine*, fall, 10–17.

Jameson, Fredric. 1984. "Postmodernism, or the Cultural Logic of Late Capitalism." *New Left Review* 1, no. 146: 53–92.

———. 1986. "Third World Literature in the Era of Multinational Capitalism." *Social Text* 15: 65–88.

Joseph, Gilbert M., and Mark D. Szuchman, eds. 1996. *I Saw a City Invincible: Urban Portraits of Latin America*. Wilmington, Del.: Scholarly Resources.

"Justiça barra Guggenheim." 2003. *Centro de midia independente cmi brasil*, May 21. http://brasil.Indymedia.org/pt/blue/2003/05/255090.shtml.

"Justiça do Rio veta construção do Museu Guggenheim." 2003. *Terra*, June 26. http://www.terra.com.br.

Kagan, Richard L. 2000. *Urban Images of the Hispanic World, 1493–1793*. New Haven: Yale University Press.

Kaminsky, Amy. 2008. *Argentina: Stories for a Nation*. Minneapolis: University of Minnesota Press.

Kandiyoti, Dalia. 1998. "Comparative Diasporas: The Local and the Mobile in Abraham Cahan and Alberto Gerchunoff." *Modern Fiction Studies* 44, 1: 77–122.

Katz, Judith. 1997. *The Escape Artist*. Ithaca, New York: Firebrand Books.

Kipnis, J. 1993. "Towards a New Architecture." In AD *Profile 102: Folding in Architecture*, edited by Greg Lynn, 40–49. London: Academy Group.

Kohen, Natalia. 1997. *Todas las máscaras*. Buenos Aires: Temas Grupo Editorial.

Königs, Ulrich. 1999. "On Grafting, Cloning, and Swallowing Pills." *Daidalos* 72: 18–27.

Koolhaas, Rem. 1995. *Small, Medium, Large, Extra-large*. Rotterdam: 010 Publishers.

Koolhaas, Rem, Stefano Boeri, Nadia Tazi, et al. 2000. *Mutations*. Bordeaux: Actar / Arc en Rêve.

Kozameh, Alicia. 1987. *Pasos bajo agua*. Buenos Aires: Contrapunto. Translated by David Davis as *Steps under Water*. Berkeley: University of California Press, 1996.

Krauss, Rosalind. 1989. "Photography's Discursive Spaces." In *The Contest of Meaning:*

Critical Histories of Photography, edited by Richard Bolton, 286–301. Cambridge, Mass.: MIT Press.

Krauss, Rosalind, and Yve Alain Bois. 1997. *Formless: A User's Guide*. Cambridge, Mass.: MIT Press.

Kubitschek, Juscelino. 1957. *Por que construí Brasília*. Rio de Janeiro: Bloch Editores.

Landry, Charles. 2000. *The Creative City: A Toolkit for Urban Innovators*. London: Earthscan.

Landry, Charles, and Franco Bianchini. 1995. *Creative City*. London: Demos in association with Comedia.

Le Corbusier, Charles-Edouard Jeanneret. 1957. *La charte d'Athenes*. Paris: Editions de Minuit.

Lefebvre, Henri. 1991. *The Production of Space*. Translated by Donald Nicholson-Smith. Oxford: Blackwell.

———. 1996. *Writing on Cities*. Translated and with an introduction by Eleonore Kofman and Elizabeth Lebas. Cambridge, Mass: Blackwell.

Lejeune, Jean-François, ed. 2003a. *Cruelty and Utopia: Cities and Landscapes of Latin America*. New York: Princeton Architectural Press.

———. 2003b. "Dreams of Order: Utopia, Cruelty, and Modernity." In Lejeune, *Cruelty and Utopia*, 30–49.

Lévi-Strauss, Claude. 1973. *Tristes Tropiques*. Translated by John Weightman and Doreen Weightman. New York: Viking Penguin.

Lewis, Oscar. 1961. *Antropología de la pobreza: Cinco familias*. Mexico: Fondo de Cultura Económica.

———. [1961] 1979. *Los hijos de Sánchez*. Mexico City: Mortiz.

Lindstrom, Naomi. 1989. *Jewish Issues in Argentine Literature*. Columbia: University of Missouri Press.

Lo, Fu-Chen, and Uye-man Yeung, eds. 1998. *Globalization and the World of Large Cities*. Tokyo: United Nations University Press.

Low, Setha M., ed. 1999. *Theorizing the City: The New Urban Anthropology Reader*. New Brunswick, N. J.: Rutgers University Press.

Lynch, Kevin. 1960. *The Image of the City*. Cambridge, Mass.: MIT Press.

MacDonald, William L. 1979. *Piranesi's Carceri: Sources of Invention*. Northampton, Mass.: Smith College.

MacDonnell, Mercedes. 2003. "The Sphinx's Suicide: Literature, Dream, and Enigma in Liliana Porter's Photographs." In Porter, *Liliana Porter*, 203–5.

Mallea, Eduardo. 1937. *Historia de una pasión argentina*. Buenos Aires: Sur.

Marcin, Mauricio. 2005. "Guggenheim de Guadalajara, derrota para el arte mexicano." *La Crónica de Hoy*, July 18. http://www.cronica.com.mx.

Margulis, Mario. 1994. *La cultura de la noche: La vida nocturna de los jóvenes en Buenos Aires*. Buenos Aires: Compañía Editora Espasa Calpe Argentina.

Martínez Estrada, Ezequiel. 1933. *Radiografía de la pampa*. Buenos Aires: Babel.

———. 1940. *La cabeza de Goliat: Microscopía de Buenos Aires*. Buenos Aires: Club de Libro A.L.A.

Massolo, Alejandra, ed. 1992. *Mujeres y ciudades: Participación social, vivienda y vida cotidiana*. México: El Colegio de México.

McNeill, Donald. 2000. "McGuggenisation? National Identity and Globalisation in the Basque Country." *Political Geography* 19: 473–94.

Mela, Antonio. 1989. "Ciudad, comunicación, formas de racionalidad." *Diálogos de la Comunicación* 23: 10–33.

Miles, Malcolm. 1997. *Art, Space and the City: Public Art and Urban Futures*. London: Routledge.

Ministry of Justice. 1959. *Brasília: Medieda Legislativas Sugeridas à Comissão Mista pelo Ministro da Justiça e Negócios Interiores*. Rio de Janeio: Departamento de Imprensa Nacional.

Mitchell, W. J. T., ed. 1990a. *Art and the Public Sphere*. Chicago: University of Chicago Press.

———. 1990b. "The Violence of Public Art: *Do the Right Thing*." *Critical Inquiry* 16, no. 4: 880–99.

———. 1991. "An interview with Barbara Kruger." *Critical Inquiry* 17, no. 2: 434–48.

Monsiváis, Carlos. 1995. *Los rituales del caos*. México: Ediciones Era.

Moreiras, Alberto. 1998. "Fragmentos globales: Latinoamericanismo de segundo orden." In Castro-Gómez and Mendieta, *Teorías sin disciplina*, 59–83.

———. 2001. *The Exhaustion of Difference: The Politics of Latin American Cultural Studies*. Durham, N.C.: Duke University Press.

Morse, Richard. 1971. *The Urban Development of Latin America, 1750–1920*. Stanford: Center for Latin American Studies, Stanford University.

———. 1992. "Cities as People." In Hardoy and Morse, *Rethinking the Latin American City*, 3–19.

"Motines y revueltas en cárceles de América Latina desde 1978." 2005. *El Comercio*, March 8. http://www.elcomercioperu.com.pe.

Mumford, Lewis. 1961. *The City in History: Its Origins, Its Transformations and Its Prospects*. New York: Harcourt and Brace.

———. 1970. *The Culture of Cities*. New York: Harcourt, Brace, Jovanovich.

———. 1998. "What is a City?" In *The City Reader*, edited by Richard T. LeGates and Frederick Stout, 154–88. London: Routledge .

Muñoz, Boris. 2003. "La ciudad de México en la imaginación apocalíptica." In Muñoz and Spitta, *Más allá de la ciudad letrada*, 75–98.

Muñoz, Boris, and Silvia Spitta, eds. 2003. *Más allá de la ciudad letrada: Crónicas y espacios urbanos*. Pittsburgh: Instituto Internacional de Literatura Iberoamericana.

Muñoz, Susana, director. 1980. *Susana*. US/Argentina: self-produced.

Muñoz Molina, Antonio. 1999. *Carlota Fainberg*. Madrid: Alfaguara.

Navia, Patricio, Marc Zimmerman, and Saskia Sassen, eds. 2004. *Las ciudades latinoamericas en el nuevo (des)orden mundial*. México: Siglo XXI.

Needell, Jeffrey D. 1995. "Rio de Janerio and Buenos Aires: Public Space and Public Consciousness in Fin de Siècle Latin America." *Comparative Studies in Society and History* 37, no. 3 (July): 519–40.

Neustadt, Robert. 2001. *Cada día: La creación de un arte social.* Santiago: Cuarto Propio.

Nora, Pierre. 1997. *Realms of Memory: The Construction of French Past Traditions.* New York: Columbia University Press.

Nouvel, Jean. 2003. "Guggenheim Museum in Rio de Janeiro, Rio de Janeiro, Brazil." *A + U: Architecture and Urbanism* 395: 44–51.

Novacap. 1960. "Arquitetura e Engenharia." Special issue, *Brasília,* journal of Companhía Urbanizadora da Nova Capital do Brasil-Novacap (July-August).

Novacap. 1963. *Brasília,* journal of Companhía Urbanizadora da Nova Capital do Brasil-Novacap.

Oliveira, Fabrício Leal de. 2000. "Vazios urbanos e o planejamento das cidades." *Caderno de Urbanismo* 2. http://www2.rio.rj.gov.br/paginas/noticias_caderno_ed2-5.htm.

Orgambide, Pedro. 2001. *Buenos Aires: la novela.* Buenos Aires: Alfaguara.

Ortiz, Federico, and Alberto S. J. de Paula. 1968. *La arquitectura del liberalismo en la Argentina.* Buenos Aires: Sudamericana.

Ortiz Monasterio, Fernando. 1987. *Tierra profanada: Historia ambiental de México.* México, D.F.: Instituto Nacional de Antropología e Historia: Secretaría de Desarrollo Urbano y Ecología.

Oszlak, Oscar. 1991. *Merecer la ciudad: Los pobres y el derecho al espacio urbano.* Buenos Aires: El Centro de Estudios de Estado y Sociedad.

Pacioni, Michael. 2001. *Urban Geography: A Global Perspective.* London: Routledge.

Papadaki, Stamo. 1960. *Oscar Niemeyer.* New York: George Braziller.

Partnoy, Alicia. 1986. *The Little School.* San Francisco: Cleis Press.

Peixoto, Nelson Brissac. 1996. *Paisagens urbanas.* São Paulo: Editora SENAC, 1996.

Perlman, Janice E. 1976. *The Myth of Marginality: Urban Poverty and Politics in Rio de Janeiro.* Berkeley: University of California Press.

Perulli, Paolo. 1995. *Atlas Metropolitano, el cambio social en las grandes ciudades.* Madrid: Alianza.

Pichois, Claude, ed. 1973. *Lettres à Charles Baudelaire.* Neuchâtel: La Baconnière.

Pile, Steve. 1996. *The Body and the City: Psychoanalysis, Space, and Subjectivity.* London: Routledge.

Pírez, Pedro. 1993. "Las metrópolis latinoamericanas: el reto de las necesidades." In Heck, *Grandes Metrópolis de América latina,* 14–42.

Plager, Silvia. 1993. *Mujeres pudorosas.* Buenos Aires: Atlántida.

Porter, Liliana. *Liliana Porter: Fotografía y ficción.* Buenos Aires: Centro Cultural Recoleta, 2003.

Posada, Adolfo. [1912] 1986. *La Repúblic Argentina: Impressiones y comentarios.* Buenos Aires: Hyspamérica.

Pratt, Mary Louise. 1992. *Imperial Eyes: Travel Writing and Transculturation*. London: Routledge.

Prefeitura da Cidade do Rio de Janeiro. 2002. "Museu Guggenheim renovação do Rio: A cidade decide." *Rio estudos* 79 (November). http://www.armazemdedados.rio.rj.gov.br.

Quiroga, José. 2005. *Cuban Palimpsests*. Minneapolis: University of Minnesota Press.

Rama, Angel. 1982. *Transculturación narrativa en América Latina*. Mexico: Siglo XXI.

———. 1984. *La ciudad letrada*. Hanover, N.H.: Ediciones del Norte.

———. 1996. *The Lettered City*. Translated and edited by John Charles Chasteen. Durham, N.C.: Duke University Press.

Ramos, Silvia. 2006. "Juventude e polícia." *Boletim Segurança e Cidadania* 12 (October). http://www.ucamcesec.com.br.

Redfield, Robert. 1930. *Tepoztlán, a Mexican Village: A Study of Folk Life*. Chicago: University of Chicago Press.

———. 1941. *The Folk Culture of Yucatán*. Chicago: University of Chicago Press.

Rico, Alvaro. 2004. "Los márgenes de la política y la política desde los márgenes." *Relaciones*, no. 245 (October). http://www.chasque.net/frontpage/relacion/0410/margenes_politica.htm.

Ríos, Alicia. 2004. "Traditions and Fractures in Latin American Cultural Studies." In Sarto, Ríos, and Trigo, *The Latin American Cultural Studies Reader*, 15–34.

Rojas, Sergio. 2002. "El cuerpo de los signos." In Lotty Rosenfeld, *Moción de orden*, 4–37. Santiago de Chile: Galería Gabriela Mistral.

Romero, José Luis. 1976. *Latinoamérica, las ciudades y las ideas*. Buenos Aires: Siglo XXI.

Roque, Atila. 2001. "Cultura e cidadania: A experiência do Afro Reggae." In *Redução da pobreza e dinâmicas locais*, edited by Ilka Camarotti and Peter Spinks, 49–84. Rio de Janeiro: Fundação Getúlio Vargas Editora.

Rosebaum, Lee. 2003. "The Guggenheim Regroups: The Story Behind the Cutbacks." *Art in America*, February, 43–47.

Rosenfeld, Lotty. 2002. *Lotty Rosenfeld: Moción de orden*. Santiago de Chile: Ocho Libros Editores.

Rotker, Susana, and Katherine Golman, eds. 2002. *Citizens of Fear: Urban Violence in Latin America*. New Brunswick, N.J.: Rutgers University Press.

Rozenmacher, Germán. [1962] 1992. *Cabecita negra*. Buenos Aires: Centro Editor de América Latina.

Rusiñol, Santiago. 1911. *Un viaje al Plata*. Madrid: V. Prieto y Cía.

Rybczynski, Witold. 1995. *City Life*. New York: Scribner.

Salcedo Salcedo, Jaime. 1996. *Urbanismo Hispano-Americano, Siglos XVI, XVII y XVIII: el modelo urbano aplicado a la América española, su génesis y su desarrollo teórico y práctico*. Bogotá: Pontificia Universidad Javeriana.

Sarlo, Beatriz. 1988. *Una modernidad periférica: Buenos Aires 1920 y 1930*. Buenos Aires: Nueva Visión.

————. 1994. *Escenas de la vida posmoderna: Intelectuales, arte y videocultura en la Argentina.* Buenos Aires: Ariel.

————. 1995. "Olvidar a Benjamin." *Punto de Vista,* no. 53 (November): 16–19.

————. 1997a. "Cultural Studies Questionnaire." Interview by John Kraniauskas. *Journal of Latin American Cultural Studies* 6, no. 1: 85–92.

————. 1997b. "Los estudios culturales y la crítica literaria en la encrucijada valorativa." *Revista de crítica cultural* 15: 32–38.

————. 1999. "Cultural Studies and Literary Criticism at the Crossroads of Values." *Journal of Latin American Cultural Studies* 8, no. 1: 115–24.

————. 2001a. *Scenes from Postmodern Life.* Minneapolis: University of Minnesota Press.

————. 2001b. *Tiempo presente: Notas sobre el cambio de una cultura.* Buenos Aires: Siglo XXI Editores.

Sarto, Ana del, Alicia Ríos, and Abel Trigo, ed. 2004. *The Latin American Cultural Studies Reader.* Durham, N.C.: Duke University Press.

Sassen, Saskia. 1991. *The Global City.* Princeton: Princeton University Press.

————. 2000. "The Global City: Strategic Site / New Frontier." *American Studies* 41, no. 2–3: 79–95.

Schteingart, Martha. 1989. *Las ciudades latinoamericanas en la crisis: Problemas y desafíos.* México: Editorial Tillas.

————, ed. 1991. *Espacio y vivienda en la ciudad de México.* México, D.F.: El Colegio de México, Centro de Estudios Demográficos y de Desarrollo Urbano: I Asamblea de Representantes del Distrito Federal.

Schumway, Nicolas. 1991. *The Invention of Argentina.* Berkeley: University of California Press.

Schwartz, Jorge. 1983. *Vanguarda e Cosmopolitismo na Década de 20.* São Paulo: Perspectiva.

Schwartz, Marcy. 1999. *Writing Paris: Urban Topographies of Desire in Contemporary Latin American Fiction.* Albany: SUNY Press.

Scobie, James. 1971. *Argentina, a City and a Nation.* New York: Oxford University Press.

Sebreli, Juan José. [1964] 2003. *Buenos Aires, vida cotidiana y alienación; seguido de, Beunos Aires, ciudad en crisis.* Buenos Aires: Editorial Sudamericana.

Segre, Roberto. 2004. "Rio de Janeiro metropolitano: Saudades da Cidade Maravilhosa." *Arquitextos* 46 (March). http://www.vitruvius.com.br.

Senkman, Leonardo. 1983. *La identidad judía en la literatura argentina.* Buenos Aires: Ediciones Pardes.

Serres, Michel. 1994. *Atlas.* Paris: Julliard.

Sheriff, Robin E. 2001. *Dreaming Equality: Color, Race, and Racism in Urban Brazil.* New Brunswick, N. J.: Rutgers University Press.

Sholem Aleichem. 1909. "The Man from Buenos Aires." In *Tevye's Daughters,* translated by Frances Butwin, 128–40. New York: Crown, 1949.

———. 1983. *Favorite Tales of Sholom Aleichem*. New York: Avenel Books.

Shteyngart, Gary. 2003. "The City of Stories Again." *The New York Times Magazine*, October 5, 51–53.

Sienna, Pedro, director. 1925. *El Húsar de la Muerta*. Chile: Film Andes.

Silva, Armando. 1992. *Imaginarios urbanos, Bogotá y São Paulo: Cultura y comunicación urbana en América Latina*. Bogotá: Tercer Mundo Editores.

———. 1993. "La ciudad en sus símbolos: Una propuesta metodológica para la comprensión de lo urbano en América Latina." In Heck, *Grandes metrópolis de América latina*, 87–101.

Singer, Isaac Bashevis. 1991. *Scum*. Translated by Rosaline Dukalsky Schwartz. New York: Farrar Straus Giroux.

Skinner, Quentin. 1989. "The State." In *Political Innovation and Conceptual Change*, edited by Terence Ball, James Farr, and Russell L. Hanson. Cambridge: Cambridge University Press.

Soares, Luiz Eduardo, M. V. Hill, and Celso Athayde. 2005. *Cabeça de porco*. Rio de Janeiro: Editora Objetiva.

Soja, Edward W. 1990. *Postmodern Geographies: The Reassertion of Space in Critical Social Theory*. London: New Left Books.

———. 1996. *Thirdspace: Journeys to Los Angeles and Other Real-and-Imagined Places*. Cambridge, Mass: Blackwell.

———. 2000. *Postmetropolis: Critical Studies of Cities and Regions*. Oxford: Blackwell.

Solá Morales, Ignasi. 1995. "Terrain Vague." In *Anyplace*, edited by Cynthia C. Davidson. Cambridge, Mass.: MIT Press.

———. 1996. "Presente y futuros: La arquitectura en las ciudades." In *Presente y futuros: Arquitectura en las ciudades*, edited by Solá Morales and Xavier Costa, 10–23. Barcelona: Comitè d'Organització del Congrés UIA Barcelona 96.

Solomianski, Alejandro. 2003. "Del autoritarismo a la persuasión: Metáfora y poder en el pasaje de las dictaduras a los neoliberalismos del Río de la Plata." *Encuentros* (Montevideo) 9 (December):149–87.

Sosnowski, Saúl. 1987. *La orilla inminente: Escritores judíos argentinos*. Buenos Aires: Editorial Legasa.

Spitta, Silvia. 2003. "Prefacio: Más allá de la ciudad letrada." In Muñoz and Spitta, *Más allá de la ciudad letrada*, 7–23.

Strejilevich, Nora. 1997. *Una sola muerte numerosa*. Miami: North/South Center Press. Translated by Cristina de la Torre, in collaboration with Strejilevich, as *A Single Numberless Death*. Charlottesville: University of Virginia Press, 2002.

Szuchman, Mark D. 1996. "The City as Vision: The Development of Urban Culture in Latin America." In Joseph and Szuchman, *I Saw a City Invincible*, 1–30.

Tàpies, Antoni. 1992. *Comunicació sobre el mur*. Barcelona: Fundació Antoni Tàpies.

Tiempo, César. *See* Béter, Clara.

Timmerman, Jacobo. 1981. *Prisoner without a Name, Cell without a Number*. New York: Knopf.

Torres, María de los Angeles. 1999. *In the Land of Mirrors: The Politics of Cuban Exiles in the United States*. Ann Arbor: University of Michigan Press.

Trigo, Abel. 2004. "General Introduction." In Sarto, Ríos, and Trigo, *The Latin American Cultural Studies Reader*, 1–14.

Tucker, Anne Wilkes. 1999. "Brassaï: Man of the World." In *Brassaï: The Eye of Paris*. Houston: Museum of Fine Arts, 16–135.

Vasconcelos, José. [1925] 1928. *La raza cósmica, misión de la raza iberoamericana: Notas de viajes a la América del Sur*. Paris: Agencia Mundial de Librería.

Ventura, Zuenir. 1994. *Cidade Partida*. São Paulo: Companhia das Letras.

Verbitsky, Bernardo. 1957. *Villa Miseria también es América*. Buenos Aires: Kraft.

Versteegh, Peter. 1997. "Urban Mapping: Drawing the An-/Un-architectural." In *Fields, Studio '95-'96*, 16–30. Rotterdam: 010 Publishers.

Vila, Pablo Sergio. 1994. "Everyday Life: Cultural and Identity on the Mexican-American Border; The Ciudad Juárez-El Paso Case." PhD dissertation, University of Texas, Austin.

Villa, Miguel, and Jorge Rodríguez. 1996. "Demographic Trends in Latin America's Metropoli, 1950–1991." In Gilbert, *The Mega-city in Latin America*, 25–52.

Viñar, Marcelo, and Maren Ulrikensen. 1993. *Fracturas de memoria: Crónicas de una memoria por venir*. Montevideo: Trilce.

Viñas, David. 1966. *En la semana trágica*. Buenos Aires: Editorial Jorge Alvarez.

Virilio, Paul. 1984. *L'espace critique*. Paris: Christian Bourgois.

Vogel, Carol. 2005. "Guggenheim Loses Top Donor in Rift on Spending and Vision." *New York Times*, January 20. http://www.nytimes.com.

Wade, Peter. 2000. *Music, Race, and Nation: Música Tropical in Colombia*. Chicago: University of Chicago Press.

Ward, Peter. 1998. *Mexico City*. West Sussex, UK: Wiley.

Wirth, Louis. 1938. "Urbanism as a Way of Life." *American Journal of Sociology* 44: 1–24.

Yúdice, George. 2003. *The Expediency of Culture: Uses of Culture in the Global Era*. Durham, N.C.: Duke University Press.

Zamora, Lois Parkinson. 1999. "Interartistic Approaches to Contemporary Latin American Literature." *Modern Language Notes* 114: 389–415.

———. 2003. "Ciudades sin dimensiones: Las urbes filosóficas de Jorge Luis Borges y Xul Solar." In Muñoz and Spitta, *Más allá de la ciudad letrada*, 307–32.

Zimbalist, Jeff, and Matt Mochary, directors. 2005. *Favela Rising*. Brazil/United States: All Rise LLC.

Contributors

Hugo Achugar is the national director of culture in the Uruguayan Ministry of Education and Culture. He has been a professor of Latin American literature at the Universidad de la República, Uruguay, the University of Miami, Northwestern University, and others, and currently directs the Observatorio de Políticas Culturales at the Universidad de la República. His recent publications include *Planetas sin boca: Escritos efímeros sobre arte, cultura y literatura* (2004) and *Imaginarios y consumo cultural* (2003).

Rebecca E. Biron is an associate professor of Spanish and comparative literature at Dartmouth College. She works in Mexican studies, Latin American literary and cultural studies, and gender studies. She is the author of *Murder and Masculinity: Violent Fictions of Twentieth-Century Latin America* (2000). Her current book project concerns the rhetoric of modernization and globalization in twentieth-century Mexico.

Néstor García Canclini is a distinguished professor at the Universidad Autónoma Metropolitana in Mexico and a researcher emeritus in the Sistema Nacional de Investigadores. His most important publications include *Hybrid Cultures* (1995); *Consumers and Citizens* (2001); *Diferentes, desiguales y desconectados: Mapas de la interculturalidad* (2004); and *Imagined Globalization* (forthcoming from Duke University Press).

Adrián Gorelik is an architect and historian. He is a professor at the Universidad Nacional de Quilmes in Argentina and a member of the editorial boards of *Punto de Vista* and *Prismas: Revista de Historia Intelectual*. He is the author of *La grilla y el parque: Espacio público y cultura urbana en Buenos Aires, 1887–1936* (1998); *La sombra de la*

vanguardia: Hannes Meyer en México, 1938–1947 (1993) (in collaboration with Jorge F. Liernur); *Miradas sobre Buenos Aires: Historia cultural y crítica urbana* (2004); and *Das vanguardas à Brasília: Cultura urbana e arquitetura na America Latina* (2005).

James Holston is a professor of anthropology at the University of California, Berkeley. His current research examines the worldwide insurgence of democratic urban citizenships, their entanglement with entrenched systems of inequality, and their contradiction by violence and misrule of law under political democracy. His publications include *Insurgent Citizenship: Disjunctions of Democracy and Modernity in Brazil* (2008); *The Modernist City: An Anthropological Critique of Brasília* (1989); and the edited volume *Cities and Citizenship* (1999).

Amy Kaminsky is a professor of gender, women, and sexuality studies and global studies at the University of Minnesota. Her books include *Reading the Body Politic: Latin American Women Writers and Feminist Criticism* (1992); *Water Lilies / Flores del Agua: An Anthology of Spanish Women Writers from the Fifteenth through the Nineteenth Century* (1995); *After Exile: Writing the Latin American Diaspora* (1999); and *Argentina: Stories for a Nation* (2008). Her current research focuses on Jews, gender, and modernity in Argentina.

Samuel Neal Lockhart (translator) graduated from the University of Miami in 2005 with a Bachelor of Science degree, summa cum laude, specializing in neuroscience and with a minor concentration in Spanish literature. He is currently a graduate student in neuroscience at the University of California, Davis, where he is engaged in the study of human cognitive and translational neuroscience. He is thankful to his mom and his dad for most everything they did for him, especially supporting him through that summer with Dr. Biron.

Nelson Brissac Peixoto is a philosopher working on art and urbanism. He is a professor at the Catholic University, in São Paulo. Since 1994, he has been the organizer and curator of Arte/Cidade, a project of urban interventions in São Paulo. He is the author of *Intervenções urbanas: Arte, cidade* (2002); *Paisagens urbanas* (1996); *Cenários em ruínas: A realidade imaginária contemporânea* (1987); and *A sedução da barbárie: o marxismo na modernidade* (1982).

José Quiroga is a professor of Spanish and comparative literature at Emory University. He is the author of *Cuban Palimpsests* (2005), *Tropics of Desire: Interventions from Queer Latino America* (2001), *Understanding Octavio Paz* (2000), and, in collaboration with Daniel Balderston, *Sexualidades en Disputa* (2005). He is a co-editor of two book series at Palgrave Macmillan: New Directions in Latino American Cultures and New Concepts in Latino American Cultures.

Nelly Richard is a critic and essayist and the director of *Revista de Crítica Cultural*. She also directs the Graduate Program in Cultural Studies and serves as the vice-rector of outreach, communications, and publications at the Universidad de Arte y Ciencias Sociales. She is the author of *Intervenciones críticas: Arte, cultura, género e política* (2002); *Residuos y metáforas* (1998); *La insubordinación de los signos: Cambio político, transformaciones culturales y poéticas de la crisis* (1994); *Masculino/Femenino: Prácticas de la diferencia y cultura democrática* (1993); *La estratificación de los márgenes* (1989); and *Margins and Institutions: Art in Chile from 1975* (1987). She is the editor of *Arte y Política* (co-edited with Pablo Oyarzún and Claudia Zaldívar, 2005); *Utopías(s): Revisar el pasado, criticar el presente, imaginar el futuro* (2004); *Pensar en/la postdictadura* (co-edited with Alberto Moreiras, 2000); and *Políticas y estéticas de la memoria* (1999).

Marcy Schwartz is a professor of Latin American literature and the director of graduate programs in Spanish at Rutgers University. She is the author of *Writing Paris: Urban Topographies of Desire in Contemporary Latin American Fiction* (1999); co-editor (with Daniel Balderston) of *Voice-Overs: Translation and Latin American Literature* (2002); and co-editor (with Mary Beth Tierney-Tello) of *Photography and Literature in Latin America: Double Exposures* (2006). Her current book project examines literary and visual representations of Latin American urban space.

George Yúdice is a professor of Latin American studies and modern languages and literatures at the University of Miami. He is the author of *Vicente Huidobro y la motivación del lenguaje poético* (1977); *Cultural Policy* (2002) (with Toby Miller); and *Nuevas tecnologías, música y experiencia* (2007). He has written more than one hundred articles on literature, art, culture, and cultural policy in the United States and in Latin America.

Index

Rebecca E. Biron is an associate professor in the
Department of Spanish and Portuguese at Dartmouth
College. She is the author of *Murder and Masculinity:
Violent Fictions of Twentieth-Century Latin America* (2000).

Library of Congress Cataloging-in-Publication Data
City/art : the urban scene in Latin America /
Rebecca E. Biron, editor.
p. cm.
Includes bibliographical references and index.
ISBN 978-0-8223-4455-1 (cloth : alk. paper)
ISBN 978-0-8223-4470-4 (pbk. : alk. paper)
1. City and town life—Latin America. 2. Public art—
Latin America. 3. Street art—Latin America. 4. City
planning—Latin America. I. Biron, Rebecca E.
HT384.L29C57 2009
307.76098—dc22 2009003600